"Despite his often biting criticism and emphatic rejections of modern art, those who read Hans Rookmaaker closely know that the care and attentiveness he displayed in engaging the art of his day intimated a valuation far beyond mere condemnation. The same spirit of eager and attentive hospitality can be seen in this rejoinder by Bill Dyrness and Jon Anderson. With the studied investment in their diverse subjects and the poignant reflections emerging throughout, they have demonstrated that both Rookmaaker's vocation and burden are live categories for our time. More than a response to the original, *Modern Art and the Life of a Culture* is an invaluable companion to Rookmaaker and essential reading for any serious Christian encounter with modern art."

Taylor Worley, associate professor of faith and culture, Trinity International University

"This is a book we have needed for a long time. The standard story of modern art, told by religious and nonreligious people alike, is that it is the art of secularism and pervaded by nihilism. That was the story told by Hans Rookmaaker more than forty years ago in the book that became enormously influential among evangelicals, *Modern Art and the Death of a Culture.* Anderson and Dyrness tell a very different story. They show that modern art has been pervaded by religious concerns and theological issues. What they have dug up is truly amazing; the book is an eye-opener. They frame their story as a response to Rookmaaker. But the story they tell and the interpretations they offer are for everyone. Only those who refuse to read can ever again think of modern art in the old way."

Nicholas Wolterstorff, Noah Porter Professor Emeritus of Philosophical Theology, Yale University, senior research fellow, Institute for Advanced Studies in Culture, University of Virginia

"As insightful as Hans Rookmaaker's provocative book *Modern Art and the Death of a Culture* (1970) was in tracing with broad strokes his concern with the cultural demise of Christian values in the post-Enlightenment West, Anderson and Dyrness make probing and illuminating use of the forty-five years of subsequent research to show that the sacred and secular have been far more complexly interwoven than Rookmaaker recognized. The authors, using the same end date, open up a broad spectrum of well-researched and illuminating contextual material that serves as a needed corrective to Rookmaaker's generalized schema and models a multidisciplinary, art-historical and theological approach that is deliberately generous, open and sympathetic rather than confrontational."

E. John Walford, professor emeritus of art history, Wheaton College

GW00775935

MODERN
ART AND
THE LIFE OF
A CULTURE

THE RELIGIOUS
IMPULSES OF
MODERNISM

Jonathan A. Anderson
and William A. Dyrness

IVP Academic

An imprint of InterVarsity Press
Downers Grove, Illinois

InterVarsity Press
P.O. Box 1400, Downers Grove, IL 60515-1426
ivpress.com
email@ivpress.com

InterVarsity Press® is the book-publishing division of InterVarsity Christian Fellowship/USA®, a movement of students and faculty active on campus at hundreds of universities, colleges and schools of nursing in the United States of America, and a member movement of the International Fellowship of Evangelical Students. For information about local and regional activities, visit intervarsity.org.

All Scripture quotations, unless otherwise indicated, are taken from THE HOLY BIBLE, NEW INTERNATIONAL VERSION®, NIV® Copyright © 1973, 1978, 1984, 2011 by Biblica, Inc.™ Used by permission. All rights reserved worldwide.

Cover design: David Fassett
Interior design: Beth McGill
Images: A Shower of Eyes by Jan Groneberg (Contemporary Artist) / Private Collection / Bridgeman Images

ISBN 978-0-8308-5135-5 (print)
ISBN 978-0-8308-9997-5 (digital)

Printed in the United States of America ♾

 As a member of the Green Press Initiative, InterVarsity Press is committed to protecting the environment and to the responsible use of natural resources. To learn more, visit greenpressinitiative.org.

Library of Congress Cataloging-in-Publication Data

Names: Anderson, Jonathan A., 1977- author. | Dyrness, William A., author.
Title: Modern art and the life of a culture : the religious impulses of
* modernism / Jonathan A. Anderson and William A. Dyrness.*
Description: Downers Grove, IL : InterVarsity Press, 2016. | Series: Studies
* in Theology and the Arts | Includes bibliographical references and index.*
Identifiers: LCCN 2016007933 (print) | LCCN 2016008542 (ebook) | ISBN
* 9780830851355 (pbk. : alk. paper) | ISBN 9780830899975 (eBook)*
Subjects: LCSH: Modernism (Art)--Themes, motives. | Christianity and art. |
* Rookmaaker, H. R. (Hendrik Roelof), 1922-1977. Modern art and the death of*
* a culture.*
Classification: LCC N6494.M64 A53 2016 (print) | LCC N6494.M64 (ebook) | DDC
* 261.5/7--dc23*
LC record available at http://lccn.loc.gov/2016007933

P	24	23	22	21	20	19	18	17	16	15	14	13	12	11	10	9	8	7	6	5	4	3	2	1
Y	36	35	34	33	32	31	30	29	28	27	26	25	24	23	22	21	20	19	18	17	16			

One should reject nothing without a determined attempt to discover the living element within it.

VASILY KANDINSKY

Contents

Preface

In 1970 InterVarsity Press published *Modern Art and the Death of a Culture*, a book by the Dutch art historian Hans Rookmaaker that offered a retelling of the history of modern art by linking it to broader dynamics of religious (un)belief in Western cultures. Rookmaaker argued that beneath all its other orders of meaning, modern art was shaped by fundamentally *theological* assumptions and practices—and in his view there were some deeply problematic theologies that were in play. His book has become a classic in some circles: the majority of Christians interested or involved in the visual arts have read it at some point. At the same time, however, it is almost entirely ignored outside of those circles: within the academic art discourse, Rookmaaker's theological method and the narrative of modernism that emerged from it are foreign and idiosyncratic. This incongruity is emblematic of larger disconnects between the worlds of modern art and Christianity, particularly in its evangelical forms.

Written four and a half decades later, this present book, *Modern Art and the Life of a Culture*, is in some ways a grandchild of Rookmaaker's volume. We share Rookmaaker's belief that the history of modern art does indeed carry an enormous amount of theological freight, even if it generally remains under-interpreted as such in the academic discourse. However, as might be surmised by comparing our title and his, this is also a kind of belated riposte to his book. Our sympathies with Rookmaaker are tempered by some deep reservations and disagreements about the ways he interpreted modern art history and its theological meanings. His work was surely ennobling to many Christians who were struggling to think more carefully about twentieth-century artistic practices—indeed, he opened up intellectual space that the present authors have certainly benefited from—but his critical method and his declinist

account of modern art history have also produced significant impediments to understanding and constructively contributing to the primary art discourses. Readers of Rookmaaker who spend extended time in a graduate art program inevitably encounter these impediments in one way or another.

In what follows we intend to pay tribute to Rookmaaker's pioneering study and to the generative thinking it fostered for many Christians, yet at the same time we will critique and supplant the central theses of that book. In contrast to Rookmaaker's approach, we propose to attend to modern art in terms of "the *life* of a culture," by which we mean to signal at least two themes that we will highlight throughout: (1) This book is an attempt to trace some of the ways that religious life—within Christian traditions in particular—continued to influence and constructively shape the development of the modernist avant-garde, despite general impressions to the contrary. And (2) we wish to investigate the ways that modernist artists were attempting to come to terms with (the meanings of) life in the age of modernity, which consistently pulled unresolved theological questions and concerns into the cultural foreground. In light of these themes, this book is a preliminary attempt to revisit the rise of modernist art in visual art in the nineteenth and twentieth centuries and to contest the reigning narrative of that period (which Rookmaaker only reinforced)—namely, that it represents a growing secularization and antipathy toward religion. Rather, we will argue for a rereading of modern art history that recognizes the more complicated roles of religious tradition and theological questioning in the formation of that history.

In taking up these tasks, this book is also an attempt to press into what Sally Promey has called the "historical absence of interdisciplinary collaboration between those invested in the academic study of art and religion—and especially the disinclination of art historians to come to scholarly terms with religion."[1] The argument presented here is the product of collaboration between a theologian of culture, William Dyrness, and an artist and art critic, Jonathan Anderson. This collaboration is intended to bring modern art history and theology—two disciplines that have historically been in conflict or simply unintelligible to each other—into more direct, mutually enriching conversation.

[1]Promey, "The Visual Culture of American Religions: An Historiographical Essay," in *Exhibiting the Visual Culture of American Religions*, ed. David Morgan and Sally M. Promey (Valparaiso, IN: Brauer Museum of Art, 2000), 5.

We hope that by including the different perspectives and disciplinary backgrounds of the two authors, this partnership will contribute to a more holistic view of this period.

Such collaboration inevitably produces multiplicity in the points of view, writing styles and positions taken; and the methods and angles of approach in the following pages will vary accordingly. Bill is drawn to a more historical and genealogical approach, tracing the lines of *influence* by which religious practices and theological thinking have, directly or indirectly, shaped the lives of modern artists and their communities. Jonathan's framework is more critical and philosophical, oriented toward questioning the ways that religious contexts and theological concerns bear upon our encounters with and *interpretations* of particular artists and artworks. Our differences are also evident in the use of key vocabulary, which a careful reader may notice. For example, Bill will use *theology* in the sense of God's actual presence (or absence) in the development of cultural products and in the way theological ideas and traditions have, often unnoticed, exercised continuing influence. Jonathan understands *theology* as a particular kind of questioning within a particular field of concerns—one that explores the meaning of some aspect of human experience (an art object, for instance) in relation to the presence (or absence) of God. Ultimately these approaches need one another and are meant to be complementary, though they tend to proceed by paying attention to different things in different ways (and thus tend to produce different insights). With whatever strengths and weaknesses the resulting book may have, we let it stand as an artifact of the kind of collaborative engagement that we hope will happen with greater depth and regularity in the years ahead.

This book unfolds in two parts. Part one includes two introductory chapters that situate our project in its relevant critical contexts and work through some of the difficulties that must be addressed. Chapter one provides an introduction to the strange and challenging place of religion in the contemporary discourse of modern art. Chapter two narrows the focus to one of the dominant strands of Christian commentary on modern art history and criticism, focusing specifically on Rookmaaker and the ways his work has carried through to the present with both helpful and hindering effects.

Part two then engages in more focused art historical studies that are organized by geographical region, each offering a series of investigations of varying

lengths and scopes into particular artists, artworks, texts and histories asso-
ciated with those regions. In chapter three, Bill considers the historical devel-
opment of styles and attitudes in France, showing the influence of theological
reflection not only on French but also (subsequently) on British modernism.
In chapters four and five, Jonathan investigates modernist painting in northern
Europe and Russia, focusing especially on the ways that the dismantling of
pictorial space in these regions was bound up (often explicitly) in theological
concerns inherited from the traditions of Protestantism and Russian Or-
thodoxy, respectively. In chapter six, Bill explores the early periods of painting
and religion in North America during a time when such influences were easier
to track down and describe. And in chapter seven Jonathan examines a handful
of postwar American artists who grappled with difficult questions about visual
meaning in an age of mass-media consumerism—and did so within specifi-
cally theological frames of reference.

It might be appropriate to include a word here about the limited parameters
of this project. Our choice to limit ourselves to a narrow set of geographical
and cultural centers of influence—France, England, Germany, Holland,
Russia and the United States—follows from two considerations: (1) we are
specifically revisiting the regions and the artists most commonly associated
with modernism, including those who were the focus of Rookmaaker's book,
and (2) since our interest is in the influence of religion and religious traditions,
we have focused our attention on tracking the influences of the major Christian
traditions: Catholic, Orthodox and Protestant.[2] Obviously these limitations
produce various lacunae that are evident in the chapters that follow. Nu-
merous extremely important artists have been left out or given regrettably
short shrift; the full scope of what Robert Rosenblum calls the "Northern
Romantic tradition" will not be covered; southern and eastern Europe deserve
much more attention than they receive here; the early history of art in the
United States has been passed over; and the rich religious heritage of Britain
before the influence of French traditions has been left to one side. And of
course by limiting ourselves to North Atlantic modernism we have had to
remain silent about the work of numerous important modernists working in
Central and South America, Africa and Asia—many of whom would

[2]An early general outline of our proposed argument appears in William A. Dyrness, "A Lasting
Impression," *Harvard Divinity Bulletin* 35 (Spring/Summer 2007): 79-84.

contribute enormous insights to this discussion. Nevertheless, we hope our selection provides significant points of entry into this period, and we hope that other scholars will follow up with further studies. We make no claim to provide anything like a full portrait of artistic modernism here; these are rather a series of snapshots that hopefully will help shift the center of focus in discussions about religion and modernism.

We have accumulated many debts in the preparation of this work. Bill wants to thank colleagues at the Brehm Center for Worship, Theology and the Arts at Fuller Seminary, especially Robert Johnston and Todd Johnson. Jonathan thanks his colleagues in the art department at Biola University, all of whom have been generous friends and patient dialogue partners. We both thank Daniel Siedell for his encouragement and his contribution of an afterword, as well as Taylor Worley and the anonymous reviewers who offered very helpful feedback on an earlier version of the manuscript. We are grateful to Fuller PhD students Maria Fee and Christi Wells for their research assistance. And we thank our excellent editors, David McNutt and Daniel Reid, who carefully and patiently supported this project through its long gestation.

Los Angeles
August 2015

CRITICAL CONTEXTS

Introduction

Religion and the Discourse of Modernism

> *God is almost always the wrong word when it comes to modern art, and every viewer has to find her own way among the other options.*
>
> JAMES ELKINS[1]

> *Let us say this clearly: our modern, secular discourse emerges from a Christian context that contemporary discussions of art ignore because they trace the roots of the discourse on art only to Kant and to the European classification of the fine arts that emerged in the eighteenth century . . . often ignoring the broadly religious context in which even ancient sources were embedded in the Early Modern discourse.*
>
> DONALD PREZIOSI AND CLAIRE FARAGO[2]

> *What use did the artist make of pictorial tradition; what forms, what schemata, enabled the painter to see and to depict? It is often seen as the only question. It is certainly a crucial one, but when one writes the social history of art one is bound to see it in a different light; one is concerned with what prevents representation as much as what allows it; one studies blindness as much as vision.*
>
> T. J. CLARK[3]

[1]Elkins, *Pictures & Tears: A History of People Who Have Cried in Front of Paintings* (New York: Routledge, 2001), 195.

[2]Preziosi and Farago, *Art Is Not What You Think It Is* (Malden, MA: Wiley-Blackwell, 2012), x.

[3]Clark, *Image of the People: Gustave Courbet and the 1848 Revolution* (London: Thames & Hudson, 1973), 15.

Publishing a book that explores the religious (particularly Christian) influences and impulses running through modern art may seem an act of folly or hubris. During the rise of high modernism—which we will take to extend roughly from 1800 to 1970—the mutual influences and connections between visual art and Christianity are not obvious, at least not in most histories of the modern period. In fact, from reading the academic literature on this period, one might believe that religion played almost no constructive role at all in the development of modern art, other than as adversary and rival. Indeed, the dominant narratives of modern art portray it as achieving a progressive independence from religious influence, even as it usurped roles once confined to traditional religion. In these pages we want to contest and revise this narrative.

In part this narrative rests on a more sweeping story of secularization, which has in recent years come under attack—so it makes sense for us to begin our account there. Nearly all quarters of academia today are grappling with what appears to be a "return of religion." In the late 1990s, the sociologist of religion Peter Berger published his repudiation of "secularization theory"—the hypothesis that modernization implies and produces a decline of religion in both social institutions and individual belief—contending that contrary to his own predictions the modern world is in fact *de*secularizing.[4] The two exceptions he identified (the primary spheres in which the secularization thesis still holds descriptive power) were western Europe and the elite "international subculture" of higher education.[5] But in the nearly two decades since Berger's article first appeared, even these exceptions no longer align with the theory.

Much of the pressure that has challenged secularization theory has been historical and sociological: the thesis simply doesn't describe what has happened in the world over the past few decades, nor does it square with current sociodemographic projections for the coming decades.[6] So it seems that some

[4]See Berger, "Secularism in Retreat," *National Interest* 46 (Winter 1996–1997): 3-12. Berger's essay was subsequently adapted and republished as "The Desecularization of the World: A Global Overview," in *The Desecularization of the World: Resurgent Religion and World Politics*, ed. Peter L. Berger (Washington, DC: Ethics and Public Policy Center; Grand Rapids: Eerdmans, 1999), 1-18. See also Rodney Stark, "Secularization, R.I.P.," *Sociology of Religion* 60, no. 3 (Fall 1999): 249-73.

[5]Berger, "Desecularization of the World," 9-10. Regarding the influence of academia, he continues: "While its members are relatively thin on the ground, they are very influential, as they control the institutions that provide the 'official' definitions of reality, notably the educational system, the media of mass communication, and the higher reaches of the legal system" (10). Indeed, "the plausibility of secularization theory owes much to this international subculture" (11).

[6]See, for example, Eric Kaufmann, *Shall the Religious Inherit the Earth? Demography and Politics in*

significant blind spots were intrinsic to the theory, which have corresponded with some serious misunderstandings about the ongoing influence of religious life within modernity. As some scholars have recently argued, "whatever the causes of this scholarly inattention to religion—and they are many and varied— the consequences are clear enough: some of the most important features of modern life have been misapprehended or ignored entirely."[7]Alongside this pressure from sociology, there has also been a gradual and decisive unraveling of the historical, philosophical and theoretical fabric of secularization theory.[8] It has become evident that "secularization has been as much 'a program' as it has been an empirically observable reality"[9]—a program fueled by questionable premises and maintained through selective fields of vision. It is becoming increasingly the case that understanding modernity as "a straightforward narrative of progress from the religious to the secular is no longer acceptable."[10]

While this does not imply a return to religious belief on the part of most scholars, it does mean that religious belief and practice are back on the table with a visibility that they have not had for decades, both as objects of study and as resources for thinking and inquiring. In January 2005 Stanley Fish recounted in *The Chronicle of Higher Education*:

> When Jacques Derrida died [in October 2004] I was called by a reporter who wanted to know what would succeed high theory and the triumvirate of race, gender, and class as the center of intellectual energy in the academy. I answered

the Twenty-First Century (London: Profile Books, 2011). See also coauthored essays by Eric Kaufmann, Anne Goujon and Vegard Skirbekk: "Secularism, Fundamentalism, or Catholicism?: The Religious Composition of the United States to 2043," *Journal for the Scientific Study of Religion* 49, no. 2 (June 2010): 293-310; and "The End of Secularization in Europe?: A Socio-Demographic Perspective," *Sociology of Religion* 73, no. 1 (Spring 2012): 69-91.

[7]Philip S. Gorski, David Kyuman Kim, John Torpey and Jonathan VanAntwerpen, "The Post-Secular in Question," in *The Post-Secular in Question: Religion in Contemporary Society*, ed. Philip S. Gorski (Brooklyn: Social Science Research Council, 2012), 5.

[8]See, for example, Charles Taylor, *A Secular Age* (Cambridge, MA: Belknap / Harvard University Press, 2007), esp. part 4. See also David Sorkin, *The Religious Enlightenment: Protestants, Jews, and Catholics from London to Vienna* (Princeton, NJ: Princeton University Press, 2011); Nigel Aston, *Christianity and Revolutionary Europe, 1750–1830* (Cambridge: Cambridge University Press, 2003); idem, *Art and Religion in Eighteenth-Century Europe* (London: Reaktion Books, 2009); and Jonathan Sheehan, *The Enlightenment Bible: Translation, Scholarship, Culture* (Princeton, NJ: Princeton University Press, 2007).

[9]Gorski et al., "Post-Secular in Question," 14.

[10]Talal Asad, *Formations of the Secular: Christianity, Islam, Modernity* (Stanford, CA: Stanford University Press, 2003), 1. And, more recently, see Brad S. Gregory, *The Unintended Reformation: How a Religious Revolution Secularized Society* (Cambridge, MA: Belknap / Harvard University Press, 2013).

like a shot: religion. . . . Announce a course with "religion" in the title, and you will have an overflow population. Announce a lecture or panel on "religion in our time" and you will have to hire a larger hall.[11]

The disciplines of art history and criticism (similarly to literary history and criticism) are still working out what this will mean. In many ways these fields remain deeply enmeshed in the secularization thesis, but things are changing. In 2003, six years after Berger's original article appeared, Yale art historian Sally Promey published an essay in *The Art Bulletin* arguing that the scholarship on American art history was experiencing (and needed to welcome) the "return" of religion to its field of inquiry.[12] And over the past two decades an increasing number of other scholars (from an increasing number of perspectives) have begun exploring the problems and possibilities of including religion in the study of modern art: James Elkins, David Morgan, Debora Silverman, John Golding, Andrew Spira, Eleanor Heartney, Mark C. Taylor, Daniel Siedell, Lynn Gamwell, Erika Doss, Cordula Grewe, James Romaine, Donald Preziosi, Charlene Spretnak, Aaron Rosen and many others.[13]

The subsequent results have tended to be noisy and confusing, taking on board a wild array of positions and interests, but there are two general ways that this return is shaping today's art discourse. On the one hand, there is a

[11]Fish, "One University, Under God?" *Chronicle of Higher Education* 51, no. 18 (January 7, 2005): C1, C4.

[12]Promey, "The 'Return' of Religion in the Scholarship of American Art," *Art Bulletin* 85, no. 3 (September 2003): 581-603.

[13]Many of these scholars will be cited in what follows. In addition to those works cited below, and in order to highlight some of the more recent publications, see Alberta Arthurs and Glenn Wallach, eds., *Crossroads: Art and Religion in American Life* (New York: New Press, 2001); Eleanor Heartney, *Postmodern Heretics: The Catholic Imagination in Contemporary Art* (New York: Midmarch Arts Press, 2004); Ena Giurescu Heller, ed., *Reluctant Partners: Art and Religion in Dialogue* (New York: Gallery at the American Bible Society, 2004); Maria Hlavajova, Sven Lütticken and Jill Winder, eds., *The Return of Religion and Other Myths: A Critical Reader in Contemporary Art* (Utrecht: BAK and Post Editions, 2009); Rina Arya, ed., *Contemplations of the Spiritual in Art* (Bern: Peter Lang, 2013); James Romaine and Linda Stratford, eds., *ReVisioning: Critical Methods of Seeing Christianity in the History of Art* (Eugene, OR: Cascade Books, 2013); Donald Preziosi, *Art, Religion, Amnesia: The Enchantments of Credulity* (New York: Routledge, 2014); Charlene Spretnak, *The Spiritual Dynamic in Modern Art: Art History Reconsidered, 1800 to the Present* (New York: Palgrave Macmillan, 2014); Cordula Grewe, *The Nazarenes: Romantic Avant-Garde and the Art of the Concept* (University Park, PA: Penn State University Press, 2015); David Morgan, *The Forge of Vision: A Visual History of Modern Christianity* (Oakland: University of California Press, 2015), esp. chap. 7; Nicholas Wolterstorff, *Art Rethought: The Social Practices of Art* (Oxford: Oxford University Press, 2015); and Aaron Rosen, *Art + Religion in the 21st Century* (New York: Thames & Hudson, 2015).

growing sense that art history and criticism cannot adequately account for the depth and complexity of how art "means" in a given cultural context without accounting, even if only on a strictly sociological level, for the religious backgrounds and dynamics in that society. This is not a recovery of belief as much as it is the reinclusion of religious institutions, histories and practices into the relevant evidence base for historical-critical study. As Promey sees it, for example, the return of religion is a necessary part of "an effort to recuperate a closer approximation to the historical whole, to include within scholarly purview the full range of practices that make images work."[14] Thus, even from a strictly (materialist) sociological perspective, it is becoming a rhetorical question: "how much of social life can we understand if we exclude religion from our analyses?"[15] But Promey has something further in mind: the long histories of art out of which modernism grows have been, for the most part, deeply religious histories, even if these have been suppressed. She argues that "time and again we encounter evidence that secular modernity in the West has not been what it has made itself out to be. It has, in fact, been shaped through a process of purging, purifying, and neutralizing, from within itself, those [religious] things most dear to it, those things most fearful: casting them out into other vessels in contrast to which it has then come to understand itself."[16] How can the meanings of modern art be sustained over the long term, when these dear and fearful roots are uniformly ignored?

On the other hand, the return of religion has also begun functioning on more personal and philosophical levels. Numerous scholars—many who still self-identify as resolutely secular—are voicing their own personal "disenchantment with modern disenchantment,"[17] and they are beginning to

[14]Promey, "The 'Return' of Religion," 589. See also Sally M. Promey, "Situating Visual Culture," in *A Companion to American Cultural History*, ed. Karen Halttunen (Malden, MA: Blackwell, 2008), 279-94; and David Morgan, "Visual Religion," *Religion* 30 (2000): 41-53.

[15]Gorski et al., "Post-Secular in Question," 15.

[16]Sally M. Promey, "Religion, Sensation, and Materiality: A Conclusion," in *Sensational Religion: Sensory Culture in Material Practice*, ed. Sally M. Promey (New Haven, CT: Yale University Press, 2014), 651.

[17]Jeffrey L. Kosky, *Arts of Wonder: Enchanting Secularity—Walter De Maria, Diller + Scofidio, James Turrell, Andy Goldsworthy* (Chicago: University of Chicago Press, 2013), xi. For a further sampling, see also Suzi Gablik, *The Re-Enchantment of Art* (New York: Thames & Hudson, 1991); Dawn Perlmutter and Debra Koppman, eds., *Reclaiming the Spiritual in Art: Contemporary Cross-Cultural Perspectives* (Albany: SUNY Press, 1999); and Mark C. Taylor, *Refiguring the Spiritual: Beuys, Barney, Turrell, Goldsworthy* (New York: Columbia University Press, 2012). Regarding the reference to Max Weber's notion of "disenchantment," see below for further discussion.

conduct their scholarship from this position, exploring the possibilities for fostering "reenchantment" in the visual arts. This body of literature pushes past many of the sociological concerns that drive the reconsideration of religion in art and actually brings religion, spirituality and theology into the *interpretative encounter* with the work. In his recent book *Arts of Wonder*, Jeffrey Kosky argues precisely along these lines:

> In denying themselves recourse to religious vocabulary or theological conceptuality, modern art critics give up what would be advantageous to a profound encounter with the works in question. Religion and theology has [*sic*] let me name what the art critic often names and addresses with only limited vocabulary. In this sense, it lets me prolong the encounter with the work of art, deepening the event of its coming intimately over me and bringing its strangeness to light.[18]

Kosky's aim is not to revive religion but to enchant secularity: he wants to "break the necessary connection between secularity and disenchantment," thus opening "a future for a more appealing secularity, one full of charm."[19] As he sees it, the reigning narrative of art cannot sustain its value without recourse to religion, or at least to a discourse that borrows heavily from religious tradition.

Daniel Siedell has similarly argued that religious vocabulary and theological conceptuality are uniquely capable of naming an important level of meaning in modern and contemporary art, but by contrast he pursues this kind of critical engagement from a position that inhabits religious belief. He argues that "a critical perspective nourished by the Nicene Christian faith can contribute to the understanding of contemporary art" by expanding our sensitivities to "the sacramental and liturgical identity of human practice" within the arts.[20] Siedell takes his lead from Paul's discourse in the council of the Areopagus about "the unknown god" (Acts 17:16-34), and he orients his criticism in its terms: "Altars to the unknown god are strewn about the historical landscape of modern and contemporary art. They are often remarkably beautiful, compelling, and powerful. But they have been too often ignored or

[18]Kosky, *Arts of Wonder*, 173.
[19]Ibid., 173, 177.
[20]Siedell, *God in the Gallery: A Christian Embrace of Modern Art* (Grand Rapids: Baker Academic, 2008), 110, 130.

condemned out of hand." Siedell's critical method is thus "the result of choosing the way of St. Paul: to take the cultural artifacts and to reveal and illuminate their insights into what they are only able to point to, not to name. But point they do, and they should be examined and celebrated as such."[21] From a wide array of positions, both secular and religious, there are increasing examples of modern art criticism becoming a realm of theological thinking.

This does not mean that religious *belief* enjoys any kind of pride of place in the discourse of art, but it does mean that religious histories, practices and theological traditions have a renewed relevance and weight in the discussion. It is probably most accurate to say that the scholarship of modern art is becoming increasingly "postsecular," emerging into an indeterminate space beyond the lifespan of the secularization thesis. As Canadian philosopher Charles Taylor makes clear, this postsecular space doesn't necessarily entail a return to traditional religious faith; rather (1) it is "a time in which the hegemony of the mainstream master narrative of secularization will be more and more challenged," and (2) this will be accompanied by "a new age of religious searching, whose outcome no one can foresee."[22] In other words, if one effect of modernity was the possibility of envisioning the secular without any recourse to the sacred or transcendent, then the discourse of postsecularity throws open a wide range of possibilities for envisioning the modern without recourse to a reductive secular*ism.*[23] At any rate, simply the openness of this condition invites the reintroduction of religious questioning back into the conversation.

However, there are still numerous problems that must be faced in the midst of this widening conversation. First, there are *historical* problems. The postsecular turn is not only shifting the conditions for the production and interpretation of art in the present and near future; it also begs for a rereading of

[21]Ibid., 11.

[22]Charles Taylor, *Secular Age*, 534-35. One way to interpret this is to say that *postsecular* refers to a contraction of the secular*ism* of what Taylor calls secularity 2 (a turning away from God, p. 2) but an expansion of the effects of secularity 3 (a condition in which belief in God is no longer axiomatic, p. 3). Thus in a postsecular age one of the central features of secular 3 modernity simply expands: "We are now living in a spiritual super-nova, a kind of galloping pluralism on the spiritual plane" (300). See below for further discussion of Taylor's definitions of secularity.

[23]Sarah Bracke makes a similar statement in "Conjugating the Modern/Religious, Conceptualizing Female Religious Agency: Contours of a 'Post-secular' Conjuncture," *Theory, Culture & Society* 25, no. 6 (2008): 59.

the recent past. The canonical texts of modern art history were extensively shaped (sometimes explicitly so) by the secularization thesis, and as this thesis is called into question so too are the narratives that have been structured by it. The histories of modernism will be increasingly opened to reconsideration along religious and theological lines of inquiry, but this must be done carefully and with historical rigor. The theological content of modernist artworks and the religious contexts that shaped them are complex and sometimes deeply conflicted, and the most helpful scholarship in this discussion will be that which brings greater clarity to these complexities without neatly smoothing them out for ideological convenience. Second, there are *theoretical* problems to deal with here: namely, it is unclear how theological reconsiderations of modern art are to proceed in terms of interpretive method. Rereading modernist history in a postsecular setting places new demands on one's critical theory, and it is immediately evident that there are significant deficits in the available critical methods with regard to conducting sustained theological thinking about modern art. Though each of these problems requires further treatment beyond what we are able to offer here, in this book we will need to wrestle with the problems of both history and theory.[24]

MODERNITY AND SECULARITY

As should be clear, none of this implies that the postsecular turn simply dissolves the links between modern art and secularity, nor does it sidestep the truly conflicted relationships that developed between modern artists and the church. It does imply, however, a reconsideration of how we understand these links and these relationships. The title of our book, *Modern Art and the Life of a Culture*, subtly gestures toward this kind of reconsideration: we want to reopen the meanings of modernism—and its secularity—in relation to the conditions of cultural (and religious) life within which it emerged.

To do this, we need to clarify the terms we will use to address these conditions. As is typical, we will use the term *modernity* to refer to the sociocultural conditions of modernization—especially the complex transformations

[24]As explained in the preface, we seek to merge discussions of history and genealogy with those of criticism and interpretation; and in this each of the authors is drawing from his particular strengths. Jonathan is working on another work that deals with theory and criticism in more detail. As will be clear, Bill's chapters focus more on historical influences and relationships.

associated with industrialization, urbanization and democratization—which profoundly reshaped the attitudes, presuppositions and patterns of life fitted to those conditions. In his definitions of modernity, Charles Taylor refers to a threefold "historically unprecedented amalgam" of (1) new institutional forms and practices, which are centralized in cities and organized by science, technology, economics and industrial production; (2) new values and attitudes that privilege individualism, democracy and instrumental rationality; and (3) new forms of malaise that include alienation, meaninglessness and a sense of impending social dissolution.[25]

Art historian T. J. Clark summarizes the meaning of this cultural amalgam by arguing that the primary identifying experience of life within modernity is *contingency*.[26] On many levels this experience is simply integral to living within the mechanized speed of the modern metropolis;[27] but more profoundly it also refers to a "distinctive patterning of mental and technical possibilities" by which a society becomes generally persuaded that *all things might be otherwise*. Chiefly through the powers of rational scrutiny, technological innovation and social-political organization, the various facets of human life, history and cosmos have become unprecedentedly malleable. As Clark argues, this has fundamentally reorganized human orientations toward not only space but also time, creating a social order that has turned from forms of worship and sources of authority organized and stabilized by what has happened in the past "to the pursuit of a projected future—of goods, pleasures, freedoms, forms of control over nature, or infinities of information."[28] This turning entailed "a

[25]See, for instance, Charles Taylor, *Modern Social Imaginaries* (Durham, NC: Duke University Press, 2004), 1.

[26]Clark, *Farewell to an Idea: Episodes from a History of Modernism* (New Haven, CT: Yale University Press, 1999), 7.

[27]One of the most insightful and interesting accounts on this issue is still the 1903 essay "The Metropolis and the Mental Life" by German sociologist Georg Simmel. Writing at the turn of the twentieth century, Simmel carefully studied the ways that urbanization was altering "the sensory foundations of psychic life." In contrast to rural and small-town life, he argued that "the intensification of nervous stimulation" in the city was such that "the metropolis exacts from man as a discriminating creature a different amount [and different quality] of consciousness than does rural life." Simmel, "The Metropolis and the Mental Life," trans. H. H. Gerth and C. Wright Mills, in *The Sociology of Georg Simmel*, ed. Kurt H. Wolff (Glencoe, IL: Free Press, 1950), 409-24.

[28]Clark, *Farewell to an Idea*, 7. His actual phrase identifies modernity with "a social order which has turned from *the worship of ancestors and past authorities* to the pursuit of a projected future" (emphasis added). This is an odd formulation, given that in Western societies ancestor worship is generally associated with more archaic pre-Christian (rather than simply premodern) societies, which would appear to impossibly ignore the Christian Middle Ages against which modernity is

great emptying and sanitizing of the imagination" by which the horizons of what is collectively considered possible and plausible across the many spheres of human life were thrown wide open. And while this has had some enormously liberating and empowering effects, it has also fostered a deeply unsettling sense that

> we are living a new form of life, in which all previous notions of belief and sociability have been scrambled. And the true terror of this new order has to do with its being ruled—and obscurely felt to be ruled—by sheer concatenation of profit and loss, bids and bargains: that is, by a system without any focusing purpose to it, or any compelling image or ritualization of that purpose.[29]

According to Clark, "'Secularization' is a nice technical word for this blankness."[30]

Even if the sweeping claims of secularization *theory* are defunct, modernity is still by all accounts deeply associated with *secularity*. However, as already touched on, we must have greater clarity about what this really does—and does not—entail. Clark identifies his descriptions of this "new form of life" with what the German sociologist Max Weber (1864–1920) famously called the "disenchantment of the world." Adapting the phrase from Friedrich Schiller (1759–1805),[31] Weber used it to characterize a general comportment toward the world within North Atlantic modernity: "The fate of our times is characterized by rationalization and intellectualization and above all by 'the disenchantment of the world,'" whereby "we" find ourselves generally persuaded that "there are no

generally juxtaposed. It seems Clark is subtly relabeling Christianity (at least premodern Christianity) as a type of ancestor worship—e.g., reducing the covenant-making God of Abraham, Isaac and Jacob; the worship of Jesus of Nazareth; and the traditional veneration of historical saints to "the worship of ancestors and past authorities." This relabeling is unfair and (deliberately) reductive, but the point of Clark's sentence—that modernity involves a societal reorientation from forms of worship and authority organized by the *past* toward the pursuit of a projected future—is helpful.

[29]Clark, *Farewell to an Idea*, 8.

[30]Ibid., 7.

[31]It is often noted (beginning with Weber's translators, Gerth and Mills) that he borrowed the phrase from Schiller's 1788 poem "The Gods of Greece." However, it must also be noted that if Weber was borrowing from Schiller he did not quote him directly: Schiller's word is *Entgötterung* (a loss of gods), whereas Weber's is *Entzauberung* (a loss of magic—i.e., "disenchantment"). The difference is subtle but significant. As Bruce Robbins has noted, Weber's phrase "may bow gently to Schiller but, whether for reasons of diplomacy or not, it certainly takes the emphasis off divinity. . . . Orthodox belief is not the object Weber is chiefly mourning. Whatever magic is a figure for, non-believers suffer from its loss as much as believers." See Robbins, "Enchantment? No, Thank You," in *The Joy of Secularism: 11 Essays for How We Live Now*, ed. George Levine (Princeton, NJ: Princeton University Press, 2011), 74-94.

mysterious incalculable forces that come into play, but rather that one can, in principle, master all things by calculation."[32] This formulation does not remove God from the world—indeed, Weber believed that disenchantment was primarily attributable to the development of Judeo-Christian (especially Protestant) theology.[33] But it does generally detach divinity from our explanations of the everyday functioning of the world and eradicate "magic" from the field of explanatory possibilities—a field that is reconceived in terms of contingent mechanical causes that are calculable, manipulable and manageable through technological innovation. This detachment and eradication might be understood as a secularizing process but, according to Weber, not in the sense that religious belief collapses. Rather, he believes that religious belief gets pressed into the more private realms of human life: "The ultimate and most sublime values have retreated from public life either into the transcendental realm of mystic life or into the brotherliness of direct and personal human relations."[34]

In his remarkable study of modern secularity, Taylor helps to clarify what this means by carefully distinguishing between at least three ways of defining modern "secularity."[35] The first, which he designates secularity$_1$, exists in the Weberian differentiation between (public) secular space and (private) sacred space as the basic realms or orders of human existence. This secularity consists in the privatization of religion. Secularity$_2$ refers more specifically to the loss of religious belief and practice: a turning away from God, an incredulity and denial at both social and individual levels that there is any need to postulate a transcendent order. This is the secularity of theological renunciation. Though both of these describe major aspects of what it might mean to identify the age of modernity as "secular," Taylor argues that neither of these frames the issue quite correctly. Rather, he proposes a third designation—secularity$_3$—to refer to a profound pluralizing that has occurred in the *conditions* of belief, whereby we have transformed "from a society where belief in God is unchallenged and

[32]Max Weber, "Science as a Vocation" (1918), in *From Max Weber: Essays in Sociology*, trans. and ed. H. H. Gerth and C. Wright Mills (New York: Oxford University Press, 1946), 155, 139.

[33]See Weber, *The Protestant Ethic and the Spirit of Capitalism*, trans. Talcott Parsons (1930; repr., New York: Routledge, 1992); cf. Charles Taylor, *A Secular Age*, esp. 73-89, where he refers to the Protestant Reformation as "an engine of disenchantment" (77). For a discussion of the religious influences on Weber's thinking, see William H. Swatos Jr. and Peter Kivisto, "Max Weber as 'Christian Sociologist,'" *Journal for the Scientific Study of Religion* 30, no. 4 (December 1991): 347-62.

[34]Weber, "Science as a Vocation," 155.

[35]See Taylor, *Secular Age*, esp. 1-3.

indeed, unproblematic, to one in which it is understood to be one option among others, and frequently not the easiest to embrace."[36] In other words, if we associate secularity$_1$ with privatization and secularity$_2$ with renunciation, secularity$_3$ refers to a "mutual fragilization" of many different religious (and irreligious) beliefs and practices such that there is no longer one that functions as axiomatic.[37] Though secularity$_1$ and secularity$_2$ are often presumed to be definitive in discussions of modernization (it is precisely this presumption that the "postsecular" discourse calls into question), Taylor contends that it is actually secularity$_3$ that carries far more explanatory power for understanding the modernity not only of the past but also that of the present (which might be considered a hypermodernity as much as a postmodernity). Modern secularity has much less to do with disbelief in God than with a shift in "the whole background framework in which one believes or refuses to believe in God" and therefore "in the whole context in which we experience and search for fullness."[38] And as such, modern secular society cannot be characterized simply in terms of its unbelief but in terms of the widely diverse forms of belief and unbelief that have become possible: it is an open field in which all of these forms are rendered optional, contestable and contingent.[39]

Taylor's distinctions are also extremely helpful for understanding the *art* of modernity. And here we encounter a vital distinction that shapes our study: within the arts, modern*ism* is generally understood as a response (often a revolt) from within and against the culture of modern*ity*. Modern art is not simply any work made in the modern age; rather it is artwork that is self-consciously responsive and critical with respect to its own social situation and its participation in the (aesthetic) operations of modernity. Properly speaking, modern art is modernist art. And of course the range of responses and critical gestures within modernist art encompass a wide variety of (sometimes widely divergent) artistic movements and positions. For T. J. Clark, the defining characteristic that draws all of these modernisms together is that they attempt to stand and face the disenchantment of the world and the insolvency of tradition as directly and consciously as possible: "Modernism," he writes, "is the art of

[36]Ibid., 3.

[37]Ibid., 595; cf. 303-4, 437, 531-32.

[38]Ibid., 13-14.

[39]For an insightful and accessible commentary on Taylor's work, see James K. A. Smith, *How (Not) to Be Secular: Reading Charles Taylor* (Grand Rapids: Eerdmans, 2014).

these new circumstances. It can revel in the contingency or mourn the desuetude. Sometimes it does both. But only that art can be called modernist that takes the one or other fact as determinant."[40]

Modern art was (is) a profoundly secular enterprise but not, we contend, in the narrow sense of secularity$_2$. Modernism often foregrounded radical unbelief and outright rejections of God, church and transcendence, but to totalize these into a characterization of the whole—or to regard them as determinative of the essential grain of modernism—is to skew the history. The primary feature of modernist art was not its secular$_2$ unbelief but its wrestling with the conditions of a deeply secular$_3$ *contestability* of belief. The artworks (and art histories) under consideration in this book emerged amidst a cultural scrambling of theological concepts and religious practices, and they embody an extremely variegated range of positions, convictions and sensitivities within this highly uncertain, though ideologically pressurized, space. In this context, the fact that modernists challenged or left the church (or that they were sometimes unsavory characters) is not enough to warrant collapsing the theological content of their works into the register of secularity$_2$. Modern art is not principally an art of unbelief; it is an art of *fragilized* belief. It is an art of doubt and searching and, above all, of heightened sensitivity to the contingencies of modern secularity$_3$. And to take it seriously—to really enter into its discourse and the social "art world" through which it circulates—often involves (or reveals) the fragilization of one's own belief. As Taylor puts it, we modern people develop (or discard) our beliefs while looking over our shoulders.[41]

In this context, consider one of modernism's defining characteristics: its oppositional stance toward established norms and traditions.[42] On the one hand, this opposition was directed toward the dominant artistic establishments. Consistently flowing from the mouths and pens (and canvases) of the modernists

[40]Clark, *Farewell to an Idea*, 18. Clark argues that this range (or oscillation) between reveling and mourning is a byproduct of the fact that "modernism is caught interminably between horror and elation at the forces driving it" (8).

[41]Taylor, *A Secular Age*, 11. "We live in a condition where we cannot help but be aware that there are a number of different construals, views which intelligent, reasonably undeluded people, of good will, can and do disagree on. We cannot help looking over our shoulder from time to time, looking sideways, living our faith also in a condition of doubt and uncertainty."

[42]Cf. Frederic Jameson, who argued that what drives modernity is not the need to innovate but the conviction that certain forms are "worn out." Jameson, *The Modernist Papers* (New York: Verso, 2007), 7.

were bitter protests against the "moldy vault"[43] of nineteenth-century academic
art, of which the Académie des Beaux-Arts in Paris and the Royal Academy in
London were most representative (though influential academies flourished in
most major European cities). The academies enshrined subjects and styles
from an idealized past in artworks that appeared to modernist eyes to be es-
capist affectations of the privileged classes, following conventions designed to
be deliberately insulatory from the contemporary energy and dysfunctions of
urban life. In contrast, the "new generation of creators and spectators" held that
an art that is truly new and life-affirming must be attuned to the meanings of
the present moment and must be willing to disentangle itself from whatever
geriatric and outmoded forms have been held in place by history and
convention—regardless of whatever vitality they may once have had.[44] Central
to modernism was an ambition (sometimes calculated, sometimes wildly des-
perate) to be more fully and freely "alive" in the face of and in resistance to all
that was deadening and dehumanizing about modern life.

And in fact there was much to resist. In the increasingly industrialized and
urbanized patterns of modern life, the fragilizing space of modern secularity$_3$
was further pressurized by real suffering and ethical outrage. Alongside every-
thing that is ennobling and liberating about modernity, it has also been a period
of enormous cruelty and suffering—sweatshops, world wars, revolutions,
gulags, death camps, nuclear warfare, postcolonial civil wars, genocides, envi-
ronmental catastrophes and so on—all of which have been given increasing
and historically unprecedented visibility through photographic media and
international news coverage. Indeed, many of the artists who were most central
to the modernist project were people "whose modernism was tempered by the
worst kinds of experience."[45] And in the face of such experience what became
tempered was a persistent faith that the ever-newness of the present moment

[43]Kazimir Malevich, "From Cubism and Futurism to Suprematism," in Harrison and Wood, *Art in
Theory, 1900–2000*, 176.

[44]To take one example, the German expressionist group Die Brücke (the Bridge) staged their first
group exhibition in 1906 in the showroom of the Seifert lamp factory in a suburb of Dresden,
Germany, and distributed block-printed leaflets with this manifesto: "With faith in progress and
in a new generation of creators and spectators we call together all youth. As youth, we carry the
future and want to create for ourselves freedom of life and of movement against the long-established
older forces. Everyone who reproduces that which drives him to creation with directness and au-
thenticity belongs to us." See Ernst Ludwig Kirchner, "Programme of the Brücke" (1906), in *Art
in Theory, 1900–2000*, 65.

[45]Clark, *Farewell to an Idea*, 407.

(and the potential futures it might give way to) might be the realm of something more just and more truly "living" to stand over against the received (often calcified) forms of life that persist from the past. This does not necessitate the rejection of religion, but it does imply a fragilized relation to its traditions.

On the other hand, however, modernist opposition also was directed specifically toward religious institutions and doctrines. For people who care deeply about the health of Christian orthodoxy, this is the aspect of modern art that generally appears most problematic and threatening. Its doubtfulness, its obscurity, its testing of norms and conventions, its eclectic and sometimes unmoored will-to-searching have often been seen as antagonistic to religious belief—or at least as clearly indicative of the erosion of religious tradition in the social imagination. For this reason, when modern art is allowed a theological voice in the writing of art history, it is often represented as (either heroically or belligerently) heterodox, or sometimes as openly nihilistic. The story is much more complex and interesting than that, even among those artists and movements most commonly portrayed as nihilistic, but this is not to deny the remaining deep tensions and difficulties, which must not be simply sanitized or redecorated. The episodes of irreverence and blasphemy must not be handled reductively or dismissively, taking them only in their most superficial or silly forms. Nor must we overlook the extent to which modernism was confronting some real theological failures on the part of North Atlantic churches. All these difficulties must bear on the argument that follows.

The fact is that mutual incomprehension between religious leaders and modern artists prevailed in the modern period, often amounting to an impasse. On the one hand, it is well known that church officials during this period, from a variety of Christian traditions, were notoriously conservative about artistic developments. As a result, some of the most famous artists, even those working with deeply religious motivation, were spurned by the leadership of their communions. Rachmaninoff's famous *All-Night Vigil*, or *Vespers* (1915), was meant to serve the Orthodox liturgy, though it was never officially accepted by the church. Georges Rouault was not given any formal recognition by the Catholic Church until a few years before his death. And so on.[46]

[46]The antipathy of prominent Christian thinkers like G. K. Chesterton and C. S. Lewis toward modern art is also well known. But in general this issue needs a full-scale study, which as far as we know has not been undertaken.

Meanwhile, artists, for their part, have been notoriously diffident about their relationship to formal religious structures. Many modernists were famously allergic to all formal structures and affiliation, whether social, religious or political; but this too says little or nothing about the religious significance of their work. Pablo Picasso provides an interesting example. Critics on the left have been quick to claim Picasso and his famous *Guernica* painting as a distinctly leftist protest against the awful injustices of the Franco regime. The painting certainly was a protest, but as John Richardson has shown, Picasso's political affiliations were not at all settled.[47] And Richardson goes on to liken his unresolved politics to his lifelong struggle with Catholicism, which he tried (Richardson thinks unsuccessfully) to repudiate. Indeed, Picasso himself likened his conflicted politics to his conflicted religion, telling Kahnweiler: "My family . . . they have always been Catholics. They didn't like the priests and they didn't go to mass, but they were Catholics. Well, I am a Communist and I . . ."[48] The moral outcry of the iconic *Guernica* was strongly politically charged, even if Picasso's particular political commitments were unresolved, in much the same way that the painting is also extremely theologically charged, despite (or in light of) the fact that the artist's religious commitments were deeply conflicted. The imagery draws heavily on traditional religious imagery—including paintings of the crucifixion (particularly Grünewald's *Isenheim Altarpiece*), the Pietà, the massacre of the innocents, the penitence of Mary Magdalene and so on—indeed, several theologians have claimed this as "one of the most powerful religious pictures" of the twentieth century.[49]

[47]It is quite true that Picasso was for some time a member of the Spanish Communist Party (though he did not join until 1944), but Richardson has shown that Picasso had earlier claimed to be a monarchist and had eagerly accepted the hospitality of the conservative Falange party because they offered the prospect for a Picasso retrospective in Spain. His dealer and close friend D. H. Kahnweiler called Picasso the most apolitical man he ever met, saying, "His Communism is quite unpolitical. He has never read a line of Karl Marx, nor of Engels of course. His Communism is sentimental. . . . He once said to me, 'pour moi, le Parti Communiste est le parti des pauvres [for me, the Communist Party is the party of the poor].'" John Richardson, "How Political Was Picasso?," *New York Review of Books,* November 25, 2010, 27-30. This is a highly critical review of a 2010 exhibition "Picasso: Peace and Freedom" at Tate Liverpool, which was presumably "celebrating" Picasso's left-wing commitments.

[48]Picasso, quoted in ibid., 30 (ellipses original).

[49]See, for example, Paul Tillich, "Existentialist Aspects of Modern Art" (1956), in *On Art and Architecture,* ed. John Dillenberger and Jane Dillenberger (New York: Crossroad, 1987), 95-96. Tillich famously referred to *Guernica* as "the most Protestant painting of our time," in the sense that "it encounters the reality of the world with protest and prophetic wrath against the destructive and demonic powers of the world." Tillich, "Religious Dimensions of Contemporary Art," in ibid., 179; cf. 119-20, 191.

So it is possible to suggest that the iconic *Guernica*, widely interpreted as a political statement, may just as easily have been a response of religious compassion as it was a political commitment. In any case Picasso's paradoxical affiliations, which are shared by many artists in the modern period, make it hazardous to correlate the ecclesiastical (non)commitment of the artist with the religious significance of his or her work.

Even so, it is no surprise then that for the bulk of the twentieth century many Christians opted to retreat to the sanctuary—or even to Shakespeare's "bare ruin'd choirs"[50]—leaving the art world to its own devices. Some have attempted to mount an offensive, criticizing the tenets of modern and contemporary art that they regard as most anti-Christian. These efforts are aimed at changing minds and redirecting the art discourse, but generally they come from the margins of that discourse and simply drive a deeper wedge between the worlds of Christianity and those of the arts—a wedge that most acutely affects Christian artists and Christian intellectuals and is ignored by almost everyone else. Many others, on the more liberal end of the theological spectrum, have followed Alfred Barr in celebrating modern art as an embodiment of spiritual yearning, "a visible symbol of the human spirit in its search for truth, freedom and perfection."[51] A fairly large body of literature, emanating mostly from a mainline Protestant perspective, has represented this more hopeful view of modernism, seeing artistic innovations as expanding the languages of art and increasing its ability to open (spiritual) worlds of meaning. One of the more perceptive scholars to take this view, Jane Dillenberger, has argued that the separation of art from religion has in fact increased its religious potential: "The more the work of art is separated from the religious drama of worship and liturgy, the more it has to carry a religious totality in itself.... By entering into the dynamics of art of this kind, we find a new form of celebration takes place."[52]

[50]This is from the fourth line of Shakespeare's Sonnet 73:
> That time of year thou may'st in me behold
> When yellow leaves, or none, or few, do hang
> Upon those boughs which shake against the cold,
> Bare ruin'd choirs, where late the sweet birds sang.

[51]Barr, *What Is Modern Painting?* (New York: Museum of Modern Art, 1943), 3. See below for further discussion of Barr's views.

[52]Dillenberger, *Secular Art with Sacred Themes* (Nashville: Abingdon Press, 1969), 126-27. George S. Heyer similarly argues that these new forms "invite us to enter a certain fullness of time that adumbrates . . . the time of God's own Kingdom, in which the sheer succession of moments, the tyranny of time, loses its power.... Like the Gospel, art re-creates us in a fashion nothing else can

This celebration, she thinks, offers new potential for evoking an interior reality that can be deeply religious.

What all these approaches get right is the intuition that theological meanings are in play (and at stake) outside of the territory generally marked as religious. Modern art generated a discourse packed with anthropologies and cosmologies, eschatologies and protologies, meditations on goodness and evil, meaning and meaninglessness, yearning and lament, immanence and transcendence, eternality and ephemerality, Being and Nothingness. And it begs for further interpretation along these lines. However, Christians have often allowed a fairly narrow set of critical gestures to determine and constrain their postures as viewers of art.[53] Because this discourse is so diverse and complex, a wide range of responses might well be legitimate at various points, so we do well to foster a greater agility and creativity in our critical posture toward modern art, allowing for the wide range of responsive gestures between resistance and celebration.

REREADING MODERNISM

Perhaps in a postsecular context the question stands forward in different relief, but it still persists: these two worlds—call them MoMA and Jerusalem—what have they to do with each other? As we hope to show, these worlds have actually had quite a lot to do with each other, despite the profound confusions and conflicts that have often marked their relationship. Consider the example of Alfred H. Barr Jr. (1902–1981), the first director (from 1929 to 1943) of the Museum of Modern Art (MoMA) and a leading figure in the New York art world between the wars. Barr is a particularly interesting case because his father and grandfather were Presbyterian ministers and he was a faithful Presbyterian lay elder throughout his life. In 1943 he published an influential book in which he sought to address the question *What Is Modern Painting?* for a public mystified by its "bewildering variety" and difficulty. He argued that

duplicate." Heyer, *Signs of Our Times: Theological Essays on Art in the 20th Century* (Grand Rapids: Eerdmans, 1980), 69. Interestingly, this point was also central to Abraham Kuyper's influential argument that the Reformation freed art from bondage to church structures. See his "Calvinism and Art," chap. 5 in *Lectures on Calvinism: The Stone Foundation Lectures* (Grand Rapids: Eerdmans, 1931).

[53]The distinction between cultural gestures and postures is helpfully articulated in Andy Crouch, *Culture Making: Recovering Our Creative Calling* (Downers Grove, IL: InterVarsity Press, 2008), chaps. 4–5.

"artists are the sensitive antennae of society": at one level their work helps to disclose the "vanity and devotion, joy and sadness" of "ordinary life" in modern society, while at another level they aid us in struggling with "the crucial problems of our civilization: war, the character of democracy and fascism, the effects of industrialization, the exploration of the subconscious mind, the revival of religion, the liberty and restraint of the individual."[54] And in light of all of this, Barr argued that we must recognize that "the work of art is a symbol, a visible symbol of the human spirit in its search for truth, freedom and perfection."[55]

Written during the darkest days of World War II, these words make an ambitious claim for the role of this new art, which seemed to carry distinctly religious undertones. Barr himself probably did not mean to posit art as alternative to religion, or to set art over against religion; rather, he wanted to identify modernism as articulating concerns and drives that might be recognized as deeply consonant with religious concerns and drives. Indeed, one comes away from his argument wondering what role traditional religion played in his understanding of art's ability to reveal, to disturb, to "lift us out of humdrum ruts." In what ways is this human search for "truth, freedom and perfection" coextensive with religion's claims toward these same ends? Barr seems to have had his own thoughts on this, but he did not widely publish on the matter and this aspect of his thinking has not yet received sufficient attention.[56] He recognized that in a world where religion has, for many, lost its

[54]Barr, *What Is Modern Painting?*, 3. Barr wrote these words in the midst of World War II. In subsequent revised editions of the book (published after the end of the war) he made two significant changes to this sentence: he changed *fascism* to *tyranny*, and he changed the *revival* of religion to the *survival* of religion (see, for example, the 1956 rev. ed., 5). In the wake of WWII and the rise of the Cold War, both of these changes signal a shift in Barr's sense of "the crucial problems of our civilization": it was no longer German Nazism but Soviet Communism that loomed in the background of his text.

In fact Barr repeatedly argued that modernist art was inherently subversive to totalitarian regimes (whether Nazi or communist) and thus should be championed by liberal democracies. See, for example, Barr, "Is Modern Art Communistic?" (1952), in *Art in Theory, 1900–2000: An Anthology of Changing Ideas*, ed. Charles Harrison and Paul Wood (Malden, MA: Blackwell, 2003), 670-73. For further treatment of Barr's politics, see Patricia Hills, "'Truth, Freedom, Perfection': Alfred Barr's *What Is Modern Painting?* as Cold War Rhetoric," in *Pressing the Fight: Print, Propaganda, and the Cold War*, ed. Greg Barnhisel and Catherine Turner (Amherst: University of Massachusetts Press, 2010), 251-75.

[55]Barr, *What Is Modern Painting?*, 3.

[56]One exception is Sally M. Promey, "Interchangeable Art: Warner Sallman and the Critics of Mass Culture," in *Icons of American Protestantism: The Art of Warner Sallman*, ed. David Morgan (New

appeal, art has become a domain for "the human spirit" in its searching, even taking on qualities that once characterized religion; and he thought that this might be named for what it was. We will revisit Barr's influence in chapter six, in our discussion of American art.

Further examples of this kind of intersection and mutual influence between modern art and religion recur throughout modernism—a number of which will be explored in part two of this book. Indeed, as we will see, much of the modernist discourse prior to World War II was explicitly preoccupied with theological problems and structured in terms of spiritual crises and strivings. However, by the second half of the twentieth century the dominant texts about the history of modern art were regularly constructed without reference to faith or spirituality of any kind. Operating under a powerful form of secularization theory, art historian and critic Rosalind Krauss had by 1979 taken the mutual exclusivity of religion and modern art to be a matter of fact:

> Given the absolute rift that had opened between the sacred and the secular, the modern artist was obviously faced with the necessity to choose between one mode of expression and the other. . . . In the increasingly de-sacralized space of the nineteenth century, art had become the refuge for religious emotion; it became, as it has remained, a secular form of belief. Although this condition could be discussed openly in the late nineteenth century, it is something that is inadmissible in the twentieth, so that by now we find it indescribably embarrassing to mention *art* and *spirit* in the same sentence.[57]

Thus not only did Krauss collapse the range of discernible theological content in modern art to "secular" forms of belief, but she then proceeded to seal off even this range—or at least the legitimacy of openly discussing this range—as academically "inadmissible." While this synopsis may only have been intended

Haven, CT: Yale University Press, 1996), 149-80. She rightly notes that "a large primary literature concerns Barr's efforts to set aesthetic standards for Protestant Christianity; [yet] the secondary literature does not even mention this aspect of his life" (172). Studies of his work usually make only formal (and mostly negative) reference to his religious life. See, for example, Alice Goldfarb Marquis, *Alfred H. Barr, Jr.: Missionary for the Modern* (Chicago: Contemporary Books, 1989), who suggests that his "evangelical" support of modern art may have something to do with his religious background (122-23, 135, 363); Sybil Gordon Kantor, *Alfred H. Barr, Jr., and the Intellectual Origins of the Museum of Modern Art* (Cambridge, MA: MIT Press, 2002); and Irving Sandler and Amy Newman, eds., *Defining Modern Art: Selected Writings of Alfred H. Barr, Jr.* (New York: Abrams, 1986), 14.

[57]Krauss, "Grids," *October* 9 (Spring 1979): 54.

to carry descriptive weight at the close of the 1970s, it would exert prescriptive force well into the 1980s and 1990s.

The book that is perhaps most directly (and irenically) addressed to understanding this condition of inadmissibility is James Elkins's 2004 meditation *On the Strange Place of Religion in Contemporary Art*. Early in the book he offers an aerial view of the situation: "Contemporary art, I think, is as far from organized religion as Western art has ever been, and that may be its most singular achievement—or its cardinal failure, depending on your point of view. The separation has become entrenched."[58] The historical narratives one might tell to account for this separation are complex and contestable, and there are numerous points of entry through which one might begin such a telling. For his part, Elkins largely sidesteps these difficulties and instead argues that the entrenchment is a function of the historical narratives themselves, which have structured the academic discourse of modern and contemporary art: "Art that sets out to convey spiritual values goes against the grain of the history of modernism," such that "to suddenly put modern art back with religion or spirituality is to give up the history and purposes of a certain understanding of modernism."[59] This may seem dogmatic, but he intends it to be purely descriptive of the canonical literature of modern art history and the normative processes of enculturation in major academic art programs (his personal experiences in educational contexts provided the primary impetuses for writing his book). And as a descriptive (rather than prescriptive) statement, it is fairly easy to agree with: both in theory and in practice, the normative "grain" of the discourse of twentieth-century art history—and collegiate art education more generally—has generally run, often explicitly, counter to that of (devout) religious thought and practice.

However, there is a lot of subtext packed into Elkins's claim, and in order to achieve clarity about why and in which way it may or may not be accurate, the terms of the discourse need to be unpacked and submitted to scrutiny. The core of Elkins's argument is that there are at least two factors now in play that make it difficult to interpret religious content in art made since the nineteenth century.

The first of these factors is that over the course of the development of modern art overtly religious *themes* became problematized or simply

[58]Elkins, *On the Strange Place of Religion in Contemporary Art* (New York: Routledge, 2004), 15.
[59]Ibid., 20, 22.

disappeared altogether. In a short chapter titled "A Very Brief History of Religion and Art" he offers a whistle-stop history that hinges on the observation that "gradually, the most inventive and interesting art separated itself from religious themes."[60] This doesn't necessarily mean that artists stopped thinking about art in religious, spiritual or theological terms, but it does mean that this thinking became generally dislocated from traditional religious subject matter, format and patronage. Elkins recognizes that this does not in itself imply a secularization story: after all, if modernism has taught us anything, it is that the meanings of an artwork are not reducible to or circumscribed by its "themes." But his point is that this thematic shift does produce a conundrum for "reading" the religious content of the work: If religion doesn't have any salient thematic presence in modern art, then on what basis can we say that it really has any common purchase on our critical discussions about it? Without the thematic handholds that have historically demarcated religious content, what can we interpretively grab on to as being particularly "religious"? Elkins wonders whether coherent religious content simply lives or dies by the quality and clarity of its thematic presence. In one sense, this suggestion that religious meaning might be constrained to overt religious imagery is intensely problematic, not only as critical theory—this is no more defensible than similarly constraining sociopolitical meanings to their overt thematic presence—but also as a historical account. This calls for a response that we will offer in more detail in chapter four in our discussion of German and Dutch modernism, but here we simply note that Elkins's account needs to pay more attention to the role of Protestantism in this development, wherein artists turned away from traditional religious "themes" for overtly theological reasons.[61] In another sense, however, Elkins's questions about the waning of religious imagery do

[60]Ibid., 12. Elkins's narrative identifies the Renaissance as the crucial point at which "the meaning of art changed," and by the late nineteenth century and throughout the twentieth "it appears that religion has sunk out of sight" (7, 12). For an earlier version of this chapter see James Elkins, "From Bird-Goddesses to Jesus 2000: A Very, Very Brief History of Religion and Art," *Thresholds* 25 (2002): 75-80. Elkins's telling of the history is self-consciously provisional, and it is not essential to the primary argument of his book anyway. Whatever historical explanation might be offered, Elkins's thesis is that religion has no functional *interpretive* voice in the modern art discourse.

[61]As we will see in chap. 4, a central characteristic of the Protestant imagination, especially the Reformed variety, is that it takes all of life and the whole of creation as a religious site, whether or not this is denominated in overtly Christian terms. This, along with Protestantism's historically iconoclastic attitude toward religious images, makes it impossible to limit religious content to religious "themes."

serve to highlight some pervasive critical deficits regarding the (narrow) range of theological thinking in modernist art criticism: without recognizable themes such thinking is rendered essentially inoperative. And thus if we take it only as indicative of the thinness of theological thinking in modern art criticism, then Elkins is right to suggest that the degree to which we confine religious content to religious themes is the degree to which we have at least one (presumably nonsecularist) explanation for why religion seems to have wasted away in the writing of modern art history.[62]

The second and more significant factor that Elkins identifies is that modern artworks and the critical methods developed to interpret them became severely self-critical, so that even where religious themes may be present they cannot be taken at face value. Elkins acknowledges several examples in which major twentieth-century artists did engage religious subjects in their work (the numerous religious paintings by Emil Nolde or Barnett Newman) or accept commissions for religious contexts (the chapels by Henri Matisse or Mark Rothko), but he rightly notes that these works hardly encourage straightforward interpretation. He insists that at most we can conclude that "such art is *about* religion; it doesn't *instantiate* religion."[63] Or more to the point: even if any of these artists were earnestly attempting to "instantiate religion," that kind of content would be uninterpretable in the discourse of modern art. As Elkins says: "Contemporary art in its most serious and ambitious forms is a matter of the philosophy and theory of art and visuality. The idea is that religion is not only beside the point of contemporary art, but that it has actually become inaccessible to art."[64] Central to the critical methods that have been primarily responsible for writing the histories of twentieth-century art is an intense suspicion, a doubtfulness, a hermeneutical doubling back that dismantles the kinds of signification (and sincerity) that religious content generally requires. Thus Elkins

[62]For the record, we should note that theologian Paul Tillich (1886–1965) tried to handle this problem by shifting the locus of the spiritual "import" (*Gehalt*) of an artwork from its theme to its *style*. For Tillich, the theological content of a modernist painting had much less to do with its pictorial themes than with its "expressivity" of "religious depth"—its ability to stir feeling for that which is of ultimate concern. See Tillich, "Contemporary Visual Arts and the Revelatory Character of Style" (1958), in *On Art and Architecture*, ed. John Dillenberger and Jane Dillenberger (New York: Crossroad, 1987), 126-38.

[63]Elkins in conversation with Caroline Jones, "Caroline Jones Responds [to James Elkins, 'From Bird-Goddesses to Jesus 2000']," *Thresholds* 25 (2002): 83. Emphasis original.

[64]Elkins, *On the Strange Place of Religion in Contemporary Art*, 90.

persuasively argues that within the discourse of modern art "it is impossible to talk sensibly about religion and at the same time address art in an informed and intelligent manner": where religious content is clear it will be pulled to pieces in the machinery of critical method; where it is implicit it simply becomes functionally invisible.[65] In short, intentional religious content cannot survive the interpretive processes of modern or postmodern art criticism.[66]

Elkins's study is essential reading on this topic, and in its light one can understand why the prospect of "suddenly put[ting] modern art back with religion or spirituality" seems dubious: their respective modes of visual meaning appear structurally incompatible. However, stating the matter in terms of putting two structures back together again might confuse the issue from the outset, and at any rate it is not the only way to understand or respond to the current situation. Rather, we are interested in rereading the "grain of the history of modernism"—an enormously complex and layered organism—by questioning the ways in which its narratives *already* bear theological structures, formations and textures. What do these grains look like under the light of theological inquiry or when considered in the context of religious practices? Are there always already theological axes of meaning running through the very grain that Elkins is referring to, even if they are difficult, convoluted and underinterpreted? And if submitting modern art to this kind of religious and theological questioning might force us to "give up the history and purposes of a certain understanding of modernism," what exactly would be given up? And what would remain? Is it only a certain kind of interpretive constriction that would be given up, or would there be heavier costs? Is it viable to traffic in a rather *un*certain understanding of modernism, one for which theological questioning is well suited and even necessary?

In what follows we are frankly much less interested in "art that sets out to convey spiritual values," or in art made for a specifically religious setting, than we are in deciphering the ways that "spiritual values," even theological values, are already in play and at stake throughout modern art, even (perhaps especially) in artworks that do not set out to convey any such thing. Our aim is to

[65]Ibid., 116.

[66]For a further development of this argument, see Jonathan A. Anderson, "The (In)visibility of Theology in Contemporary Art Criticism," in *Christian Scholarship in the Twenty-First Century: Prospects and Perils*, ed. Thomas M. Crisp, Steve L. Porter and Gregg Ten Elshof (Grand Rapids: Eerdmans, 2014), 53-79.

draw out and interpret the religious contexts and theological concerns that run through the developments of modernism. Or rather: it is an attempt to draw out the ways that modern art takes up and wrestles with human experience within contexts that were already religious and in terms that are unavoidably theological. The argument of this book is that the crises and labors of modernist art were, among other things, *theological* crises and labors.

RETHEOLOGIZING MODERNISM

To claim that religious traditions are alive and well in modern art would be claiming too much. However, some more modest—though significant—claims might be advanced. First, religious traditions have had deep shaping influence on the social and imaginative development of many important modern artists and movements, despite whatever ambivalence artists may have felt toward those traditions. Can the work of Picasso, for example, be thoroughly understood apart from his own Catholic childhood? What about the Catholicism of Paul Cézanne or of Andy Warhol? The importance of Russian Orthodoxy to Vasily Kandinsky or Natalia Goncharova? Or the influence of Protestantism on Vincent van Gogh, Piet Mondrian or Robert Rauschenberg? Could it be the case that some central aspects of these religious traditions—the Catholic sacraments in France, the Orthodox icon in Russia, and Protestant spirituality in northern Europe and North America—have played a decisive role in modernist artistic innovations? And if so this raises a further possibility that might be explored: perhaps these innovations may in turn have an influence on these religious traditions. Traditions, after all, are not fixed entities; they are always in process.

Second, aside from arguing that a background "religious imagination" was operative in the lives of particular modernist artists and in the construction of particular artworks, we also want to argue that modernism is, in itself, a theologically meaningful project, whether or not religion played a conspicuous role in the biography of this or that artist. When interpreted through and in relation to the traditions of Christian theology, modern artworks are often able to sustain a remarkable degree of theological intelligibility and meaning. This might be stated in three different ways: (1) The primary concerns that shaped and developed modern art *included* concerns that are essentially theological (i.e., seeking to understand life in relation to the presence or absence

of God), whether or not particular artists articulated their concerns in these terms; (2) modern art functions in ways that are *akin to and resonant with* the problems that also preoccupied modern theology; and (3) modern art has something to *contribute to* theological inquiry, offering unique sites and modes of thinking for encountering and wrestling with theological questions, intuitions and conceptualizations. Fully addressing each of these lines of inquiry is beyond the scope of this book, but we hope that our investigations in the pages that follow will stimulate further thinking along these lines. Modern art has many stories to tell, and some of those stories are theological.

CRITICAL PRESSURES

However, as Elkins reminds us, there are serious challenges that need to be addressed if we hope to really sustain this conversation: "The pressure of history is crucial: it has to be decided before it can be possible to seriously weigh academic and non-academic descriptions of religion and art."[67] The requirement to "decide" the history before a serious weighing of the issues is possible is overstated, but Elkins is certainly right to argue that the discourse of religion and art will always remain inept and irrelevant until it can be shown to have compelling explanatory power with respect to "the pressure of history" in terms of (1) *what actually happened* in art over the past two centuries and (2) *the primary discourses that have been used to understand it* up to this point. And this explanatory power has surely been lacking in both respects.

Daniel Siedell has claimed that "a history of modern art can be written that reveals that Christianity in all its myriad cultural and material manifestations is never absent from the modern artist."[68] But, as Jonathan Evens has remarked, Siedell didn't undertake that task in his book, nor has anyone else to date.[69] Where serious Christian engagements with modern art have appeared, they have tended to betray a relative ignorance of and nonparticipation in the most important theoretical and historical work being done in the field. While we don't presume to decide anything here (or presume to span these tremendous gaps in a single leap), this present volume is an attempt to occupy more informed, conversant and sympathetic positions within the discourse of

[67]Elkins, "From Bird-Goddesses to Jesus 2000," 80.
[68]Siedell, *God in the Gallery*, 47.
[69]Evens, review of *God in the Gallery: A Christian Embrace of Modern Art* by Daniel A. Siedell, *Art and Christianity* 57 (2009): 17.

modern art and to exegete and decipher *some* of the theological dimensions of its histories. Or perhaps we might say that this is an attempt to explore the ways in which these histories were shaped by significant theological "cross-pressures," to borrow a term from Charles Taylor,[70] some of which demand a more careful accounting of the religious contexts that produced these pressures. Our argument is that these are deeply significant to the formation of modern (and contemporary) art, despite their general neglect in the literature (and especially in the teaching) of the discipline.

And, as alluded to earlier, we might as well raise the ante even further: the religion-and-art discourse must account not only for the pressure of history; it must also (perhaps primarily) account for the pressure of *criticism*. If religion—or more precisely, theology—is to have anything of relevance to say about modern art, then it ultimately needs to be able to say it while facing (or standing inside of) specific works of art. And such a saying needs to persuasively interpret the ways these works present themselves as particular objects in particular contexts.[71] It may well be that nineteenth- and twentieth-century art is a field rich with theological thinking (far more than has been articulated up to this point), and as such it stands to be renarrated along theological axes of meaning. But the measure of such claims will be the degree to which the critical and historical analyses produced are able to persuasively account for the artworks themselves. Christian scholars of art, alongside all other religious and postsecular scholars interested in this discussion, must make themselves accountable both to history and to thick personal encounters with artworks. We hope to do this in the chapters that follow, which are structured partly as a historical argument and partly as a series of critical engagements.

This objective places this book in at least two different contexts simultaneously and demands that it function persuasively in both. On the one hand, this is to some extent a modestly revisionist account of the history of modern art.

[70]Charles Taylor, *Secular Age*, 302. Taylor argues that when faced with "the opposition between orthodoxy and unbelief, many, and among them the best and most sensitive minds, were cross-pressured, looking for a third way. This cross-pressure is, of course, part of the dynamic which generates the nova effect, as more and more third ways are created" (302).

[71]As Rosalind Krauss noted at the beginning of her career, the practices of art history and criticism are at their best when they become "mutually inclusive." See Krauss, "The Sculpture of David Smith" (PhD diss., Harvard University, 1969), 2. In other words, history is most meaningful when it clarifies and is supported by critical encounters with artworks, as is criticism when it focuses and pressures the questions of history. History and criticism are structures of meaning that must always be begging each other's questions.

This account is not in any way comprehensive, but it does attempt to trace some long and significant threads of religious and theological thinking that run through the past two centuries of Western art—threads that have been neglected or quietly taken for granted. Rather than presenting a full history, this book might be understood as a series of partial interventions into existing histories. We are not introducing an alternative set of obscure artists or attempting to overhaul the canon. Indeed, for this particular project we have specifically chosen to focus on familiar artists and artworks, those already central to the "grain" of the modernist art discourse. This effort is thus revisionist only to the extent that once these interventions are accounted for, the warp and woof of the history begin to hold together somewhat differently.

On the other hand, this book is also positioned in the context of previous attempts by Christian scholars to theologically interpret the histories of modern art. Christian engagements with modern art history have generally populated an alternative subcultural discourse of its own over the past few decades, one that has been generally ignored in the mainline academic art discourse(s). This book acknowledges, engages and inevitably participates in this subculture. Specifically, our title places this study in direct relationship to Hans Rookmaaker's *Modern Art and the Death of a Culture* (1970), a book that has deeply influenced the course of (particularly Protestant) Christian thinking about the visual arts for more than four decades. We wish to recover some of the virtues of Rookmaaker's project while also identifying its weaknesses and attempting to move beyond them. We explore this relationship in some detail in the following chapter.

Within these two frames of reference, we are modestly challenging the standard histories of modern art, which have largely excluded religion from their accounts, while also challenging many of the attempts by Christian scholars and commentators to (re)engage these accounts.

Elkins reminds us that the theory one deploys in understanding modernism "constitutes a choice that implies very different objects, artists, and movements, and strongly affects what is taken to be worth saying about a given painting, period, or problem."[72] The wager of this book is that "what is taken to be worth saying" about modern art includes discussion of its religious

[72]James Elkins, *Master Narratives and Their Discontents*, vol. 1 of *Theories of Modernism and Postmodernism in the Visual Arts* (New York: Routledge, 2005), 42.

influences and its theological content and implications. However, rather than insisting on very different objects, artists and movements as our object of study, this project will more or less stay within the bounds of a canonical history of North Atlantic modern art while offering a rereading and restaging of artists, artworks and events within that history.

Consequently, we are imposing limits to the scope of this project that may seem ill-advised in at least three ways: first, given the recent breakdown and dispersion of these canons into "global histories," to once again take up the problems of specifically Euro-American art seems an admittedly shortsighted way to structure this project. This study would certainly benefit from following this dispersion into cultural locales throughout the Global South in which the old antagonisms between art and religion appear narrow and irrelevant. It would make enormous sense to call these Western histories into question by turning toward a variety of non-Western modernisms, many of which have even stronger threads of religious and theological content. However, in limiting the focus of our questioning to the Western canon, we hope to address some contested ideas on familiar territory in order "to chase a single insight through material that we already know all too well."[73] Rethinking the meaning of North Atlantic secularity is of primary concern here, and thus this study is structured as a *re*reading more than as a search for new texts.

Second, modernism itself is an extremely contested and internally conflicted category within the arts today, and it is by most accounts now over, having unraveled into a tangle of competing postmodernisms, hypermodernisms, remodernisms, altermodernisms, postpostmodernisms, etc. If modernism is where the problems originally lie, then it would seem advisable to just abandon the old edifice and concentrate on building something new. However, not only are we doubtful that the West really is so cleanly beyond modernism (or modernity); we also believe that, in any case, it is vital to more clearly understand the ways that the (religious) pressures of modernist history have been formative to contemporary identities and conceptualities.

As art historian Stephen Bann argues, "the very concept of Postmodernism is fated to be a fragile one in historical terms, to the extent that the postmodern is defined as existing in a relationship of exclusion vis-à-vis the modern, and

[73]Robert Nelson, *The Spirit of Secular Art: A History of the Sacramental Roots of Contemporary Artistic Values* (Melbourne: Monash University ePress, 2007), 01.13.

not in a dialectical relationship to the past that would take into account the multiple determinations to which Modernism itself was heir."[74] Borrowing from Nietzsche's metaphor of historical study as a ladder, Bann warns that "standing on the 'utmost rung of the ladder' is not a recipe for clear-sightedness, but rather for becoming off balance (perhaps fatally so).... Taking 'A few steps back,' in Nietzsche's terms, is not just a matter of straightforward historical procedure, but the best way, in my opinion, to keep a clear head in the contemporary period."[75] Indeed, the entire point of taking these steps backward into the history of modernism is to more securely "look out over the upmost rung of the ladder" in order to more wisely "contribute to the development of the critical discourse of the present day."[76] The aim of this present book is to back up and reconsider some of the stories we have used to define the religious and theological dimensions of our artistic heritages, which have for better and worse provided significant framing for "the critical discourse of the present day."

Third, our considerations of religion and theology in relation to modern art will be primarily concerned with Christianity (in its various forms). There are of course many other religious perspectives that would be very relevant to include here—Judaism, Buddhism, Islam, Native American spirituality and so on, all deserve much deeper investigation with respect to modern and contemporary art than they have yet received—but limiting our scope to Christianity allows for greater coherence to our investigations and a more rigorous (self-)searching on the part of the authors, both of whom are Christians. The Western secularity of modern art grew out of Western Christianity, and there are still strong roots, connections and resonances that will serve as the foci of our investigation. However, in orienting our study in this way, we are not attempting to colonize or Christianize modern art. Our project is not to dig up marginal, overlooked Christian artists in an attempt to repopulate the history books with artists more suitable to our cause. Nor would we want to retroactively coerce artists into affirming some preordained set of orthodoxies that we want them to affirm. Were this project to err in either of these directions the result would be intellectually dishonest and unhelpful. Nor is this a

[74]Stephen Bann, *Ways Around Modernism*, vol. 2 of *Theories of Modernism and Postmodernism in the Visual Arts* (New York: Routledge, 2007), 36.

[75]Ibid., 38.

[76]Ibid.

rearguard attempt to undermine or overthrow modern art. Daniel Siedell has rightly complained that Christian commentators on modern and contemporary art have tended to show "a remarkable lack of interpretive charity" and have too often resorted to "a shrill polemics in public discourse that has grown immune to subtleties, qualifications, nuances, and ambivalences."[77] We have no interest in following that pattern.

Rather, our aim in this book is to employ a more charitable hermeneutic. We believe that part of what this means is being willing to pay attention to artists as spiritual beings, and to attune our sensitivities to (among other things) the theological subtleties, qualifications, nuances and ambivalences of their work. And this arises from the pressure of artworks themselves. As Charles Harrison and Paul Wood argue: "To consider the extensive history of modern art is inescapably to feel the force of questions raised in practice"[78]— questions that include, at least for us, difficult theological questions. Our account of modern art is generated by a series of interpretive problems that arise from encounters with particular artists and artworks. We are lovers of modern art, and when we submit ourselves to open and honest encounters with the works, we cannot help but experience them as grappling with questions and concerns that strike us deeply. Perhaps more than anything, this book grows out of our efforts to articulate how these works are meaningful for us.

Our intent, then, is to recover at least two of the untold stories about modern art: first, Western art still carries the mark of its religious roots, often in ways that go unacknowledged, and, second, in its articulation of deeply felt human concerns modern art is always already doing theology at some level. Charles Taylor has recently asked why it is that the artifacts that consistently move contemporary people are connected to religion—the Gothic cathedrals, the music of Bach or Handel. Is it possible, he wonders, that "the old religion has not been fully replaced in a supposedly 'secular' age?"[79] This possibility, still largely unexplored in the literature on modern art, is what we hope to develop.

[77]Siedell, *God in the Gallery*, 13.
[78]Charles Harrison and Paul Wood, "General Introduction," in Harrison and Wood, *Art in Theory, 1900–2000*, 1.
[79]Charles Taylor, *Secular Age*, 712.

H. R. Rookmaaker, *Modern Art and the Death of a Culture*

One thing binds all these [modernist] groups and arts together: the assertion that reality is at stake, that it has become a question-mark, that it seems to be something man cannot be happy with, something that is strange to him. Crisis, alienation, absurdity, it is words like these which describe the artistic situation.

H. R. ROOKMAAKER[1]

In the last few decades, what other single piece of writing has had more influence on Christian artists? . . . What other book has done more to provide a specifically Christian intellectual environment for the practice and understanding of art?

JEREMY BEGBIE[2]

The tendency has been, at least since Rookmaaker, to paint as dire a picture as possible of the history of modern art and the contemporary art world.

DANIEL A. SIEDELL[3]

[1]Rookmaaker, *Modern Art and the Death of a Culture* (Downers Grove, IL: InterVarsity Press, 1970), 170.

[2]Begbie, speaking of *Modern Art and the Death of a Culture* in the foreword to *The Complete Works of Hans R. Rookmaaker*, ed. Marleen Hengelaar-Rookmaaker (Carlisle, UK: Piquant, 2002), 1:xiii. In all subsequent footnotes, this six-volume *Complete Works of Hans R. Rookmaaker* will be abbreviated as *CWR*.

[3]Siedell, *God in the Gallery: A Christian Embrace of Modern Art* (Grand Rapids: Baker Academic, 2008), 159.

One of the many factors contributing to the critical estrangement between modern art and religion in the twentieth century was the relative paucity of religious voices in the writing of modern art history and criticism. The artistic avant-garde may well have been aggressively disentangling itself from Western religious (Christian) traditions and institutions, but, as noted in the last chapter, the acts of estrangement were certainly reciprocated: well-educated, devout Christians collectively shunned the modern art discourse for much of the twentieth century and thereby contributed very little to the construction of its primary narratives. Christians from across the denominational spectrum tended to see modern art as deeply antagonistic to religious belief, and, as we've seen, so too did many historians of modern art. There are a few exceptions, but for the most part the writing that has been most formative to developing the "grain" of the primary modernist narratives—especially those written from the 1920s through the 1990s—were constructed with little critical reflection on the religious and theological implications of the artworks in question.

In the 1960s and 1970s a handful of Christian academics began to emerge into this space of mutual estrangement and attempted to engage modern art from a range of Christian positions.[4] The most influential of these scholars among evangelical Christians was Hendrik (Hans) Roelof Rookmaaker (1922–1977), professor of art history at the Free University of Amsterdam (where one of the present authors—Bill—studied with him in the 1970s). Rookmaaker began speaking and writing about Christianity and modern art at a time when few others were and with a rare forthrightness, sophistication and charisma. Calvin Seerveld was perhaps his most significant peer in this respect.[5] Rookmaaker traveled and lectured widely in Britain and the United States during the 1960s and 1970s, attracting a great number of young Christians to his views. For many evangelicals his lectures and essays became a primary means of

[4]For example, see John W. Dixon Jr., "On the Possibility of a Christian Criticism of the Arts," *Christian Scholar* 40, no. 4 (December 1957): 296-306; Finley Eversole, ed., *Christian Faith and the Contemporary Arts* (New York: Abingdon, 1962); David B. Harned, *Theology and the Arts* (Philadelphia: Westminster Press, 1966); Roger Hazelton, *A Theological Approach to Art* (Nashville: Abingdon, 1967); Calvin Seerveld, *A Christian Critique of Art and Literature* (Toronto: Association for Reformed Scientific Studies, 1968); John W. Dixon Jr., "Faith and Twentieth-Century Forms," *Theology Today* 26 (April 1969): 14-33; Jane Dillenberger, *Secular Art with Sacred Themes* (Nashville: Abingdon, 1969).

[5]See, for example, Calvin Seerveld, *Christian Critique of Art and Literature* and *Rainbows for the Fallen World: Aesthetic Life and Artistic Task* (Toronto: Tuppence Press, 1980).

making modern art—and visual and musical culture more generally—a viable and vital arena for serious Christian thinking and participation.

These lectures were eventually developed into his best-known and most influential work, *Modern Art and the Death of a Culture*, a popular-level account of modern art that first appeared in 1970.[6] This book served two primary aims: (1) it was an argument for a renewed Christian participation in the visual arts, and (2) it was an argument for a particular interpretation of modern art history.

On the one hand, the book was aimed at adjusting pervasive assumptions and attitudes about the visual arts on the part of North Atlantic Christians. Ultimately, it was a kind of rallying cry for Christians to reengage the visual arts and the attendant academic discourses about the arts. Rookmaaker lamented that "for so long Christians have taken no part in artistic discussion or activity," which he attributed to chronic deficiencies and failures in *theological* thinking, particularly with regard to the Western church unwittingly imbibing "gnostic" and "mystical" streams of thought that pit spirituality and holiness against materiality and embodiment.[7] He saw these streams spilling across denominational lines—he specifically highlights dualisms within Anabaptist, Puritan and Roman Catholic thought[8]—and he devoted a significant portion of the book (and his career) to redressing these theologies with a more thoroughgoing "Reformation attitude."[9] He argued that one of the principal insights of Reformed Christianity is that in fact "there is no duality between a higher and a lower, between grace and nature. This world is God's world. He created it, He sustains it, He is interested in it. He called the work of His hands good in the very beginning. Nothing is excluded."[10] Christians must therefore not think along binaries that divide the spiritual from the material. Rather, he argued, the only truly Christian duality exists between "the kingdom, the rule, the realm of God and the kingdom of darkness. . . . This is the true division. It goes through all mankind, affecting every human being; two opposite ways, one as God wants, the other against His will."[11] This

[6]H. R. Rookmaaker, *Modern Art and the Death of a Culture* (Downers Grove, IL: InterVarsity Press, 1970; with many subsequent reprintings). Hereafter this volume will be abbreviated as *MADC*.
[7]Rookmaaker, *MADC*, 32-33.
[8]Ibid., 29-35.
[9]Ibid., 35-38; cf. 225-52.
[10]Ibid., 36.
[11]Ibid., 36; cf. 224.

division is thus not a matter of metaphysical dualism as much as it is moral, ethical and aesthetic: "There is a duality, between good and bad, right and wrong, beautiful and ugly."[12] Ultimately, Rookmaaker's aim in his book was to trace and clarify *this* duality as it runs through modern art, while upholding art as a good in itself.

The theological problems wound up in the varieties of acultural or anticultural "mysticism" in Western society have, he believed, harmed both the church and the art world. As he saw it, the evacuation of Christians from the modern art discourse not only "allowed" the arts "to become completely secular";[13] it also rendered the church profoundly culturally impoverished, both in terms of its intellectual resources—"Any sort of critical way of thinking [about the arts] is almost completely lacking [among evangelical Christians]"—and in terms of its artistic community and enculturation: "Many want to be artists in a Christian sense—but have to find the answers for themselves."[14] In each case the result is a reduced form of life: "If the world's system was a secularized one, missing true spirituality, the Christians' attitude also became a reduced one, missing its foundation in reality due to lack of interest in the created world. . . . In concentrating on saving souls [Christians] have often forgotten that God is the God of life."[15]

Beyond its call for Christian reengagement in the arts, *Modern Art and the Death of a Culture* is, on the other hand, also a particular narration and interpretation of modern art history, which he begins in about 1800 with Francisco de Goya (1746–1828) and extends through the 1960s with some cursory attention paid to pop art, happenings, minimalism and conceptualism.[16] In many

[12]Ibid., 36.

[13]Ibid., 31. He puts this more stridently elsewhere: "Under the banner of piety and Reformed rectitude we vacated this field; and the forces of darkness moved in to replace us." Rookmaaker, "The Christian and Art Today" (1963), in *CWR*, 4:364.

[14]Rookmaaker, *MADC*, 32; cf. 75. Elsewhere he writes: "As there is little help coming from the leaders of the church, the Christian intellectuals, every artist has as it were to work it out for him or herself. . . . We leave artists too much on their own." Rookmaaker, *Art Needs No Justification*, in *CWR*, 4:328.

[15]Rookmaaker, *Art Needs No Justification* (1978), in *CWR*, 4:322-23.

[16]Rookmaaker repeatedly explains that he has "no intention of giving in this book a complete history of modern art"; instead his aim "is simply to point out its main features—and some of its problems" (*MADC*, 138, cf. 11, 54). While it must be received on these terms—it is not a comprehensive history and nor should it be judged as such—*Modern Art and the Death of a Culture* is nevertheless a historical account, a narration of the "grain" of modern art that traces lineages from one artist to another across decades and centuries.

ways it is a deeply negative account (as might seem rather straightforwardly indicated by the book's title), but the character of and reasons for this nega-tivity are complex and mingled with relentless evangelical optimism. The book is manifestly a product of its time, and much of its negativity comes into sharper focus as we sensitize ourselves to the historical context from which it emerges and to which it was aimed. Written in the mid to late 1960s, this book took form in the midst or immediate memory of the Cuban Missile Crisis (1962), the height of the American civil rights movement and its accompanying racial violence (1963–1968), the international student and worker uprisings of May 1968, the bloodiest years of the Vietnam War (1967–1969), the assassina-tions of Martin Luther King Jr. and Robert Kennedy (1968), and the massive emblematic countercultural event in Woodstock (1969). A strong sense of in-ternational conflict and sociopolitical instability is palpable throughout the text. The first sentences of the book open and orient the train of thought with precisely this instability in view: "We live at a time of great change, of protest and revolution. We are aware that something radical is happening around us, but it is not always easy to see just what it is."[17] This historical location for the book makes it feel dated and alarmist today (four and a half decades later), but it also makes more intelligible—and elicits greater sympathy for—the sense of urgency and fear that characterizes its train of thought.

In some ways Rookmaaker's stance was classically conservative: he feared the consequences of the changes that were taking place in the culture more than he was expectant that these changes were signs of progress toward more just or peaceful social configurations. His narrative of history includes a strong sense of loss and impending disaster; indeed, he believed that Western culture was clearly (though not inevitably) in the process of suffering some kind of "death." At the same time, however, he is decidedly not conservative in his trenchant criticism of the "bourgeois" character of North Atlantic Christianity, especially regarding its general preoccupations with money, social status, se-curity, technology, sentimentality, rationalism, moralism and sexuality.[18] He saw in the "progress" of Western modernity—both within and without the church—an increasingly dire unbalancing: the image of a pendulum swinging between extremes is a favored metaphor throughout the book.

[17]Rookmaaker, MADC, 9.
[18]Ibid., 76-81; cf. 209-12, 221-22.

The tenor of Rookmaaker's book might also be interpreted in the context of his own life, though we don't have space here to explore this in any sufficient detail.[19] After growing up in the colonial Dutch East Indies—an upbringing that almost certainly heightened his sensitivities to how Western culture might look from the outside[20]—he returned to Holland and enlisted in the Royal Netherlands Naval College prior to the Nazi occupation in 1940. The years of World War II would be deeply transformational for him. In March 1941 he was arrested for possession of anti-Nazi literature—a pamphlet titled *De vrije Katheder* (The Free Podium)—and spent most of the next four years in prison and in Nazi prisoner-of-war camps.[21] It was during this time that he became a Christian.

By his own account he was raised in "a family that can in no way be described as religious," but soon after arriving in Nuremburg as a prisoner of war, Rookmaaker began reading the Bible. As he later recalled: "There were no other books available and, as a civilized man with cultural interests, I thought it would be good to know something about it."[22] He studied the text with increasing care, filling the margins of his copy with notes and cross-referential commentary—a process that deeply altered his thinking. In late 1942 Rookmaaker's camp was moved to Stanislau (now in Ukraine), which, as David Bruce Hegeman puts it, "turned out to be a virtual university,"[23] given the large number of officers and intellectuals imprisoned there. While at this camp Rookmaaker was tutored in Latin and Greek; he had access to numerous

[19]For a biography of Rookmaaker's life see Laurel Gasque, *Art and the Christian Mind: The Life and Work of H. R. Rookmaaker* (Wheaton, IL: Crossway Books, 2005). See also Graham Birtwistle, "H. R. Rookmaaker: The Shaping of His Thought," in *CWR*, 1:xv-xxxiii.

[20]Rookmaaker's father was a resident colonial official at a time when the Dutch colonial enterprise was crumbling; it is likely that his childhood home included discussions about the problems of Western colonialism and the general weakening of Western culture. See Gasque, *Art and the Christian Mind*, 30-40.

[21]He initially spent nine months in prison in The Hague awaiting trial for possession of anti-Nazi literature. He was released in December 1941, but then because of his status as a commissioned officer he was again arrested by the Nazis in April 1942 and was incarcerated for the next three years in a variety of POW camps: primarily in Nuremberg, Germany; Stanislau, Ukraine; and Neubrandenburg, Germany. In August 1942, Rookmaaker's fiancée Riki Spetter, who was Jewish, was arrested and disappeared without a trace—only after Rookmaaker's death in 1977 was it discovered that she had died at the Auschwitz extermination camp on September 30, 1942.

[22]Rookmaaker, "What the Philosophy of the Cosmonomic Idea Has Meant to Me" (1967), in *CWR*, 2:10.

[23]Hegeman, "The Importance of Hans Rookmaaker," *Comment Magazine* 22, no. 9 (November 1, 2004), www.cardus.ca/comment/article/244/the-importance-of-hans-rookmaaker.

books on philosophy and history that changed hands among prisoners; and (perhaps most significantly) he met the Christian philosopher J. P. A. Mekkes, who would have an enduring impact on his life and thought. Mekkes loaned Rookmaaker his copy of Herman Dooyeweerd's massive three-volume *De Wijsbegeerte der Wetsidee* (*A New Critique of Theoretical Thought*, 1935–1936), which Rookmaaker "devoured," and Mekkes mentored him through what amounted to a "Dooyeweerdian catechism."[24] Rookmaaker emerged from the POW camps of World War II a deeply devout Christian, well schooled in the neo-Calvinism of Abraham Kuyper and Dooyeweerd and intensely interested in the possibilities for doing cultural criticism from such a position. Following the war he became well read in Reformed theology and grew attentive to the growing movement of evangelicalism in North America and Britain. In 1948 he met the American evangelist Francis Schaeffer, who would become a lifelong personal friend and collaborator.[25]

After the war Rookmaaker studied for his PhD in art history at the University of Amsterdam, focusing on the work of Paul Gauguin.[26] He was particularly drawn to what he called the "iconic" aspect of Gauguin's work, by which he meant the potential for artworks to represent the meaningful "structure of things" without necessarily depicting their naturalistic appearance.[27] As we'll see later in this chapter, this distinction between "structure" and "appearance" that he developed in his study of Gauguin remained central to his interpretive method throughout his career. He believed that this notion of the "iconic" that he saw in Gauguin "has been of primary importance for the genesis and the development of modern French art,"[28] though it is significant in the context of our project that Rookmaaker made no attempt to investigate the ways that this development—and its derivation from the traditions of religious icons—might have been influenced by Gauguin's Catholic background (something we discuss in the next chapter). Instead, Rookmaaker's

[24]Rookmaaker, "What the Philosophy of the Cosmonomic Idea Has Meant to Me," in *CWR*, 2:11-12.
[25]For a description of his scholarly development see Birtwistle, "Rookmaaker: The Shaping of His Thought," in *CWR*, 1:xv-xxxiii, and Gasque, *Art and the Christian Mind*, chaps. 4–7.
[26]Rookmaaker's dissertation was subsequently published as *Synthetist Art Theories: Genesis and Nature of the Ideas on Art of Gauguin and His Circle* (Amsterdam: Swets & Zeitlinger, 1959), and then republished as *Gauguin and Nineteenth-Century Art Theory* (Amsterdam: Swets & Zeitlinger, 1972); available in vol. 1 of *CWR*.
[27]See Rookmaaker, *Gauguin and Nineteenth-Century Art Theory*, in *CWR*, 1:169-70.
[28]Ibid., 201.

own Reformed perspective made him especially attentive to the "humanity" in Gauguin's work and his "adherence to reality" precisely while "he rejected naturalism."[29] Indeed, these became the distinguishing (theological) preoccupations that would frame Rookmaaker's entire account of modernist art history: what is most at stake in the arts is not how naturalistically they reproduce "appearances" but the ways in which they explore the "structure" of what it means to be human in this world. He felt that creation (and human creatureliness as such) was a good and extravagant gift of God, not a problem or a prison—and modern artworks could be judged according to their iconic handling of precisely that issue.

Rookmaaker's work as an art historian developed in the convergence of all of these influences. He was a Kuyperian Christian who believed that art provided a salient "sign of the times,"[30] and as such it badly needed spiritually sensitive reflection and cultural criticism. His experiences of World War II certainly shaped his sense of how much might be at stake in cultural discourse and in the exchange of ideas—including its aesthetic modes—and how potentially tragic and brutal a social ethos and the structures it produces can be. The formation of his Christian thinking and convictions specifically in the context of a Nazi prison camp likely amplified his sense of oppositional contrast between Christianity and secularism. As Graham Birtwistle notes, Rookmaaker's declinist narrative of modern art directly links up to (and finds intellectual precedence in) similar breakdown narratives written by the Calvinist thinkers who influenced him most: his project, for example, very intentionally recalls Guillaume Groen van Prinsterer's *Lectures on Unbelief and Revolution* (1847, rev. ed. 1868) and Herman Dooyeweerd's *In the Twilight of Western Thought* (1960).[31] Rookmaaker also drew influence from a variety of

[29]Ibid., 200.

[30]In *MADC* he refers to modern art as "one of the keys to an understanding of our times. For many of these works, particularly the more extravagant ones, are signs of the crisis of our culture" (135). Elsewhere he cautions: "Let us not mock all this, or call it charlantry; let us not cry 'woe and alas' but let us take note of this sign of the times. For it is here, right here in these extreme expressions in painting and poetry, that the spirits make themselves manifest." Rookmaaker, "The Experimental in (or out of) the Stedelijk Museum of Modern Art," in *CWR*, 1:342.

[31]See Birtwistle, "Rookmaaker: The Shaping of His Thought," xxviii. Rookmaaker was in fact open about these links, admitting that "in a way the thesis of my book [*Modern Art and the Death of a Culture*] is the same as his [referring to Groen van Prinsterer's *Lectures on Unbelief and Revolution*]." See Rookmaaker's interview with Colin Duriez (November 30, 1971), in *CWR*, 6:152, where he also self-identifies as "a pupil of Dooyeweerd." References to Groen and Dooyeweerd appear

art historians, perhaps especially from the controversial Roman Catholic and antimodernist Austrian art historian Hans Sedlmayr in his well-known *Loss of the Center* (1948) and *The Revolution of Modern Art* (1955). It might even be argued that Rookmaaker's project was essentially to reconceive Sedlmayr's art history from within a Dooyeweerdian framework.[32]

In the convergence of all of these influences, *Modern Art and the Death of a Culture* emerged as a statement of Christian art criticism—and it did so with considerable effect. Malcolm Muggeridge featured *Modern Art and the Death of a Culture* as one of the four best Books of the Year in a December 1970 edition of *The Observer*,[33] and it quickly shot to bestseller status, particularly among Christian readers.

ART AND WORLDVIEW

At the outset of *Modern Art and the Death of a Culture* Rookmaaker articulates the governing premises of his narrative of modern art history: "The issues at stake are not just cultural and intellectual but spiritual. What is involved is a whole way of thinking that leaves out of account, and so largely negates, vital aspects of our humanity and our understanding of reality."[34] Packed into these lines are the contours of the entire book, in terms of both his method and his thesis.

First, here we glimpse the method of "worldview" analysis that was funda-mental to Rookmaaker's art criticism.[35] For him, the most significant aspect of any artwork is that it inevitably presupposes and is a product of "a whole

throughout Rookmaaker's writings, but for a concise discussion that includes his views on both scholars, see his L'Abri lecture "A Dutch Christian View of Philosophy," in *CWR*, 6:174-84.

It should also be noted that there were plenty of other breakdown narratives on offer from a range of positions, including secularist ones. The most well known of these was Oswald Spengler's *The Decline of the West* (1918–1923), which Rookmaaker was familiar with—and critical of (see *CWR*, 2:4, 85).

[32]In 1957 Rookmaaker wrote a review of Sedlmayr's *Die Revolution der modernen Kunst* [The Revo-lution of Modern Art] (see *CWR*, 5:346-50). His account of Sedlmayr's book maps closely onto the "three step" narrative of *Modern Art and the Death of a Culture* (see discussion below) and shares many of its conclusions.

[33]*Observer*, December 20, 1970, 17; see also *Esquire*, March 1971, 16.

[34]Rookmaaker, *MADC*, 9-10.

[35]For further discussion and critique of the development of Rookmaaker's worldview analysis within a neo-Calvinist framework, see Jeremy S. Begbie, *Voicing Creation's Praise: Towards a Theol-ogy of the Arts* (Edinburgh: T&T Clark, 1991), part 2, esp. pp. 127-41; and Taylor Worley, "Theology and Contemporary Visual Art: Making Dialogue Possible" (PhD diss., University of St. Andrews, 2009), 44-72.

way of thinking" about the world; it discloses and makes visible a particular orientation toward the world. Whether consciously or unconsciously, in majestic or seemingly trivial ways, any artwork made by a human person "always portrays reality in a human way" and thus inevitably "gives a particular view on reality."[36] In this sense, Rookmaaker believed that artworks "give a philosophy of the world and of life," and these philosophies can and must—for the sake of understanding the ways they are both reflecting and affecting us— be sensitively exegeted and interpreted.[37]

It is vital to note that for Rookmaaker the kind of "philosophy of the world and of life" that is most importantly manifested in an artwork is often much more basic than the conscious, cognitive ideas the artist had in mind while making the work. The worldview Rookmaaker is interested in includes the entire network of assumptions, affections and dispositions that locate, orient and motivate a person in and toward the world. Modernist paintings, no less than any other art forms, are significant not only for the ways they function as intentional expressions or statements of belief but also for the ways they (often unintentionally) disclose a "general spirit of the age."[38] In other words, what interested Rookmaaker about any given artwork was the way that it reveals the complex structure of social and cultural moods, values and beliefs that underwrite and uphold the work at a deeper level than is ever fully in the field of any artist's conscious intentions. And, once again, for him the deepest issues and concerns that are in play here are "not just cultural and intellectual but spiritual"—and they are not adequately understood until they are interpreted as such.[39]

[36]Rookmaaker, MADC, 21.

[37]Ibid., 28. Elsewhere he writes: "Everything human attests to the human, and the human is never just something neutral, a void. The painting is loaded with meaning. . . . Art is not neutral. We can and ought to judge its content, its meaning, the quality of understanding of reality that is embodied in it." Rookmaaker, Art Needs No Justification, in CWR, 4:331, 336.

[38]Rookmaaker, MADC, 9.

[39]Elsewhere, he clarifies his reasoning on this point: "The unseen world is inextricably intertwined with the natural world, and each has a significant effect on the other. . . . Our actions have far wider results than we could ever have imagined." Rookmaaker, The Creative Gift: Essays on Art and the Christian Life (1981), in CWR, 3:136. Calvin Seerveld, Rookmaaker's friend and contemporary, states the matter more evocatively: "When a woman acts artistically she does not jump out of her skin. When a man is symbolically objectifying what he finds to be meaningful, his whole modal makeup is subterraneanly involved, including the genetic evolvement of its present composition. . . . The whole human creature is somehow, and naturally so, busy in the act of making art. That means especially this too: the condition of humanity's inescapable relationship to God, the temper

Furthermore, it is vital to note that he was looking for this disclosure of worldview to appear not only in the themes and subject matter taken up by an artist but, more importantly, in "the way the theme and the subject-matter were handled."[40] For Rookmaaker, artists' choices of what they turn their attention toward are less significant than how they construe and construct these subjects in artistic form: this, he believed, is where an artist's deeper assumptions, dispositions and structures of belief—the artist's "particular *view* on reality"—are most operative and discernible. And on this point, we can already see why his attentiveness to art as a *picturing* of the world would lead him to privilege painting over other visual art forms.

The subtle but important implication of Rookmaaker's method is that it is the artwork itself that discloses worldview, and thus *it*—not the artist—is the proper object of critical analysis. Regardless of whatever may have been in the minds of modern artists as they worked and spoke about their work, what is of primary importance is the concrete picturing of the world—the "handling" of subjects, themes and materials—that is embodied in the artworks themselves. It is, after all, the art object that "gives a particular view on reality, a philosophy," not the artist per se.[41] In other writings he repeatedly insisted on this point: "In the final analysis we are concerned with the critique of the concrete paintings. We must not judge the artist when we are looking at a picture, but consider the painting itself."[42] In fact, "let there be no mistake:

of that deep, underlying religious focal point to a human creature which is what makes him or her human, in other words, the status of a human's stand . . . even though it is not consciously articulated and especially because it is not consciously articulated, that quietly guiding focus of an entire human casts a decisive spell over and through what the artist produces." Seerveld, *A Christian Critique of Art and Literature*, 38-39.

[40]Rookmaaker, *MADC*, 18.

[41]Ibid., 21.

[42]Rookmaaker, "The Christian Critique of Art" (1952), in *CWR*, 4:354. It needs to be noted that Rookmaaker's frequent talk about paintings having "a message" has muddled this issue considerably. On the one hand, he refers to traditional religious paintings as conveying a biblical "message" (e.g., 28, 31), but on the other hand he asserts that even a work that appears senseless and haphazard inevitably still conveys "a message of almost religious importance, interpreting man and his world" (18). Many have taken Rookmaaker to be saying that the "message" in the work is the *artist's* message delivered through a material form, thus reducing visual art to a kind of communication system—and thereby effectively collapsing art criticism into speculation about artistic intention (derived largely from artist biography). Admittedly, Rookmaaker's "message" vocabulary is problematic, but when placed in the broader context of his work, it is fairly clear that the message of an artwork is "what *it* wants to say," rather than what the artist intends to say (28, emphasis added). In this sense, *message* becomes more or less a synonym for *meaning* or *content*.

we are not saying that the artist determines the content, the thought, the idea that takes shape and is given form. That may sometimes be the case, but usually the artist . . . will only give form to the ideas that are 'in the air,' so to speak."[43]

Second, beyond providing a sketch of his method, the lines quoted at the beginning of this section also offer a staging of Rookmaaker's thesis and his chief complaints about modernist art. Namely, he argued that modernism misconstrues and in fact "largely negates" some of the most "vital aspects of [1] our humanity and [2] our understanding of reality." In other words, Rookmaaker believed that modern art is fundamentally *dehumanizing* and *disorienting*. Given his commitment to interpreting artworks in terms of the ways they convey and generate "views" of the "structure" of reality—that is, as a picturing of the world and a handling of the subjects that compose human life—he naturally interpreted the flattening, compressing, distorting and fracturing of visual space in modernist painting as manifesting and promoting a variety of flattened, compressed, distorted and fractured understandings of the realities themselves. It is on this basis that he was particularly troubled by the handling of the human form in modernist painting and the doubts it generates about our perceptions of reality. Those who studied with him remember his ability to find much in the work of Picasso or Klee to admire, but when he felt that the new languages of art represented an estrangement from reality or a distortion of humanity, he protested.

AN AGE OF CRISIS

On the basis of his pictorial worldview analysis, the story of modern art history that Rookmaaker tells is of a gradual decline into nihilism and absurdism. He did not think that modern art is itself responsible for this decline—he considered it symptomatic of a dying culture but not a cause of it, and perhaps not even a serious contributor to it. The villain in Rookmaaker's narrative is not artistic modernism but the Enlightenment, the intellectual engine of what we have been calling modernity: "Modern art did not just happen. It came as a result of a deep reversal of spiritual values in the Age of Reason, a movement that in the course of a little more than two centuries changed the world."[44]

[43]Rookmaaker, "The Influence of Art on Society" (1968), in *CWR*, 4:374.
[44]Rookmaaker, *MADC*, 11.

As he saw it, the character of this reversal and the fundamental effect of Enlightenment thinking was that "however gently, [God] was pushed out of the door."[45] The primary mechanism of this push was an overly optimistic (and increasingly materialist) rationalism for which "there is nothing more in the world but what the senses can perceive and reason can apprehend" and in which "the only way to come to any understanding of [the universe] is to use our senses (seeing, hearing, weighing, measuring) and to use our reason to coordinate the sensations or perceptions we have had."[46] By this path, he argues, Enlightenment science became a pseudoreligious "scientism," promising "the revelation of the new world" and demanding only that devotees "cling superstitiously to the word scientific as true to reality. But it is a reduced reality."[47]

Thus we need to be careful about exactly which "culture" and which "death" we assume the title of his book references. We might initially suppose—and many readers have supposed—that Rookmaaker's book was a panicked warning about the death of Western *Christian* culture, wherein modern art is identified as a clear symptom of the disease(s) afflicting it. This view is certainly supportable from the book itself, but it is also clear that the dying cultural ethos he has in mind is already significantly post-Christian.[48] The book might be more precisely addressed to "Modern Art and the Death of *Enlightenment* Culture"—his primary aim being to consider what modern art tells us about what happens *after* modernity.[49] The first page of the book declares Rookmaaker's overarching intention: "My aim in this book is to show the relationship between the great cultural revolution of our time [modernism] and the general spirit of the age [modernity]—an age which, as we shall see, would seem to be

[45]Ibid., 44.

[46]Ibid., 45-46.

[47]Ibid., 46-47. It should be noted that this characterization of the Enlightenment, which necessitates some version of the modern secularization thesis, has been persuasively called into question in recent years. See, for example, David Sorkin, *The Religious Enlightenment: Protestants, Jews, and Catholics from London to Vienna* (Princeton, NJ: Princeton University Press, 2011).

[48]In the broadest sense he was referring to "Western culture, as built since the Renaissance and the Reformation, slowly undermined since the Enlightenment, [which] is still there, but as a tottering ruin, while the new culture is coming in" (*MADC*, 190). But as the Enlightenment draws to a close he asserts that already "we have seen the crumbling of a culture. Increasingly we see ourselves living in a world that is post-Christian and even post-humanist. . . . It must be clear that every day we come nearer to the situation of the early Christians" (*MADC*, 246).

[49]This follows Nicholas Wolterstorff's review of the book: "When Rookmaaker speaks of the death of a culture, it is of the death of Enlightenment culture that he is speaking." Wolterstorff, "On Looking at Paintings: A Look at Rookmaaker," *Reformed Journal* 22, no. 2 (February 1872): 11.

drawing to a close."[50] In the waning of this Age of Reason, modern art appears (in Rookmaaker's reading) as a tragic, quixotic protest against modernity—tragic because it ingests the same underlying nihilism of modernity that it attempts to revolt against and quixotic because it misidentifies the "much greater crisis." As he puts it in his last (unfinished) book, "This greater crisis is of a spiritual nature and, as such, affects all aspects of society including economics, technology and morality."[51] With this he reverses at least one of the causal arrows assumed by the modern secularization thesis: spiritual crisis gives shape to modernization, not simply vice versa.

Rookmaaker never mentions Max Weber in any of his writings, nor are there any indications that he ever read his work, but his discussions of scientism can be mapped onto Weber's descriptions of the modern "disenchantment of the world" (see chapter one). Rookmaaker accuses scientistic rationalism of constructing "a reduced reality" insofar as it required that "the world was no longer open to a transcendent God. It had become a closed box, and man was caught in that box."[52] And for Rookmaaker this is not simply an abstract problem; it is utterly concrete in its everyday social, political and economic implications: under the regime of scientism humans increasingly become units in the mechanics of technocracy and consumerism.

Over against these dehumanizing undercurrents of modernity, Rookmaaker believed that existentialism (following Kierkegaard) and avant-garde modernism (following Baudelaire) mounted vital protests: "They have told man to jump out of the box. . . . You are more than matter, more than the naturalistic sciences can tell you."[53] In fact, in numerous places he asserts that the chief virtue of modernism was precisely its will to protest on this point (taking the oppositional stance described in the last chapter), even though he also believes that it erred in not protesting deeply enough: Christians "must realize that the protesters and revolutionaries are often fighting against the same evils of society as they are themselves. But they must also see the inadequacy of all answers that do not tackle the root of the problem."[54] For Rookmaaker, the "root

[50]Rookmaaker, *MADC*, 9.
[51]Rookmaaker, *Art Needs No Justification* (1978), in *CWR*, 4:321-22.
[52]Rookmaaker, *MADC*, 47.
[53]Ibid., 48.
[54]Ibid., 10; cf. 198-203. Later in the book he elaborates on this objection: modern art "is a fruit of the Enlightenment; it expresses the consequences of its basic principles. . . . But we must also account

of the problem" is that God has been excised: the world will always remain disenchanted, humans will continue to be dehumanized and ethical norms will remain undecidable—in short, the world will always be a "closed box"—as long as we live as though the world is mechanically closed to the Giver (and the Giving) of being itself.[55] In its simplest terms, Rookmaaker's argument (1) pits modernism's avant-garde against modernity's scientistic rationalism, (2) faults both of them for harboring an inescapable nihilism[56] and then (3) posits (Reformed) Christianity as the only viable ground for a third way.

A DECLINIST ART HISTORY

Rookmaaker's historical narrative traces the development of modernist art through three "steps." The first step spans the nineteenth-century transition from romantic to realist painting, which he sees as playing out a series of epistemological crises and "deep spiritual problems" generated by the Enlightenment.[57] As modern scientism sought naturalistic explanations for every dimension of human experience, it proceeded by methodically demanding empirical and rational verification for each aspect of human belief. The necessary flip side of this was that all perceptions, all received conventions, all traditional explanations must be procedurally doubted and subjected to this same process of authentication—they might well survive but only as rigorously reconstructed with the tools of logic and scientific method. This placed pressure especially on those deliverances of history that held most sway over human lives: inherited forms of cosmology, political hierarchy and religious tradition were all subjected to deep and sustained efforts to "demythologize"

for another aspect of our age, the reaction against rationalism and naturalistic science. It is a reaction, and yet dependent on what it is reacting against: it makes sense only because it does in fact acknowledge the truth (or at least the inevitability) of naturalism and naturalistic science" (62; cf. 111-12, 196, 211).

[55]The key to his argument is his belief that because humans are made in the image of God and cannot change their own basic created being, people will always protest dehumanization, regardless of their (a)theism. This is his most significant point of connection and commonality with modernist art (see *MADC*, 48).

[56]In fact Rookmaaker's position might be understood as an intellectually weaker version (or precursor) of John Milbank's claim that there are essentially two paths leading through Western history: Christianity and nihilism. See Milbank, *Theology and Social Theory: Beyond Secular Reason*, 2nd ed. (Malden, MA: Wiley-Blackwell, 2006). An argument might be made that Rookmaaker's narration of modernity might not need to be discarded as much as simply made more sophisticated, using the resources provided by Milbank and others.

[57]Rookmaaker, *MADC*, 50.

whatever verifiable truths might be contained within them. Christianity, for instance, was distilled down to a more credible *Religion Within the Bounds of Bare Reason* (Immanuel Kant, 1793), the Bible was dissected and intensely scrutinized by higher biblical criticism, and (as Rookmaaker points out) theology was reconstructed through the demythologizing skill of scholars like Rudolf Bultmann.[58]

Many positive developments (and many necessary corrections) emerged from this methodical doubt, but according to Rookmaaker it was also reductive, extensively unraveling an intricate and longstanding weave of religious, political and social ideals. And this had considerable implications for visual art, pressing artists increasingly toward empirical observation and casting the various grand traditions into their own processes of demythologization, by which the once-celebrated modes of dramatic storytelling, theological commentary and neoclassical poesis became increasingly problematic. Indeed, "the problem for the artist was now what to paint, what to see."[59] Rookmaaker tracks the ways that "thematic" subject matter gradually collapsed in the nineteenth century: whereas art once devoted itself to meditating on the meanings of history, the Scriptures and mythopoeic archetypes, now the old "principles of choosing subject-matter" were abandoned in favor of more thoroughly naturalized meanings.[60] Where once there was Venus (an allegorical embodiment of transcendent Love and Beauty), now there were wholly immanent "nudes"; where once landscape paintings celebrated the sphere of God's common grace, now they were simply artifacts of immediate sense perception; and so on.

Faced with enduring epistemological doubts about "the true source of knowledge,"[61] painters like Gustave Courbet (1819–1877) and Édouard Manet (1832–1883) painted what they saw without any predetermined narrative or iconographic meaning governing what they depicted. In fact, they actively subverted and degraded the old thematic principles and ideals. Manet's *Luncheon on the Grass* (1863), for example, is a particularly clear instance of an artist turning the thematic traditions of painting against themselves: here the

[58]Ibid., 72; cf. 208-9.
[59]Ibid., 50.
[60]Ibid., 58.
[61]Ibid., 56.

conventions for painting a multifigure narrative, a landscape, a still life, a nude and even a bather are wound into a single incoherent picture constructed with obvious spatial incongruities, irreconcilable sources of light and a scandalizing (and scandalizingly "low") narrative. And all this is presented at the massive scale reserved for the grand statements of history painting. It is a Salon painting meant to confound—and to be highly critical of—the thematic conventions of the Salon. Manet's *Olympia* (1864), from the following year, similarly recasts the Salon (and its crowds of idealized nudes) as a kind of intellectual brothel. Rookmaaker states the historical progression evocatively: "To Titian she had been Venus, to Goya a mistress," but to Manet "a prostitute."[62] And thus the first step toward modern art: "Themes in the old sense had become obsolete."[63]

Rookmaaker identifies the second step with impressionism, particularly the paintings that Claude Monet (1840–1926) made after 1885. Following on the heels of Courbet and Manet, subject matter continued to lose importance, and artists became increasingly preoccupied with the epistemological status of vision. In other words, painting shifted its attention from the symbolic and thematic meanings of *what* was seen to the sensory experience of *seeing itself.* And Monet's mature paintings pushed this shift very far indeed: he does not present a solid world of things as much as he rigorously "recorded what reached his eyes, the light beams that caused a sensation on his retina"— which for Rookmaaker implied an epistemological crisis at the most basic level: "the question is whether there is something behind them, a reality of things that caused the light beams."[64] For reasons that are unclear, Rookmaaker believed that Monet's work promoted the conclusion that in fact "there is no [knowable] reality. Only sensations are real."[65] He characterized

[62]Ibid., 61-62.

[63]Ibid., 61.

[64]Ibid., 85.

[65]Ibid., 86. The best explanation we get for this claim is his appeal to "the positivist and impressionist principle that there are no laws that govern reality, that only experimental facts can be called true and certain" (96). It is worth noting, however, that on this issue his position unexpectedly echoes that of the famous American critic Clement Greenberg, who argued that the impressionists believed that "modern life can be radically confronted, understood and dealt with only in material terms. What matters is not what one believes but what happens to one. From now on you had nothing to go on but your states of mind and your naked sensations, of which structural, but not religious, metaphysical or historico-philosophical, interpretations were alone permissible. It is its materialism, or positivism, presented more explicitly than in literature or music, that made painting

this extreme epistemological doubt as the second step. In fact, he thought this was the "decisive step" that marks the birth of modernist art as such.[66]

The postimpressionist paintings of Paul Gauguin (1848–1903), Vincent van Gogh (1853–1890), Georges Seurat (1859–1891) and Paul Cézanne (1839–1906) form a moment of suspension in Rookmaaker's telling of the development (or degeneration) of modern art. Rookmaaker retained sympathy especially for Gauguin, who had been the subject of his doctoral dissertation. In many ways Gauguin and his fellow postimpressionists appear as the tragic heroes of Rookmaaker's narrative: "These four tried to solve the problem, to regain the ground, to bring humanity and reality back into art. . . . They looked for a way to find something of the true values and the lasting principles of reality, the deeper universal."[67] Specifically, he saw their work as attempting to forge a "synthesis" between the positivist "principle of starting from sense-perception to gain knowledge of the universe" and the antipositivist "principle of human freedom, the search for a humanist humanity," thus "bringing together the best of the two opposing streams."[68] In fact, he thought they had achieved this synthesis so elegantly that he crowned their work as "probably the fullest and richest the world had seen since the seventeenth century."[69] Ultimately, however, "the harmony they achieved was an unstable one . . . soon to be broken," throwing these competing principles into discord.[70] And the effects might be understood as deeply damaging: from this point forward, according to Rookmaaker, "the personal, the human, the 'real'" became increasingly "lost" in modernist painting.[71]

Whereas the postimpressionists had sought "an equilibrium," with the advent of French fauvism and German expressionism "the pendulum swung completely to the side of the freedom of the artist," unhampered by the demands of either naturalism or decorum.[72] Ultimately it would be Pablo

the most advanced and *hopeful* art in the West between 1860 and 1914." Greenberg, "The Present Prospects of American Painting and Sculpture," *Horizon* (October 1947): 24-25. As an assessment of what the impressionists believed, Rookmaaker would have objected only to that last line.
[66]Rookmaaker, *MADC*, 85, 96.
[67]Ibid., 96.
[68]Ibid., 96-97.
[69]Ibid., 97.
[70]Ibid.
[71]Ibid., 119.
[72]Ibid., 102-10.

Picasso (1881–1973) and then Marcel Duchamp (1887–1968) who would take a definitive "final step." Rookmaaker represents Picasso as clearly understanding what was at stake in the previous two "steps"—which is why he thinks Picasso appears to hesitate around 1909—but eventually

> Picasso must have realized that [the postimpressionists'] quest had failed. They had searched for the universal, the general structure of things, that which is more than the strictly individual and specific—and in doing so had lost the personal, the human, the "real." . . . [Picasso] accepted the failure, and took the consequences. There are no universals. The general, the absolute, is non-existent. And if there are no universal principles, if there are no absolutes, then . . . we can understand his hesitation . . . then this world is absurd, nonsensical, without meaning.[73]

And with this, Rookmaaker's narrative launches into increasingly negative proclamations: "Picasso, in breaking through the barriers of reality, opened a kind of Pandora's box. The spirits took their abode in the minds of men like Duchamp, and brought a whirlwind of anarchy, nihilism and the gospel of absurdity. The wind is still blowing, and becoming a storm: a storm called revolution."[74] No doubt Duchamp was "one of the most influential men of our century, a man of great intellectual ability, a man who could and did dare to risk the consequences of his thinking," but he was also the foremost among the artists and thinkers who "accepted the truth of the absurdity of this world and this life."[75] His ready-made sculptures, for instance, are mundane found cultural artifacts (a snow shovel, a bottle rack, a urinal, etc.) exhibited as works of art—acts of defiance in which the "absurdity is willed." Rookmaaker regarded these works (partially correctly) as assaults on the very idea of "high art standing for high human values," but he saw no constructive project or alternative theory of art in them.[76] Indeed, he regarded the project as pure antagonism: under Duchamp's influence, like-minded artists "saw that now all values, norms, forms, traditions, all that belonged to western culture including its art, had lost their meaning. They looked for a great upheaval, the breakdown of our culture, in the acceptance of nihilism and anarchism."[77]

[73]Ibid., 119-20 (last two ellipses original).
[74]Ibid., 130.
[75]Ibid., 128, 126.
[76]Ibid., 130.
[77]Ibid., 126.

Hereafter, as far as Rookmaaker is concerned, the dominant theme of modern art is that "man is dead. He is nothing but a machine, a very complex machine, an absurd machine."[78] In fact from here on the word *absurd* appears dozens of times in the book and is used to characterize nearly every major artistic movement in the twentieth century.[79] We might well expect it to be applied to Dada:

> It was Dada that tried to laugh away all that is of value in our world, a nihilistic, destructive movement of anti-art, anti-philosophy . . . a nihilistic creed of dis-integration, showing the meaninglessness of all western thought, art, morals, traditions. It destroyed them by tackling them in an ironic way, with black humor, by showing them in their absurdity, by making them absurd.[80]

We might also expect it for surrealism, though this language gets rather over-heated:

> Surrealism is . . . an attitude of intellectual agony. Surrealism is revolutionary and destructive: the whole of western culture and its society are thrown away in a battle against all that exists, in a revolt against everything to which a bour-geois world had previously held firm. They were against nation, God, and reason—particularly the latter. They were against personality, conscience, beauty as an aim, talent, artistry, even the very will to live.[81]

The work of Paul Klee (1881–1973) is characterized as nihilistic mysticism, "a cold romanticism . . . the art of a man who knows about absurdity, chance, alienation and agony."[82] Vasily Kandinsky (1866–1944) painted "the irratio-nality of the rational," displacing traditional iconography for "a sort of volcanic,

[78]Ibid., 129.

[79]Interestingly, Rookmaaker clarifies that he has a specific theoretical referent in mind when he uses this word: "The term absurd here is really an anachronism: it was used only later by Sartre, Camus and the theatre of the absurd. But the idea of the absurd had already been there for some years [in the work of Alfred Jarry, Arthur Rimbaud, Stéphane Mallarmé, et al.]." *MADC*, 120-21.

[80]Rookmaaker, *MADC*, 130.

[81]Ibid., 144. He differentiated between two kinds of surrealism—the "concrete" and the "abstract"—and he was displeased with both. The concrete surrealists (de Chirico, Dalí, Magritte, Delvaux and Ernst) make paintings that are "'normal' as far as technique goes," but their subject matter presents the world as "strange, abnormal, irrational, not so much a nightmare as a horrible day-dream. . . . This is alienation—what looks real is unreal. Man is a stranger in God's creation" (147-48). By comparison, the abstract surrealists (Masson, Matta, and sometimes Miró, Ernst and Tanguy) present "an image of hell, a confrontation with the haunted, the evil, a feeling of 'floating in an empty space,' as if being itself collapses and falls to its utter destruction" (148).

[82]Ibid., 138.

destructive force in this strange geometry."[83] And in Rookmaaker's estimation, modernism slides downhill from there. He gives gloomy assessments of Jackson Pollock, Robert Rauschenberg, Lucio Fontana, Henry Moore, pop art, op art, happenings, minimalism, conceptualism and so on—seeing violence, "crisis, alienation, and absurdity" as characteristic to them all.[84] Although in principle "our reaction to modern art has no need to be wholly negative,"[85] Rookmaaker's reaction is nevertheless overwhelmingly pessimistic. He identifies very few exceptions to the general unraveling. The Roman Catholic artist Georges Rouault (1871–1958) is presented as one of the rare artists to have shown that within a modern stylistic paradigm "another kind of art is possible . . . an art which is a positive answer to absurdity and surrealism and existentialism."[86] But he laments that Rouault went largely unnoticed, both in the church and the art world, and he regrets the absence of any significant "Protestant counterpart" who might have helped the cause.

By the 1960s, Rookmaaker was ready to concede that "modern art has won the battle."[87] Modernism had gained considerable power in the major art institutions—particularly in museums and academia—and the writing of modernist art history had already been developed and codified to such an extent that it effectively defined what "the modern" means in the arts. The grain of art history now ran decisively through modernism, which came to delineate the contours (for both inclusion and exclusion) of what counted as the most significant artmaking over the past century. But as Rookmaaker read it, within these contours resided something deeply nihilistic at its core: the modernists "tell us that everything is rotten, nothingness, putrid, empty, senseless."[88]

Whereas modernism almost always narrated itself in terms of progress—social, political, philosophical or aesthetic—Rookmaaker saw it as a story of digress into a despairing (or sneering) nihilism. In many ways he subscribed to a modern secularization narrative similar to the one articulated by Belgian art historian Thierry de Duve, who has argued that the noble function of "the best modern art" was "to redefine the essentially religious terms of humanism

[83]Ibid., 140.
[84]Ibid., 168.
[85]Ibid., 133.
[86]Ibid., 157. For further example (and explanation) of Rookmaaker's regard for Rouault, see "Rouault" (1954), in CWR, 5:236-39.
[87]Rookmaaker, MADC, 159-65.
[88]Ibid., 209.

on belief-less bases."[89] Rookmaaker would have basically agreed; he just saw this as profoundly tragic rather than hopeful (as it is for de Duve) and as evidence of spiritual failure rather than progress. All in all, his account plays neatly into Elkins's narrative of the modern gulf between art and religion, with the exception that he saw only calamity where Elkins sees puzzling curiosities.

PROBLEMS

For Christians (and others) who are interested in the discourse of religion and art, Rookmaaker's work includes many important contributions. He ventured into the historical and cultural rifts between Christianity and modern art at a time when very few Christians gave it their attention, and he called others to do the same. And as he did so, he helpfully addressed and diagnosed several problems on both sides of this rift. On the one hand, much of his work urges critical self-reflection on the part of Christians, particularly regarding the gnostic, privatist and escapist renderings of the gospel that have plagued modern Christianity. In fact, it seems that he regarded this to be the hub of his project. As he wrote in one of his most famous statements, "We should remind ourselves that Christ did not come to make us Christians or to save our souls only, but that he came to redeem us in order that we might be human, in the full sense of that word. To be new people means that we can begin to act in our full, free, human capacity in all facets of our lives."[90] We could well understand all of Rookmaaker's work as addressed to Christians, trying to get them to digest and develop the implications of that statement (particularly as it pertains to cultural theology).

On the other hand, as we've seen, he was also intent upon initiating more critical self-reflection about the meanings of modern art, especially with

[89]De Duve, *Look, 100 Years of Contemporary Art*, trans. Simon Pleasance and Fronza Woods (Brussels: Palais des Beaux-Arts; Ghent-Amsterdam: Ludion, 2001), 14. Elsewhere, de Duve proceeds to define postmodernism as the proper child of modernism: "It means post-Christian, and inasmuch as Christianity is the religion that signals the exit from religion, it also means radically nonreligious. . . . Today's art institution is a Church but a nihilistic Church." De Duve, "Mary Warhol/ Joseph Duchamp," in *Re-Enchantment*, ed. James Elkins and David Morgan, vol. 7 of *The Art Seminar*, ed. James Elkins (New York: Routledge, 2009), 103.

[90]Rookmaaker, *Art Needs No Justification* (1978), in *CWR*, 4:324. In fact quite a large portion of his writing was directly addressed to theological topics: see esp. *CWR*, vol. 3, vol. 4 part 2, and vol. 6 parts 1–2. It seems clear that he considered his primary audience to be other (Protestant) Christians, given both his mode of address and his venues for publication: the vast majority of his articles were published in Christian journals and his books by Christian publishers.

regard to its own visions for a "full, free, human" life. The key feature (and chief contribution) of his work on this point is that modernism was at all points theologically charged: insofar as modern art was a *human* enterprise, its significance is always inevitably theological at some level.[91] And as he saw it, the deepest resources for conducting a fuller critical engagement with modern art are found within a (Reformed) Christian theological framework. James Romaine summarizes: "For Rookmaaker, there was no theologically neutral content in art. All content, whether dressed in 'religious' subject-matter or not, was measured in terms of its biblical truthfulness."[92] In this respect Rookmaaker's work greatly expanded the possibilities for theological thinking in the interpretation of modern art.

Despite these contributions, however, many who reread Rookmaaker's book today are increasingly dissatisfied with both his methods and his conclusions. Art historian and curator Daniel Siedell has registered the most significant criticisms:

> Rookmaaker's history of Western art in general, and modern art more specifically, was crafted not so much to maximize understanding of the history of modern art but to maximize space for the Christian artist. . . . The history of modern art that it presents is intended to serve as a rhetorical tool that demonstrates culture's need for the Christian artist.[93]

The result is a handling of modernism that is reductive both historically and critically, even if tactically expedient: "The tendency has been, at least since Rookmaaker, to paint as dire a picture as possible of the history of modern art and the contemporary art world" in order "to drive a significant wedge between the past of nihilistic modern art and a future where Christian artists can shape culture."[94] Siedell worries that in fact the entire project of the contemporary "Christian artist" has been constructed such that it simply "requires a nihilistic, elitist, anti-Christian history of modern art and an impenetrable,

[91]It needs to be noted (again) that in making this claim he placed less emphasis on artistic intention than on the function of the art object within broader cultural contexts; and in doing so he generally avoided indulging the intentionalist fallacy in the ways that subsequent Christian engagements with the arts have tended to.

[92]Romaine, "You Will See Greater Things than These: John Walford's Content-oriented Method of Art History," in James Romaine, ed., *Art as Spiritual Perception: Essays in Honor of E. John Walford* (Wheaton, IL: Crossway, 2012), 36.

[93]Siedell, *God in the Gallery*, 155-56.

[94]Ibid., 159-60.

corrupt, and inaccessible contemporary art world against which to react."[95] This version of art history has indeed been effective in motivating large numbers of Christians in recent decades to pursue artmaking with great seriousness and intentionality, but it has also produced stifling effects. The Rookmaakerian narrative of twentieth-century art (and, as we will see later in this chapter, his alternative criteria for what good contemporary art might be) is so idiosyncratic in the current context of academic art history that adopting it as one's own is often functionally crippling for those hoping to participate in and contribute to the primary discourses and institutions of contemporary art (as artists, critics, theorists, curators or historians).

The central problem is that Rookmaaker's account hinges on a theory of art that interprets visual representations as making *ontological* assertions about the things represented. In other words, as we have already seen, he regarded an artist's handling of subject matter as presenting "a particular view on reality," which thereby reveals "a whole way of thinking" about what and how *the world is*. Of course this is one of the ways that images can function—indeed historically it was a primary function[96]—but Rookmaaker did not adequately recognize the extent to which this is no longer the central task of *painting*. In the context of a visual culture increasingly saturated by mass-produced photographic imagery—much of it deployed through the machinery of journalism, advertising and celebrity culture—the purposes and meanings of representations had become much more complicated and contestable, and numerous modernists embraced painting as a means of contesting or creating alternative spaces within that visual culture. This means that a modernist painting might offer much less of "a particular view on reality" than it does a particular (often particularly critical) view on image construction in the age of modernity.

As already noted, Rookmaaker's art theory is most clearly on display (and most clearly problematic) when he interprets the fragmentation and dissolution

[95]Ibid., 160.

[96]This function is a deeply significant issue throughout the history of Christian art, in which there were serious theological debates about whether the ontic function of images was inherently idolatrous (especially when holy events or persons were depicted). Among Protestants, particularly within the Reformed tradition, the depiction of religious subjects was considered especially problematic, and this ontic-pictorial function was turned toward other subject matter (see chap. 4 below for further discussion). Given Rookmaaker's own Reformed background, it is not surprising that his art theory is structured as it is.

of pictorial space in modernist painting as an attack on or a loss of *what* is represented, which he finds particularly troubling when it pertains to humanity and to "reality." This thematic approach is conspicuous throughout his work, and, interestingly, it once again plays into Elkins's conclusions. In Rookmaaker's discussion of nineteenth-century painting, for example, he argues that "by removing Christ, or Mary, or other Christian themes from the picture itself, leaving them outside the picture-frame, it is as if Christ himself, and the reality of the things Christians believed in, were placed outside the world."[97] As he moves further into twentieth-century painting, the problem becomes more acute and his method more strained. For instance, he turns a critical eye toward Joan Miró (1893–1983):

> What has become of man? Miró once painted a picture of a picture. He took a reproduction of a secondary seventeenth-century Dutch picture [*The Lutenist* (1661) by Hendrick Martenszoon Sorgh] (it could just as well have been a Vermeer or a Rembrandt [Miró is traipsing over Rookmaaker's home turf here]) and gave his own reinterpretation. Nothing is more telling. Man is dead, it says. The absurd, the strange, the void, the irrationally horrible is there. The old picture is treated with humor, scorn and irony—black humor and devastating irony—until nothing is left. As the image is destroyed, so too is man.[98]

It is unclear why we should regard Miró's *Dutch Interior (I)* (1928) as simply transposing Sorgh's imagery into the domain of "the absurd, the strange, the void, the irrationally horrible." We might just as readily associate it with the whimsical, the improvisational, the mystical, the intuitively playful. Indeed, Miró himself would have found the latter list to be a more appropriate description.[99] It is also unclear why we should believe that Miró's "picture of a picture"

[97]Rookmaaker, *MADC*, 70. This is an argument from silence, but it is also uneven in its application. Rookmaaker does not make any similar claim about seventeenth-century Dutch painting, which also largely removed Christ, Mary and other Christian themes (with some notable exceptions like Rembrandt) in favor of careful observation of common grace in everyday life. In that case these removals were done for explicitly theological reasons that he embraced (such painting was profoundly Calvinist, as we shall see in chap. 4), and Rookmaaker holds them up as the finest artworks in Christian history, precisely because of the ways they turn reverent pictorial attention toward reality.

[98]Rookmaaker, *MADC*, 146-47.

[99]Among his other influences, Miró drew strongly from the Spanish Christian mystics Teresa of Ávila and John of the Cross, and he thought of his artmaking as a work of reenchantment: "Every grain of dust has a wonderful soul, but to understand it, one needs to regain the religious, magic sense of things." See Charlene Spretnak, *The Spiritual Dynamic in Modern Art: Art History Reconsidered, 1800 to the Present* (New York: Palgrave Macmillan, 2014), 101-2.

is making sweeping pronouncements on the topic of "man" more than it is commenting on (or critiquing) the older *painting* from which it was derived, or even the formal conventions of "painting" more generally.

But it is that last statement—"as the image is destroyed, so too is man"—that most deserves our suspicion. Rookmaaker so closely associates pictorial representation with the dignity of whatever is pictured that its dismantling (or dissembling) on the surface of a modernist canvas is interpreted as a violation of the dignity of whatever is pictured, even in this case where it is a picturing of another artist's picturing.[100] In this way he interprets the modernist flattening and distorting of human form as a flattening and distorting of human dignity itself—and, as we have already seen him argue, *that* kind of flattening signals very problematic developments in the broader cultural consciousness, both ethically (dehumanization has infiltrated our vision) and epistemologically (the intelligibility of the world has fallen into question).[101] But why would that be the best way to interpret Miró's painting—or "modernist painting" as a general category?

The narrative hinge of *Modern Art and the Death of a Culture* is the development of Picasso's so-called analytic cubism, which Rookmaaker refers to as his "first 'horrible' period." (He proceeds to track Picasso's progress through at least three "horrible" periods.)[102] Rookmaaker uses the year 1911 to mark "Picasso's great break through the boundaries of reality," wherein he begins painting "absurd man, absurd reality; man made up of some planks; man as non-man."[103] Once again, for Rookmaaker these paintings of humans are received as presenting a pictorial ontology of those humans—"man *made up of* . . . man *as*"—as opposed to any number of other ways these paintings might be read. For fellow cubist artist and critic Jean Metzinger, for example, the significance of these paintings had little to do with the disfigured face of

[100]Similarly, he interprets Picasso's handling of Diego Velázquez's *Las Meninas* (1656) as "a kind of artistic anarchistic murder of the whole royal family and their way of life." Rookmaaker, *MADC*, 154.

[101]Cf. Siedell: "Modernist art is often dismissed by Christian commentators because it looks like it is doing violence to traditional figurative art and thus by (dubious) extension doing violence to traditional (Christian) concepts of humanity and divinity" (*God in the Gallery*, 40).

[102]Rookmaaker, *MADC*, 117-22, 151-56.

[103]Ibid., 151-52. Elsewhere he writes, "Picasso's art, for example, is often not sound in that he pictures many parts of the body in a wrong place, i.e. in a place contrary to God's created order." Rookmaaker, "The Christian and Art" (1964), in *CWR*, 4:357.

humanity; rather "Picasso unveils to us the very face *of painting*. . . . I am aware of no paintings from the past, even the finest, that belong to painting as clearly as his."[104] In fact, he believed that the discontinuity and fragmentation of Picasso's pictorial space follows from a *realist* impulse to include the passage of time (and the shifting position of the artist in space) in the construction of the image: "Whether it be a face or a fruit he is painting, the total image radiates in time; the picture is no longer a dead portion of space."[105] Alternatively, for the famous American art critic Leo Steinberg, "semiotics" (rather than ontology) was the right handle for interpreting cubism: "In the end, the materials of Picasso's gerrymandering are not heads as such, since these come with their proper structure of slopes and planes, but those remembered *signs that stand for* eye, mouth, oval perimeter, and so forth."[106]

The point here is that the problems of analytic cubism might have less to do with *what humans are* than with what it means for a human likeness (or any likeness) to be presented in the rectangular flatness of the canvas. That was the philosophical (or semiotic) set of problems that analytic cubism was designed to address. We emphasize this here because much of one's reading of modernism—and certainly one's theological reading of modernism—turns on this. By all accounts there was some sort of deep doubt being worked through in Picasso's gerrymandering; but we come to very different conclusions about the significance of that doubt if we understand it in terms of Steinberg's "signs that stand for" versus Rookmaaker's "man *made up of*"—the first an interrogation of Western visual language in a photographic age, the second an effacement of human dignity. Perhaps the artist's "worldview" is also discernible

[104]Metzinger, "Note on Painting" (1910), in Charles Harrison and Paul Wood, eds., *Art in Theory, 1900–2000: An Anthology of Changing Ideas* (Malden, MA: Blackwell, 2003), 184-85 (emphasis added). Metzinger was one of the most important of the early theorists of cubism. In the 1912 book *Du Cubisme*, which he coauthored with Albert Gleizes (discussed further in the following chapter), he similarly argued that the aim of cubism was to "indefatigably study pictorial form and the space which it engenders" within the "different kind of space" intrinsic to "the picture, a plane surface." In fact they believed that a logical trajectory for cubism is to "let the picture imitate nothing." Albert Gleizes and Jean Metzinger, selection from *Cubism* (1912), in *Theories of Modern Art: A Sourcebook by Artists and Critics*, ed. Herschel B. Chipp, with Peter Selz and Joshua C. Taylor (Berkeley: University of California Press, 1968), 211-12.

[105]Metzinger, "Note on Painting," 185.

[106]Steinberg, "The Algerian Women and Picasso at Large," in *Other Criteria: Confrontations with Twentieth-Century Art* (New York: Oxford University Press, 1972; repr., Chicago: University of Chicago Press, 2007), 166 (emphasis added). It should be noted that in this passage Steinberg is specifically discussing Picasso's "proto-Cubist" portraits from 1907 to 1908.

in Steinberg's hermeneutic, but it stands forth in a different way than Rook-maaker anticipates.[107]

As might be expected from his art theory, Rookmaaker had a strained rela-tionship with abstract painting. He praised the use of abstract formal elements in the fields of functional or commercial design, where these elements are "appropriate to their function, because they have no pretentions to mean something of great depth."[108] Within the discursive context of an exhibition space, however, he interpreted abstract painting primarily in terms of epis-temic *negation*: it is "the breaking down of the clear image, the failure to retain the natural."[109] If Picasso took the decisive step in the shattering of art's ca-pacity to convey the goodness and the intelligibility of the world, then abstract artists seemingly abdicated the responsibility altogether. Rookmaaker re-garded abstraction as a (gnostic) search for universals that operated specifi-cally by turning away from the world and attempting "to build something detached from reality."[110] He agreed with Sedlmayr that art generally loses its meaning and comprehensibility "when people seek to depict through it basic principles of reality without referring to anything concrete. For it is a fact that abstract concepts can never be grasped as such. . . . [They] appear only when one divests concrete givens of their concrete characteristics."[111] In contrast to abstract painting, he believed that "a *Street* by Vermeer or a *St. Nicholas*

[107]It is important to note, however, that there is surprising agreement between Rookmaaker and the Marxist social art historian T. J. Clark on this issue. Like Rookmaaker, Clark believes that cubist paintings say something about the things depicted (not only about the act of depicting), pointing us toward a certain "texture of difficulties inhering in objects or objecthood." In fact, Rookmaaker could well have written this: "Something is happening to the things of the world in [Picasso's] *The Architect's Table*, something is being done to them: different, unstable relations between things (or aspects of the same thing) are being imagined or denoted. . . . What is being done to the world in the oval is done not by 'painting' alone but by painting-in-the-service-of-epistemol-ogy." Clark, *Farewell to an Idea: Episodes from a History of Modernism* (New Haven, CT: Yale University Press, 1999), 184-85. Ultimately Clark's view seems to include and reframe both Rook-maaker's and Steinberg's, arguing that the rhetoric of analytic cubism is "two-faced": "On the one face . . . there is a darkness and obscurity, a deep shattering of the world of things; but on the other, there are the signs of that darkness and obscurity being produced by sheer tenacity of attention to the world and its merest flicker of appearance; and a deep fear, not to say loathing, of the pic-ture's totalization looking 'unverifiable'" (186).

[108]Rookmaaker, *MADC*, 195.

[109]Ibid., 97. He says this even more directly elsewhere: "Abstract art is more than the purely aesthetic alone. It is first of all a negation, a negation of the value of the reality around us." Rookmaaker, *Art and Entertainment* (1962), in *CWR*, 3:70.

[110]Rookmaaker, *Art and Entertainment*, in *CWR*, 3:70.

[111]Rookmaaker, review of *Die Revolution der modernen Kunst* by H. Sedlmayr (1957), in *CWR*, 5:349.

Morning by Jan Steen offers us much more. . . . In and with these objects some-
thing of value is told us that can never be given in separation from them, for
then I would either be saying nothing or else no one would be able to under-
stand me."[112]

It is unclear, however, why Rookmaaker did not recognize the painted
surface itself as a constellation of meaningful "concrete givens," offering
"something of value" that can never be given apart from that surface. In other
words, why doesn't Rookmaaker's advocacy for artworks exploring the
goodness of creaturely reality extend to the materiality of painting itself and
the extraordinary range of (abstract) formal relationships possible within it?
He generally continued interpreting abstraction in essentially pictorial terms,
ignoring the variety of other factors (and critical possibilities) at work in an
encounter with abstract painting. The American art critic Donald Kuspit
sharply criticized the tendency by which "philosophy exaggerates the artwork
into an epistemological problem, into the problem of epistemology itself,"
thus obscuring "the concreteness that is the source of the artwork's intense
particularity."[113] Rookmaaker would appear to fall squarely under the weight
of that critique.

DISCERNING THE SPIRITS

Even if Rookmaaker's representational theory of art predisposed him toward
a negative reading of modern art, this still does not fully account for the tre-
mendous momentum that pushes his three-step narrative along its downward
path. A further reason that he read modernist paintings in the way he did be-
comes clearer as we return to his claim that the issues at stake in the arts are
"not just cultural and intellectual but spiritual." As he saw it, the spiritual issues
involved here were not merely individual (as though *spiritual* were simply syn-
onymous with some aspect of private experience); they were also caught up
in the more costly conflicts among spiritual "principalities and powers."[114]

[112]Ibid.

[113]Kuspit, "Philosophy and Art: Elective Affinities in an Arranged Marriage" (1984), in Kuspit,
 Redeeming Art: Critical Reveries, ed. Mark Van Proyen (New York: Allworth Press and the School
 of Visual Arts, 2000), 12-13. Over against this philosophizing of art, Kuspit advocates for the art
 critic, who recognizes the artwork "as a knot of consciousness, an intransigent texture not easily
 shaped to intellectual order." Indeed, one of the critic's primary tasks is "to restore the concrete-
 ness of the artwork by recognizing its resistance to thought—its 'poetic' character" (13).

[114]Rookmaaker, *MADC*, 132-33, 227.

Throughout his writing he regularly referenced (sometimes directly, sometimes allusively) Paul's caution to the early church in Ephesus: "For we wrestle not against flesh and blood, but against principalities, against powers, against the rulers of the darkness of this world, against spiritual wickedness in high places" (Eph 6:12 KJV).[115] Rookmaaker regarded modernist art as one site where this wrestling was obviously going on (and generally being lost) in Western culture, and as such the artistic discourse could not for him be simply academic or aesthetic; he thought the stakes were extremely high.

For this reason, even if he was highly critical of the work of Picasso (to take one example), he was not dismissive of it. This is perhaps most exemplified in Rookmaaker's biting review of J. M. Prange's cranky screed against modern art in his book *The God Hai-Hai and Rhubarb*. Prange's book mockingly characterized modernism as a pseudocultic spectacle equivalent to worshiping an invented god named Hai-Hai. What makes Rookmaaker's review especially interesting—and illuminating of his own criticisms of modernists like Picasso—is the basis of his critique:

> The question remains who the god Hai-Hai is. . . . For what Prange did is mortally dangerous. He says to us: this god is not there, it is pure bluff, idle sputtering and empty raving. But for all that this god, the spirit of the century, *is* there to be sure, and force of error though it may be, this god is in any case a deeply spiritual reality that we cannot just frivolously kick aside. Those who really want to be engaged in today's spiritual struggle must take their opponent seriously. . . . Prange reports that he stood in front of Picasso's *Guernica* and laughed; he ought to have wept.[116]

Rookmaaker firmly believed that modern artworks like *Guernica* were key contributors not only in the drama of human values and ideologies but also in the drama of human allegiances to real spiritual forces and regimes. It was no laughing matter. And he felt that this aspect of the life of a culture—including the history of art—must be named and considered: this spiritual

[115]For a sampling of Rookmaaker's numerous references to this verse, see *CWR*, 2:150; 3:44-46, 139, 175, 347, 399, 473-74; 4:374n587; 5:180, 225, 260, 278; 6:62, 82, 84, 109, 168.

[116]Rookmaaker, review of *De God Hai-Hai en rabarber. Met het kapmes door de jungle der moderne kunst* [*The God Hai-Hai and Rhubarb: With a Machete Through the Jungle of Modern Art*] by J. M. Prange, and review of *Die Revolution der modernen Kunst* [*The Revolution of Modern Art*] by H. Sedlmayr (1957), parts 1 and 2 of a four-part review, in *CWR*, 5:346-47 (emphasis original). Playing off of Prange's book title, Rookmaaker adds: "Prange used a machete, rough and without nuance, more than the fine lancet of analysis" (346).

dimension "exists and endures as a power that one may not mentally dismiss without falsifying or even rendering impossible one's apprehension of today's world."[117] However, one can also see why engaging art in terms of "today's spiritual struggle" against "the spirit of the century" would make it impossible for Rookmaaker to interpret Picasso's cubism, or any other work like it, within the more modest framework of Metzinger's formalism or Steinberg's semiotics. The prospect of offering a theologically informed account that runs alternative to Rookmaaker probably necessitates arguing for a different "discernment of the spirits" in the history of modern art—one that sees the Holy Spirit as more active in that history than Rookmaaker realized.

THE QUESTION OF NORMS

Perhaps the crux of the issue becomes clearer as we investigate Rookmaaker's use of the term *normal*, which appears regularly throughout the book and is a key to his interpretive process—in fact, it functions as the counterpart to *absurd*, both in meaning and frequency of usage. He usually places the word in quotation marks, as if to indicate his discomfort with its connotations, but he continues to make it carry content. He refers to the concrete surrealists (such as Dalí and Magritte) as presenting a world that is intensely "abnormal" and irrational, but they do so through "meticulously precise painted images, 'normal' as far as technique goes."[118] He also directs our attention to a 1918 painting in which Picasso painted his first wife, Olga, "in a 'normal' way, resembling an Ingres portrait."[119] In these examples *normal* apparently refers to the construction of traditional pictorial space—however surreal or idealized the subject matter may be—rendering light, volume and spatial depth "in an almost normal way, as any classicist would have done."[120] The term thus designates a *familiar* sense of form in space.

But this is not to imply that by *normal* he simply meant naturalistic. The kind of familiarity he had in mind was richer than that: it had more to do with one's sense that an artwork articulates something about "reality in its fullness."

[117]Ibid., 5:346.

[118]Rookmaaker, *MADC*, 147.

[119]Ibid., 152. Rookmaaker only identified this painting as being painted in 1915, but Picasso didn't meet Olga until 1917. The painting he was referring to is almost certainly *Olga in an Armchair* from 1918, which is indeed strikingly reminiscent of the portraiture of Jean-Auguste-Dominique Ingres (1780–1867).

[120]Ibid.

Early in the book, for example, he praised "the naturalness, the full humanity" of Jan Steen's *The Feast of Saint Nicholas* (c. 1665–1668), which he admired because the naturalistic rendering was not simply for its own sake but was "controlled by a true insight into reality, an insight that must have a deep foundation, one that really leads to the opening up of reality. The very normality of the picture is founded in a deep understanding, a 'philosophy.'"[121] Achieving this generative insight into "normal" reality was the central issue; and while this insight might propel an artist toward the pictorial naturalism of paintings like Steen's, it might also potentially demand other approaches to painting. In his discussions of Georges Rouault, for instance, Rookmaaker argued that modernist painting offers valuable correctives to more strictly naturalistic ways of conceptualizing this "opening up of reality":

> Undoubtedly one must count it as one of the positive renewals brought about by modern art that it broke with the naturalistic notion that, in the art of painting, the effort must be made to render [natural] reality as exactly as possible. For... reality is more than its natural aspect, which was all that naturalism ever had an eye for, at least when it was consistent. No, art must not just render the visible, external, measurable and weighable. Far from it. It also can and should depict reality in its fullness.[122]

This potential (or necessity) for artworks to disclose everyday reality with a stronger sense of its unquantifiable "fullness" was one of Rookmaaker's highest values in the visual arts, and it was precisely this potential that he thought modernism could have been well poised to actualize. But it was also by these same criteria—the presentation of a fuller vision of humanity and the dense meaningfulness of the world—that he found modern art to be most tragically disappointing (or offensive): it disfigured "the visible, external, measurable and weighable" rather than offering a fuller vision of it. In contrast to the tradition that gave us Diego Velázquez's painting of *Pope Innocent X* (1650), for example, which is "very human, very 'normal,' very beautiful and very much the great man," modernism has given us the "paralytic, neurotic, leprous schizoids" of Francis Bacon's numerous appropriations of Velázquez's portrait (1946–1965).[123] In fact Rookmaaker took this contrast to be exemplary: it is

[121]Ibid., 26.

[122]Rookmaaker, "Rouault" (1954), in *CWR*, 5:236.

[123]Rookmaaker, *MADC*, 173. Elsewhere Rookmaaker adds: "As painting was once concerned with

no accident that one of Bacon's screaming popes (*Head VI*, 1949) appears on the cover of *Modern Art and the Death of a Culture* as a quintessentially modernist icon.

Of course none of this is simply a stylistic matter; Rookmaaker believed that pictorial aesthetics were intrinsically linked to ethics. For instance, he interpreted Picasso's return to the more traditional representational style of his "classicist" period (roughly 1917–1924) as denoting "a more 'loving' and free expression when he loves a woman," in contradistinction to the misogynistic pictorial violence of his "more absurd, more cubist" style.[124] This associating of violence with cubism was bolstered by the presumption that Picasso generally would "begin with a 'normal' drawing, and then he would begin to change it, each picture going further than the last. It gets more cubistic, loses more and more of its normal appearance, is reduced to almost nothing."[125] As is consistent with everything we've already seen from his theory of art, Rookmaaker interpreted this violating of "normal appearance" as in some sense a violating of the persons and places being pictured.

The deeper reasoning supporting all of this comes into view when Rookmaaker frames his notion of "normal" (or reveals that for him it was always framed) as a theological category: "When things are in accordance with God's created possibilities and his will for his world, they are just 'normal.' When love reigns in a community, that community is not strange but healthy."[126] The concept of "normal" that weaves throughout his writing is thus ultimately an appeal to "the structures and norms [that] are universal and given by God in Creation."[127] And it is an appeal made while acknowledging an extraordinary

what is sacred and true, what is good and beautiful, the modern artist now appears and says: 'Look what it really *is*, this truth, this goodness . . . it is nothing; it is absurd. Human being is dead, and so-called "humanity" is fiction.' On this basis we can understand why modern art is sometimes a direct comment on old paintings. . . . Bacon's whole series of portraits based on one work of Velasquez's come to mind." Rookmaaker, "Commitment in Art" (1969), in *CWR*, 5:192.

It should be noted, however, that divergent readings of Velázquez's painting are possible here, even from a Christian perspective. The British theologian T. J. Gorringe, for instance, argues that "Velázquez has managed to say something about how power corrupts: it is chilling, for example, to read this painting alongside the Beatitudes [Mt 5:1-16]." Gorringe, *Earthly Visions: Theology and the Challenges of Art* (New Haven, CT: Yale University Press, 2011), 94.

[124]Rookmaaker, *MADC*, 152.

[125]Ibid., 154. He also detected the same disfiguring process in Henri Matisse's work, which (as with Picasso's work) he understood as a process of *loss* (105).

[126]Rookmaaker, "The Artist as a Prophet?" (1965), inaugural lecture for his professorship in the history of art at the Free University at Amsterdam, in *CWR*, 5:186.

[127]This comes from a lecture titled "To Do the Truth in Art" that Rookmaaker delivered in London

sense of contingency about the ways that we (ab)use these structures and (mis)realize these norms—a contingency that is inscribed into the "when" in those previous sentences. Rookmaaker believed that the structures of creation are open structures and the norms are the patterns most conducive to systemic organic health, but they are not deterministic: they determine the range of healthy (and unhealthy) possibility, "but we have to give form to this possibility. We have to make it concrete, for the universal structures and norms never exist as universals but always in specific, concrete and individual forms. Reality is always the concrete realization of a given possibility."[128] And, as should be expected, Rookmaaker's conceptualization of both evil (systemic destructive *ab*normality) and salvation (restoration into a fullness of life) are tightly aligned with this framework: "Christ came for the very purpose of breaking through the reign of evil and sin and suffering. He came to make the world normal."[129]

And thus followed his philosophy of art: his advocacy for "works which are more human and normal"[130] was grounded in a concern to care for and cultivate the "norms" of the created order and of flourishing human life. Rookmaaker's book culminates with a program for "Faith and Art" (as his final chapter is titled)[131] in which he argued that good art is that which embodies and adheres to the "norms for art," which "are in fact basically no different from the norms for the whole of life. Art belongs to human life, is part of it,

in October 1970 (about nine months after the publication of his book), in which he specifically concentrated on the question of norms in art. See Rookmaaker, "To Do the Truth in Art" (1970), in *CWR*, 6:225-35; quotation from p. 232. Indicating the importance of this lecture, Rookmaaker's daughter notes that he regarded it as "more a programme than a finished result. He said: 'It is what I want to work on in the following years, and I hope that others will begin to think along with me, ask questions, give criticisms, and add things, so that something may evolve that could be very important'" (*CWR*, 6:433n45).

[128]Ibid., 232. It is worth noting that Rookmaaker, had he been so inclined, might have taken this position to imply an extraordinary rationale for abstract painting.

[129]Rookmaaker, *MADC*, 151; cf. 159. Later in the book, he elaborates: "Love and freedom belong to normal human life as given by God to man, but now, after the Fall, they are hard to achieve, to create, to realize. Christ came to make them possible. He died in order that we might be truly human, to have love, freedom and beauty and all the good things" (244).

[130]Rookmaaker, "Pondering Four Modern Drawings" (1952), in *CWR*, 5:230. It should be noted that "more human and normal" didn't necessarily mean naturalistic. Immediately after using this phrase he argued that "van Gogh's art still evidenced a 'normal' sense of reality. It left things in their proper places and viewed them with loving eyes" (ibid.).

[131]It is profitable to read this concluding chapter of *MADC* alongside Rookmaaker's final book, *Art Needs No Justification* (Downers Grove, IL: InterVarsity Press, 1978), which is essentially an expansion and elaboration of that chapter.

and obeys the same rules."[132] Using Philippians 4:8 as his springboard, he identified six norms for art (and for life): (1) truth/honesty, (2) honor/decorum, (3) righteousness/fittingness, (4) purity/goodness, (5) loveliness/beauty and (6) excellence/praiseworthiness.[133] And once again aesthetics are tightly linked to ethics: to eschew any of these norms as an artist "is to do wrong to the beholder, to fall short of being truly loving":

> For basically these norms are all aspects of the great command to love. Love is the great norm, in art as well. Love is to make things that are right and fitting, to help our fellow-man, to make this world more beautiful, more harmonious, more suitable for human living, more suitable for expressing that inner beauty and love for which all men are searching. . . . Beauty, as it were, is a by-product of love, of life in its full sense, of life in love and freedom.[134]

The artist's task, his or her "very special and wonderful calling," is therefore "to make life better, more worthwhile, to create the sound, the shape, the tale, the decoration, the environment that is meaningful and lovely and a joy to mankind."[135]

On the one hand, this is a vision well worth affirming: Rookmaaker's core concern is to advocate for an art that is principally oriented by love of God and love of neighbor. His critique of modernist art was that even though it may have rightly rebelled against the unjust and dehumanizing aspects of modernity, it in turn demonstrated its own kinds of cruelty and diminished, rather than contributed to, the reconciliation and flourishing of others. That is a critique that should be taken quite seriously.

On the other hand, his formulation of the "norms for art" also suffers from some serious weaknesses: (1) Perhaps strangely, it fostered impatience and defensiveness in Rookmaaker's interpretive and critical engagements with artworks. His summary statements of one artist's career after another tended toward reductive, even uncharitable, readings of their works. Early on he arrived at the conviction that "*abnormality*, strangeness and distortion are part of the very essence of modern art,"[136] and this caused him to eschew much more of modernism than he should have. There was in fact a great deal more

[132]Rookmaaker, *MADC*, 236.

[133]Ibid., 236-43.

[134]Ibid., 242-43.

[135]Ibid., 243.

[136]Rookmaaker, "Pondering Four Modern Drawings" (1952), in *CWR*, 5:230 (emphasis added).

in modern art that was life-affirming and concerned with the spiritual well-being of others—perhaps even lovingly so—and Rookmaaker missed much of it as it was screened out by his normative formulations. (2) A further problem is that his countervailing directive "to create the sound, the shape, the tale, the decoration, the environment that is meaningful and lovely and a joy to mankind" is, practically speaking, extremely susceptible to becoming an essentially decorative and consumerist conceptualization of the arts. In fact, this susceptibility becomes blatant as Rookmaaker identified what he saw as positive and viable alternatives to modernism:

> Maybe the real art of our times, comprising both the aesthetic and the imagi-
> nation and command of technique, is to be found in advertising, or in magazine
> layout, or in the graphic design of leaflets or even in scientific drawings. Or
> there is the often very fine visual means of depicting statistics, and so on. The
> forms are often strongly influenced by modern "high" art, but they have got a
> meaning, a sense, have become "normal" and to the point. . . . Perhaps too most
> real art today is in television. There are not only the often very imaginative
> openings, using drawings, letters, animated figures, photography and so on, but
> also the representation of many aspects of reality. . . . The message is often hard-
> core reality, "facts" themselves, and that is all.[137]

In one sense, his recognition of popular culture as a primary site of aesthetic and religious value (and the challenge this poses to high-low cultural dichot-omies) was progressive for its time. But it is also precisely here that we get Rookmaaker's extremely conservative criteria for "real art": it (1) is aestheti-cally beautiful, (2) is imaginative, (3) displays a command of technique, (4) can be absorbed by viewers as fairly "normal" and "to the point," and (5) rep-resents the "facts" of reality. In the context of the discourse of modernism these criteria—and especially their identification with advertising, scientific charts and television—are extremely problematic for Rookmaaker's position. Not only is looking to advertising and television for messages of "hard-core reality" highly contestable,[138] he has, in the interest of cultivating a more loving art, essentially collapsed the space for criticality, difficulty or even intel-lectual complexity within the category of "real art."

[137]Rookmaaker, *MADC*, 195.

[138]Elsewhere in the book he severely takes mass media to task (ibid., 200-201, 211), which makes this passage even more confusing.

To further complicate things, there is another "normal" in Rookmaaker's work that amplifies problems on precisely this issue. Near the end of his book Rookmaaker presumably confronts the question directly in a section titled "What is normal?"[139] In stark contrast to his other uses of the term, however, here he associates "normal human life" with the "bourgeois mentality," which he sharply criticized as embodying "this lack of commitment, this lack of real values, this lack of 'daring to live.' The shallowness and emptiness are appalling."[140]

The problem is that when Rookmaaker speaks of norms, he has at least two sets in mind: on the one hand *normal* refers to a healthy adherence to God-given "law-spheres" (as Dooyeweerd called them), and on the other hand it refers to socially constructed systems—including traditions of art—which are often death-dealing and oppressive.[141] This ambiguity causes deep problems for Rookmaaker's art criticism: while one might appreciate the Reformed notion, it becomes difficult to tell how these norms are rightly distinguished from those of the "bourgeois mentality" that Rookmaaker believed should be resisted. And this difficulty becomes especially acute with regard to modernist art: given its persistent violations of traditional visual norms and bourgeois visual culture, it becomes difficult to sort out which normal is really under attack and which should and should not be defended within the Rookmaakerian schema. Perhaps it is true, for example, that "Dada's black humor can only live in the negation of, or in play with, these norms,"[142] but in the midst of the catastrophic pain of World War I, how are we to decide *which* norms Dada was really working to negate? (We will consider this question further in chapter five.)

Still, in light of (or despite) all of this, Rookmaaker's work has been helpful to generations of Christians active in the arts, and his overall influence has been positive. His reading of modern art was flawed, but his consistent aim was to urge fellow Christians toward a fuller and more intensely constructive vision for the arts: "Christianity is about the renewal of life. Therefore it is also about the renewal of art. . . . It is for Christians to show what is meant by life and humanity; and to express what it means for them to have been 'made new'

[139]Ibid., 209-12.
[140]Ibid., 210-11; cf. 76.
[141]See, for instance, Rookmaaker, "The Philosophy of Unbelievers" (1953), in *CWR*, 2:17.
[142]Rookmaaker, *MADC*, 242.

in Christ, in every aspect of their being."[143] In his lecture tours throughout the United States and Britain, in his university teaching and in his later writings he emerged as one of the most encouraging voices in support of Christian involvement in the arts, a voice that was sadly cut short by his sudden death in 1977 (when he was only fifty-five years old).

Rethinking Modernism (With and Without Rookmaaker)

Within the framework developed in these first two chapters, the chapters that follow in part two offer some avenues for rethinking the religious contexts and the theological implications of the history of modern art. And in this Rookmaaker's work provides more of a starting point than an orientation: these avenues will function as *alternative* routes to those that Rookmaaker forged. We will refer to him occasionally in the following pages (sometimes only in footnotes), signaling some important points where our understandings of particular artists are especially divergent from his, but we are not interested in aligning our remaining chapters into a tit-for-tat engagement with his positions. Nor are we interested in simply revising or repackaging his narrative; we are offering a different account, one that places the emphases on other points and approaches from other angles.

In the following studies we will, however, restrict ourselves to the general geography and time period of Rookmaaker's book: namely, North Atlantic modernism from about 1800 to 1970, the year that *Modern Art and the Death of a Culture* was first published. But our remaining chapters will follow a different logic than his: our investigations will be arranged more geographically than chronologically (allowing us to highlight cultural contexts that were broadly Catholic, Orthodox or Protestant), and we will overlook numerous artists that Rookmaaker included in his account, instead slowing down to focus more carefully on fewer artists. Our primary conversation partners will shift from Rookmaaker to a selection of critics and art historians who have significantly contributed to the scholarship on the artists who will concern us. Obviously we cannot be comprehensive here—with respect to either our selection of artists or to our engagement with the massive literature on each of the artists that we will discuss—but we hope to highlight at least some of the

[143]Ibid., 229.

significant religious influences and theological meanings that are too often left buried in the academic literature. Part of what the remaining chapters seek to do is to make the resources of this literature available to a wider (or at least to another) readership, including people of faith (of whatever tradition) who are interested in modern art.

We might frame our larger goal as an attempt to encourage a greater interpretive generosity—or what we called in the first chapter a more "charitable hermeneutic"—within the discourse of modern art. If the narratives of modernism have often been too narrowly framed in political or formal aesthetic terms, to the exclusion of adept religious and theological thinking, then religious believers (including Rookmaaker) have also often approached and evaluated modern art within narrow religious grids. While not denying the importance of any of these available critical frames—whether secular or religious—we want to expand our vision to consider the ways that these multiple frames and impulses intermingle in modern artworks and issue organically from the cultural and religious contexts in which the artists worked. The following chapters represent a few steps forward in these considerations, and we hope that others who are perhaps sparked (or provoked) by what we write will take the next steps.

GEOGRAPHIES, HISTORIES AND ENCOUNTERS

France, Britain and the Sacramental Image

Painting is the most beautiful of all arts. In it, all sensations are condensed; contemplating it, everyone can create a story at the will of his imagination and—with a single glance—have his soul invaded by the most profound recollections; no effort of memory, everything is summed up in one instant.

PAUL GAUGUIN[1]

The imagination of Delacroix! This has never been afraid to climb the difficult heights of religion; the sky belongs to him, so does hell, and war. . . . Here is the true painter-poet! One of the few elect whose spirit extends to comprehend religion. . . . All the pain of the Passion impassions him; all the splendor of the Church illumines him.

CHARLES BAUDELAIRE[2]

When Rookmaaker launched his description of the steps of modern art in France, he began with the challenges posed by the Enlightenment—the challenges not only to faith in God but to how we can know the world. This starting point finds support in events surrounding the French Revolution (1789), which, as is well known, set in motion a deliberate process of dechristianization during the 1790s in France. Christian worship was to be replaced by a cult of reason.[3] Moreover, the subsequent separation of church and state was

[1]Gauguin, "Notes synthetiques" (c. 1888), in *Theories of Modern Art: A Sourcebook by Artists and Critics*, ed. Herschel B. Chipp, with Peter Selz and Joshua C. Taylor (Berkeley: University of California Press, 1968), 61.

[2]Baudelaire, "Salon de 1859: Religion, Histoire, Fantaisie," in *Curiosités esthétiques, Salon 1845–1859* (Paris: Michel Lévy Frères, 1868), 281-82 (translation by Dyrness).

[3]On this period, see John Walsh, "Religion: Church and State in Europe and the Americas," in *War and Peace in an Age of Upheaval, 1793–1830*, ed. C. W. Crawley, vol. 9 of *The New Cambridge Modern History* (Cambridge: Cambridge University Press, 1965), 146-60.

based not on mutual respect (as in the United States) but on a mutual hostility. This separation and the accompanying antagonism toward Christianity certainly had its influence on the rise of modern art.

But alongside this antireligious and anticlerical process there were other currents at work that vigorously disputed the secularism of the Revolution; indeed, the romantic movement that was to deeply mark nineteenth-century French art gathered its support and energy in part by opposing the secular rationalism of the Enlightenment. By 1815, accompanying the romantic reassertion of feeling and spirituality were signs of religious awakenings in many places in Europe, including France. In ways parallel to Schleiermacher in Germany (see chapter four), François-René de Chateaubriand (1768–1848) had introduced, with the publication of his *Génie du christianisme* (The Genius of Christianity, 1802), a new apologetic for Christianity that was consistent with the affective impulses of romanticism. As in Germany, the French purveyors of this new apologetic were more often artists and novelists than theologians. Maurice Denis (1870–1943), an artist who did much to recover sacred art in France, begins the modern chapter of his *Histoire de l'art religieux* by praising three nineteenth-century artists inspired by this revival: Pierre-Paul Prud'hon (1758–1823), who painted an influential crucifixion in 1823, copies of which were widely circulated; Jean-Baptiste-Camille Corot (1796–1875), who read from Thomas à Kempis's *The Imitation of Christ* each day and approached nature with humility; and Victor Hugo (1802–1885), who was greatly influenced by Chateaubriand. Denis wondered how the nineteenth century, which began so spiritually alive, could succumb to the stagnation of academicism.[4]

COURBET AND THE IMPRESSIONISTS

Working in the middle of the century, Gustave Courbet (1819–1877) represents an example of this influence at one remove. When Courbet showed his large (10 × 22 ft.) painting *Tableau of Human Figures: A History of a Funeral at Ornans*, known popularly as *A Burial at Ornans* (1849–1850), in the Salon of 1851, it was clear to everyone in Paris that a blow had been struck against the traditions of painting. (See fig. 3.1.) But the exact nature of the challenge—or better the various challenges—was not at all clear. For, as T. J. Clark points

[4]Denis, *Histoire de l'art religieux* (Paris: Flammarion, 1939), 264, 271-72. Denis thinks that Prud'hon escaped the influence of the revolution.

out, the picture represents multiple tensions—artistic, political, social and even religious.[5]

The picture provides an offhand glimpse of a rural burial. In a forlorn landscape, a group of mourners gathers before an open grave. There appears to be no visual focus—distracted and grieving peasants on the right are balanced by a (tellingly off-center) group of clergy and acolytes on the left carrying their liturgical implements: holy water, prayer book and crucifix. In typical fashion the women mourners are separated from the men. A man on the right gestures toward the open grave barely visible below while a priest to the left fumbles with his prayer book as he tries to gain the attention of a distracted crowd. All of this seems to resist a grand-scale interpretation to match the grand size of the canvas; indeed, nothing draws the viewer's attention for long. And as Clark points out, "There is no exchange of gaze or glance, no reciprocity between these figures." Courbet "deliberately avoids emotional organization" such that there is no dramatic moment, no affectation, no revelatory moment.[6]

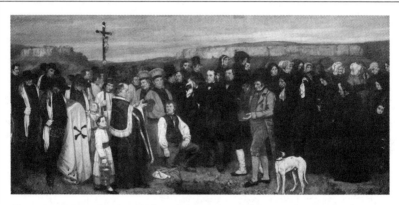

Figure 3.1. Gustave Courbet, *Tableau of Human Figures: A History of a Funeral at Ornans* or *A Burial at Ornans*, 1849–1850

Though nothing in the picture shocks the modern viewer, something about it is vaguely unsettling. Though Courbet was famously anticlerical, the picture

[5]Clark notes that the *Burial* and *Stonebreakers* represent these multiple tensions. He notes they are "supercharged with historical meaning, round which significance clusters." Clark, *Image of the People: Gustave Courbet and the 1848 Revolution* (London: Thames & Hudson, 1973), 17.
[6]Ibid., 83.

is free of irony. In fact, Hélène Toussaint has pronounced it "full of religious feeling."[7] Though it operates on the scale of Jacques-Louis David's massive *Coronation of Napoleon* (1805–1807), and though the full title seems to place it in the grand tradition as the *History of a Funeral at Ornans*, the anonymous funeral is clearly not intended to portray any person or event of significance. At the same time, even though it is a rural scene, *Burial* did not fit the peasant genre championed by Millet's *The Sower* (1850), which was shown in the same Salon. Indeed, Courbet seems to have gone out of his way to make it unadorned, banal, inelegant—following the canons of popular prints more than those of the academy. What bothered contemporary viewers was precisely its quotidian immediacy: "It was precisely its lack of open, declared *significance* which offended most of all."[8] It lacked the uplifting charm, idealism and beauty that attended the usual academic painting. But more than this, it boldly refused any clear narrative or iconographic meaning.[9] Perhaps this is why Rookmaaker argued that Courbet took the critical step in the nineteenth-century tendency to reject subject matter: he had come to suppose that all previous principles and themes were empty and meaningless, and thus Courbet resolved to paint only what he could see.[10] But with respect to religious influence and content, there is more to be said. To fully understand Courbet's role, and its subsequent influence, one needs to pay careful attention to, among other things, the religious context of his work.

The renewal of faith that we described at the beginning of this chapter was not always compatible with the institutional church, even though its religious devotion issued in a strong commitment to social and political justice. In many ways it represented an attempt to recover a pristine form of Christianity, to return to the religion of Jesus. The politician and political theorist Pierre-Joseph Proudhon (1809–1865) urged workers to "worship God without priests, work without masters, and trade without usury." This call, Clark

[7]Toussaint, *Gustave Courbet* (London: Arts Council of Great Britain, 1978), 209. Given this was painted before Courbet moved to Paris and that Franche-Conté was a deeply religious province, Toussaint argues that it is best to see this as representing the religion of Courbet's youth, which he only later threw over.

[8]Clark, *Image of the People*, 83 (emphasis original).

[9]Sarah Faunce and Linda Nochlin, *Courbet Reconsidered*, exh. cat. (New Haven, CT: Yale University Press; New York: Brooklyn Museum, 1988), 4.

[10]Rookmaaker, *MADC*, 58-59.

thinks, was influential on Courbet, who rode on its fervor, if not its substance.[11] Hélène Toussaint in fact believes that *Burial at Ornans* reflects the religious commitments that lay behind the 1848 revolution.[12] Proudhon himself was a follower of Claude Henri de Saint-Simon (1760–1825), who published his influential book on the *New Christianity* in 1825. There Saint-Simon focused on the spiritual aspects of society as the most important, and called on artists ("men of imagination") to recover the way of Jesus and lead the way to a new period of social and political harmony.[13] All of this was critical to Courbet's program. Courbet and Proudhon were close friends, and Courbet's program of social realism grew from Proudhon's ideas, which in turn were rooted in Saint-Simon's notion of a new Christianity. Proudhon joined those defending Courbet's *Burial*, denying that it could be sacrilegious: "Of all the most serious events in life, the one which least lends itself to mockery is death, the last event of all."[14] The realism and social concerns represented by Courbet would have been impossible apart from this larger religious context. And as we will argue, these commitments also provided an arena for new forms of religious art to appear.

These influences also created a favorable climate for artists who were drawn to religious themes. One who represented this openness, perhaps surprisingly, was Eugène Delacroix (1798–1863), who deserves a brief treatment here. Recent study has underlined the influence on Delacroix of the religious renewal we have sketched.[15] Theological reflection in Germany and a revived Thomism in France combined with the emerging influence of romanticism to

[11]Clark, *Image of the People*, 32. Proudhon's socialism later influenced Karl Marx, with whom he corresponded.

[12]Toussaint, *Gustave Courbet*, 210-12. The idea of the reconciliation of all humankind in Christ, Toussaint thinks, took political form in the 1848 revolution. She notes that it is wrong to read Courbet's later anticlericalism back into this early work.

[13]See Donald D. Egbert, "The Idea of the 'Avant-Garde' in Art and Politics," *American Historical Review* 73, no. 2 (1967): 341-43. Egbert notes that Saint-Simon's ideas were carried forward in Marxist thought and became influential in the development of the artistic avant-garde. His comments on Courbet and Proudhon, referred to here, are on 346.

[14]Proudhon, quoted in Toussaint, *Gustave Courbet*, 209.

[15]See Joyce Carol Polistena, *The Religious Paintings of Eugène Delacroix (1798–1863): The Initiator of the Style of Modern Religious Art* (Lewiston, NY: Mellen, 2008), 51-88, for what follows. This book is better on the religious context than on the ways this context actually impacted Delacroix's development. See also Polistena, "Historicism and Scenes of 'The Passion' in Nineteenth-Century French Romantic Painting," in *ReVisioning: Critical Methods of Seeing Christianity in the History of Art*, ed. James Romaine and Linda Stratford (Eugene, OR: Cascade Books, 2013), 260-75. Cf. Baudelaire's statement in the epigraph of this chapter.

create a socially progressive Catholicism represented by Chateaubriand and Hugues-Felicité Robert de Lamennais. This environment encouraged painters to focus more on Jesus' humanity and his life than on Catholic doctrine or creed. The undeniable influence of the French Revolution on this period has tended to obscure the continuing presence and seasoning of what we might call the Catholic imagination. Especially in rural France, where so many artists had their roots, and—as we will see in the case of Gauguin—found their inspiration, people retained a deep-seated sense of spiritual presence behind what the eye can see.

The work of Pierre-Paul Prud'hon reflected these influences, which in turn had a large impact on Delacroix, who said of him: "[Prud'hon] always spoke to the eyes through the soul." He was deeply moved upon seeing a copy of Prud'hon's *Christ on the Cross* (1822), probably during attendance at Mass. Afterward he recorded in his journal, "The emotional part seemed to rise up from the picture and to reach me on the wings of the music."[16] Delacroix's choice of subjects—*Jacob Wrestling with an Angel* (1854–1861), *Agony in the Garden* (c. 1850–1851) and *Christ on the Sea of Galilee* (c. 1853–1854)—reflects a combined fascination with the forces of nature and the power of religion.[17] The space and liturgy of churches especially stimulated his creativity: "The music, the bishop, everything is done to move one." He was fascinated by the transcendence and beauty of sacred spaces, and he believed the inner presence of God "makes us admire the beautiful . . . and creates the inspiration of men of genius."[18] Though his religious paintings make up only about 10 percent of his output, they represent some of his most important work— especially in the last decades of his life. In *Christ on the Sea of Galilee* (1854), for example, Christ is endowed with a veil of light, sleeping peacefully amidst the fury of the disciples' struggles with sails and rigging. In this painting (fig. 3.2), Delacroix employs his familiar palette and tumultuous style in the service of this familiar biblical story.[19] In the turmoil created by the diagonal

[16]Polistena, *Religious Paintings*, 57.

[17]Cf. Frank Anderson Trapp: "Two recurrent themes in Delacroix's art were wild animals and religious subjects." Trapp, *The Attainment of Delacroix* (Baltimore: Johns Hopkins University Press, 1971), 203.

[18]Delacroix, selection from his journal quoted in ibid., 229.

[19]Polistena argues that with these stylistic devices "Delacroix imbued the images with a subjective ideology about the person of Christ." Polistena, *Religious Paintings*, 57.

thrusts of the picture the eye is constantly brought back to the off-center figure of the sleeping Christ, as though to assure the viewer that amidst chaos divine peace can be found.

Figure 3.2. Eugène Delacroix, *Christ on the Sea of Galilee,* 1854

Still, if Delacroix shows the attraction religion had for artists of his generation, it would be wrong to call him a religious artist. Even Polistena admits that "Delacroix did not record an explicit yearning for the God of Christianity," and he was never formally received into the church.[20] Rather, his significance lies in proposing new possibilities for religious art, in a style that was more congenial to romantic sensitivities. Note that the influence of religion for Delacroix emphatically lay not in the doctrines but in the practices that it encouraged and the aura this evoked. This testimony from his journal is typical: "I was greatly struck by the Mass on the Day of the Dead, by all that

[20]Ibid., 262. Trapp notes that "Delacroix was far from a devoted churchgoer," though it is wrong to call him a son of Voltaire and an atheist, as is often done. Trapp, *Attainment of Delacroix,* 229. Maurice Denis believed this accounts for why Delacroix, deprived of the sacraments, focused on the salvation of the righteous outside of the church. Denis, *Histoire de l'art religieux,* 273.

religion offers to the imagination, and at the same time how much it addresses itself to man's deepest consciousness."[21] While working on his murals at the Church of Saint-Sulpice in Paris, he especially enjoyed working on Sundays: "I have profited well from the time I spend in church, not to mention the music they make there, beside which everything else sounds thin. . . . I work twice as hard on the days the masses are sung."[22] Whether or not Delacroix deeply believed that the liturgy communicated God's presence, he sensed the significance of these practices as openings to the transcendent. His awareness of the sacramental depth of things represented a constant influence in Catholic France, and this would again become important later in the century.

The decade of the 1850s, meanwhile, marked a turning point in France. From this point on public response to traditional religious subjects weakened dramatically. Nikolaus Pevsner in his review of the period notes that Delacroix was the last painter until the 1890s who could paint religious subjects. "The mid-nineteenth century was not religious and not enthusiastic," he notes. "It was too realistic for that."[23] Courbet's pride in being "without ideals and without religion" reflects this new secular spirit. (The Catholic Church for its part made a radical turn against modern developments in the 1850s, and strict Roman control won over the revitalized Gallican Church.) But it would be a mistake to believe this turn to realism was incompatible with religious expression. Indeed, we have argued that Courbet's innovations rested, in part at least, on previous religious influences. And even if his (subsequent) refusal of faith is taken at face value, the fact remains that for most modern artists Courbet's realism was a liberation that opened the way to new possibilities of expression, even religious expression. We might take the statement of Albert Gleizes and Jean Metzinger as typical. In their 1912 book on cubism they paid tribute to Courbet, claiming that "to estimate the significance of Cubism we must go back to Gustave Courbet," who "magnificently terminated a secular idealism . . . [and] did not waste himself in servile repetition: he inaugurated a realistic impulse which runs through all modern efforts."[24]

[21]Trapp, Attainment of Delacroix, 229.

[22]Ibid.

[23]Pevsner, "Art and Architecture," in The Zenith of European Power, 1830–70, ed. J. P. T. Bury, vol. 10 of The New Cambridge Modern History (Cambridge: Cambridge University Press, 1960), 146.

[24]Albert Gleizes and Jean Metzinger, selection from Cubism (1912), in Chipp et al., Theories of Modern Art, 207.

Nevertheless, while they admired this realistic impulse, they believed Courbet did not go far enough: "he remained the slave of the worst visual conventions," not understanding that in order to discover a deeper truth one must be willing "to sacrifice a thousand apparent truths."[25] For them Courbet was "like one who observes the ocean for the first time, and who, diverted by the movements of the waves, has no thought of the depths."[26] That these comments were made by Gleizes is significant: he later became a devout Catholic and was one of the most important exponents of the use of abstract forms to convey religious feeling, which was his way of sacrificing appearance for something deeper.

But what did Courbet believe painting could do? He must have felt that his 1861 statement about painting was consistent with his political commitments: "Painting is an essentially concrete art and can only consist in the representation of things that really exist. An abstract object, invisible, does not belong to the domain of painting. The imagination in art consists in finding the most complete expression of an existing thing."[27] On the one hand, this influential pronouncement reflects developments in Europe during the previous century: the growing empiricism attendant on the scientific revolution, the focus on common people in their natural contexts that Rousseau encouraged and the growing opposition to entrenched authority that resulted from the French Revolution. These had already begun to influence culture in numerous ways. *Burial at Ornans* surely reminded many viewers of the popular prints that had become common in newspapers of those days. On the other hand, a turn toward the observation of the surrounding world, with its social and cultural crises, could just as easily reflect deep religious convictions as occlude them, even if that is not what Courbet intended. This is clear from the portrayal of landscape in the United States during this same period, which we will describe in chapter six.

It is common for art historians to see impressionism as a natural development of Courbet's focus on what can be seen, and this is partially true. But if Courbet (and his contemporary Édouard Manet) sought, at least in part, to

[25]Ibid.
[26]Ibid., 208.
[27]Courbet, *Courrier du dimanche* (December 25, 1861), quoted in Rookmaaker, *Synthetist Art Theories: Genesis and Nature of the Ideas on Art of Gauguin and His Circle* (1959), in *CWR*, 1:39-40.

pique the contemporary bourgeois conscience, clearly this was not the intention of the impressionists. These followers of Courbet and of Manet turned their attention to the ordinary by focusing strictly on what can be seen with the eyes. Beyond this it is difficult to propose any unifying theory. They were an even more disparate lot than the symbolists who followed them— held together, as John Rewald has pointed out, more by the independent nature of their salons than by any common artistic program. But they are associated in most peoples' minds with Claude Monet, who sought to portray the immediate impressions of nature, however fugitive its effects.

The popularity of impressionist paintings, especially among American audiences drawn to their bright airy quality, could not be more at odds with the critical views of subsequent critics and artists. Indeed, the short-lived character of the movement was due in large part to the ephemeral nature of the subject matter—artists immediately felt the need to move beyond this to something more substantial, something that carried symbolic meaning. As a contemporaneous painter Camille Mauclair writes later of the impressionists' work, "The eye and the hand! superb, and it was enough: but nothing else."[28] In 1891 critic G.-A. Aurier, the promoter of Gauguin, had complained that the impressionists only conveyed form and color, an imitation of the material surface. The truth of things lay much deeper, he insisted.[29] Gleizes and Metzinger offered a similar criticism: "The art of the Impressionists involves an absurdity: by diversity of color it seeks to create life, and it promotes a feeble and ineffectual quality of drawing. The dress sparkles in a marvelous play of colors; but the figure disappears, is atrophied. Here even more than in Courbet, the retina predominates over the brain."[30]

Interestingly, these complaints sound much like those made by theologians commenting on the period. Colin Gunton argues that artistic movements of this time reflected a loss of substance: "G. K. Chesterton is reported to have said of the paintings of the Impressionists that the world in them appears to have no backbone, and some analyses of late modernity appear to confirm the

[28]Mauclair, quoted in Rookmaaker, *Synthetist Art Theories*, in *CWR*, 1:74. Mauclair was writing in 1922; he goes on to note that what really held them together was their reaction against the art establishment. Mauclair echoes Cézanne's famous description of Monet: "Monet is nothing but an eye, but what an eye!"

[29]Aurier, "Symbolisme en Peinture," *Mercure de France* 2 (March 1891): 157.

[30]Selection from *Cubism*, in Chipp et al., *Theories of Modern Art*, 208.

judgment that a loss of substantiality is at the heart of the matter."[31] Gunton goes on to quote philosopher Robert Pippin, arguing that Manet's choice of subject matter involves "a denial of the 'dependence' of the intelligibility of objects or persons or moments on the universal categories or descriptions of science or philosophy or even language as originally understood."[32] Rookmaaker's judgment of the decisive step taken by Monet is even more strongly stated. He argued that Monet's paintings claim that "there is no reality. Only the sensations are real."[33]

But even if this were the case, there is a problem with making impressionism a precursor of twentieth-century modernist (and postmodernist) troubles. Whatever the weaknesses of the impressionist program, it cannot simply be a step in the direction of later cultural evils, as Rookmaaker and Gunton imply, precisely because the following generation of artists departed from impressionism at exactly this point: they rejected the notion that reality was all surface and that particulars exist in no intrinsic relationship to each other. The moves made by Cézanne and Gauguin in the 1880s and 1890s, which were to have the most significant influence on twentieth-century art, were precisely those that diverged most dramatically from Monet—in the search for a deeper structure of things in the case of Cézanne and for the mystical depths of a spiritual reality in the case of Gauguin. Since the full extent of Cézanne's influence became apparent only later, we postpone that discussion and turn first to Gauguin.

PAUL GAUGUIN, VINCENT VAN GOGH AND THE BIRTH OF A MODERN SACRED ART

Gauguin's *Vision After the Sermon: Jacob Wrestling with the Angel* (plate 1) was finished in Pont-Aven by late September 1888 and represents a convergence of events that would transform not only Gauguin's work but the course of modern art. Gauguin's own title—*Vision of the Sermon* (*vision du sermon*)—

[31]Gunton, *The One, the Three, and the Many: God, Creation and the Culture of Modernity* (Cambridge: Cambridge University Press, 1993), 192.

[32]Ibid., 193.

[33]Rookmaaker, *MADC*, 86. He admits that Monet is wrestling with these epistemological questions as a painter and not as a philosopher, and, moreover, we need to recall that impressionists were wrestling with the condition and importance of images in the light of the rise of photography. They were working primarily on a phenomenological level.

more closely reflects his intention to reflect an interior vision that abstracts from nature. A group of Breton women stand in the foreground praying immediately following a sermon (the priest at the far right is a self-portrait of the artist). An abnormally curved tree—which Gauguin specifically identified as an apple tree[34]—arches from the lower right corner of the composition to the upper left, creating a visual division between the foreground and the background. The pious congregants all have their heads lowered in prayer—everyone except for a single female figure just left of center: she raises her head and looks across the diagonal tree where she sees a vision of Jacob wrestling with an angel (cf. Gen 32:24-32). The earth beneath these biblical wrestlers is a blazing vermillion red, which also extends beneath the feet of the churchgoers. Through his use of high-key color and strong composition he sought to convey the feelings aroused by the events portrayed—a method that came to be called "symbolist."[35] Thus the natural world of the pious women and the supernatural world of the vision are portrayed together in a single space that appears simultaneously unified and bifurcated.

This ambiguity raises the central question of the painting: are we to regard this vision with belief or incredulity? Is this community receiving revelatory insight into the biblical text, or is this only an illusory projection of the onlookers' piety? Gauguin described this painting as having "a superstitious simplicity in the figures," and it is precisely this superstition that he calls into question: "For me, the landscape and the wrestling exist only in the imagination of the people at prayer after the sermon; that's why there's a contrast between the real people and the wrestling in its landscape, [which is] not real and out of proportion."[36] On this basis, Judy Sund argues that "the religious fervor of the artist's Breton neighbors is the real subject of The Vision. . . . The text from Genesis is peripheral to both narrative and image, and the artist's stance is that

[34]Gauguin to van Gogh, L688 (c. September 26, 1888). Among the available publications of van Gogh's written correspondence there is wide variance in the numbering systems used to catalog the letters. In what follows all citations of van Gogh's letters, including their numbering, will be from Vincent van Gogh, The Letters: The Complete Illustrated and Annotated Edition, ed. and trans. Leo Jansen, Hans Luijten and Nienke Bakker, 6 vols. (Amsterdam: Van Gogh Museum and Huygens ING; New York: Thames & Hudson, 2009). The entirety of this excellent scholarly work is available online at www.vangoghletters.org.

[35]As Rookmaaker explains in his discussion of this painting: Gauguin shows that "the artist should not copy nature, but use particular methods of arranging lines and colors in order to denote particular feelings." Rookmaaker, MADC, 89.

[36]Gauguin to van Gogh, L688 (c. September 26, 1888).

of a curious skeptic who is emotionally distanced from what he observes. . . .
The Vision presents religious experience through the eyes of a dubious outsider."[37]

What led Gauguin, the curious skeptic, to such a striking portrayal of religious feeling? When in 1886 he fled the high prices (and summer heat) of Paris for Pont-Aven in Brittany, Gauguin little expected that the simple peasants of the area would influence him as they did. Brittany, like other parts of France, was in the midst of a religious revival of an apparitional Catholicism, and the arresting subject of *Vision* suggests that the religious context of Pont-Aven had stirred religious feelings in Gauguin. The revival at Pont-Aven included the recovery of a variety of medieval mystical practices and a flowering of devotional cults, especially the Pont-Aven Pardon, a two-day penitential celebration during the fall equinox. Gauguin found these so moving that he began to wear traditional clothes and attend the local parish church.[38]

Debora Silverman has argued that these experiences touched Gauguin especially as a lapsed Catholic because they resonated with his education in the seminary in Orleans, where he had trained for the priesthood. There he had been taught an idealist antinaturalism that focused on inward vision and imagination. Though he had subsequently rejected Christianity formally, Silverman thinks this rejection "co-existed with a mentality indelibly stamped by the theological frameworks and religious values that formed him."[39] Clearly he was recalling this instruction when he wrote in a 1888 letter to a critic: "Art is an abstraction; derive this abstraction from nature while dreaming before it. . . . This is the only way of rising toward God—doing as our Divine Master does, create."[40]

The interest in religious things and the increasing religious references in his letters during this year had another cause as well. In 1888 Gauguin had just returned to Pont-Aven from a trip to the Caribbean island of Martinique, where a number of artists had gathered to escape the distractions of Paris.

[37]Sund, "The Sower and the Sheaf: Biblical Metaphor in the Art of Vincent van Gogh," *Art Bulletin* 70, no. 4 (December 1988): 670-71.

[38]Debora Silverman, *Van Gogh and Gauguin: The Search for Sacred Art* (New York: Farrar, Straus & Giroux, 2000), 101.

[39]Ibid., 123, 132.

[40]Gauguin, quoted in ibid., 98. Rookmaaker believed that "in an explicit and definite way," Gauguin's aim in the *Vision* was to "overcome the positivist approach to reality, with (as Gauguin said himself) its loss of all feeling 'for the mystery and the enigma of the great world in which we live.'" Rookmaaker, *MADC*, 90.

Though his trip to the tropical Martinique had enlivened his palette, Gauguin was still working in the impressionist mode of his teacher, Camille Pissarro. But he told his friends he was seeking a "synthesis" between his focus on colors and something deeper.[41]

When the young painter Émile Bernard (1868–1941) arrived in Pont-Aven in August 1888, he immediately looked up Gauguin, whom he had heard about from Vincent van Gogh, and they soon became close friends. Van Gogh had come to Pont-Aven in February, and after Bernard's arrival their animated conversations undoubtedly touched on religious as well as artistic subjects. Though much younger (Bernard was barely twenty, Gauguin an aging forty), Bernard was an articulate and convincing champion for some of the newer ideas he brought from Paris. He surely contributed to Gauguin's attraction to the intellectual and systematic construction of space and the Japanese cloisonné style (areas of solid colors divided by sharp outlines). These proved influential on Gauguin, who (as the more talented artist) developed them beyond what Bernard had been able to do.[42] The synthesis that Bernard and Gauguin sought was between their experience of nature and the colors and forms of their painting. According to Caroline Boyle-Turner, their aim was to "adapt what they saw in nature to their own emotional experience and graphic sensibilities."[43] Such was the ability of young Bernard to express his views that he soon won over Gauguin, and, whatever differences they would later have, at the time they seemed to be in complete agreement.

Beyond his stylistic influence, Bernard also sparked the spiritual sensitivities of the older painter. As already noted, Gauguin was struck by the mystical depth of Brittany's Catholicism and by the starched collars and embroidered vests the faithful wore to church on Sunday. And Bernard was enlivened by the recent recovery of his own Catholic faith. Urged on by Bernard, they attended services together and became friends with the priest. One of their number, the Dutch painter Jan Verkade, converted to Catholicism as a result

[41]John Rewald, *Post-Impressionism: From Van Gogh to Gauguin*, 3rd ed. (New York: Museum of Modern Art, 1986), 170.

[42]Ibid., 177. See also Rookmaaker, *Synthetist Art Theories*, 127, in *CWR*, 1:44-45. The superior use Gauguin made of these innovations is discussed in Douglas Lord's "Note on Émile Bernard," in *Vincent van Gogh: Letters to Émile Bernard*, trans. and ed. Douglas Lord (New York: Museum of Modern Art, 1938), 13.

[43]See Boyle-Turner, *Gauguin and the School of Pont-Aven* (London: Royal Academy of Art, 1986), 23-25; the quotation is from p. 25.

of these experiences and later became a monk. In fact, Denys Sutton suggests, "Bernard's growing devotion to Catholicism possibly helped Gauguin paint [*Vision*]."[44] John Rewald characterized the relationship this way: "So great was the younger painter's ascendancy over [Gauguin] that even Bernard's religious fervor was reflected in Gauguin's letters."[45] Taking account of Silverman's claim for the continuing influence of Gauguin's religious instruction, it is not a stretch to see that Bernard's impact alongside the medieval faith of Brittany's peasants may have awakened Gauguin's sensitivities to the spiritual depth of what he observed. Moreover, he must have been impressed with the role of liturgical practices in appropriating those depths. While it may be difficult to specify precisely what this meant for his artistic practice, it is surely part of the stimulus that led to the development of his symbolism.

Van Gogh's Immanent Spirituality

Van Gogh had arrived in Paris from Holland in 1886 (having only started painting in 1880), and by 1887 he and Gauguin had begun exchanging letters and drawings. Debora Silverman notes that both artists were working within the symbolist agenda but were moving in opposite directions: "Gauguin by dematerializing nature in a flight to metaphysical mystery; van Gogh by naturalizing divinity, in the service of what he called a 'perfection' that 'renders the infinite tangible to us.'"[46] Van Gogh's religious background, in its particularly Protestant form,[47] clearly motivated his vehement search for transcendence in and through the empirical world—a search that will be more fully explored in the next chapter. "With van Gogh," Robert Rosenblum notes, "we feel anew the kind of passionate search for religious truths in the world of empirical observation."[48] In 1888 van Gogh, stimulated by his exchanges with Gauguin, painted *The Sower*, a work of similar size to *Vision*, reflecting his divergent religious trajectory.

[44]Sutton, introduction to *Gauguin and the Pont-Aven Group* (London: Tate Gallery, 1966), 8. Sutton notes that Gauguin's correspondence during this time reflects a deep wrestling with religious questions. Bernard probably persuaded him to attend church.

[45]Rewald, *Post-Impressionism*, 178.

[46]Silverman, *Van Gogh and Gauguin*, 50.

[47]Ibid., 49-50. See also Kathleen Powers Erickson, *At Eternity's Gate: The Spiritual Vision of Vincent van Gogh* (Grand Rapids: Eerdmans, 1998). Both Silverman and Erickson describe the way van Gogh's religious beliefs influenced the development of his work.

[48]Rosenblum, *Modern Painting and the Northern Romantic Tradition: Friedrich to Rothko* (New York: Harper & Row, 1975), 72.

Van Gogh painted multiple versions of *The Sower* in the latter half of 1888, but it is the third version (plate 2), painted in November of that year,[49] that is of particular interest here: he seems to have intended it as a direct riposte to Gauguin's *Vision*. Van Gogh borrows Gauguin's compositional structure, dividing the image diagonally in half with the same kind of curved tree growing from the lower-right corner of the foreground. This compositional quotation sets the two paintings into a dialectical relationship (all dissimilarities suddenly becoming loaded with significance), and it provides the means by which van Gogh asserts a pointedly different visual theology. According to Judy Sund, "Van Gogh himself probably measured this latest *Sower* against *The Vision*, and very likely conceived it as a subtle rebuttal to Gauguin's approach and attitude. The tree probably should be seen as simply the most visible manifestation of the web of ideas that connects the two pictures."[50]

If the tree "connects" these two works, van Gogh's construction of the space surrounding this tree—particularly his management of the contrasts that the tree sets up between left and right, foreground and background—creates sharp intentional contrasts with Gauguin's religious *Vision*. Gauguin's tree serves as a means to distinguish between the tangible, factual "here" of the congregants and the intangible, visionary "elsewhere" of the biblical subject matter. Van Gogh accepts this division but radically revises its logic: he places the biblical figure—the messianic Sower—in the foreground on the left side of the tree, concretely on *our* side. And in fact the sower moves toward us as though the field on which we stand is also the object of his labor. The revelatory vision of God confronting us happens in the foreground rather than in the distance and in the guise of a working peasant rather than an angel—van Gogh is thinking through the logic of incarnation here. He retains the "elsewhere" of the space beyond the tree, but he renders the distance as eschatological rather than only metaphysical or imaginative: in the far distance appears the house of the Farmer to whom the harvested wheat will eventually be brought in.

[49]There are actually two versions of this "third version," both painted in November 1888: one is almost exactly the same size as Gauguin's *Vision* (73.5 × 93 cm, in the collection of the Foundation E. G. Bührle in Zurich), and one is a smaller though more well-known "study" made either immediately before or after the larger version (32 × 40 cm, Van Gogh Museum in Amsterdam), which we reproduce in plate 2.
[50]Sund, "Sower and the Sheaf," 670.

PAUL
GAUGUIN

Vision After the Sermon: Jacob
Wrestling with the Angel

1888

PLATE 1

VINCENT
VAN GOGH

The Sower

1888

PLATE 2

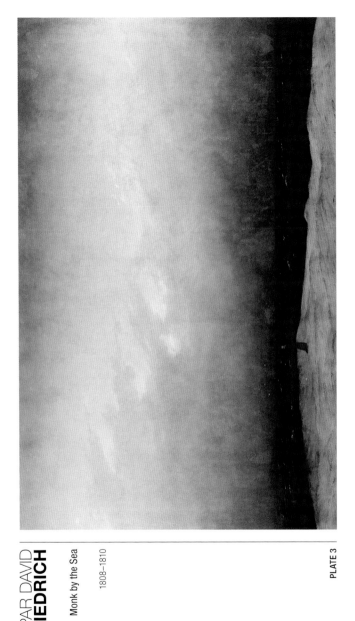

CASPAR DAVID **FRIEDRICH**

Monk by the Sea

1808–1810

PLATE 3

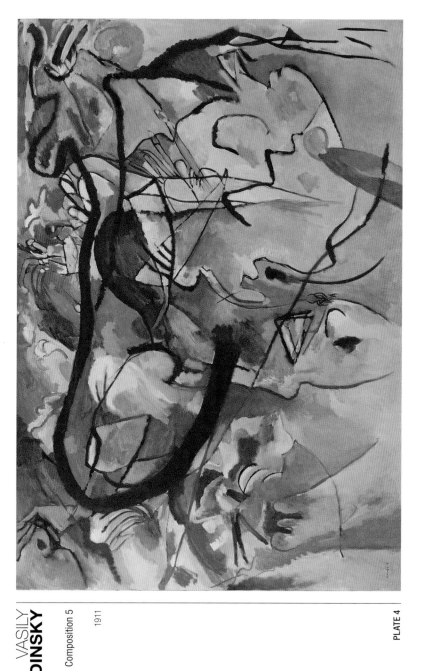

VASILY
KANDINSKY

Composition 5

1911

PLATE 4

NATALIA
GONCHAROVA

Saint Michael the Archangel

1910

PLATE 5

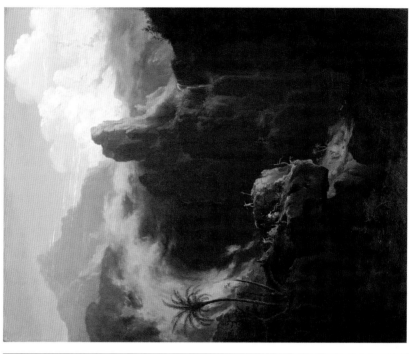

THOMAS
COLE

Saint John the Baptist
Preaching in the Wilderness

1827

PLATE 6

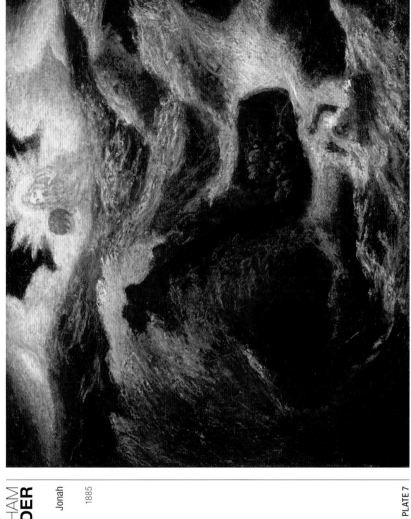

ALBERT PINKHAM **RYDER**

Jonah

1885

PLATE 7

ANDY
WARHOL

The Last Supper (Dove)

1986

PLATE 8

Like Gauguin's painting, this too is an image of wrestling with God; but (as is consistent with his Protestantism) van Gogh has relocated the arena for the struggle into the heart. This painting is, after all, derived from the biblical parable of the sower (Mt 13; Mk 4; Lk 8), which is actually a parable about the soils over which the sower toils: the focus of Jesus' story is the quality of people's hearts (soils) as they hear him, some of which will sustain growth while others will not. The implication is that if one is going to wrestle with the person of Jesus, one must also tend to the quality of one's heart. In reconstituting Gauguin's compositional structure around this parable in this way, van Gogh is presenting his own sense of what it means to wrestle with God—one that is alternative to Gauguin's take on the matter. Notice the contrast: Gauguin sought to use images in the fashion of Catholic mysteries, which refer to a transcendent spiritual world; van Gogh pursued a spirituality incarnated in, with and under his twisting forms and lively palette. Sund summarizes:

> Van Gogh—for all his unorthodoxy—was a firm believer.... While *The Vision* presents religious experience through the eyes of a dubious outsider, *The Sower* suggests that for the true believer, religious impulse is not so much the stuff of visions as a part of daily life, as Christ reveals himself by less sensational, much more down-to-earth means.[51]

Though he visited Gauguin in Brittany, van Gogh was drawn more to the Provençal landscape at Arles (in the South of France), which reminded him of his native Holland.[52] The motif of the sower was no doubt inspired by Millet's famous work, but it is clearly indebted to the technique of building up subjects by individual brushstrokes characteristic of the early Gauguin (before the impact of Bernard) and his teacher, Pissarro. It also anticipates the rough textures characteristic of van Gogh's subsequent work. The rich colors were intended to add their own radiance to the scene. Van Gogh had written to his brother Theo in September 1888: "I'd like to paint men or women with that indefinable something [*je ne sais quoi*] of the eternal, of which the halo used to be the symbol, and which we try to achieve through the radiance itself, through the vibrancy of our colorations."[53] Van Gogh presents the world of

[51]Ibid., 671.
[52]See the description in Silverman, *Van Gogh and Gauguin*, 78-81, to which this discussion is indebted.
[53]Van Gogh, L673 (September 3, 1888).

his *Sower* as not only radiant with color; he also retains the symbolic weight of the halo in the massive sun that sets on the horizon directly behind the sower's head—all of which, one must presume, was aimed at identifying the sower's labor with that "something of the eternal."

Van Gogh's painting then was also symbolist in that he sought by means of color and composition to portray the emotion and meaning that his subjects stimulated in him. But the forms were symbols not of dreamlike visions as in Gauguin—van Gogh pointedly avoided representing the popular Catholicism around him—but of his longing for an ineffable "something on high" (*quelque chose là-haut*) that enlivens all things with its presence and meaning. But as Silverman puts it, he believed this something on high in fact reveals itself as "emanation from below, embodied in a generic labor figure framed by a blazing sun, luminescent with the color once reserved for Christ's nimbus."[54]

Silverman argues that these pictorial choices, as with Gauguin, grew naturally from van Gogh's unique religious background. This is revealed even in his choice of peasant workers as a favorite topic, reflecting his Dutch Reformed conviction that useful and productive manual work could be a means of grace. Indeed, he likened his own artistic work to weavers at the loom or laborers in the field: "I keep my hand to the plow, and cut my furrow steadily," he reported to Theo. "I keep looking more or less like a peasant," except that "peasants are of more use in the world."[55]

This also reflects the influence of the Groningen theologians, an evangelical group to which van Gogh's family subscribed and which his father, a minister of the Dutch Reformed Church, had preached to his congregation for two decades.[56] This movement stressed an inner surrender to Christ that manifested itself in a humble outward service to others in the name of Christ. These Dutch Christians treasured Thomas à Kempis's *Imitation of Christ* and Bunyan's *Pilgrim's Progress*, which van Gogh had with him in Arles.

Little wonder that van Gogh was immediately attracted to the faith of Émile Bernard. Their extensive correspondence reveals a deeply shared faith. In June 1888 he told Bernard how happy he was that they both loved the Bible, even if

[54]Silverman, *Van Gogh and Gauguin*, 89.
[55]Van Gogh, quoted in ibid., 79. This also displays the longstanding Reformed suspicion that art is not as important as other more productive callings.
[56]See the discussion in ibid., 146-55.

they had ongoing doubts about it and even if it impacted their artistic practices differently. Despite the "despair" and "indignation" that van Gogh had come to feel toward some aspects of the Bible, he nevertheless clung to "the consolation it contains, like a kernel inside a hard husk, a bitter pulp—[which] is Christ."[57] For him, Christ was "an artist greater than all artists—disdaining marble and clay and paint—working in *living flesh* . . . [making] living men, immortals."[58] And as van Gogh saw it, the kind of artistic practice to be derived from this was one that was intensely alert to the realities of everyday "living flesh." His submission to Christ was manifested in a commitment to the natural order rather than to representations of biblical subject matter.

In November 1889 van Gogh wrote to Bernard, taking issue with that painter's "biblical paintings," which he considered a "setback." He agreed that "it is—no doubt—wise, right, to be moved by the Bible, but modern reality has such a hold over us," such that devoting oneself to pictorially reconstructing ancient biblical narratives was a distraction from the more pressing theological work to be done. Rather, van Gogh believed that an artist's religious striving should be more directly concerned with contemporary life, "always giving due weight to modern, possible sensations common to us all."[59] He urged Bernard to recognize that the spiritual themes he was wrestling with in his work might be better grounded in observation of the world around him: "In order to give an impression of anxiety, you can try to do it without heading straight for the historical garden of Gethsemane; in order to offer a consoling and gentle subject it isn't necessary to depict the figures from the Sermon on the Mount."[60] Indeed, he advocated for a religious sensibility oriented toward concrete, lowly subjects: "My ambition is truly limited to a few clods of earth, some sprouting wheat. An olive grove. A cypress." And such subjects were, for van Gogh, intensely spiritual: "I adore the true, the possible, were I ever capable of spiritual fervor; so I bow before that study, so powerful that it makes you tremble, by *père* Millet—peasants carrying to the farmhouse

[57]Van Gogh to Émile Bernard, L632 (June 26, 1888).
[58]Ibid. (emphasis original). For the biblical allusions van Gogh is making here, see Jn 5:21; Rom 8:11; 1 Cor 15:22. He pressed this point about the highest form of artmaking being Christ's redemption and transformation of human lives, immediately adding, "That's serious, you know, especially because it's the truth."
[59]Van Gogh to Émile Bernard, L822 (c. November 26, 1889).
[60]Ibid.

a calf born in the fields."[61] But, as he argued, this kind of spiritual perception necessitated a different frame of reference from the one Bernard was assuming: "It's truly first and foremost a question of immersing oneself in reality again, with no plan made in advance, with no Parisian bias."[62] Here van Gogh mined a strong theme in the Reformed tradition that saw the created order as a reflection of God's goodness—a theater for the glory of God, as John Calvin put it.

Despite their differences—van Gogh's focus on nature differed markedly from Bernard's popular images of faith—Bernard remained faithful to his friend Vincent. In fact he later arranged the first solo exhibition of his work. Douglas Lord claims that it is "to Émile Bernard more than to anyone else that the early recognition of van Gogh is due."[63] By the time he had written this letter to Bernard, van Gogh's mental state was deteriorating; he had been hospitalized in Arles and later admitted himself to an asylum at Saint-Rémy. His brother Theo continued to faithfully support him, despite his obligations to a new wife, and he managed to show Vincent's paintings in Paris (1889) and Brussels (1890), though nothing sold. Vincent, despairing that he was only a burden to Theo, shot himself in the chest on July 27, 1890, and with Theo at his side he died two days later.

THE FAITH OF GAUGUIN

The precise nature of Gauguin's faith is harder to assess than that of van Gogh. Though he clearly was wrestling with deep religious questions, he did not formally embrace Bernard's Catholic faith. For this reason scholars have been inclined to dismiss, or more often simply ignore, the influence of religion on his work. But our discussion has shown that the very different religious traditions represented by Gauguin and van Gogh played a significant role in their different approaches to symbolism, and even in the stylistic innovations to which they were drawn. Debora Silverman, in her study of these two artists, sought to show how "religious legacies provide a new point of entry with which to consider van Gogh and Gauguin's collaboration." But her claim is more ambitious than this; she wants to use these case studies as evidence for

[61]Ibid.
[62]Ibid.
[63]Lord, "A Note on Émile Bernard," in *Vincent Van Gogh: Letters to Émile Bernard*, 15.

the larger "role of religiosity in generating form, structure and content of varied types of modernist expressive arts."[64]

How might this claim be supported? The case of Gauguin is more complex than that of van Gogh in part because of his subsequent career and his two sojourns in Tahiti between 1891 and 1900, and even more by the variety of religious influences at play during this time. During his travels, Gauguin's anticlerical views seemed to have hardened as he sought in Tahiti new kinds of mystical experience. He admitted in a letter to Paul Sérusier that his work there disturbed him and he was sure it would appall Parisian audiences as well: "What a religion, this old Oceanic religion! What a marvel! My brain is bursting with it and all the things it suggests to me will frighten everybody."[65] But this does not mean that he simply abandoned his own Catholic heritage. At one point he could echo Nietzsche in calling for the death of God—or at least the death of a "God-creator who is tangible"—while simultaneously claiming, however, that the "unfathomable mystery" to which the word *God* refers even now resides with the poets.[66] Gauguin believed that deep links and "affinities" remained between Christianity and modern society, but these needed to be worked through more rigorously and reconciled into "a single, revitalized whole, richer and more fertile. But! But, outside of the Catholic Church, which is petrified in its hypocritical pharisaism of forms draining away the truly religious substance."[67]

Though he maintained a deeply antagonistic attitude toward the "pharisaism" of the institutional church, he nevertheless retained a positive view of Christianity, as he did, for example, in his 1903 article on "Catholicism and the Modern Mind."[68] Echoing the call of reformers through the centuries, he

[64]Silverman, *Van Gogh and Gauguin*, 9, 13.

[65]Gauguin, letter written in March 1892, quoted in Rewald, *Post-Impressionism*, 469.

[66]According to Gauguin, "What must be attacked is not the fabled Christ but, higher up, further back in history: God. . . . What must be killed so that it will never be reborn? God. Our souls today, gradually shaped and taught by other souls that have come before, no longer want a God-creator who is tangible or has become tangible through science. The unfathomable mystery remains *what it was, what it is, what it will be*—unfathomable. God does not belong to the scientist, nor to the logician; he belongs to the poets, to the realm of dreams; he is the symbol of Beauty, Beauty itself. To define him, to pray to him is to deny him." Thus, even though he repudiated some version of a creator God or God-of-the-philosophers, he maintained that apophatic or even "poetic" forms of theology must remain very much open. See Gauguin, "The Catholic Church and Modern Times" (1897), in *The Writings of a Savage: Paul Gauguin*, ed. Daniel Guérin, trans. Eleanor Levieux (New York: Viking Press, 1978), 163-64; cf. xviii-xix.

[67]Ibid., 166.

[68]Gauguin, "Catholicism and the Modern Mind" (1903), in Guérin, *Writings of a Savage*, 167-73.

lamented how the truth of Christ had been denatured by the Catholic Church.[69] For the teachings of Christ lie at the basis of all human society, and we need to bring these together into a "new revitalized whole, richer and more fertile."[70] While he conceded that much in Scripture is unclear, some of the teachings are "clear enough for us to grasp their real meaning at first sight," which he thought was especially true of what he called "the parable of the Last Supper."[71] Gauguin was haunted by the central Catholic ritual whereby the bread and wine become the body and blood of Christ, though he continued to believe that there is some real sense in which Christ's meal invites us into "those perfections which will gradually assimilate us into divine nature":

> And calling himself the son of God, he says: "I am the living bread; if any man eat of this bread, he shall have life forever." And to make his meaning perfectly clear, the Bible has the apostles say: "How can this man give us his flesh to eat?" which enables him to answer, "He that eateth my flesh . . . even he shall live by me," and this clearly explains that we must take this to refer to the spirit [or Spirit]. When he partakes of the Last Supper with his disciples, he symbolizes the bread and the wine which, eaten and drunk together in a gathering of companions, form one flesh and one blood. . . . "Eat . . . drink . . . do this in remembrance of me." These words mean, "I shall be in you and you in me." Is not all of this outstandingly rational, intelligent?[72]

The problem, he goes on to argue, is that the church has lost sight of this simple reality and made it into a lifeless dogma. Perhaps his experience of the ritualized religion of Tahiti had caused him to reflect more deeply on the sacramental depths of a reality that was grounded in the Catholic view of God. One scholar has argued that Gauguin went to Tahiti seeking "a culture where art and life were interchangeable: where religious ritual, myth and mystery still had meaning."[73] If this is true, then it is likely that the motivation to seek such ritual experience was, in part at least, religious. And his reflections in this article show, even in this new context, how deeply ingrained Catholic practices

[69]Ibid., 168.
[70]Ibid., 166.
[71]Ibid., 171.
[72]Ibid. See Jn 6.
[73]Jehanne Teilhet-Fisk, *Paradise Reviewed: An Interpretation of Gauguin's Polynesian Symbolism* (Ann Arbor, MI: UMI Research Press, 1983), 21.

continued to shape his artistic imagination. Especially notice how he sought to retrieve the central Eucharistic practice and its symbolic content, even if he eschewed the dogmatic teachings.

Maurice Denis, a younger member of the 1890 symbolist movement, later wrote that Gauguin allowed them to escape the dilemma of the real and the ideal posed by the neoclassical artist Jacques-Louis David. It was Gauguin, Denis notes, who saw painting as first and foremost a colored canvas, but in symbolist thought this idea was developed to mean that painterly media, especially color, could evoke religious feelings. Denis defined symbolism as "the art of translating and provoking states of the soul, by means of relations of colors and forms."[74] For Denis these states of the soul clearly had a spiritual dimension, and the symbolic power of art, for him, reflected the underlying reality of Catholic liturgy and the sacraments. As he later summarized these movements: "The liturgy, being based on the traditional rapport between the images of the sacred text and revealed truths, between the phenomena of nature and those of the interior life, brings a special light to artists, whose function is to translate the truths of faith into the language of poetry."[75]

Gauguin's writings and those of other artists of the period show that other religious influences were at work as well. A Western appropriation of Eastern philosophy called theosophy and various forms of the occult were becoming influential throughout western Europe during this period. During the 1880s many artists and writers were becoming disillusioned with the realism of Zola and the growing positivism. In 1884 J.-K. Huysmans broke with Zola and published *À rebours* (Against the Grain), which celebrated the symbolic connection between things and the poetry of Verlaine and Mallarmé. Of the latter, Huysmans wrote, "Perceiving the most remote analogies, he often designates an object or being by a word, giving at the same time, through an effect of similarity, the form, the fragrance, the color, the specific quality, the splendor."[76]

[74]Denis, *Nouvelles théories sur l'art moderne sur l'art sacré, 1914–1921* (Paris: Rouart & Watelin, 1922), 175, and for what follows p. 239. See his discussion of Gauguin, p. 24. Rosenblum sees Gauguin's *Yellow Christ*, for example, as a consequence of Friedrich's search for surrogates of traditional Christian symbolism. See Rosenblum, *Modern Painting and the Northern Romantic Tradition*, 27.

[75]Denis, *Du symbolisme au classicisme: théories*, ed. Oliver Revault d'Allonnes (Paris: Hermann, 1964), 83. However, Denis also believed that too many Catholics, especially those influenced by Ernest Hello or Léon Bloy, did not understand the spiritual importance of beauty.

[76]Huysmans, *À rebours*, quoted in Rewald, *Post-Impressionism*, 135.

Later, after converting to Catholicism, Huysmans became an important en-
couragement to the Catholic artistic revival.[77]

Perhaps the most influential expression of this spiritualist movement in
France was Édouard Schuré's book *Les grands initiés*, published in 1889.[78]
Schuré develops what he calls the ancient truth that has been secretly passed
on from the time of ancient Egypt, essentially a gnostic vision of reality
wherein the spiritual soul is seeking liberation from its material context. The
book fit well with the reactionary mysticism that rejected the filth and deca-
dence of a rapidly industrializing society, and it made the rounds among the
artists in Paris and Brittany. Interestingly, after elaborate portraits of (among
others) Rama, Krishna, Hermes, Moses and Plato, Schuré ends his book with
a long and adulatory chapter on Jesus. There are three events in the life of
Christ, he argues, that are essential for the life of the divine nature to be ap-
propriated: the last supper, the trial and death, and the resurrection. But it is
the first of these that is, for him, the symbolic and mystical culmination of all
the teaching of Christ—as well as being the rejuvenation of ancient symbols
of initiation such as grapes, bread, etc.[79] By giving these symbols to his dis-
ciples, Schuré says, Jesus "enlarges them. For, by means of these, he extends
the fraternity and initiation, formerly limited to some, to humanity at large.
Christ introduces there the most profound mystery, the greatest power: that
of his holy sacrifice."[80] This makes possible, he thinks, a chain of loving that
unites all people and represents the spread of the social temple of Christ
around the world.[81] Schuré calls this the greatest religious revolution of all
time, which captures and combines all the esoteric wisdom of previous eras.
However, he insists that all this must be separated from the absurd claim that
Jesus' bodily resurrection is real, a doctrine that he believes came into the
church only after Gnosticism had been suppressed.[82]

[77]George Maunier notes that although Verkade and Maurice Denis rejected the occult because of
their orthodox Catholic faith, Verkade later noted that theosophy had been for him a step toward
rediscovering Christian mysticism. Maunier, "The Nature of Nabi Symbolism," *Art Journal* 23
(Winter 1963–1964): 96-102.

[78]Schuré, *Les grands initiés. Esquisse de l'histoire secrète des religions* [The Great Initiates: A Study of
the Secret History of Religions] (1889), rev. ed. (Paris: Librairie Académique Perrin, 1921, 1960).

[79]Ibid., 601.

[80]Ibid., 602.

[81]Ibid., 623.

[82]Ibid., 617.

This version of Christian truth would not have earned the approval of the religious authorities of that time, but it did take a basic teaching of the symbolic nature of material reality—and the focal point of that symbolism in the central rite of Catholic Christianity (the participation in the body and blood of Christ)—and put it in terms that artists were able to apply to their understanding of form, color and structure. And for some the spiritual searching represented even by theosophy and the occult served as a way station on the way to Christian faith. Werner Haftmann reports that Paul Sérusier brought Schuré's book to Pont-Aven, where it evidently played a role in Verkade's conversion to Catholicism.[83] What is often overlooked is the way that in France a sacramental sense of reality—that there is a depth to things that can be symbolically elicited—was indebted to the deeply ingrained traditions of the Catholic Church. However resistant artists may have been to the church as an institution, they often displayed the persistent influence of this sacramental imagination.

This was particularly true of Gauguin. As he says: "Painting is the most beautiful of all arts. In it, all sensations are condensed; contemplating it, everyone can create a story at the will of his imagination and—with a single glance—have his soul invaded by the most profound recollections; no effort of memory, everything is summed up in one instant. [It is] a complete art which gathers all the others and completes them. Like music, it acts on the soul through the intermediary of the senses: harmonious colors correspond to the harmonies of sounds."[84] Rather than impeding the development of sacred art, the symbolists believed that this imaginative alchemy of lines, colors and objects greatly expanded it, and this impulse became critical for the revival of religious art in the subsequent decades. Joseph Pichard says of Gauguin: "haunted by the sacred [he] reinvented a language for sacred art."[85] The significance of this period for the subsequent developments of modern art is widely recognized, of course. But this discovery of symbolic depth surely depended on the Catholic sacramental ideas that symbolists embraced, and it was this sacramental sensibility that prepared the way for a significant flowering of religious art in France and beyond.

[83]Haftmann, *Painting in the Twentieth Century*, ed. and trans. Ralph Manheim (London: Lund, 1965), 1:37.

[84]Gauguin, "Notes synthetiques," in Chipp et al., *Theories of Modern Art*, 61.

[85]Pichard, *L'art sacré moderne* (Paris: Arthaud, 1953), 24.

In a way, the revolution launched by Courbet—that painting must function first and foremost as a flat canvas covered by forms and colors—remained unfinished until artists determined *what* this function meant. Impressionists made the play of light and colors their focus, but this proved unsatisfying to subsequent artists. Gauguin was the first to suggest that the form, supported by the structured use of "abstracted" color, was essentially a sign of something else, something deeper and more real. There were many factors that led him to take this step, but significant among these was surely the sacramental context of his Catholic culture and his own theological training, which was vividly displayed for him in the pious Bretons. And as Maurice Denis and Georges Rouault (among others) were to demonstrate, if the roots of these stylistic moves were partially religious, they could fruitfully be appropriated in the service of a new kind of sacred art. At the very least nothing about them was intrinsically secular.

Rookmaaker shares the assessment of many critics of this period, that the naturalism of impressionism prepared the way for twentieth-century developments. Rookmaaker in fact goes so far as to say of Gauguin and his circle that in their synthesis of human freedom and respect for the substance of nature, "their art was probably the fullest and richest the world had seen since the seventeenth century."[86] But he did not see any relation between this advance and the recovery of a religious view of the world. In fact he believed that these artists were wrestling with the Enlightenment motifs of form and freedom, from which they were unable to free themselves. They were struggling, he thinks, with "the primacy of the human personality (in his freedom) and that of the primary science motif (in its search for laws of nature)." No synthesis between these was possible, Rookmaaker claimed. The Catholic faith of Bernard meanwhile was "a pure Neoplatonism only slightly christianized," confined within its own nature/grace dichotomy.[87] But such an ideological reading of this period is mistaken on both historical and theological grounds. Historically the period is far too complex to be understood in terms of such a simplistic reading of the Enlightenment. Indeed, one can

[86]Rookmaaker, *MADC*, 97.

[87]Rookmaaker, *Synthetist Art Theories*, 169, 173, in *CWR*, 1:144. He goes on to claim that because of this humanistic polarity "the Roman Catholic basic motif did not have any profound influence on art-historical thought in general" (175).

argue the contrary view: romantic and symbolist poets had introduced emotional and religious values that undermined the Enlightenment project, which they specifically rejected. And this suggests the theological error of Rookmaaker's reading of this period. It is true that this recovery of spirituality, for many, was mixed with forms of esotericism and occult practices. Still, fundamental Christian values and liturgical practices, with ancient roots in medieval liturgical and mystical rituals, allowed many artists to understand the depth of nature and its symbolic potential. Seeds were being planted that later came to full flower in the Catholic revival in art and literature, to which we now turn.

THE CATHOLIC REVIVAL AND A NEW SACRED ART

Émile Bernard's influence was not to be limited to his impact on Gauguin and van Gogh. Along with many others, he would be part of a religious revival that would have a deep and lasting impact on French culture. Bernard's sojourn in Brittany had deepened his faith and his determination to support the church. He says of this time: "I became a Catholic ready to fight for the church. . . . I became intoxicated with incense, with organ music, prayers," which he knew would isolate him more and more from his own period.[88] Bernard's views on the symbolism he sought and its religious grounds were articulated in a programmatic article he published in the *Mercure de France* in 1895. "If visible things are the face [*la figure*] of invisible things," he writes, then it follows that the artist, "reflecting the divine and gifted with harmony, takes and transforms nature exercising his own supremacy, to make it express his unique and supernatural origin."[89] He deplores that art has lost sight of its religious origins and has been taken over by specialists. He argues that originally mysticism and art were joined, and the language of art was symbolic, so that theology, properly understood, is insatiable (*avide*) for painting.[90] He was surely thinking of the simple piety of the Breton believers when he wrote, quoting the sixth-century

[88]Bernard, quoted in Boyle-Turner, *Gauguin and the School of Pont-Aven*, 62.

[89]Bernard, "Ce que c'est que l'art mystique," *Mercure de France* 13 (March 1895): 29. This article is in the form of a letter to a priest friend with whom he had been discussing these things. *Mercure* was a symbolist journal founded in 1890. Rookmaaker was certainly not wrong in seeing a Platonist influence on Bernard, but, as we will see, this was true of many Catholic writers during this period and indeed of the tradition more generally.

[90]Ibid., 33.

mystic Pseudo-Dionysius, "The veil is only lifted for the sincere lovers of sanctity, [who] by the simplicity of their intelligence and the energy of their powers of contemplation, penetrate the simple, supernatural and supreme truth of these symbols."[91]

The secularizing and anticlerical influence of the 1789 French Revolution had made deep inroads in nineteenth-century France, often making common cause with a growing faith in science and rationality. But this proved unsatisfying to artistic sensitivities. Toward the end of the century, artists and writers like Bernard began to look longingly toward their Christian past, much as their contemporaries, the Pre-Raphaelites, were doing in Britain. Bernard lamented that though the best art is religious art, in the past three hundred years nothing had captured the Christian ideal like the cathedrals had before that.[92] Religious and mystical stirrings became common among artists, whether influenced by the Catholic tradition or by Eastern religions expressed in the new theosophical movements. These movements were welcomed by many artists as a means of escaping the confining materialism around them.

Maurice Denis, in his *Histoire de l'art religieux*, locates the rebirth of modern sacred art in Pont-Aven, where Paul Sérusier, Bernard and Pierre Puvis de Chavannes learned from Gauguin to return painting to the "purity and naiveté" of primitive poverty. Denis believed that it was Puvis, in particular, who had given the clearest expression of symbolism. He was able to "elucidate a confused emotion [existing like] a chicken in an egg . . . translating this with exactitude."[93]

The journal *Mercure de France* was founded in 1890 specifically to promote these symbolist ideas. In an important article in 1891, G.-Albert Aurier identified Gauguin as the key to this movement.[94] With an epigraph from Plato's *Republic*, Aurier frames the movement as a progression beyond the "realist" impulse in art to the "idealist" (*idéist*). He alludes to the night when Emanuel Swedenborg claimed his interior eyes were opened to "see into the heavens in the world of ideas," which fulfilled Plato's goal of leaving the shadows for the

[91]Ibid., 32.
[92]Ibid., 29.
[93]Denis, *Histoire de l'art religieux*, 287. Credit needs to be given to Denis for describing the rise of this new sacred art sixty years before Debora Silverman's work (in which Denis's discussion makes no appearance).
[94]Aurier, "Le Symbolisme en peinture: Paul Gauguin," *Mercure de France* 2 (March 1891). Apparently the indomitable Bernard had been urging Aurier to write this article for some time. See Rewald, *Post-Impressionism*, 416.

light of day.[95] The goal of the symbolist artist is then to select from multiple means, such that "the forms, and general and distinctive colors serve to write clearly the idealist [*idéique*] signification of the object"—and in this he thinks Gauguin has been the leader, the true "seer."[96] What mattered was that all hint of materialism had been banished from his work. Clearly here, as Rookmaaker observed, the recovered Catholic faith was mixed with Platonism and the new spirituality represented by Swedenborg. Bernard apparently was not worried, and he forged ahead with his program of renewal.

From these varied roots, in the early 1890s a group of artists gathered in the Saint-Germain quarter of Paris and began to consider a new kind of sacred art, one that might recover some of the glory of its Christian history. Such was the enthusiasm for the sacred, Maurice Denis argues, that they took for themselves the appellation *Nabis* (Hebrew for prophets). Critic Joseph Pichard similarly pointed out that during this time a few pioneers, painters of the soul, including Gustave Moreau and Odilon Redon, had opened the way for development of a truly sacred art.[97] These alone, Denis says, maintained the "rights of the soul in the plastic arts."[98]

One of the leading voices in the movement was J.-K. Huysmans (1848–1907), who argued that "the real proof of Christianity is the art it has created, art which has never been surpassed."[99] Huysmans prepared the way with the publication of his novel *À rebours* (1884), to which we have referred. This recognition of the symbolic connection of things represented a clear break from the realism of Émile Zola and the impressionists, and marked a significant stage in Huysmans's own pilgrimage, which was typical of others during this period. In 1890 he became deeply involved with the occult, an experience that he recorded in the novel *Là-bas* (1891).[100] But in 1895 he published *En route*, which was a thinly disguised account of Huysmans's own conversion to Catholicism.

[95]Aurier, "Le Symbolisme en peinture," 158.
[96]Ibid., 162, 159.
[97]Pichard, *L'Art sacré moderne*, 23-24.
[98]Denis, *Histoire de l'art religieux*, 280.
[99]Huysmans, quoted in Pichard, *L'Art sacré moderne*. In this 1953 book, Pichard was one of the first (along with Maurice Denis) to point out the significance of this period for a renewal of *sacred* art.
[100]Although the most literal translation of this title would be "Over There," English publications of this book generally translate it as *Down There* or *The Damned*, in order to clarify the hellish connotation that Huysmans intended.

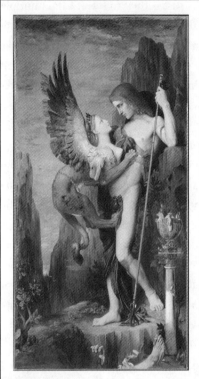

Figure 3.3. Gustave Moreau, *Oedipus and the Sphinx*, 1864

During the 1890s Huysmans contributed to the discovery of Gustave Moreau and Odilon Redon, who were little known at the time. Moreau, who later became the teacher of Henri Matisse, Edvard Munch and Georges Rouault, developed his intricate allegories to reflect what he called "imaginative reason." Redon stressed the role of imagination and effaced, Huysmans believed, the border between reality and fantasy. Moreau, Redon and their contemporary Puvis de Chavannes opened the way, often by dream or hallucination, to another world and stressed the need for forms to take on symbolic meaning.

Moreau pointed his students to an interior vision. Later Rouault recalled Moreau's confession:

I am asked: Do you believe in God? I believe only in God. In fact I do not believe in what I touch nor in what I see. I only believe in what I cannot see; solely in what I feel [*sens*]. My mind and my reason seem to me ephemeral and of a dubious reality. My inner consciousness [*sentiment intérieur*] alone appears eternal and unquestionably certain.[101]

A good example of his influence can be seen in *Oedipus and the Sphinx* (1864), a work displayed earlier in the Salons of 1864 and 1865, in both of which he won medals. (See fig. 3.3.) Though critics complained about his pedantic insistence on Renaissance imagery, and his annoying accumulation of detail, his handling of this theme was riveting for many viewers. The theme is explained in Édouard Schuré's work as the human struggle to outwit the hierarchy of forces in nature. The two mythical figures are transfixed as they gaze at one

[101]Georges Rouault and André Suarès, "Moreau," *L'Art et les artistes* (April 1926): 240.

another, each a kind of mirror image of the other.[102] Moreau here employs mythical imagery as symbols, thereby suggesting a reality we cannot see rather than describing the one we see. This project set artists influenced by him on a quest to find pictorial means to evoke this unseen reality.

The decades around the turn of the twentieth century in France witnessed the full flowering of this Catholic revival, one much more profound and long lasting than a century earlier, in a culture that had grown tired of the secularism of the 1789 Revolution.[103] Sparked by radical voices like J.-K. Huysmans and Ernest Hello, this movement featured highly visible conversions that led to a widespread recovery of Catholic faith among intellectuals. The major exponents in addition to Huysmans were Paul Claudel, Charles Péguy, George Bernanos, and Jacques and Raïssa Maritain, though this movement was later to influence François Mauriac and even the British author Graham Greene. In one way or another all of these had their roots in the symbolism we have described.[104] The most important visual artist among these was Georges Rouault. Of these, Jacques Maritain (1882–1973), a close friend of Rouault and arguably dependent on Rouault for certain emphases of his aesthetics, proved to be the most prominent influence on artists of faith, not only in France but also subsequently in Britain and America.

GEORGES ROUAULT AND JACQUES MARITAIN

During the early 1890s Georges Rouault (1871–1958) studied at the École des Beaux-Arts under Gustave Moreau, who urged his students to seek a spiritual rather than a literal truth in their work. Moreau played a large role in Rouault's life, and the teacher's death (when Rouault was twenty-seven) marked a turning point in the young painter's life.[105] During that time he sought out a priest for instruction and preparation for his first Communion. In 1901 he

[102]Dore Ashton, in John Rewald, Dore Ashton and Harold Joachim, *Odilon Redon, Gustave Moreau, Rodolphe Bresdin*, exh. cat. (New York: Museum of Modern Art, 1961), 115.

[103]On this period, see Richard Griffiths, *The Reactionary Revolution: Catholic Revival in French Literature, 1870–1914* (London: Constable, 1966); and more recently, Stephen Schloesser, *Jazz Age Catholicism: Mystic Modernism in Postwar Paris, 1919–1933* (Toronto: University of Toronto Press, 2005).

[104]Haftmann says of a similar listing of Catholic voices, "All of these men came from this Symbolism." See *Painting in the Twentieth Century*, 1:37.

[105]For details of Rouault's life and conversion see William Dyrness, *Rouault: A Vision of Suffering and Salvation* (Grand Rapids: Eerdmans, 1971), 60-71.

spent time in a commune with Huysmans and other artists and writers, but it
was his encounter with the writer Léon Bloy in 1904 that was to have the major
impact on his life. Bloy, who was also the catalyst in the conversion of Jacques
and Raïssa Maritain, wrote a series of novels that featured human suffering as
mystically expressive of the suffering of Christ. Though Bloy never under-
stood the darkness of Rouault's painting, the painter remained a devoted
friend, visiting him every Sunday until Bloy's death in 1917. The influence of
Bloy on Rouault's work is evident, not least in his view of sacred art. In his
Soliloques, Rouault writes of Bloy: "It is not always the subject that inspires
the pilgrim, but the accent that he puts there, the tone, the force, the grace,
the unction. That is why some so-called 'sacred art' can be profane."[106] The
darkness of Rouault's earlier work was not appreciated by the art establishment
either, and he toiled in relative obscurity until the 1920s. According to Stephen
Schloesser, a turning point came with a review by critic Michel Puy in 1921.
Puy recognized that "Rouault is a religious spirit. Under the human rag, he
discerns the soul. . . . [In the clown he explores] 'a mask whose simplicity is at
one and the same time comic and tragic: . . . beneath the illusory presence,
humanity *subsists with its true nature.'*"[107] He was able to capture this, Schloesser
says, because "Rouault's spirit was sacramental."[108] In paintings such as *Christ
in the Suburbs* (1920), he often painted spare landscapes where Christ was seen
with his disciples, or as here with children. But Christ's strong presence, at the
center of the picture, is mirrored by the way a light in the richly colored sky
with its small sun illumines the empty and often dark streets.

 Jacques and Raïssa Maritain met Rouault for the first time in 1905. Raïssa
recalls sitting with her husband listening to Rouault and Bloy discuss "every
question about art."[109] The relationship with Bloy resulted in the Maritains'
baptism in the summer of 1906. Given Bloy's influence and the fact that
Rouault (who was eleven years Maritain's senior) was well known for having
exhibited with the Fauves, these discussions were surely significant in the evo-
lution of their own thinking about art and faith. Raïssa notes that it was in

[106]Rouault, *Soliloques* (Neuchâtel: Ides et Calendes, 1944), 53.
[107]Puy, quoted in Schloesser, *Jazz Age Catholicism*, 232-33 (emphasis original). Schloesser notes that
 Puy's use of dogmatic language of christological discussions was intentional and probably influ-
 enced by Maritain.
[108]Ibid., 233.
[109]See Dyrness, *Rouault*, 42.

thinking of Rouault especially that Jacques wrote his influential book *Art and Scholasticism*, first published in 1920.[110]

Jacques Maritain has probably done more than any other person to provide an intellectual justification for the Christian artists working in the modern styles, though he has yet to receive the critical attention in this respect that he deserves.[111] In *Art and Scholasticism*, his first work, Maritain laid out a theological foundation for understanding art in a holistic way that was based on the philosophy of medieval theologian Thomas Aquinas. With an emphasis that may have been dependent on Rouault, who identified so strongly with medieval artisans, Maritain championed the medieval notion of art-making as ordered toward a particular practical end.[112] The artist works alongside God the creator because she or he works necessarily with the "treasure house" of the creation. Moreover, artists seek to produce, "by the object they make, the joy or delight of the intellect through the intuition of the sense."[113] The artist of faith never stopped with forms or colors of things alone, as the symbolists seemed to do. The images must point beyond themselves; they must become signs of something else. "The more the object of art is laden with signification . . . the greater and richer and higher will be the possibility of delight and beauty."[114] Such beauty ultimately reflects a Divine beauty, Maritain believed; though made of creation, it draws the soul beyond the created order. In his important discussion of Maritain, Stephen Schloesser argues that this thinker succeeded in reconciling ancient and modern discourses about art. He saw the form as deeper than imitation, something he learned from Aquinas's notion of the splendor of form, and he saw the subject

[110]Jacques Maritain, *Art et Scolastique* (Paris, 1920), trans. Joseph W. Evans from the 3rd and final ed. (1935), with the essay "Frontiers of Poetry," translated from the 2nd ed. (1927), *Art and Scholasticism and the Frontiers of Poetry* (New York: Scribner, 1962).

[111]See Rowan Williams, *Grace and Necessity: Reflections on Art and Love* (London: Morehouse, 2005). Williams notes that Maritain's work, for various reasons, suffered eclipse in the second half of the century but has recently begun receiving fresh attention (5-9). Williams provides a helpful exposition of Maritain in relation to British art, something we explore below.

[112]Maritain, *Art and Scholasticism*, 8.

[113]Ibid., 54.

[114]Ibid., 55. Maritain did not agree entirely with the symbolists however. He took issue with Maurice Denis's implication that the *end* of such art was to induce specific affective states. He believed that this is an *effect* but not properly its *end*, which lies elsewhere in the larger impact of participating in the poetic knowledge of the artist. Maritain, *Art and Scholasticism*, 203, 204n138. Also see Dyrness, *Rouault*, 57-59, which explores a similar tension between Rouault's view of art and that of Maurice Denis.

of art as a "sensible sign" of this, something that captured the sacramental depths of creation.[115]

Later, in a series of lectures given in 1952, Maritain drew out many of the implications of this early work. Art, he said, is "the creative or producing, work-making activity of the human mind," which generates experiences of beauty wherever there is a genuine interaction between humanity and nature.[116] The critical notion of the self in Western art, he claimed, emerged in relation to theological formulations of the person of Christ: the self was first seen as an object in the revelation of Christ's divine self (especially in the great councils that defined that self), then humanity came to understand the self as subject, and finally it came to see the creative subjectivity of the person as poet or artist.[117] So even in the modern promotion of the self, Maritain claimed, the artist cannot escape the influence of Christ. Modern art then brings with it a new potential by which the inner meaning of things is grasped through the interaction with the artist's self; both are manifest in the work.[118]

This theological grounding of the artist's work, both in creation and in the selfhood of Christ, makes possible a striking view of the process of art-making. Working out a lived logic (*habitus*), the artist furrows into the inner workings of nature, "in its own way the labor of divine creation."[119] This "knowledge-with" things, Maritain termed "connaturality." That is, the soul of the artist seeks itself by "communicating with things," effecting knowledge through "affective union."[120] Beauty emerges out of this "connatural" knowledge of the self and things. It "spills over or spreads everywhere, and is everywhere diversified."[121] Notice that beauty emerges from the work— from below, as it were, not from above. Even if it reflects the radiance of the transcendent, it is a spontaneous product of the affective union of self and nature, which comes to expression in the work. This unique union sug-gested both the promise of modern art and also its peril. Modern art's temp-tation, Maritain believed, was to favor the antirational rather than the

[115]Schloesser, *Jazz Age Catholicism*, 148-51, 163-64. Schloesser adds: Catholics can say that all tables are holy because there is Eucharist.
[116]Maritain, *Creative Intuition in Art and Poetry* (New York: Meridian, 1954), 3-5.
[117]Ibid., 20.
[118]Ibid., 25.
[119]Ibid., 50.
[120]Ibid., 83.
[121]Ibid., 124.

superrational, to seek beauty at the expense of the beauty of the human form, or to choose the self over the thing seen—distortions amply illustrated in the history of modern art.

Maritain's genius was to create a language and a way that artists could see themselves as both fully modern and yet nourished by the Catholic tradition, especially the Thomism of the Middle Ages. His influence was considerable among writers and artists in France. While standard treatments of this period have overlooked his influence, voices recently have been raised to argue for the lasting impact of the Catholic revival on avant-garde art in France. Gino Severini (1883–1966), for example, when he had become disillusioned with the futurist quest to adapt cubist forms to movement, met Jacques Maritain (and read *Art and Scholasticism*) in 1923.[122] Having converted to Catholicism in 1919, he was moved by his encounter with Maritain. They shared, among other things, an early encounter with Henri Bergson, though they later repudiated his vitalism. Severini had already argued in his *Du cubisme au classicisme* (1921) that artists needed a new sense of space, but he was searching for a more universal foundation for this. Maritain (and to a lesser extent Maurice Denis) helped him see that the artist could "recreate" the universe "according to the laws by which it is determined," and that art could be productive action.[123] Severini was able to go on to "construct an aesthetic framework in which the formal language of modernism, the harmony provided by the Church and the craftsmanship of the past would co-exist and mutual[ly] benefit one another."[124]

Later, Albert Gleizes (1881–1953), who had been an important contributor to cubism, returned to Catholicism in 1941 and sought to renew sacred art in the language of modern art—especially of cubism to whose principles he remained faithful throughout his life. Gleizes felt that the modern language of abstraction was uniquely suited to express a pure spirituality. His project might be summed up, in a way that recalls Maritain, as the attempt to integrate the formal discoveries of cubism with the religious sensitivities of the Middle

[122]See Zoë Marie Jones, "Spiritual Crisis and the 'Call to Order': The Early Aesthetic Writings of Gino Severini and Jacques Maritain," *Word and Image* 26, no. 1 (January-March 2010): 59-67. Jones submits this case as an example of the "relevance of neo-Catholicism for an understanding of the avant-garde in interwar France" (59).

[123]Ibid., 63.

[124]Ibid., 65.

Ages.[125] Gleizes's influence on the sacred in French art during the second half of the twentieth century remained strong.

One who followed in the way forged by Gleizes was Alfred Manessier (1911–1993). In the late 1930s a group called Témoignage (Testimony) kept alive Christian mystical ideas nourished by Thomism and by Maritain. While Manessier showed with this group in the 1930s, it was not until after the war had begun, in 1943 following a period in a Trappist monastery, that he formally converted to Catholicism. From this point on he worked to develop means to express a greater interiority and to advance the ideas of Christian mysticism and Thomism. In this later period he oriented his work more toward specifically Christian themes, though he worked with forms abstracted from sensations of the outside world. Like Gleizes, he preferred nonfigurative means. As he put it, "Non-figurative art seems to give the opening at present by which a painter can better move toward reality and take conscience of what is essential in himself."[126] Both Gleizes and Manessier demonstrate that the ideas of Maritain, and the explicit expression of religious faith, were present in some of the best work that is associated with the School of Paris.

CÉZANNE AND PICASSO

The influence of the Catholic revival can be seen in significant members of the School of Paris, but what about the more influential artists of the century, Cézanne and Picasso? There is no doubt about the influence of these artists on the twentieth century, yet very few have proposed that religion has played any significant role for either. Paul Cézanne (1839–1906) was a reclusive figure, working alone in Aix en Provence (in the South of France) and supported grudgingly by his banker father. His correspondence reveals little about his personal life—as he believed that the person behind the work should stay out of sight,[127] and he was

[125]See Jacques Busse, "Gleizes," in *Dictionnaire des Peintres, Sculpteurs, Dessinateurs et Graveurs*, 4th ed. (Paris: Grund, 1999), 6:212. See also Daniel Robbins, *Albert Gleizes, 1881–1953: A Retrospective Exhibition*, exh. cat. (New York: Solomon R. Guggenheim Foundation, 1964). Pichard says that Gleizes "remains a source of one of the great currents of contemporary sacred art." See Pichard, *L'Art sacré moderne*, 119.

[126]Busse, "Manessier," *Dictionnaire*, 9:136. Interestingly, Maurice Denis felt that abstract forms were inappropriate for a sacred art since they are not easily understood by the faithful. See Denis, *Histoire de l'art religieux*, 302.

[127]See John Rewald, ed., *Paul Cézanne: Correspondance* (Paris: Grasset, 1978), 312. Hereafter referred to as *Correspondance*.

impatient with conversations about theory. His advice to younger artists was simple: study nature and seek to discover its secrets. When pressed he would say, study it some more. But his mode of working with nature was anything but simple. He wanted to paint from nature, but with the substance of the great masters of the past—to redo Poussin, as he put it, but from nature. This involved a meticulous study of subjects to discern their structures—cylinder, sphere, cone. He sought, as Rookmaaker put it, "the universal ideas that ordered what he saw."[128]

Though Cézanne worked from nature, he liked to visit the Louvre to seek confirmation of his pictorial researches. "The Louvre is the book in which we learn to read," he told Émile Bernard.[129] Werner Haftmann reports that Veronese's *Marriage at Cana* filled Cézanne with enthusiasm: "It is beautiful and alive," the artist wrote, "and at the same time it is transposed into a different yet entirely real world. The miracle is there, the water is transformed into wine, the world into painting."[130] Transforming the world into painting serves as a useful shorthand for Cézanne's goals. Haftmann characterizes the results as something that more religious epochs would call "revelation." For as Cézanne liked to say: "Nature is more depth than surface, the colors are the expression on the surface of this depth; they rise up from the roots of the world."[131]

Little wonder the younger artists were struck when they came upon his work in the basement of Père Tanguy, who sold artist supplies in Paris in the 1880s and 1890s. Tanguy sometimes allowed Cézanne to leave his work there in exchange for paint and brushes. Pissarro was an early admirer and urged van Gogh to study these careful compositions; Tanguy used them to give young Émile Bernard art lessons. The artists were smitten—never mind that Cézanne's work was hard to sell, brought only half the price of a Monet and was repeatedly spurned by the salons.[132]

A look at a work from 1884–1885, *Farmhouse and Chestnut Trees at Jas de Bouffan* (fig. 3.4), gives some indication of what these artists found striking. A pleasant house, the Cézanne's family estate in the south of France, is framed

[128]Rookmaaker, *MADC*, 95. Rookmaaker had a generally favorable view of Cézanne, but he did not seem to give any thought to his religious context or its influence. See Rookmaaker, *Synthetist Art Theories*, 95-99.

[129]Cézanne, letter to Bernard (1905), in Chipp et al., *Theories of Modern Art*, 21.

[130]Cézanne, quoted in Haftmann, *Painting in the Twentieth Century*, 1:32.

[131]Ibid., 1:34.

[132]Rewald, *Post-Impressionism*, 21, 45-46.

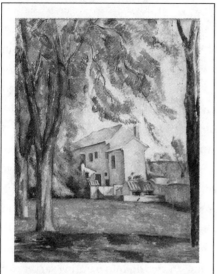

Figure 3.4. Paul Cézanne, *Farmhouse and Chestnut Trees at Jas de Bouffan*, 1884–1885

by trees and set back amidst a loosely sketched lawn. There is a tension set up between the trees and the solid triangles and rectangles of the house. But the very visual tensions—between solid and blotched colors, and between lightly drawn trees and the strong structure of the building—reach out to challenge the viewer. The imagery dissolves into lines and colors on a flat surface, but one that plays and skips as it is seen, pushing the possibilities of color and lines in a new direction.[133]

Standing before this picture, one recalls the words of Walter Benjamin before a similar painting in Moscow:

> As I was looking at an extraordinarily beautiful Cézanne, it suddenly occurred to me that to the extent that one grasps a painting, one does not in any way enter into a space; rather this space thrusts itself forward, especially in various specific spots. . . . There is something inexplicably familiar about these spots.[134]

The work Cézanne's composition performs on the viewer may suggest one of the ways that he became influential on the cubists who followed him.

His reputation slowly began to grow. After his death, a large exhibit opened in Paris in 1907 that proved revolutionary to the cubist generation. And since then Cézanne has come to displace even van Gogh and Gauguin as "the godfather of modern art."[135] What accounts for this influence? There are many accounts of his formal dependence on Monet and Pierre-August Renoir, and even on Georges Seurat. Like them he had abandoned the variations in light

[133]The house held deep meaning for Cézanne, and he was traumatized when his brother sold it to settle the estate in 1899. See Alex Danchev, *Cézanne: A Life* (New York: Pantheon, 2012), 322-23.

[134]Benjamin, diary entry from December 24, 1926, cited in Danchev, *Cézanne*, 365. In typical Benjamin fashion he goes on to note ways this can "localize crucial experiences of the past."

[135]Robert Herbert, "Godfather of the Modern?," *New York Review of Books*, August 13, 2009, 21. Herbert cites William Rubin in saying that "the difference between [Cézanne] and the Cubists was as much one of degree as of kind."

and dark, substituting shifts won through juxtaposition of separate strokes of color. But unlike them he sought to build up the structure of his forms through the application of more classical methods of composition, which he had learned from the masters.

But as Robert Herbert notes, "Analyses based mostly on aspects of formal structure are seductive, but they deny Cézanne's range and depth."[136] And this range and depth may have had deeper roots. Cézanne was notably reticent to reveal much about his personal life—indeed the publication of Émile Zola's fictionalized life of Cézanne, *L'Oeuvre* (The Work) (1886), caused Cézanne to break with his old childhood friend. But there are significant hints that have yet to be explored. Not surprisingly, it was the irrepressible Émile Bernard who sought to draw out Cézanne late in his life. Bernard had long been an admirer of the older painter and had published an article on him in 1892. But it wasn't until 1904, on his return from a trip to Egypt and Italy, that Bernard, with his wife and two children, stopped off to meet Cézanne in Aix. Bernard tried to open conversations on a variety of philosophical issues, in which Cézanne took little interest. But Bernard did succeed in getting the aging artist to write down his thinking in some detail. A letter written April 15, 1904, provides the most detailed explanation:

> Treat nature by the cylinder, the sphere, the cone, putting the whole in perspective, so that each side of an object, within the plan, is directed toward a central point. The lines parallel to the horizon give the extension, whether of a section of nature, or, if you prefer, of the spectacle the *Pater Omnipotens Aeterna Deus* [omnipotent Father, eternal God] lays out before us. The lines perpendicular to this horizon give the depth. Because nature, for us humans, is more depth than surface.[137]

Cézanne goes on to note how important is the choice of colors for evoking this feeling of depth—reds and oranges for the surface, and enough blue to make one "sense" the air. Significant is the detailed sense of structure, line and color to which his research had led him. But embedded in these descriptions is a reference to the ground of this in the Creator—perhaps in response to Bernard's prompting.

[136]Ibid. Herbert means this both in terms of Cézanne's subsequent formal influence on modernism and also in seeking sources of his own style.

[137]Cézanne, *Correspondance*, 375-76. Unless otherwise indicated, the translations are by Dyrness.

Cézanne's references to the micro and macro perspective of nature recalls Frederic Jameson's advice on "reading" Cézanne.[138] We must take, he writes, two distinct "viewpoints"—"nose-close and ten feet away." We must first observe it closely and discern the narrative of the surface before being pushed back to see it as a whole. Together this movement—the breadth and the depth, as Benjamin saw—helps us to discover something unmistakably familiar about this narrative. This is the only way to explore, Jameson argues, both the unity of the work and its architectonic composition. But how did Cézanne arrive at this way of imagining nature?

That Cézanne was a person of faith, at least later in his life, is clear from his letters. In February 1891 his friend Alexis wrote to Zola to give him news of Cézanne (after the rupture of their friendship, Zola had pressed all his friends who knew his old companion to send him news): "Finally to complete the picture of his psyche he has converted! He believes and practices! [He says:] 'It's fear! I feel I have only a few more days on earth, and then what? I believe I will "survive" and I don't want to burn *in aeternum*.'"[139] His letters contain increasingly more references to faith and his dependence on God, or "heaven." In 1899 he wrote to his niece upon hearing news of her first Communion: "Once we reach a certain age, there's no better support or consolation than in religion."[140] In 1902 his advice to a young artist was to keep studying nature, and "God will do the rest."[141] He began to see art as a kind of priestly calling; like Moses, he felt that he could see the Promised Land but might not enter it![142] He went to Mass faithfully at Saint Saveur, the cathedral in Aix, where he loved the Abbé Poncet and knew personally the beggars whom he frequently helped.[143]

Of course it is difficult to tie Cézanne's faith directly to the stylistic innovations that he proposed. It is no stretch, however, to connect his insistence on depth over surface to his sense of God's creative presence in his beloved nature, especially in light of the Catholic and sacramental perspective that had shaped

[138]Jameson, *The Modernist Papers* (New York: Verso, 2007), 258-60.

[139]Cézanne, *Correspondance*, 295. It is possible that Cézanne's conversion took place sometime earlier and Alexis is only reporting it when he hears of it later.

[140]Ibid., 337.

[141]Ibid., 352.

[142]Ibid., 366.

[143]He wrote to his son Paul in August 1906 that he couldn't stand the priest sent to replace his friend. Ibid., 401.

him. Another indication is the admiration that, especially, Bernard and Maurice Denis expressed for his work. While Bernard's own aesthetic was vastly different, preferring to work in museums with philosophical texts rather than returning to nature as Cézanne urged him to do, the young artist continued to promote Cézanne's work.[144] Maurice Denis had long been a supporter and began exchanging letters in 1901, telling the artist about his many followers. Later in 1906 he visited the artist in Aix. Bernard and Denis clearly saw Cézanne as part of the renewal of means that artists were using to express the sacred. In a standard treatment of this period of French art, Christopher Green notes that Bernard's interpretation of Cézanne was widely known, but Denis's role in mediating Cézanne to his contemporaries was even greater. Writing a significant critical essay on the famous 1907 retrospective in Paris, according to Green, Denis did as much as anyone to promote this "Poussin of Impressionism."[145]

But what was Cézanne's role in the subsequent development of cubism? As we noted in the introduction, it is a mistake to assess cubism in terms of what is being represented, as Rookmaaker did. For clearly it was Cézanne's focus on the means of representation—on cylinders and squares—that was to have a major impact on the development of the cubism. George Braque and Picasso took Cézanne's handling of planes and surfaces and employed them in the service of a new way of representing the world. For Braque, in particular, exposure to Cézanne was a revelation. As he wrote:

> The discovery of [Cézanne's] work overturned everything. . . . I had to rethink everything. I wasn't alone in suffering from shock. There was a battle to be fought against much of what we knew, what we had tended to respect, admire or love. In Cézanne's work we should see not only a new pictorial construction but also—too often forgotten—a new moral suggestion of space.[146]

Fernand Léger argued that the traditions of "visual realism," which demand an object, a subject and the devices of illusionistic perspective, are in Cézanne overtaken by a "realism of conception"—that is, these artists were preoccupied

[144]See, for example, ibid., 409.

[145]Green, *Art in France, 1900–1940* (New Haven, CT: Yale University Press, 2000), 189-95. See also M. Provence, "Cézanne chrétien," *Revue des Lettres*, December 1924.

[146]Braque, quoted in Danchev, *Cézanne*, 232-33. Danchev notes: "For the cubists, the discovery of Cézanne was decisive."

with the *means* and *operations* of representation more than with the subject.[147]
Art historian Yve-Alain Bois characterizes Picasso's primary efforts during this
same period as "mapping the entire visual field (thus figure and ground) with
a 'unitary pictorial idiom.'"[148] The role of Cézanne in this, and in particular in
his framing of the moral significance of space, must have been substantial, but
it has yet to be fully explored. Similarly, the significance of his faith commit-
ments may be unclear, but it is surely likely that there is some relationship
between his dedication to follow nature and to discover there its deep struc-
tures and his persuasion that an eternal Presence underlies these things—this
too is something deserving of more attention.

Turning more briefly to Pablo Picasso (1881–1973), what can be said about
religious influences on this creative genius? It is well known that Picasso grew
up within an ultraconservative Catholic environment in Spain.[149] Though he
spent much of his life trying to distance himself from the institutional church
and its pernicious association with oppressive regimes in Spain, there is a
growing realization that he never fully lost his religious sensitivities. Indeed,
his biographer John Richardson notes that his encounter with classical
sculpture during a 1917 trip through Italy embodied for him a "sacred fire—in
this case the sacred fire of Olympus—for which he was always searching."[150]
We noted in the introduction the folly of identifying too closely the apolitical
Picasso with the communist movement he nominally supported while eagerly
denying his Catholic heritage. According to Richardson, Picasso's faith was
something he "had tried and failed to repudiate and seemingly drew on
throughout his life."[151]

[147]This is what makes Rookmaaker's interpretation of cubism questionable. Léger, "The Origins of
Painting and Its Representational Value" (1913), in Charles Harrison and Paul Wood, eds., *Art in
Theory, 1900–2000: An Anthology of Changing Ideas* (Malden, MA: Blackwell, 2003), 202-5.

[148]Bois, "Pablo Picasso: The Cadaqués Experiment," in *Inventing Abstraction, 1910–1925: How a
Radical Idea Changed Modern Art*, ed. Leah Dickerman (New York: Museum of Modern Art,
2012), 42. The phrase "unitary pictorial idiom" is borrowed from Pierre Daix.

[149]Arianna Huffington notes that many of his early drawings were of religious subjects, including
one of Christ blessing the devil (his own genius, she wonders?), and he continued to paint Christ
as a symbol of his own suffering. See Huffington, *Picasso: Creator and Destroyer* (New York: Avon
Books, 1988), 33-34.

[150]Richardson, quoted in Andrew Butterfield "Recreating Picasso," a review of the third volume of
Richardson's biography of the artist, *A Life of Picasso: The Triumphant Years, 1917–1932*, in *New
York Review of Books*, December 20, 2007, 12-17.

[151]See John Richardson, "How Political Was Picasso?," *New York Review of Books*, November 25, 2010,
27. In the same article Richardson quotes Picasso's second wife, Jacqueline Roque, as saying of

But what effect, if any, did this have on his work? One way of thinking about this is to note the influence of the theater on his work. During the 1920s, Picasso collaborated with choreographers and composers in a series of major ballets, creating costumes and set designs. This collaboration provided an outlet for his prodigious vitality, but it also reinforced the sense of drama and ritual that accompanied Picasso throughout his life.[152] Accordingly, critic David Carrier has seen the theme of performance running through all of Picasso's greatest work. His focus on acrobats and matadors is well known, but often the larger performative meaning of these figures has been overlooked. Picasso can be said to propose that painting was a kind of magic, and that life was a *theatrum mundi*. When seen in this light, his most influential works, such as *Les Demoiselles d'Avignon* (1907) or the much later *Guernica* (1937), do not simply break up the unitive perspective that had reigned since the Renaissance; rather, Carrier argues, they suggest a dramatic performance that draws the viewer into the dramatic action. His subsequent use of erotic elements would then be understood in terms of his quest for a totemic or "disturbatory" power of imagery.[153] *Guernica* of course has been seen as the triumph of Picasso's political commitments, but as we suggested in the introduction, the cry of horror at injustice could just as well be rooted in his continuing religious sensitivities—a dramatic performance rooted in ritual. Picasso later in his life became obsessed with Ovid's *Metamorphoses*. There, Ovid famously sings in the opening lines:

> My soul would sing of metamorphoses.
> But since, o gods, you were the source of these
> bodies becoming other bodies, breathe
> your breath into my book of changes.

Of this Andrew Butterfield comments, seeking "divine inspiration both for and through the transfiguration of the body is a fundamental principle in

Picasso that he was "plus Catholique que le Pape [more Catholic than the Pope]" (30).

[152]Cf. Andrew Butterfield: "Picasso had a nearly inexhaustible need for social and intellectual stimulus, and he fed off the energy, and sometimes the ideas, of friends and acquaintances." See Butterfield, "Recreating Picasso," 14.

[153]Carrier, in Betsy G. Fryberger et al., *Picasso, Graphic Magician: Prints from the Norton Simon Museum* (Palo Alto, CA: Iris and B. Gerald Cantor Center for the Visual Arts at Stanford University, 1998), 81-82. The reference to the "disturbatory" power of Picasso's work is attributed to Arthur Danto.

[Picasso's] work."[154] It is hard to imagine this affection and its accompanying artistic drives could have existed apart from the haunting echo of the transformation of the body that he had seen performed in the liturgy of his childhood.

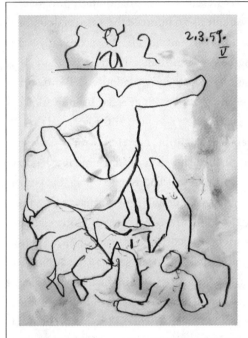

Figure 3.5. Pablo Picasso, *Drawing V: La Corrida*, 1959

In a recent work on Picasso's religious art, Jane Dillenberger and John Handley note that Picasso was drawn to the drama of suffering and specifically to Christ's suffering—drawing several versions of the crucifixion over several years.[155] At the end of his life he brought together the crucified and the matador in a series called *La Corrida*. In *Drawing V* (1959), for example, Christ's arms are stretched out on the cross while his loincloth stretches down, morphing into a cape that the matador holds out to the charging bull (fig. 3.5). Christ becomes here the power that defeats the darkness represented by the bull in Picasso's work. Dillenberger and Handley argue that Picasso's outsized genius here creates "a means to transport the artist to some other realm of feeling and thought, where he too, despite his profession of atheism, could take part in the Christian drama, as it unfolded under his own hand."[156]

Rookmaaker recognized the violence of Picasso's *Demoiselles*—"not of the figures but of the artistic expression"—but he believed it represented his quest for the general, the universal in reaction to "trite individualism."[157] But there

[154]Butterfield, "Recreating Picasso," 16.
[155]Dillenberger and Handley, *The Religious Art of Pablo Picasso* (Berkeley: University of California, 2014).
[156]Ibid., 89.
[157]Rookmaaker, *MADC*, 116-17.

may be something deeper going on that also accounts for the painter's attraction to the primitive masks that he included and his attraction to the *corrida de toros*: an antiliturgy that intends a kind of magic spell.[158] That would account for the stir the *Demoiselles* caused when it was first shown, a reaction related not only to the resonance the artist may have felt for a lost ritual but to the echo the first audience felt of their own religious heritage. These hints call out for further treatment than we can give them here.

MODERN ART IN BRITAIN: THE CONTINUING
INFLUENCE OF FRENCH SACRAMENTALITY

The acceptance of modernism by British artists is a complex story that we will not attempt to tell here. By 1900, apart from John Constable and Joseph M. W. Turner, there were no great models to follow, and after the visibility of the Pre-Raphaelites faded, there was little sense of direction.[159] But in the early decades of the twentieth century, influenced by French precedents and nourished by indigenous traditions, a vibrant modernism developed.[160] Though we are unable to treat these developments fully, it may be profitable to show the afterlife of French Catholic impulses in Britain. Our brief comments and the few artists referenced here will not do justice to modernism in Britain, but they give some indication of the continuing life of the Catholic revival in this new setting.[161]

In the twentieth century, artist Eric Gill (1882–1940) did more than any other person to explore the integration between the Catholic tradition and the practice of art. While Gill differed in important ways from the earlier Arts and Crafts movement—a movement that he felt served "to supply beautiful

[158]Haftmann notes of this picture that "to the right, a demonic incursion of masks, reminiscences of sculptures from French Africa. This demonic zone breaks up the eurhythmics of the composition." Haftmann, *Painting in the Twentieth Century*, 1:97.

[159]Frederick Gore, introduction to Susan Compton, ed., *British Art in the 20th Century: The Modern Movement*, exh. cat. (London: Royal Academy of Art; Munich: Prestel-Verlag, 1986), 9.

[160]Charles Harrison, *English Art and Modernism: 1900–1939* (New Haven, CT: Yale University Press, 1981). Harrison notes that though Henry Moore and Barbara Hepworth are better known, artists like Walter Sickert and Paul Nash deserve a more prominent place in the history of modern art.

[161]Consistent with this focus, we will also not treat cases in which apparently antireligious figures, such as Francis Bacon (who played a prominent role in Rookmaaker's account), were struggling with deeper theological and religious concerns. We leave that for another time, or for others to address. See, for example, Taylor Worley, "Theology and Contemporary Visual Art: Making Dialogue Possible" (PhD diss., University of St. Andrews, 2009), chap. 4.

hand made things to the rich and imitation ditto to the not so rich"[162]—like
them he was drawn to medieval precedents. Margaret Grennan notes that Gill
became "a radical by contemplating the reasoned beauty of medieval town
planning."[163] He was especially attracted by the idea of the workman as a "min-
ister of truth" and lamented the modern degradation of the worker into a mere
instrument. Though Gill studied architecture in the first decade of the new
century, he became disillusioned both with that vocation and with the An-
glican beliefs in which he had been raised. So he became agnostic and, vaguely,
a socialist.[164] In his protest against production for profit—which he con-
sidered the root principle of modern civilization[165]—he became a workman:
a letterer and stonemason and, he claims, by accident, a sculptor. Believing the
churches were more concerned with preserving their sectarian existences than
with love and justice, Gill set about to develop his own faith. He became con-
vinced that one came to justice through love, not the reverse, and that God
must be approached through love.[166] As he described his spiritual pilgrimage,
he gradually worked out his faith, and when he had done so he awakened to
discover that it was Roman Catholicism he had found. So he joined the church
and was baptized in 1913.[167]

The decisive influence on his work as an artist was his encounter with
Father Vincent McNabb, O.P., after the war. McNabb introduced Gill to Mar-
itain and to Thomas Aquinas. In 1923 a translation of *Art and Scholasticism* by
John O'Connor was published at Ditchling, Sussex, where Gill had formed a
small community of artists. This book, Gill notes, "was destined to make a
very considerable revolution in intelligent circles, . . . and we hailed it as a
Daniel come to judgment."[168] Gill was especially attracted to Maritain's insis-
tence that the end of work consists in the good of the thing made—that beauty
follows from the integrity of what is made.[169] But in a move beyond Maritain's

[162]Gill, *Eric Gill: Autobiography* (London: Cape, 1940), 270. I am indebted to this work for the details
of Gill's career.

[163]Grennan, quoted in Peter Faulkner, *William Morris and Eric Gill* (London: William Morris Soci-
ety, 1975), 5.

[164]Gill, *Eric Gill: Autobiography*, 110-11.

[165]Ibid., 144.

[166]Ibid., 150-51.

[167]Ibid., 166, 192.

[168]Ibid., 208.

[169]See the discussion of Gill in Williams, *Grace and Necessity*, 45-55, which offers a very helpful de-
scription of this period.

thought, Gill believed that an artist who expresses integrity will surely be embedded in a community, and so good work will be done in service to the community and will express the values of that community. Here Gill expresses a very unmodern notion of the relation between the artist and community. Though he believed strongly that art was the one intransitive thing a human being can do—an idea developed by his follower David Jones—he insisted throughout his life that work must be expressive of communal values. Partly for these reasons Gill's work, while impressive and finely done, stands apart from the modern movements that were developing across the channel.

David Jones, influenced both by Gill and Maritain, reflected a more direct Continental influence. Though known also as a poet, Jones (1895–1974) thought of himself primarily as a painter. In 1919 he enrolled in the Westminster School of Art in London. Interestingly, he later observed that his exposure there to postimpressionism gave him receptivity to sacramental theology and to Maritain's views of art in particular. Writing to a friend late in his life he draws the connection between his developing modernism and Catholic symbolism: "The insistence that a painting must be a thing and not the impression of something has an affinity with what the Church said of the Mass."[170] In 1921 he was received into the Catholic Church under the influence of John O'Connor, who also introduced him to Eric Gill and of course to Maritain. Soon after this encounter he left school and joined the community at Ditchling. Throughout his life he acknowledged the influence of Maritain, both in the ability of an object to say more than it is, and in the view of artist as "maker," fitting together pieces of reality.

Jones, like Gill, believed that contemporary culture offered no support for artists of faith. Indeed, Jones struggled over how one creates an aesthetic out of a dying tradition—how to glimpse beauty amidst what he saw as the decline of the West.[171] Ditchling was Gill's attempt to recreate a communal setting in which authentic art could be made, and his influence in that setting was large. In 1989 Fiona MacCarthy published a biography of Gill that offered a constructive history of that experiment while shocking the art world with a disturbing portrait of Gill.[172] According to MacCarthy, Gill began

[170]Jones, letter to Harman Grisewood (1971), quoted in ibid., 59.

[171]Nicolete Gray, *The Paintings of David Jones* (London: John Taylor, Lund Humphries and Tate Gallery, 1989), 27.

[172]MacCarthy, *Eric Gill: A Lover's Quest for Art and God* (New York: Dutton, 1989).

experimenting with new forms of sexuality soon after his conversion to Catholicism, and did so in ways that eventually proved destructive to the community, which he eventually left.[173] David Jones was caught up in the controversy, and, after a broken engagement with Gill's daughter, he left Ditchling and struggled with a series of emotional breakdowns (though he and Gill remained friends). In the 1940s he did a series of "subject pieces" that included several important religious subjects. One of the most significant of these, A Latere Dextro (1943–1949), was named for Christ's "right side" pierced during the crucifixion. The crowded picture features a priest holding up the cup at the moment the element is blessed while participants kneel before the altar. But along with this central subject, other images crowd around, added while the painter—over a period of six years—worked on the picture. Of this work Jones says: "Painting [is] odd in that one is led partly by what evolves as the painting evolves, this form suggesting that form. . . . I get in a muddle because I am really after the felicity of forms and their technical contrivance, but tend to get bogged down with a most complex 'literary' and 'literal' symbolism at times."[174] The crowded symbolism of these watercolors recalls Chagall, but the curvilinear design shows Jones's debt to the ancient Celtic style and perhaps to Gill. While recognized as a major artist, critics typically have trouble with Jones's religious content. Jonathan Miles and Derek Shiel, for example, acknowledge that Jones's view of the object as sign is consistent with his theological commitment to Christ's self-sacrifice, but they believe Jones fell short of success because he was out of step with the language of twentieth-century art: his work lacks an evocation of "mysterious incompleteness."[175]

An artist who clearly uses the language of twentieth-century art to express Christian themes is Graham Sutherland (1903–1980). Sutherland studied etching at the University of London and in the early 1920s discovered the prints of Samuel Palmer, a nineteenth-century printmaker whose prints had

[173]Ibid., x-xi.

[174]Jones, quoted in Gray, Paintings of David Jones, 42.

[175]Miles and Shiel, David Jones: The Maker Unmade (Bidgend, Wales: Seren, 1995), 142. They argue his beliefs "inhibited the full development and free play of [Jones's] sentimental and sexual nature" (230). Nicolete Gray, by contrast, reflecting the change in attitudes later in the century, acknowledges her own Catholic faith in her more positive account of Jones's work. See Gray, Paintings of David Jones.

kept alive a world of lost innocence and religious piety, and produced a series of prints interpreting these images.[176] In 1926 Sutherland joined the Catholic Church. After the stock market crash of 1929 destroyed the print market, he experimented in applied art—china and tapestries—but a visit to Pembrokeshire in 1934 inspired him to find his way as a painter. In this convoluted landscape he found that he could not simply paint what he saw but had to "paraphrase" it, making sketches from which he worked in his studio. He began to see the landscapes in his watercolors take on a life of their own, with twisting forms making a unified rhythm. He described his method in an important article in 1936 on "English Draughtsmanship." There he laid out what can only be described in terms of Maritain's conception of "connaturality." That is, the objective vision of the rhythms that attract the eye must be brought together with the interior vision of the artist, which is "essentially creative." The physical things are "absorbed in the reservoir of the subconscious mind out of which emerge the reconstructed and recreated images."[177] Here he pays tribute to Samuel Palmer and Turner, who accomplish this visual transformation. Toward the end of the article Sutherland quotes Maritain. He notes that we see Henry Moore's art, as Maritain describes it, "recomposing its peculiar world with that poetic reality which resembles things in a far more profound and mysterious way than any direct evocation could possibly do."[178] Though nature was from this point on the starting point of his work, it was a nature transposed, signified.

Sutherland's career was interrupted by the war, but he took advantage of his skills to become an official war artist, making memorable drawings of bomb damage and the blitz from 1940 to 1945. In 1944 he was commissioned to do a crucifixion for Saint Matthew's Church in Northampton. The studies done in preparation for this work show that he was influenced by the Grünewald altarpiece as well as photos of victims of German concentration camps—both of which he says made the crucifixion more real to him. As part of his preparation he literally slung himself up on cords to see in a mirror what

[176]Ronald Alley, *Graham Sutherland* (London: Tate Gallery, 1982), 9. Interestingly, Rosenblum sees Palmer as a principal figure in the nineteenth-century northern romantic tradition in the style of Friedrich. See Rosenblum, *Modern Painting and the Northern Romantic Tradition*, 53-64.

[177]Sutherland, "Trends in English Draughtsmanship," *Signature*, no. 3 (July 1936): 9.

[178]Ibid., 12. Though he cites Maritain, Sutherland doesn't give the source, which is from Maritain's "Frontiers of Poetry," in *Art and Scholasticism and the Frontiers of Poetry*, 127.

Figure 3.6. Graham Sutherland, *Crucifixion*, 1946

this would look like.[179] The painting that resulted, *Crucifixion* (1946), is a large 96 × 90 inch oil on hardboard that powerfully combines natural motifs of thorns and the human form with an angular backdrop that accentuates the suffering depicted (fig. 3.6). Sutherland says of this piece:

> The Crucifixion idea interested me because it has a duality which has always fascinated me. It is the most tragic of all themes yet inherent in it is the promise of salvation. It is the symbol of the precarious balanced moment, the hair's breadth between black and white . . . and on that point of balance one may fall into great gloom or rise to great happiness.[180]

[179]Alley, *Graham Sutherland*, 14, 111.
[180]Sutherland, "Thoughts on Painting," *The Listener*, September 6, 1951, quoted in Michael Hammer,

Sutherland worked on a number of passion scenes while he was at work on the Northampton *Crucifixion*. Ronald Alley notes that Mary Magdalene's pose in *The Deposition* (1946) recalls Picasso's *Three Dancers*. Clearly here, in what is one of his most tortured and moving pictures, Sutherland has been able to employ the best of the techniques of the modern period in the service of a religious vision, creating a unified rhythm that embodied the poetic and sacramental reality that Maritain described.

The other art theorist Sutherland paid tribute to in his article on English drawing is Herbert Read, the critic who dominated the English scene in much the same way that Clement Greenberg did somewhat later in the United States. But their views of art could not have been more different. Read recognized that the great advance in modern painting was the transformation that took place in postimpressionism. Referring to the change that Gauguin brought about, Read notes: "The whole difference between the modern movement in art and the tradition which prevailed for five preceding centuries is expressed in this substitution of the symbolic for the descriptive."[181] While he did not ground these developments specifically in religion, Read understood the rootedness of these developments in their nineteenth-century romantic context.

Stanley Spencer (1891–1959) was a painter whose religious subjects seemed to blend in perfectly with his home village, Cookham, in Berkshire. While he cannot be placed in the same sacramental tradition of others we have surveyed, he does illustrate the continuing relevance of Christian themes, and their deep public attraction, in the modern period. When Spencer was a child, his father, William, would gather his children around him in the evening to read from the Old Testament, reading as though these things were going on right outside the door of their house. Eric Newton notes that although Spencer attended the Slade School of Art from 1910 to 1914, there are really only two sources for his art: Cookham and the Bible.[182] Indeed, in his work these two—place and

Graham Sutherland: Landscapes, War Scenes, Portraits, 1924–1950 (London: Scala, 2005), 144.

[181]Read, *Art Now: An Introduction to the Modern Theory of Painting and Sculpture* (1933), 2nd ed. (London: Faber & Faber, 1960), 49. He goes on to quote Gauguin: "One must search rather for suggestion than for description, as in music." For this reason Read is critical of the formalists like Roger Fry, arguing that their understanding of symbolism dismisses "idea" and leaves us with "feeling" (95).

[182]Newton, *Stanley Spencer* (Harmondsworth, UK: Penguin, 1947), 5.

text—are so interrelated that it is difficult to tell where the one leaves off and the other begins. Music too played a large role in his life—he insisted that he saw musical structures in visible forms.[183] Members of his family were builders, and one can see this influence in the way Spencer carefully laid out his forms, piece upon piece, like a bricklayer. He worked alone for most of his life, though for a time in 1917 he wrote for Eric Gill's magazine, *The Game*. During the war he served as a Red Cross orderly in Macedonia, an experience that was celebrated in his masterpiece, the murals of the Burghclere Chapel (1926–1932). After the war as he struggled to regain his footing and the old certainties of his faith, his images became more crowded and restless. But biblical images continued to appear, with the resurrection an especially prominent theme.

<div align="center">❙❙ ❚❚❚ ❙❙</div>

Treatments of this period of art history typically focus on persons and events in Paris—just as the later period is frequently headquartered in New York. But we have seen that such a limitation is misleading, both as to its sources and the scope of its influence. While most artists had some connection with Paris, the significant sources of their inspiration ranged from Brittany and Provence on the one hand to Spain and Tahiti on the other. And in most cases these influences included significant religious dimensions. The sacramental imagination of France's (and Spain's) Catholicism was especially strong, but this did not eclipse other (Protestant, African and Oceanic) currents from playing a role. The particular impact of these currents may be difficult to describe, but what is at stake is an interpretive breadth that seeks to consider all possible sources and potential influences. Scholars have not been shy to suggest political or economic proclivities, which are often significant, but these also conspire and commingle with spiritual and moral sensitivities that can promote or subvert these other aims. What interpretive practices, if any, does this call for? Just as viewers are more likely to see the influence of some cultural context on an artist when they know something about that context, they are more likely to see something of the religious and moral sensitivities of an artist in the work if these are not ignored or misconstrued.

But our exploration of these things has only just begun. As we will see, the influence of these artists extended well beyond Paris and France, not only into

[183]Elizabeth Rothenstein, *Stanley Spencer* (Oxford: Phaidon, 1945), 6.

Britain but into the turbulent history of modern art in the United States. But before turning to that history, we turn to the other centers of modern European developments, particularly in Germany and Russia.

4

Germany, Holland and Northern
Romantic Theology

> *The Greeks achieved the highest beauty in forms and figures at the*
> *moment when their gods were dying; the new Romans [i.e., Raphael and*
> *Michelangelo] went furthest in the development of historical painting at*
> *the time when the Catholic religion was perishing; with us too something*
> *again is dying.*

<div align="right">

PHILIPP OTTO RUNGE[1]

</div>

> *The protagonists [of modern art] withdraw to the last line of defense. It is*
> *a question of the ground plan and the works all contain a philosophy of*
> *the ground plan. . . . The painters and poets become theologians.*

<div align="right">

HUGO BALL[2]

</div>

For much of the twentieth-century—and certainly in the 1960s and 1970s when
Rookmaaker was doing his most influential work—the dominant narratives of
modernism were especially preoccupied with France. As argued in the previous
chapter, the typical secularist framing of these narratives deserves reconsider-
ation in light of the ways that French modernism was shaped by, and carried
the influences of, Roman Catholic thought and practice. However, over the past
few decades numerous scholars have demonstrated that the francocentrism of

[1]Runge, quoted in Joseph Leo Koerner, *Caspar David Friedrich and the Subject of Landscape*, 2nd ed.
(London: Reaktion Books, 2009), 161-62.
[2]Ball, entry for February 10, 1917, *Flight out of Time: A Dada Diary*, ed. John Elderfield, trans. Ann
Raimes (New York: Viking, 1974), 98.

these narratives also needed to be reconsidered. The history of modern art has since rapidly expanded to account for the ways that it unfolded well beyond the purview of Paris, in each case rendering the modernist project in somewhat different terms and in the context of somewhat different social pressures.[3] This is of particular interest here because these different terms and pressures (and their respective modernisms) involved different religious traditions and frames of reference. In this chapter we shift our focus especially toward Germany and Holland, exploring a handful of ways that modern art developed within contexts that were particularly (in)formed by Protestantism.

Robert Rosenblum's 1975 book, *Modern Painting and the Northern Romantic Tradition*, provides a valuable point of entry through which to launch this investigation.[4] The premise of his study is that "there is an important, alternative reading of the history of modern art which might well supplement the orthodox one that has as its almost exclusive locus Paris, from David and Delacroix to Matisse and Picasso."[5] Rosenblum protested that the Parisian narrative of modernism—which had dominated the construction of nineteenth- and twentieth-century art history in his time—produced too narrow an understanding of the driving concerns and lineages of modern art,[6] construing them primarily in terms of (a sociopolitically charged) formalism.[7] Supplementary to this narrative—or perhaps over against it—Rosenblum

[3]The development of the history of modernism in eastern Europe (discussed in chap. 5) has especially accelerated since the collapse of the Eastern Bloc in 1989–1991.

[4]Rosenblum, *Modern Painting and the Northern Romantic Tradition: Friedrich to Rothko* (New York: Harper & Row, 1975). This volume is based on Rosenblum's eight-part Slade Lectures, delivered at Oxford University in 1972. Hereafter this volume will be abbreviated as *MPNRT*.

[5]Ibid., 7.

[6]It should be noted that Rookmaaker's *Modern Art and the Death of a Culture* is also vulnerable to Rosenblum's critique, given its preoccupation with Paris as the hub of modernist history.

[7]The French doctrines of "art for art's sake" are sometimes reductively portrayed (especially by American artists and scholars) as a socially detached, philosophical navel-gazing. T. J. Clark, however, has been particularly helpful in clarifying the extent to which it was driven by an *immanent critique* of the formal construction of images: "Certain works of art, I should say, show us what it is to 'represent' at a particular historical moment—they show us the powers and limits of a practice of knowledge. That is hard to do. It involves the artist in feeling for structures of assumption and patterns of syntax that are usually (mercifully) deeply hidden, implicit, and embedded in our very use of signs; it is a matter of coming to understand, or at least to articulate, what our ways of world-making most obviously (but also most unrecognizably) amount to. I think that such work is done with real effectiveness—and maybe can only be done—at the level of form. It is the form of our statements, and the structure of our visualizations, that truly are our ways of world-making—at any rate the ways that hold us deepest in thrall." Clark, *Farewell to an Idea: Episodes from a History of Modernism* (New Haven, CT: Yale University Press, 1999), 165.

wanted to track an "eccentric Northern route that will run the gamut of the history of modern painting without stopping at Paris."[8] He acknowledged that stating things this way might be too "schematic," evoking a "too simple-minded polarization between French and non-French art," but this polarization provides a useful heuristic device to the extent that it allows the "glimmers of a new structure of the history of modern art" to come into sharper focus.[9]

The distinguishing feature of Rosenblum's northern route is that its primary points of navigation are "the religious dilemmas posed in the Romantic movement."[10] This has two immediate implications for the way his narrative unfolds: First, he argued that the engines of northern modernism—the driving cultural pressures and concerns that shaped it—were more *theological* than political, fueled primarily by the problem of "how to express experiences of the spiritual, of the transcendental, without having recourse to such traditional themes as the Adoration, the Crucifixion, the Resurrection, the Ascension, whose vitality, in the Age of Enlightenment, was constantly being sapped."[11] He avoided telling a simplistic secularization narrative, but Rosenblum's starting point was an acknowledgment of the weakening of traditional Christian thought and practice in modern North Atlantic societies, primarily in the seventeenth through nineteenth centuries. He believed that this weakening directly corresponded to an unprecedented shift in cultural weight and explanatory power from religion to the natural sciences, a shift generally accelerated by the development of analytic philosophy, historical materialism and higher biblical criticism. Human spirituality and a general regard for a transcendent ground of being have persisted throughout this shift, argued Rosenblum, but they had to do so in fugitive forms that could no longer assume a common vocabulary, iconography and canon of narratives once provided by Christianity. And thus Rosenblum's narrative of modernism is consistently told in terms of an artistic reworking of spirituality into dechristianized (or at least post-Christian) forms. He reached for a variety of metaphors to make the

[8]Rosenblum, *MPNRT*, 10.

[9]Ibid., 7-8. For an argument similar to Rosenblum's (and for a helpful study of Scandinavian modernism), see Kirk Varnedoe, *Northern Light: Nordic Art at the Turn of the Century* (New Haven, CT: Yale University Press, 1988), esp. 25-35. The major problem with Varnedoe's account is that, like Rosenblum, he severely underinterprets the significance of Protestant theology in the development of northern modernism.

[10]Rosenblum, *MPNRT*, 7-8.

[11]Ibid., 15; cf. 93, 173, 195, 215-16.

point: the inaugural events of modern art are constituted by "secular transla-
tions of sacred Christian imagery," "transvaluations of Christian experience,"
"transpos[itions] from traditional religious imagery to nature," the "relocation
of divinity in[to] nature, far from the traditional rituals of Christianity" and so
on.[12] By borrowing his analogies from linguistics (translation), ethics (trans-
valuation), music (transposition) and geography (relocation), Rosenblum
argued that there are core spiritual meanings, intuitions and sensitivities that
are sustained and alive throughout northern modernism, despite their radical
change of *form*.[13] Though once supported by Christianity, this core spirituality
can—and presumably now must—function in the normative dialects (or
values, musical keys and localities) of secular modernity. In short, for
Rosenblum modernism was an essentially theological enterprise that took
shape within the cross-pressures of theological crisis.

Second, the theological dilemmas of northern modernism were particularly
Protestant in their construction. The lines of the "Northern Romantic tradition"
that Rosenblum traced from early nineteenth-century Germany to late twen-
tieth-century North America run through regions and lineages that were his-
torically deeply rooted in Protestant thought and culture, including Holland,
Denmark, Norway, Sweden and England. The crises of representation that
were constitutive to modernist art (in all of its strands) were grappled with in
particularly Protestant terms as they traveled along these northern lines of
influence. A rapid disintegration of Christian iconography occurred throughout
Euro-American cultures, but, according to Rosenblum, "in the Protestant
North, far more than in the Catholic South, another kind of translation from
the sacred to the secular took place, one in which we feel that the powers of
the deity . . . have penetrated, instead, the domain of landscape."[14] The inher-
ently decentered and perpetually decentering character of Protestantism—
ecclesia reformata, semper reformanda (church reformed, always being re-
formed)—historically coupled with strong iconoclastic impulses toward

[12]Ibid., 17-22.

[13]Rosenblum identifies at least three means of achieving "secular translations of sacred Christian
imagery": (1) artists redeployed conventional Christian symbols and compositional devices in
unconventional ways; (2) they created new *private* religious symbols derived from experiences; and
(3) these converged in the observation of *natural* forms. See ibid., 195, from which this list has been
adapted and reordered for greater clarity.

[14]Ibid., 17.

ossified religious imagery, created an atmosphere in which modernity was experienced with different cultural cross-pressures and different critical flashpoints than in predominantly Catholic (or Orthodox) regions. And as Rosenblum rightly noted, in the visual arts these pressures and flashpoints tended to be especially concentrated on the theologically charged practices of landscape painting.

The problem is that Rosenblum generally misinterpreted this theological atmosphere and the pressures it produced, and thus he consistently drove conceptual wedges between the "Romantic tradition" and orthodox Christianity where there needn't necessarily be any. His thesis was that the primary ambition of northern modernism was to produce a post-Christian theological framework that could sustain "a sense of the supernatural without recourse to inherited religious imagery."[15] He overlooked the distinctly Protestant framework of this "sense" and instead characterized the result as a *pantheistic* and *privatized* theology that was "usually so unconventional in its efforts to embody a universal religion outside the confines of Catholic or Protestant orthodoxy that it could only be housed in chapels of the artists' dreams or in a site provided by a private patron."[16]

Charles Taylor offers a helpful corrective to this reading of the romantic period. He agrees that long-accepted Christian assumptions about history and cosmology were being revised or abandoned during this period, and as a result "certain publicly available orders of meaning" were unraveling and defaulting toward more private languages of experience and "articulated sensibilities."[17] He also accepts that this had deep consequences for the arts: as traditional symbolic orders weakened, artists increasingly had to ground their work in some "personal vision" by which meanings could be "triangulated" within the "forest of symbols" that remained.[18] The resulting artworks may have been symbolically nontraditional, and the metaphysical and ontic commitments that they entailed were often vague, but Taylor argues that it is a mistake to call these works post-Christian *tout court*. The new symbols constructed by these artists were not made up out of whole cloth, nor were they

[15]Ibid., 215-16.
[16]Ibid., 216.
[17]Charles Taylor, *A Secular Age* (Cambridge, MA: Belknap / Harvard University Press, 2007), 353.
[18]Ibid., 352.

simply repudiations of traditional Christian faith. Rather, they were developed as part of the struggle "to recover a kind of vision of something deeper, fuller" in the context of modernity's fragilizing of religious meaning.[19] And in the course of this struggle, Taylor concludes, "God is not excluded. Nothing has ruled out an understanding of beauty as reflecting God's work in creating and redeeming the world. . . . The important change is rather that this issue must now remain open."[20]

The aim of this chapter is to further explore this struggle to recover a vision of "something deeper, fuller" as it was inherited from the northern romantic tradition and worked out through modernism. We will reconsider a handful of the key artists in Rosenblum's narrative of northern modernism while challenging his assumptions about the theological implications of their work. And in the process we will interpret these artists' works in a way that also sharply diverges from Rookmaaker's treatment of them, reframing the theological content of their work in much more constructive terms. We propose that many of the central developments in northern modernism are better understood from within Protestant theology rather than outside of it, particularly with respect to Protestant thinking about the "givenness" of creation and the eschatological redemption of all things.

CASPAR DAVID FRIEDRICH: SHORE-SERMONS

Caspar David Friedrich (1774–1840) is mostly ignored in Rookmaaker's genealogies of modern art,[21] but he is of central concern for Rosenblum, who designates Friedrich's *Monk by the Sea* (1808–1809) as the "alpha" of the northern modernist painting tradition—to which Mark Rothko's *Green on Blue* (1956), and ultimately the Rothko Chapel in Houston (1964–1971), will serve as an "omega."[22] In fact, Friedrich's *Monk* is the inaugural moment for Rosenblum's narrative in much the same way that Jacques-Louis David's *Death of Marat* (1793) is for T. J. Clark's powerful francocentric history of modernism.[23] Clark sees David's *Marat* as pictorially embodying a profound

[19]Ibid., 357.
[20]Ibid., 359.
[21]Reference to Caspar David Friedrich appears only twice in Rookmaaker's *Complete Works*, and in both cases he is cast into a fairly negative light. See the discussion of these two references below.
[22]Rosenblum, *MPNRT*, 10, 215-18.
[23]See Clark, *Farewell to an Idea*, chap. 1.

sense of historical and political contingency (the painting punctuated a crucial moment in the French Revolution), which he regards as fundamental to modernist painting.[24] Rosenblum similarly reads Friedrich's painting as embodying and articulating a particularly intense and distinctly modern sense of contingency, but this is a contingency of theological (more than political) crisis, arising from "his need to revitalize the experience of divinity in a secular world that lay outside the sacred confines of traditional iconography."[25]

Monk by the Sea (plate 3) depicts a man (probably the artist himself)[26] wearing a Capuchin monk's habit, standing alone on a beach with his back to us. From the thin strip of shoreline in the foreground, the monk peers out over the vastness of a cold, dark sea, which extends ever outward beneath the infinitely greater vastness of the heavens. Other than a few whitecaps, nothing appears on the expanse of the waters and nothing transgresses the horizon. The sandy foreground is mostly desolate, the sea is blank and heavy clouds sit on the water so that the darkest regions of the painting are gathered along the horizon. The lone monk is dwarfed by the expanses of land, sea and sky (and the expanse of the canvas itself), but all these realms seem to squeeze toward him, creating a strange spatial compression. His placement in the canvas (approximately one-third the distance from the left edge) coincides with both the highest point of the shape of the beach and the lowest point of the sky visible beyond the clouds. The shape of the sea is mirrored in the darkest band of fog that sits on the horizon, and both bands are at their narrowest where the tiny monk stands on the shore—thus pushing all the visual pressure in the image toward the extremely charged gap between the top of the monk's head and the horizon toward which he looks.

[24]Regarding David's *Death of Marat*, Clark writes, "What marks this moment of picture-making off from others (what makes it inaugural) is precisely the fact that contingency rules. Contingency enters the process of picturing. It invades it. There is no other substance out of which paintings can now be made—no givens, no matters and subject-matters, no forms, no usable pasts. Or none that a possible public could be taken to agree on anymore. . . . Modernism, as I have said, is the art of these new circumstances. It can revel in the contingency or mourn the desuetude. Sometimes it does both. But only that art can be called modernist that takes the one or other fact as determinant." Clark, *Farewell to an Idea*, 18.

[25]Rosenblum, *MPNRT*, 14.

[26]Many art historians have rightly noted that the monk's distinctive blonde hair identifies him as the artist. However, Wieland Schmied warns against treating this reductively: "It is senseless to speculate—as has often been done—whether or not *Monk by the Sea* is actually a disguised self-portrait. The monk may be Caspar David Friedrich, but more important, he is each of us." Schmied, *Caspar David Friedrich*, trans. Russell Stockman (New York: Abrams, 1995), 63.

Above and beyond the monk's head the horizon forms a sharp, unbroken line across the canvas, creating a provocative spatial ambiguity that anticipated much later modernist painting: this horizon line simultaneously rushes toward us—as a flat geometric division on the surface of the painting, parallel to the top and bottom edges—and rushes infinitely away from us as the furthest limit and vanishing point of our vision, where the earth's curvature pulls the seemingly endless sea out of view. Kristina Van Prooyen highlights a further spatial ambiguity, noting that the vast expanse of the sea occupies roughly the same amount of the painting's surface as does the beach—a visual paradox that "points to the metaphysical problem of the picture": namely, that all efforts to intellectualize and rationalize "the endlessness of nature" can only happen from a position that is thoroughly human and thus thoroughly located.[27]

X-ray and infrared studies of the painting reveal that Friedrich had originally painted at least two ships on the sea with their masts extending above the horizon—both of which he eventually painted out. Rosenblum argues that our knowledge of Friedrich's decision to remove these boats only amplifies our sense of just how "daringly empty" this landscape really is: empty of all objects, ornamentation, narrative or focal points, other than the lonely penitent who stands "on the brink of an abyss unprecedented in the history of painting."[28] And for Rosenblum this abyss represented a breach in human understanding, provoking "ultimate questions whose answers, without traditional religious faith and imagery, remained as uncertain as the questions themselves."[29] Ultimate questions are certainly in play here, and perhaps their unanswerability is implied, but it is unclear why we should force Friedrich to stand—or force ourselves to stand—to face those questions "without traditional religious faith and imagery." Friedrich described this painting in a letter:

> Even if you [presumably addressing himself in the second person] ponder from morning to evening, from evening to dawn, you will not fathom and understand the impenetrable "Beyond"! With overconfident self-satisfaction, you think you will be a light for progeny, will unriddle the future. People want to

[27]Van Prooyen, "The Realm of the Spirit: Caspar David Friedrich's Artwork in the Context of Romantic Theology, with Special Reference to Friedrich Schleiermacher," *Journal of the Oxford University History Society* 2 (2004): 12, sites.google.com/site/jouhsinfo/issue2%28trinity2004%29.
[28]Rosenblum, *MPNRT*, 13.
[29]Ibid., 215.

know and understand what is only a holy conjecture, only seen and understood in faith! Your footsteps do indeed sink deep into the lonely sandy beach, but a soft wind blows over them and your footsteps will disappear forever: this foolish man full of vain self-satisfaction![30]

For Friedrich this painting thus advocates for a faith chastened by a radical epistemic humility (vis-à-vis the confident rationalism of the Enlightenment), which is insistently acknowledging and "foregrounding" the limitations of human understanding.[31] He highlights at least three such limits: (1) The narrow strip of beach creates a compressed foreground—Friedrich wants us to feel the particularity and locatedness of personal experience both spatially (feel your heavy feet sinking into this particular sand) and temporally (watch as these seemingly deep footprints disappear, as have all those who walked here before). (2) The edge of the water marks another such limit: from our position on this side of that boundary, we are confronted with the vast expanses of sea and sky that humans can manage and traverse only in limited ways and only with great difficulty. These realms that extend indefinitely "beyond" this shoreline are nameable and imaginable, even if only from afar or in abstract ideas, but Friedrich wants to elicit an acknowledgment that the reality of these creaturely realms always exceeds and outstrips our capacities for action, perception and understanding. (3) Friedrich is ultimately interested, however, in marking a limit that is "impenetrable": one in which the "Beyond" is an Unspeakable, an Unthinkable, an infinite and uncreated Nothing. In *Monk by the Sea* this limit is most profoundly marked not by the shoreline or the expanses of sea or sky but by the *horizon* from which these realms appear and toward which they recede. The very possibility of a horizon signifies the beginning and the end of perception (and cognition), beyond which we can only gesture "in faith" toward that which is invisible, unpronounceable and unthinkable—"a holy conjecture." Indeed, perhaps the penitent humility of a Capuchin is precisely the posture from which such things might be approached.

[30]Friedrich, quoted in Wessel Stoker, *Where Heaven and Earth Meet: The Spiritual in the Art of Kandinsky, Rothko, Warhol, and Kiefer*, trans. Henry Jansen (New York: Rodopi, 2012), 27.

[31]It should be noted that Friedrich's preoccupation with epistemic limits was not only an intellectual matter; this was also bound up in political concerns (Friedrich was outraged and despairing about the Napoleonic occupation of North German territories) and in personal tragedy (his father died in November 1809).

The most consistent strategy Friedrich uses to evoke these "beyonds" is to set a limited foreground over against a vast background, creating a breach between the two. In *Monk* this gap is ultimately *ontological*: from the concrete "here" of the foreground the monk peers toward an utterly open horizon that allegorizes the unknowable Beyond from which being itself is given. In many of his other works, however, this beyond is also—sometimes even primarily—*eschatological*: the breach between foreground and background functions as a gap between a "here-and-now" and a future "elsewhere-and-someday." *Winter Landscape with Church* (1811) is perhaps the most overt example in which the distance into the background is both metaphysical (beyond immediate material conditions) and temporal (beyond immediate historical conditions), but this same pattern can be found throughout his work, in paintings like *Mountain with Rainbow* (1809–1810), *Two Men Contemplating the Moon* (1819), *Woman Before the Rising Sun* (c. 1819) or *The Abbey in the Oakwood* (1809–1810).

Friedrich painted *The Abbey in the Oakwood* (fig. 4.1) as the companion to *Monk by the Sea*. The two canvases are the same size and were first exhibited as a pair in the 1810 exhibition of the Prussian Royal Academy in Berlin. Upon Friedrich's request, *Monk* was hung above *Abbey*, and together they form complementary approaches to the same questions and concerns. In *Abbey* monks in procession carry a coffin toward the open doorway of a ruined Gothic church,[32] which stands on the vertical centerline of the painting. Immediately below the ruined façade, a freshly dug grave lies open in the middle of the foreground: the funeral procession passes it by as if to assert that the grave is neither the object of their ceremony nor the destination of this dead brother. A forest of leafless trees presides over numerous grave markers that jut through the snow, marking the old graves scattered beneath the surface of the cold ground. Wieland Schmied bluntly summarizes the scene: "The church is

[32]The church ruins are based on studies of Abbey Eldena, a former Cistercian monastery near Friedrich's hometown of Greifswald. The abbey was founded at the turn of the thirteenth century, abandoned in the sixteenth century during the Protestant Reformation, badly damaged in the seventeenth century during the Thirty Years' War, and then subsequently plundered for stone blocks. Over the course of two decades, Friedrich did several drawings and paintings of this site, from which we know that he extensively altered these ruins for *Abbey*: he edited out the fragmentary walls adjacent to this west façade, he invented the window tracery in the west window (which at the time was mostly walled up), and perhaps most significantly he placed a cross in the portal through which the monks carry the dead man. See Schmied, *Caspar David Friedrich*, 65; and Otto Schmidt, *Die Ruine Eldena im Werk von Caspar David Friedrich*, vol. 25 of *Der Kunstbriefe* (Berlin: Mann, 1944).

destroyed, the graveyard abandoned, nature dead. Still the monks are cele-
brating the mass" as if the holy were to be encountered precisely within this
destruction, abandonment and deadness.[33] Reaching up from the dark,
earthy lower portion of the painting, the derelict architecture stops just short
of the halfway point of the canvas, and the entire top half of the painting is
given over to a sky that is losing the light of the setting sun. As the sunlight
withdraws, the faint form of a waxing moon appears in the sky alongside the
evening star.

Figure 4.1. Caspar David Friedrich, *The Abbey in the Oakwood,* 1809–1810

This decrepit manmade structure was built to celebrate the glory (fullness)
of God, but it is now a wreckage, undone by the centuries-long inertia of social
transformation and natural entropy. The "soft wind" that Friedrich had in
mind erases both footprints and cathedrals alike. And in *Abbey* the two are in
fact drawn together: the ruined body of the man being carried through the
doorway is directly analogized with the broken body of the cathedral; both
are *images* of God that are finally unable to generate their own lives or to
contain that Life to which they refer. Both human life and human theology are
thus faltering pointers toward realities beneath or beyond what is speakable
and thinkable. And yet Friedrich affirms their pointing. As Joseph Leo Koerner

[33]Schmied, *Caspar David Friedrich,* 65.

notes: "The Gothic monument, while now a jagged ruin, is perfectly centered and displayed *en face*, as if to recollect for us its original symmetry.... It is the canvas's symmetry, its straight edges, rectangular format and measurable midline, that recovers the cathedral's order within dissolution."[34] Friedrich's cathedral is simultaneously broken down (by the passage of time) and held fast (by that which is eternal).[35] Whereas *Monk* pushes the religious seeker to the brink of the abyss, *Abbey* pushes him to the brink of death; and, in both, religious structures and rituals are found outstripped by the unspeakable Beyond to which they point.[36]

Koerner contends that "Friedrich empties his canvas in order to imagine, through an invocation of the void, an infinite, unrepresentable God. The precise nature of this divinity, as well as the rites and culture that might serve it, remain open questions, yet the religious intention in Friedrich's art is unmistakable."[37] This open questionability of Friedrich's religious intentions has, however, led to deep disagreements about the theological implications of his work. Rookmaaker, for instance, regarded it as a kind of despairing proto-existentialism. In his view, Friedrich's paintings "depicted humans as trivial and insignificant . . . small and lonely figures in a world of deathly loneliness

[34]Koerner, *Caspar David Friedrich and the Subject of Landscape*, 128.

[35]It is possible that the Protestant Pietist Friedrich intended this as a subtle polemic against the formal structures of Catholicism. Nearly two decades later he wrote a series of exhibition reviews in which he commented on a painting by one of his contemporaries: "At first glance this painting presents the image of a ruined cloister as a memorial of a dark and gloomy past. The present illuminates the past. . . . Perhaps the artist is a Protestant and it is possible that he was contemplating ideas such as these when he was painting this theme." Caspar David Friedrich, "Observations on Viewing a Collection of Paintings Largely by Living or Recently Deceased Artists" (c. 1830), in *Art in Theory, 1815-1900: An Anthology of Changing Ideas*, ed. Charles Harrison, Paul Wood and Jason Gaiger (Malden, MA: Blackwell, 1998), 51. We might read these comments back into Friedrich's own paintings of ruined cloisters; however, in doing so we must also account for the fact that he also repeatedly uses an intact Gothic cathedral to signify the (eschatological) kingdom of God: e.g., *Winter Landscape with Church* (1811), *Cross and Cathedral in the Mountains* (c. 1812-1813), *Vision of the Christian Church* (c. 1812), *The Cathedral* (c. 1818) and probably even *Cemetery Gate (Churchyard)* (c. 1825-1830).

[36]In the months before and after making *Monk* and *Abbey*, Friedrich made several paintings with similar compositional strategies: e.g., *Dolmen in the Snow* (1807), *Winter (Monk in the Snow)* (1807-1808), *Mountain with Rainbow* (1809-1810), *Landscape with Rainbow* (c. 1810) and *Winter Landscape* (1811). However, a more extended study of Friedrich (which unfortunately we don't have space for here) must also take into account his more affirmative use of religious symbols, including *Cross in the Mountains (Tetschen Altar)* (1807-1808), *Morning in the Riesengebirge* (1810-1811), *Cross in the Forest* (c. 1820) and those works listed in the previous note. Rosenblum considers works like *Cross in the Mountains* to be only "nominally Christian" (*MPNRT*, 25), which is highly contestable.

[37]Koerner, *Caspar David Friedrich and the Subject of Landscape*, 22.

and abandonment."[38] And thus he believed that Friedrich's paintings articulated a quintessentially modernist experience of the world as "alien and un-heim-isch, a world in which the modern person does not feel at home [*heim* is German for 'home']. . . . Far from affording them the experience of freedom, such emptiness seems instead to oppress modern viewers, since they know themselves to be lost in it."[39]

Quite to the contrary, many other scholars have aligned with Rosenblum, interpreting Friedrich's work in terms of a thoroughgoing pantheism. Friedrich sometimes sounds as though the pantheist label might in fact fit: "The divine is everywhere, even in a grain of sand. . . . The noble person (a painter) recognizes God in everything, the common person (also a painter) perceives only the form, but not the spirit."[40] Everything hinges, however, on how we understand Friedrich's conception of God being "in" all things.[41] Koerner argues that interpreting such statements as pantheistic is irreconcilable with the paintings themselves, which actually "express a thwarted reciprocity with the world"—an irresolvable "disparity between the finite and the infinite, consciousness and nature, the particular and the universal."[42] These paintings "indicate a negative path, in which God cannot be found in a grain of sand, but at best in the unfulfilled desire that He be there."[43] Or perhaps it would be better to say that the "negative path" of these paintings is that they insist on the infinite disparity between God and creaturely existence while *simultaneously* insisting that God utterly permeates and sustains the creaturely being of every molecule and every grain of sand. Friedrich's paintings are thus not concerned with pantheistic Oneness as much as they engage a human "longing for the infinite"—a desire to span the infinite interval between the creaturely and the Creator.[44] Rosenblum recognizes this interval in Friedrich's work, but

[38]Rookmaaker, "Surrealism" (1952), in *CWR*, 5:234.

[39]Rookmaaker, *Art and Entertainment* (1962), in *CWR*, 3:11 (in a section titled "Crisis in Contemporary Culture").

[40]Friedrich, "Observations," in Harrison, Wood and Gaiger, *Art in Theory, 1815–1900*, 50.

[41]Rosenblum anachronistically collates Friedrich with Ralph Waldo Emerson's proclamation that "the currents of the Universal being circulate through me; I am part and parcel of God" (quoted in *MPNRT*, p. 22). However, Friedrich's statements about God being "in" all things, or even of all things being "in" God—both of which have long precedence within orthodox Christian thought—are unrelated to Emerson considering himself part "of" God.

[42]Koerner, *Caspar David Friedrich and the Subject of Landscape*, 21, 226.

[43]Ibid., 23.

[44]Ibid.

he confusingly tries to collapse it into pantheistic terms, arguing that *Monk*, for instance, establishes "a poignant contrast between the infinite vastness of a pantheistic God and the infinite smallness of His creatures."[45] Koerner's point is that if any such *contrast* is in fact established, then talk about a pantheistic Unity becomes untenable. Unfortunately, this confusion persists throughout Rosenblum's work.[46]

And actually much rides on this point. The ways we interpret the theological significance of Friedrich's work have implications for how we revise Rookmaaker's (francocentric) declinist narrative and for how we retrace Rosenblum's northern modernist narrative. Rosenblum wants to identify a "Romantic amalgam of God and nature" that begins with Friedrich and continues to drive avant-gardism into the 1970s,[47] but Koerner provides a necessary correction:

> Against the pious cliché of an annihilation of self before Creation, Friedrich fashions a more difficult vision, one in which the experiencing self is at once foregrounded and concealed, and in which God, submitted to a Hebraic iconoclasm born perhaps from the artist's own Protestant spirituality, is shown in His absence, as the image of His consequences.[48]

Theologian Wessel Stoker clarifies further: "Friedrich's religious landscapes are not pantheistic but theistic. He stands in the tradition of physicotheology, which viewed nature, as the creation of God, as a testimony to God's presence." The sharp horizontal boundary between sea and sky in *Monk* marks "a clear line separating the human being from the infinite," but it is a separation grounded in a "Christocentric, Lutheran belief that heaven and earth are closely connected to each."[49]

[45]Rosenblum, "The Abstract Sublime," *ARTnews* 59, no. 10 (February 1961): 41.

[46]If we had the space, this discussion of Friedrich could be unfolded outward into numerous other nineteenth-century northern landscape painters who were influential to later developments in modernism, including the Germans Philipp Otto Runge (1777–1810), Karl Blechen (1798–1840), Max Klinger (1857–1920) and Franz von Stuck (1863–1928); the Swiss artists Arnold Böcklin (1827–1901) and Ferdinand Hodler (1853–1918); as well as the Englishmen Joseph Mallord William Turner (1775–1851), Samuel Palmer (1805–1881), George Frederic Watts (1817–1904) and James Abbott McNeill Whistler (1834–1903). Palmer offers an especially interesting comparison: like Friedrich he believed that creation is not in itself divine but is "the veil of heaven, through which her divine features are dimly smiling; the setting of the table before the feast, the symphony before the tune, the prologue of the drama; a dream of antepast and proscenium of eternity." Palmer, "Letter to John Linnell" (1828), in Harrison, Wood and Gaiger, *Art in Theory, 1815–1900*, 127.

[47]Rosenblum, *MPNRT*, 19, 101-2.

[48]Koerner, *Caspar David Friedrich and the Subject of Landscape*, 227.

[49]Stoker, *Where Heaven and Earth Meet*, 26, 28.

VISUAL THEOLOGY IN A PROTESTANT FRAME

One of the reasons that Rosenblum—and Rookmaaker, for that matter—misreads the theological substance of Friedrich's work is that he neglects to adequately trace the lines of Friedrich's thinking back to their theological sources—namely, to German Pietism on the one hand and to seventeenth-century Dutch Reformed painting on the other. Friedrich's deviation from traditional Christian subject matter was in fact driven by Protestant theology, rather than by any subtraction or deterioration of Christian belief. Werner Hofmann rightly argues that "it was from his Lutheran-Evangelical faith that he derived the basic tenets that determined his artistic decisions."[50]

Friedrich was a Pietist. Through his first painting teacher, Johann Gottfried Quistorp, he was introduced to the celebrated Lutheran theologian, pastor, poet and literary scholar Ludwig Gotthard Kosegarten (1758–1818), who had a lasting impact on Friedrich's theological imagination.[51] Kosegarten preached a Moravian "theology of the heart" that sought personal experience of and relationship to God—with or without the mediation of the church.[52] He held regular worship services outside on the shores of Rügen, a large island in the Baltic Sea directly north of Friedrich's hometown of Greifswald. These services were celebratory but liturgically sparse, accompanied only by the much grander "trumpets of the sea and the many-voiced pipe organ of the storm."[53] Kosegarten's famous *Uferpredigten* (shore-sermons), published posthumously, poetically rendered all of creation as the temple of God, who is everywhere sustaining and shining through all things. Kosegarten advocated a humble attentiveness to the created world, regarding God as simultaneously

[50]Hofmann, *Caspar David Friedrich* (London: Thames & Hudson, 2000), 245.

[51]In fact Kosegarten was one of Friedrich's earliest collectors, and the island of Rügen (the primary location of Kosegarten's ministry) was a crucial site for Friedrich's artistic development: his *View from Arkona with Rising Moon* (1805–1806), for example, was made from the Rügen shoreline where Kosegarten built his "shore chapel" in the fishing village of Vitt. In 1806 Kosegarten invited the painter to make an altarpiece for this chapel; the commission was derailed by the Napoleonic wars (and eventually completed by Runge), but the design for Friedrich's famous *Cross in the Mountains (Tetschen Altar)* (1807–1808) probably originated from this commission. See Koerner, *Caspar David Friedrich and the Subject of Landscape*, 95, 159.

[52]For a study of Kosegarten, see two volumes by Lewis M. Holmes: *Kosegarten: The Turbulent Life and Times of a Northern German Poet* (New York: Peter Lang, 2004), and *Kosegarten's Cultural Legacy: Aesthetics, Religion, Literature, Art, and Music* (New York: Peter Lang, 2005); chap. 8 in the latter volume focuses specifically on Kosegarten's influence on Friedrich.

[53]This is a line from Kosegarten's third eclogue in his *Jacunde* (1803), quoted in Koerner, *Caspar David Friedrich and the Subject of Landscape*, 94.

radically immanent (closer than one's own thoughts) and wholly transcendent (not equivalent to or containable within any creaturely aspect or form). In many ways Friedrich's paintings function as visual analogues of Kosegarten's shore-sermons. In fact, Friedrich's famous contemporary Heinrich von Kleist was specifically struck by the "Kosegartenian effect" of *Monk by the Sea*.[54]

Following his studies at the prestigious Academy of Fine Arts in Copenhagen from 1794 to 1798, Friedrich returned to Germany and settled in Dresden, where he quickly became associated with a group of prominent romantic thinkers, including Gerhard von Kügelgen, Ludwig Tieck and Novalis—all of whom were friends of the enormously influential romantic theologian F. D. E. Schleiermacher (1768–1834). The extent to which Schleiermacher and Friedrich knew each other personally is uncertain, although the theologian seems to have visited the artist in his Dresden studio at least once in 1818.[55] And given their mutual friends, Friedrich almost certainly had some level of familiarity with Schleiermacher's writing, including his book *On Religion: Speeches to Its Cultured Despisers* (1799). Indeed, Friedrich's *Monk* could hardly find a more striking commentary than in the words Schleiermacher had published less than a decade earlier: "When we have intuited the universe and, looking back from that perspective upon our self, see how, in comparison with the universe, it disappears into infinite smallness, what can then be more appropriate for mortals than true unaffected humility?"[56] Fundamental to Schleiermacher's theology is the notion of *Eigentümlichkeit* (individuation, particularity, peculiarity), in which each person must meet God in the particularity of his or her own conscious experience of the world. This same concept was central for Friedrich and his circle. In fact Kügelgen deployed precisely this concept in his 1809 defense of Friedrich's controversial *Cross in the Mountains*; and in his own fragmentary writing

[54]As Koerner argues: "Kosegarten's shore-sermons stand close to Friedrich's art, both in their specific settings and in their characteristic turn of thought, which at once affirms and negates God's immanence in nature" (ibid.).

[55]See ibid., 70; and Hofmann, *Caspar David Friedrich*, 50. Hofmann then argues that "it is idle to speculate about any possible influence the theologian may have had on the painter. It is enough to outline the state of mind which they both shared" (50).

[56]Friedrich Daniel Ernst Schleiermacher, *On Religion: Speeches to Its Cultured Despisers* (1799), ed. Richard Crouter, 2nd ed. (Cambridge: Cambridge University Press, 1996), 45. See also William A. Dyrness, "Caspar David Friedrich: The Aesthetic Expression of Schleiermacher's Romantic Faith," *Christian Scholar's Review* 14, no. 4 (1985).

Friedrich speaks of the "temple of *Eigentümlichkeit*," in which one's conscience must be tuned to "harken more to God than to man."[57] For both Schleiermacher and Friedrich this hearkening includes a careful attentiveness to the world as it presents itself.

In addition to his roots in German Pietism, we also need to account for the influence of Dutch Reformed painting. While studying in Copenhagen, Friedrich had access to a large collection of seventeenth-century Dutch painting at the Royal Picture Gallery, where he developed a deepened sense of landscape painting *as a theological project*. And upon returning to Dresden, Friedrich had access to further important examples of Dutch landscape painting, including Jacob van Ruisdael's *Jewish Cemetery* (c. 1654–1655), which provided a striking precedent to Friedrich's *Abbey*.[58] Rosenblum directly linked Friedrich's *Monk by the Sea* to Dutch "marine painting," which is "the tradition most accessible to and compatible with Friedrich,"[59] but apparently he interpreted this link strictly in stylistic terms, stripped of any theological content. Or rather, he regarded Dutch painting as already theologically bare: "That [Friedrich] achieved what were virtually religious goals within the traditions he inherited from the most secular seventeenth-century Dutch tradition of landscape, marine, and genre painting is a tribute to the intensity of his genius."[60] This betrays a deep misunderstanding of the theology of Dutch painting, and it leads to further misinterpretations of the ways Friedrich pursued his "religious goals"—and thus of the theological significance of large portions of the northern modernist tradition that followed.

The traditions of seventeenth-century Dutch landscape (and seascape) painting grew out of deeply Protestant—particularly Calvinist—theological thinking. In his *Institutes of the Christian Religion* John Calvin staged a multi-pronged theological polemic against the idolatrous human tendency "to pant

[57]Friedrich, "On Art and the Spirit of Art" (1803), in Hofmann, *Caspar David Friedrich*, 269; cf. Koerner, *Caspar David Friedrich and the Subject of Landscape*, 70-71. Friedrich's comment is a direct allusion to Acts 4:19-20, in which the apostles Peter and John respond to the Sanhedrin, "Which is right in God's eyes: to listen [or "hearken" (KJV)] to you, or to him? You be the judges! As for us, we cannot help speaking about what we have seen and heard."

[58]There are two versions of van Ruisdael's *Jewish Cemetery*: one that is still located in the Gemäldegalerie in Dresden (as it was in Friedrich's day) and a larger one that is now at the Detroit Institute of Arts.

[59]Rosenblum, *MPNRT*, 12.

[60]Robert Rosenblum and H. W. Janson, *Art of the Nineteenth Century: Painting and Sculpture* (London: Thames & Hudson, 1984), 86.

after visible figures of God, and thus to form gods of . . . dead and corruptible matter. . . . For surely there is nothing less fitting than to wish to reduce God, who is immeasurable and incomprehensible, to a five-foot measure!"[61] Indeed, he contended that "God's glory is corrupted by an impious falsehood whenever any form is attached to him"; only "God himself is the sole and proper witness of himself."[62] This corruption is most problematic in depictions of God, but Calvin thought that this falsehood beleaguers imagery of any religious subject matter to the extent that (1) it supplants the study of Scripture itself or (2) it "invite[s] adoration" of itself.[63] And thus depictions of biblical narratives, Christ, Mary and the saints—any visual figurations of religious subjects—are inherently problematic.

After pages of sharp criticism toward such images, Calvin devoted a single paragraph to sketching a constructive theology of visual art, which proved to be profoundly influential in opening the way forward for Reformed artists:

> And yet I am not gripped by the superstition of thinking absolutely no images permissible. But because sculpture and painting are gifts of God, I seek a pure and legitimate use of each. . . . Therefore it remains that only those things are to be sculptured or painted which the eyes are capable of seeing: let not God's majesty, which is far above the perception of the eyes, be debased through unseemly representations.[64]

Packed into that last sentence are the contours of an entire Protestant aesthetic that carefully attends to the *limits* of perception (both spatial and temporal).[65] When devout Calvinists turned away from making what they considered to be idolatrous representations of biblical subject matter, they turned their canvases toward those things "which the eyes are capable of seeing." In Holland especially this provided the intellectual basis for

[61]Calvin, *Institutes of the Christian Religion* (1536–1559), ed. John T. McNeill, trans. Ford Lewis Battles (Philadelphia: Westminster, 1960), 1.11.1 (p. 100); 1.11.4 (p. 104). For the influence of this tradition on Ruisdael, see E. John Walford, *Jacob van Ruisdael and the Perception of Landscape* (New Haven, CT: Yale University Press, 1991).

[62]Ibid., 1.11.1 (p. 100).

[63]Ibid., 1.11.7 (p. 107); 1.11.9 (p. 109).

[64]Ibid., 1.11.12 (p. 112). It might be noted that this paragraph was not in the original 1536 edition of the *Institutes*; it first appeared in the 1543 Latin edition and remained unchanged through all subsequent Latin editions.

[65]For a further treatment of this, see William A. Dyrness, *Reformed Theology and Visual Culture: The Protestant Imagination from Calvin to Edwards* (Cambridge: Cambridge University Press, 2004), esp. 72-84.

Reformed painting—and arguably for large portions of northern modernist painting in general.[66]

One of the most important effects of Calvin's aesthetic program was that it relocated the religious and theological significance of art beyond the recognition of—or even association with—Christian *subject matter*. In most sectors of Protestantism the vast majority of the production, patronage and reception of art moved outside of the church—not outside of the practices of Christian theology but outside of ecclesial institutions as the primary spaces for doing visual theology. This involved a redefinition of the dichotomies between sacred and secular, such that a painting of "worldly" subjects might be thick with theological meaning concerning the presence and activity of God. It was for *theological* reasons that devout Protestant painters carefully depicted the created world, turning their attention toward the cosmos itself—in its sheer givenness—as the cathedral of God's presence and the theater of God's prodigious goodness and grace.

This was worked out with particular power in seventeenth-century Dutch painting, where a profound link was forged between observational naturalism and the theology of common grace. Observational still-life, portrait and landscape paintings came to be understood *as* religious paintings: (1) Still-life arrangements of fruit and flowers, for instance, were made and presented as potent meditations on temporality: all these good gifts of God are to be received with delight and thanksgiving (1 Tim 4:3-4), but those who covetously grasp after such things will be left with only decay. Ants, flies and even human skulls were often included to drive the point home. (2) Portraiture became radically inclusive, depicting peasants and laypersons of all social strata—i.e., those who couldn't possibly afford or "merit" the expense of a painting—as treatises on the dignity of human persons (each made in the image of God) and as recognitions of the possibility that saints live among us unrecognized.

[66]The observational realism of Reformed Dutch painting was also deeply linked with a broader shift toward observation-based scientific method, which released cultural energies that developed well outside of the church. For a fascinating account of the development of modernist abstraction in relation to modern science, see Lynn Gamwell, *Exploring the Invisible: Art, Science, and the Spiritual* (Princeton, NJ: Princeton University Press, 2002). Similar to Rosenblum, Gamwell pays special attention to the modernism of Protestant Germanic cultures because they tended to be composed of "diverse religious sects (Lutheran, Evangelical, Catholic, and Jewish), which proved to be a fluid climate in which people could work out compromises between their scientific and religious convictions" (10, 94).

(3) Dutch painters portrayed the surrounding landscape as a sphere of God's grace, which shines through all things and gives all things their being. And within this sphere, portrayals of daily labor—herding livestock, planting, harvesting and domestic chores—became meditations on the biblical human vocation to care for and cultivate the earth. In short, seventeenth-century Dutch artists realigned all the traditional "machinery" of painting toward subject matter traditionally considered "low" and "profane," producing paintings that (at the time) were fairly radical theological statements about the inherent dignity of everyday life and the comprehensive goodness of the creaturely things "which the eyes are capable of seeing." The radicality of these paintings has long since become diffused and sentimentalized—and almost entirely undercut by photography and commercial advertising—but recovering some sense of it is crucial to understanding the course of northern modernism, including the ways that it eventually grappled with photography and advertising (see chapter seven).

The northern romantic tradition that Rosenblum traced is deeply rooted in a Calvinist theological aesthetic, which after the sixteenth century became increasingly influential in these Lutheran regions.[67] Similarly to Calvin, Martin Luther argued that "the house of God means where he dwells, and He dwells where his Word is, whether it be in the fields, or in the churches, or on the sea."[68] In the deepest sense this Word is everywhere, donating and upholding the being of all things, but Luther emphasizes another sense in which the Word (the gospel) dwells in those who have the sensitivity to hear—or to feel—its reverberations. The Word is present in the fields, the churches and the sea, but it *dwells* in those creatures who *experience* it. Friedrich (and many of his romantic peers) thus submitted Calvinist aesthetics to a Pietist Lutheran modification: "The painter should not paint merely what he sees in front of him but also what he sees within him. If he sees nothing within

[67]Though Luther was more open to the visual arts than Calvin was, this did not issue in a particularly strong Lutheran tradition in the arts. See, for example, Sergiusz Michalski, *The Reformation and the Visual Arts: The Protestant Image Question in Western and Eastern Europe* (New York: Routledge, 1993), 40. See also Erwin Panofsky, who pointed to a decline of the arts in northern Germany throughout the 1700s. Panofsky, "Comments on Art and Reformation," in *Symbols in Transformation: Iconographic Themes at the Time of the Reformation*, ed. Craig Harbison, exh. cat. (Princeton, NJ: Princeton University Art Museum, 1969), 12.

[68]Luther, "Scholien zum 118 Psalm. Das schöne Confitimini 1529" (1530), quoted in Koerner, *Caspar David Friedrich and the Subject of Landscape*, 160, 310.

himself, however, then he should refrain from painting what he sees in front of him."[69] For Friedrich this seeing "within" is not simply an interiority or a preoccupation with oneself; it is a conscious attunement to one's intuitive sense of and longing for God and one's intuitive sense of and longing for a just and right form of life.[70] As we will see in what follows, the Protestant roots of this double sensitivity deeply shaped the theological grain of northern modernism, manifested in (1) its consistent preoccupation with the givenness of the world and (2) its strong eschatological longing for the world to be set right.

VINCENT VAN GOGH: INHABITING THE INFINITE

Vincent van Gogh (1853–1890) surely belongs in the previous chapter on French modernism (his most prolific and important years of painting were in France, and many of his strongest influences included French artists and writers), but the context of this chapter also demands a discussion of his work, which remained deeply rooted—both aesthetically and theologically—in the soil of northern romantic Protestantism. His painting career was brief, lasting only from 1880 to 1890, but it provides a clear and profound example of what this tradition looked like as it encountered the kinds of crises of faith experienced among Protestant Christians in the late nineteenth century.[71]

Van Gogh was raised in a devout Arminian Dutch Reformed home, and as he studied for entrance to seminary in Amsterdam, he encountered the strongest Dutch examples of modernist theology and higher biblical criticism.[72] But as Debora Silverman points out, the Dutch modernism that influenced van Gogh was unlike the French modernism that influenced Baudelaire and Manet: liberal Dutch theologians generally prioritized the preservation of Christian piety, avoiding pantheism on the one hand and

[69]Friedrich, quoted in Hofmann, *Caspar David Friedrich*, 26.

[70]See Friedrich, "On Art and the Spirit of Art," in ibid., 269.

[71]As Kenneth L. Vaux has written: "Vincent was one of the last men of the age of faith and one of the first of the age of anxiety." Vaux, *The Ministry of Vincent van Gogh in Religion and Art* (Eugene, OR: Wipf & Stock, 2012), 4.

[72]Vincent's maternal uncle, Johannes Paulus Stricker, was an influential and devout liberal theologian who tutored Vincent for about a year during his time in Amsterdam. For an excellent introduction to van Gogh's theological formation, see Kathleen Powers Erickson, *At Eternity's Gate: The Spiritual Vision of Vincent van Gogh* (Grand Rapids: Eerdmans, 1998), esp. chap. 1.

atheism on the other, opting instead for "a Schleiermachian posture of dependence on God and Christ rather than radical independence."[73]

Van Gogh's short stint at seminary and his subsequent efforts in ministry were difficult; he left disoriented and embittered, and he shifted to painting as his primary arena for theological wrestling. In December 1883, after moving back in with his parents in the Dutch town of Nuenen (after some difficult and disorienting years), van Gogh turned his artistic attention toward an old bell tower that stood in the center of the town's main cemetery—the last remnant of a twelfth-century Catholic church that once stood on the site. Long after the tower had been stripped of its church, the churchyard continued to function as a burial ground for local peasants. Van Gogh depicted this site repeatedly over the course of more than sixteen months,[74] preoccupied with its symbolic weight: The heavy block tower stands in the center of the graveyard with its steep pyramidal steeple pointing upward into the sky, enduring the passing of seasons (and the passing of human lives) with an ancient fortitude. Traditionally, bell towers signify a proclamation of hope—their ringing calls out to the corners of the earth, announcing salvation for all people and calling them into the body of Christ—and yet this tower struck the artist as an image of that hope waning to the point of crisis.

In the *Parsonage Garden in Nuenen* (1885), for example, van Gogh positions the viewer to look out over the family's dormant, leafless garden, which lies under a thin layer of ice and snow. All the orthogonal lines in this cold landscape (formed by the low interior walls of the garden) point toward the old cemetery tower that stands on the distant horizon. The remains of innumerable dead bodies lie in the soil surrounding that distant tower; from this point of view it becomes a dark beacon against the setting sun, a threatening question mark at the center of the painting. And the question seems clear enough: can that old faltering ruin and the Christian hope that it represented

[73]Silverman, *Van Gogh and Gauguin: The Search for Sacred Art* (New York: Farrar, Straus & Giroux, 2000), 156, 158, where she is referring specifically to Allard Pierson's theological aesthetics as an influential example. See also Erickson, who argues that "the Groningen school [with which van Gogh's family was aligned] owes its deepest debt to the German Pietist thought of Friedrich Schleiermacher" (*At Eternity's Gate*, 15).

[74]Between December 1883 and May 1885 van Gogh completed at least fifteen works showing the tower and its surrounding cemetery. For a sampling, see *Old Cemetery Tower with Plowman* (1884), *Old Tower in the Fields* (1884), *Weaver with a View of the Nuenen Tower through a Window* (1884) and *Old Cemetery at Nuenen in Snow* (1885).

possibly bear the weight of our suffering-unto-death—especially in the age of modernity? Indeed, this tower was "a stone ghost that would always haunt his horizons"[75] with the cruel suggestion that an eschatological spring might never appear beyond the terrible winter of creaturely death.

On the evening of March 26, 1885, Vincent's father, Theodorus van Gogh, died suddenly, suffering a massive stroke in the doorway of the parsonage. The funeral occurred on March 30 (Vincent's thirty-second birthday), and the body was buried in the Protestant section of that cemetery. By this time the old tower had been scheduled for demolition, which was carried out in the months following the reverend's death. By late May 1885 the wooden steeple had been dismantled (the rest would be torn down in June), and Vincent returned to paint the tower in this ruined state, creating his most haunting image of it: *The Old Cemetery Tower in Nuenen (The Peasants' Churchyard)* (1885) (fig. 4.2). The dilapidated brick structure stands open to the sky without any of the upward proclamation of a steeple—an absence emphasized by the tight cropping near the top of the tower. The sky is heavy with clouds, and a handful of black crows circles overhead. Spring has come to the Dutch countryside—flowers of various colors blossom around the tower's base—and yet the Christian hope of resurrection that the tower symbolizes seems as distant as ever: the new flowers grow among cruciform grave markers, which stand facing the ruinous bell tower in ever-deferred expectation.[76] As David Hempton puts it, this painting presents us with "a relic of Christendom, the remaining stump of a culture in which church and people were indissolubly linked together in life and death. [But] even the stump was crumbling."[77] In fact this echoes van Gogh's own words about the painting:

> I wanted to say how this ruin shows that *for centuries* the peasants have been laid to rest there in the very fields that they grubbed up in life.... [These fields] make a last fine line against the horizon—like the horizon of a sea. And now

[75]Steven Naifeh and Gregory White Smith, *Van Gogh: The Life* (New York: Random House, 2011), 462.

[76]A lightly colored cross stands alone in the foreground, facing the doorway of the tower—in some sense blocking the path to the doorway. Given its singularity and compositional placement, some art historians have interpreted this to be a symbolic stand-in for the grave of Vincent's father (his father was actually buried in the nearby north section reserved for Protestants, and his grave was marked by a gravestone rather than a wooden cross).

[77]Hempton, *Evangelical Disenchantment: Nine Portraits of Faith and Doubt* (New Haven, CT: Yale University Press, 2008), 132.

this ruin says to me how a faith and religion moldered away, although it was solidly founded—how, though, the life and death of the peasants is and will always be the same, springing up and withering regularly like the grass and the flowers that grow there in that churchyard.[78]

Figure 4.2. Vincent van Gogh, *The Old Cemetery Tower in Nuenen (The Peasants' Churchyard)*, 1885

Van Gogh's *Tower* pulls much of the same theological freight as Friedrich's *Abbey*: it holds human death (visualized as a cemetery extending endlessly "like the horizon of a sea") in close proximity to the historically fragile structures of religious ritual and doctrine (visualized as a ruined church building). The passing of human lives is thus coupled with and problematized by the passing of religious norms—the very norms that have for centuries been a vital source of meaning and hope in the face of death. By locating this image

[78]Van Gogh, L507 (c. June 9, 1885) (emphasis original). In what follows, all citations of van Gogh's letters will be from *Vincent van Gogh, The Letters: The Complete Illustrated and Annotated Edition*, ed. and trans. Leo Jansen, Hans Luijten and Nienke Bakker, 6 vols. (Amsterdam: Van Gogh Museum and Huygens ING; New York: Thames & Hudson, 2009). The entirety of this excellent scholarly work is available online at www.vangoghletters.org. All letters cited below were written to Vincent's brother Theo unless otherwise noted.

of religious breakdown specifically in a graveyard, van Gogh (like Friedrich) emphasizes the limits of what is humanly perceivable and manageable: ultimately our beliefs are fragile like our bodies.

Figure 4.3. Vincent van Gogh, *The Starry Night*, 1889

Four years later, van Gogh was still grappling with these same themes in his famous *Starry Night* (1889) (fig. 4.3), which also hauntingly echoes Friedrich's *Abbey*. At the bottom of the painting a small church appears in the distance, butted up against the central vertical axis of the composition. Lauren Soth has argued that van Gogh intentionally rendered this as a Protestant church, referencing his Dutch upbringing rather than his immediate French (Catholic) surroundings.[79] In contrast to the buildings surrounding it, the church's windows are darkened and vacant, while overhead the vast night sky throbs

[79]Soth notes that at some point between van Gogh's observational studies and the finished painting "one significant transformation took place: the form of the church has changed. St. Martin, the church in Saint-Rémy [where *Starry Night* was painted], had a dome that van Gogh clearly indicates in his drawing. The church in *Starry Night* is not domed. . . . With its tall spire, it is a type of church rare in Provence but common in . . . van Gogh's homeland." Lauren Soth, "Van Gogh's Agony," *Art Bulletin* 68, no. 2 (June 1986): 304.

with (electromagnetic, psychological and/or spiritual) energy. The left half of the canvas is dominated by a cypress tree that is planted in the foreground and reaches upward as a massive mirror image of the tiny church, its verticality dwarfing that of the distant steeple. This dark cypress is a traditional *memento mori* symbol—in a work from the previous year van Gogh had painted a similar "completely black" tree, which he referred to as a "funereal cypress"[80]— and as such it subtly gathers the symbolic weight of cemetery imagery (vis-à-vis van Gogh's *Tower* or Friedrich's *Abbey*) into itself and reaches upward into the sky like a black flame. In every sense the structure of the church becomes visually overwhelmed by ciphers of death (the dark tree) and cosmic vastness (the windy, starry sky).[81]

In one sense all these paintings speak to the deterioration of institutional Christianity in European societies, but they do so while struggling to retain vital inner meanings of Christian faith—to recover whatever in it was "solidly founded." Van Gogh sharply criticized religious institutional structures (including dogmatic structures), yet he also made it clear that paintings like *The Starry Night* arose from "having a tremendous need for, shall I say the word— for religion—so I go outside at night to paint the stars."[82] In a letter to his brother Theo from 1882, van Gogh commented on the religious feeling still evident in Holland and England during the Christmas and New Year season:

> Leaving aside whether or not one agrees with the form, it's something one respects if it's sincere, and for my part I can fully share in it and even feel a need for it, at least in the sense that . . . I have a feeling of belief in something on high [*quelque chose là-haut*[83]] even if I don't know exactly who or what will be there.

[80]Van Gogh, L689 (September 26, 1888).

[81]Several art historians have argued (with varying persuasive power) for biblical derivations for *The Starry Night*. For example, Meyer Schapiro drew comparisons to the celestial apocalyptic vision in Revelation 12:1-4 (*Vincent van Gogh* [New York: Abrams, 1950], 30-33); Sven Lövgren saw a potential connection to Joseph's dream in Genesis 37:9-11 (*The Genesis of Modernism: Seurat, Van Gogh, and French Symbolism in the 1880s* [Stockholm: Almqvist & Wiksell, 1959], 150); and perhaps most interestingly Lauren Soth has connected the painting to Christ's agony in Gethsemane in Matthew 26:36-46, Mark 14:32-42 and Luke 22:39-46 ("Van Gogh's Agony," 301-13).

[82]Van Gogh, L691 (c. September 29, 1888). In this letter he is specifically referring to his *Starry Night over the Rhône* (1888), but it seems equally relevant to *The Starry Night* (1889). It is worth noting the consistency with which van Gogh links visual observation with theological meditation (or "religion").

[83]Van Gogh repeatedly uses the expression *quelque chose là-haut* (something on high) in his letters to signify the transcendent source of life and being (see letters 288, 294, 333, 396, 397, 401, 403 and 405). This expression may derive from Victor Hugo's poem "Patrie" (1877), which includes the

I like what Victor Hugo said: *religions* pass, but *God* remains.[84] And [Paul] Gavarni also said a fine thing: *the point is to grasp what does not pass in what passes.* One of the things *that will not pass* is the something on high and belief in God, even if the forms change, a change as necessary as the renewal of greenery in the spring.[85]

By this point in his life van Gogh had indeed distanced himself from the cultural forms of Christianity that he grew up with, yet he would persistently struggle to conceptualize that "something on high" that cannot pass away because it gives and sustains being itself.[86] The whole realm of creaturely beings passes, but the sheer gratuitous *giving* of being itself does not. And it is the source of that giving that van Gogh refers to as God—the "I don't know exactly who or what" that both wholly transcends and is immanently present in the giving of all things. It is in this sense that the aspiration "to grasp what does not pass *in* what passes" becomes deeply intelligible.[87]

phrase *"Et qu'on a dérangé quelque chose là-haut"* (and that something on high has been disturbed). Van Gogh also sometimes uses the related expression *un rayon d'en haut* (a ray from on high); for further discussion of this phrase, see editors' note 5 in L143 (April 3, 1878), and Anton Wessels, *Van Gogh and the Art of Living: The Gospel According to Vincent van Gogh*, trans. Henry Jansen (Eugene, OR: Wipf & Stock, 2013), 69.

[84]Jansen, Luijten and Bakker, the editors of *Vincent van Gogh, The Letters*, point out that the quotation van Gogh attributes to Hugo probably actually comes from Jules Michelet's *La sorcière*, where he writes, *"Les dieux passent, et non Dieu"* (the gods pass, but not God). See editors' note 6 in L294.

[85]Van Gogh, L294 (c. December 13-18, 1882); emphases original.

[86]There is an ongoing debate about whether van Gogh's views remained within orthodox Christianity or not. James Romaine summarizes four main scholarly positions: (1) Whatever his views may have been, they are *irrelevant* to interpreting his paintings. (2) After his departure from ministry in 1879 he remained confused and conflicted about Christianity for the rest of his life, such that *there isn't coherence* to his religious beliefs. (3) He converted away from Christianity toward some other form of belief—usually postulated as pantheism or Buddhism—such that the work is spiritually *coherent but not Christian.* (4) He remains a Christian, and there is underlying continuity of belief throughout his life even if tempered by extreme doubt and questioning along the way—i.e., his beliefs evolve but remain *coherently Christian.* See Romaine, "What the Halo Symbolized: Vincent van Gogh's *Sower with Setting Sun*," in *Art as Spiritual Perception: Essays in Honor of E. John Walford*, ed. James Romaine (Wheaton, IL: Crossway Books, 2012), 208-9.

Kenneth Vaux has argued that van Gogh was "a biblical naturalist" (*Ministry of Vincent van Gogh*, 3), who did not reject Christianity per se but only a fundamentalist "phase of Calvinism" that was pervasive at the time (62). As Vaux sees it, van Gogh "remained thoroughly evangelical and Reformed in the tradition of the biblical Calvin but not in terms of [Calvinist] Protestant Orthodoxy or fundamentalism. . . . It was not theology at all that was the criterion of rejection but more conventional manners, decorum and appearances. . . . He was not a roaring mystic or pantheist. He was not an Enlightenment Liberal but rather a pious and evangelical lad [who] also labored under some syndrome of deprecating and flagellating self-esteem" (67).

[87]This might be understood as a (perhaps Protestant) version of the analogy of being (*analogia entis*), in which the relation between creaturely "being" and the "Being" of God is *only* analogical:

The crucial point, however, is that van Gogh believed that artists only meaningfully attend to the "something on high" when they attend to the world *as it presents itself*—both in the sense of its givenness (that there is anything at all) and its intelligibility (that one has coherent consciousness of it). This (Reformed) way of thinking about transcendence drove van Gogh deeply into observation of the world, rather than away from it, and into his responsive constructions on canvas. Indeed, as Debora Silverman argues, van Gogh always retained a "visual Calvinism."[88] However, like Friedrich, van Gogh also clearly modified Calvin's injunction to depict only those things "which the eyes are capable of seeing." He wanted his work to somehow convey a deeper kind of meaning that inhered in the very capability of the eyes seeing: He wanted "to express the thought of a forehead through the radiance of a light tone on a dark background. To express hope through some star. The ardor of a living being through the rays of a setting sun. That's certainly not *trompe-l'oeil* realism, but isn't it something that really exists?"[89]

As with Friedrich's landscapes, van Gogh's point was not simply that there is an infinite depth (or height) to existence that transcends human experience but that all the concrete particularities of the world (and one's consciousness of those particularities) are sustained within that infinite depth. Writing about the vastness of the farmlands of La Crau (a village southeast of Arles), van Gogh described a "very intense" experience of a "flat landscape in which there was *nothing* but the infinite . . . eternity."[90] In letters to both Theo and Émile Bernard in July 1888, he recounted that during this experience he was accompanied by a man who was a sailor: "I said to him: look, to me that's as beautiful and infinite as the sea, he replied—and he knows it, the sea—I like that *better* than the sea because it's just as infinite and yet you feel it's *inhabited*."[91] Indeed, the overriding preoccupation of van Gogh's painting is not simply the infinite but the *inhabitable infinite*.

God cannot simply be another being among beings, an entity who participates in existence, but must instead be understood as the giver of being itself, in which and by which all things exist.

[88]Silverman, *Van Gogh and Gauguin*, 41. Seventeenth-century Dutch painting remained a primary point of reference for his work. In his letters he specifically refers to numerous Dutch painters, including Rembrandt van Rijn, Jan van Goyen, Isaac Ostade, Mendert Hobbema and Jacob van Ruisdael. James Romaine points out that van Gogh refers to Ruisdael in at least forty-two of his letters. See Romaine, "What the Halo Symbolized," 216-17.

[89]Van Gogh, L189 (c. November 23, 1881).

[90]Van Gogh to Émile Bernard, L641 (July 15, 1888) (emphasis and ellipses original).

[91]Van Gogh, L639 (July 13, 1888) (emphases original).

In fact van Gogh regarded experiences of the infinite as actually profoundly intimate—a kind of intimacy fostered by the making of paintings. He believed that the greatest artworks disclose "something complete, a perfection, [which] makes the infinite tangible to us. And to enjoy such a thing is like coitus, the moment of the infinite."[92] Thus for van Gogh the infinite and the eternal are associated not only with an ever-receding Beyond (a timeless no-thing) but also with an intense—even erotic—tangibility and immediacy. The infinite gives *this space* and *these things* and *these others*.

The givenness of other people was in fact central to van Gogh's theology. The closest he comes to defining the "something on high" is in a letter to Theo late in 1882, in which he argues that "one of the strongest pieces of evidence for the existence of 'something on high' in which Millet believed, namely in the existence of a God and an eternity, is the unutterably moving quality that there can be in the expression of an old man . . . something precious, something noble, that can't be meant for the worms."[93] The possibility of seeing this transcendent "something" in others is ultimately "the only thing in painting that moves me deeply and that gives me a sense of the infinite. More than the rest."[94] In a widely quoted passage from one of his letters, he proclaims: "I'd like to paint men or women with that indefinable something [*je ne sais quoi*] of the eternal, of which the halo used to be the symbol, and which we [now] try to achieve through radiance itself, through the vibrancy of our colorations."[95] As he wrote these words he had in mind his portrait of *Eugène Boch (The Poet)* (1888), which he had just completed. In this painting, Boch stares at the viewer with an expression that is pensive and earnest, and the flesh tones in his face flicker with passages of oranges, greens, reds and aquas—an intense "vibrancy of colorations." And as van Gogh saw it, this flickering of the eternal in his friend's face called for a different kind of spatial context: "Instead of painting the dull wall of the mean room, I paint the infinite . . . a simple background of the richest, most intense blue I can prepare."[96] This is

[92]Van Gogh to Émile Bernard, L649 (July 29, 1888).

[93]Van Gogh, L288 (November 27, 1882). The "old man" he refers to here appears in his lithograph *At Eternity's Gate* (1882), which several years later he reconceived as a painting by the same title (1890).

[94]Van Gogh, L652 (July 31, 1888).

[95]Van Gogh, L673 (September 3, 1888).

[96]Van Gogh, L663 (August 18, 1888).

in fact one of van Gogh's first at-
tempts at painting a starry sky,
which gathers around Boch's head
as a kind of halo. During this time
van Gogh also made several por-
traits of his postman and friend
Joseph-Étienne Roulin (1888–1889),
who selflessly cared for Vincent fol-
lowing his acute mental breakdown
just before Christmas 1888, in
which he had mutilated his left ear.
Van Gogh paints Roulin as if he
were a modern saint, in whom he
sees the *je ne sais quoi* of the eternal
glimmering (fig. 4.4).

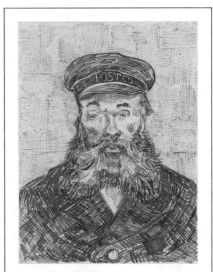

Figure 4.4. Vincent van Gogh, *Joseph-Étienne Roulin*, 1888

In an earlier letter, van Gogh
concisely drew together all these things, the inhabitable infinite in the face of
others: "I consider it absolutely essential to believe in God in order to be able
to love."[97] He insisted that belief in God has little to do with "all those petty
sermons of the ministers and the arguments and Jesuitry of the prudish, the
sanctimonious, the strait-laced, far from it."[98] Rather, he believed that there
was a much deeper sense in which it was necessary to believe in God:

> by that I mean feeling that there is a God, not a dead or stuffed God, but a living
> one who pushes us with irresistible force in the direction of "Love on." That's
> what I think. Proof of His presence—the reality of love. Proof of the reality of
> the feeling of that great power of love deep within us—the existence of God.
> Because there is a God there is love; because there is love there is a God [cf. 1
> Jn 4:7-16]. Although this may seem like an argument that goes round in a circle,
> nevertheless it's true, because "that circle" actually contains all things, and one
> can't help, even if one wanted to, being in that circle oneself.[99]

[97]Van Gogh, L189 (c. November 23, 1881).

[98]Ibid. On this point, Anton Wessels claims that "van Gogh rejects the unhealthy, sickly forms of
religion but continues to embrace authentic forms of piety." Wessels, *Van Gogh and the Art of Liv-
ing*, xvii.

[99]Van Gogh, L189 (c. November 23, 1881).

Van Gogh's entire artistic oeuvre might be understood as a meditation on the circumscription of all beings within that circle.

And yet at the same time he held this together (in continuity with his Reformed upbringing) with a deep sense of the tragic cruelty and suffering that invades life and against which the "love on" becomes an imperative. Van Gogh carried a tremendous weight of personal disappointment and doubt that corresponded to a hopeful longing that can only be regarded as eschatological in orientation:

> It always seems to me that I'm a traveler who's going somewhere and to a destination. . . . In fact, I know nothing about it, but precisely this feeling of *not knowing* makes the real life that we're living at present comparable to a simple journey by train. You go fast, but you can't distinguish any object very close up, and above all, you can't see the locomotive.[100]

The Sower with Setting Sun (1888), to take one example, is almost overtly eschatological. The lower three quarters of the composition consist of a seemingly cold, richly blue-violet field that has been prepared for planting. A peasant farmer strides across the soil, flinging seeds from his bag across the tilled earth. This figure was directly modeled after Millet's famous *Sower* (1850), but in contrast to Millet's iconic centering and monumentalizing of this figure, van Gogh greatly reduces the sower's prominence, placing his striding feet halfway up the composition walking away from the centerline rather than toward it (or simply being on it). A handful of crows follow after him, snatching up some of the seeds before they are able to take root. Of course this imagery directly calls to mind Jesus's parable of the soils (Mk 4:3-20), which van Gogh was intimately familiar with from childhood. This newly planted field recedes into the distance until it suddenly butts up against "a field of short, ripe wheat"[101] ready for harvest. Thus the spatial continuity between foreground and background actually includes a dramatic temporal fissure between them.

In the uppermost register of the painting a gigantic yellow sun appears on the vertical centerline of the composition, setting behind the ripe wheat. Heat and light radiate outward like spokes from this gigantic golden orb, filling the sky with yellow, orange and yellow-green energy. The biblical parable is thus

[100]Van Gogh, L656 (August 6, 1888).
[101]Van Gogh, L629 (June 21, 1888).

set into eschatological relief: as the sower labors in the here-and-now foreground, our vision vaults beyond him toward the setting of the sun—the end of the age, the future "harvest" of all that has taken root and borne fruit. In the center of the foreground, directly opposite of (and corresponding to) the blazing sun, an orange path (visually rhyming the color of the sky) ushers us into the sower's field. The visibility of this path (and its destination) is limited, obscured by the churned earth, but it appears to veer off toward a distant house set within (perhaps even beyond) the mature wheat. This house—presumably the farmer's house—appears on the horizon, at the furthest limit of terrestrial vision.

In Arles the seasons for sowing would have been February or October, with the second and third weeks of June devoted to the harvest,[102] which means that van Gogh made this painting exactly when *harvest* (not planting) was in full swing in Arles.[103] In this context, depicting a sower is strongly teleological, anticipating the "fullness of time" in which the sower's labor is rewarded. Indeed, van Gogh saw this painting as registering "yearnings for that infinite of which the Sower, [and] the sheaf, are the symbols."[104] These are alpha and omega symbols: the sower stands at the beginning of the planting process whereas the sheaf stands at the end. And it is evident that he thought about such images in overtly eschatological terms: he described his *Reaper* (1889), for instance, as having "the image of death in it, in this sense that humanity would be the wheat being reaped. So if you like it's the opposite of [or counterpart to] that Sower I tried before. But in this death nothing sad, it takes place in broad daylight with a sun that floods everything with a light of fine gold."[105] Van Gogh's yearnings were for a day in which all things, even death itself, would finally be flooded with light.

Though we do not have the space to develop it here, the work of Norwegian painter Edvard Munch (1863–1944) offers an important comparison, and the scholarship on his work would similarly benefit from greater attention to its

[102]Silverman, *Van Gogh and Gauguin*, 87.

[103]In fact van Gogh made several other paintings of harvest immediately prior to and following this first version of the *Sower*. See, for example, *Harvest at La Crau, with Montmajour in the Background* (*The Blue Cart*), *Harvest in Provence* and *Wheat Field with Sheaves*, all also painted in June 1888.

[104]Van Gogh to Émile Bernard, L628 (June 19, 1888).

[105]Van Gogh, L800 (September 5-6, 1889). Rosenblum almost entirely misses the point here, blandly interpreting the *Sower* as "thoroughly secular," presided over by a beaming sun that he claims is "the pantheist's equivalent of a gilded halo" (*MPNRT*, 90).

theological roots and implications. The themes of the inhabitable infinite are explored throughout his oeuvre, including paintings like his thoroughly Fried-richian *Summer Night at the Coast* (c. 1902) and in his massive *Sun* (1911), the central panel of his frieze at the University of Oslo. Like van Gogh, Munch advanced an expressionist modification of Calvinist painting: "Nature is not only what is visible to the eye—it also shows the inner images of the soul—the images on the back side of the eyes."[106] He also similarly echoed the traditions of Protestant *vanitas* painting in his tense double affirmation that (1) an underlying goodness shines through all of creation and (2) in the face of this goodness, creaturely experience is marked by profound dysfunction and suffering. The question of whether Munch believed this suffering was redeemable is powerfully foregrounded in works such as *The Scream* (1893)[107] and his remarkable *Golgotha* (1900).

And like van Gogh, Munch provides a potent example of a modernist struggling to retain an acutely fragilized faith. In 1934, toward the end of his life, Munch wrote in his notebook: "My declaration of faith: I bow down before something which, if you want, one might call God—the teaching of Christ seems to me the finest there is, and Christ himself is very godlike—if one can use that expression."[108] The simultaneous earnestness and brittleness of this confession of faith is emblematic of much modernist art within the northern tradition.

PIET MONDRIAN: FIGURING THE IMMUTABLE

The theological concerns that preoccupied Friedrich and van Gogh are also clearly discernible in the work of the Dutch painter Piet Mondrian (1872–1944). Throughout the first two decades of his artistic career (roughly 1888 to

[106]Edvard Munch, "Art and Nature" (1907–1908), in *Theories of Modern Art: A Source Book by Artists and Critics*, ed. Herschel B. Chipp, with Peter Selz and Joshua C. Taylor (Berkeley: University of California Press, 1968), 114.

[107]There are multiple versions of *The Scream* (including paintings, drawings and prints) made between 1893 and 1910. Though interpretations of the work often assume the "scream" is that of the anguished individual, according to Munch it is creation itself that is screaming. Munch's title for the work was *The Scream of Nature*, and in an entry from his notebook (which he then recomposed with variations in several other places, including the frame of the 1895 pastel version of the work), Munch identified the source of the painting as an experience in which he was walking at sunset and "felt a great, infinite scream pass through nature." Munch, quoted in Jay A. Clarke, *Becoming Edvard Munch: Influence, Anxiety, and Myth*, exh. cat. (New Haven, CT: Yale University Press and the Art Institute of Chicago, 2009), 83.

[108]Munch, quoted in Alf Bøe, *Edvard Munch* (Barcelona: Ediciones Poligrafa, 1989), 29.

1910), Mondrian's numerous landscape, still-life and portrait paintings exhibit a deep and direct indebtedness both to seventeenth-century Dutch Reformed painting[109] and to German romanticism.[110] Mondrian's *Oostzijdse Mill Along the River Gein by Moonlight* (c. 1903) (fig. 4.5), for example, is strikingly Friedrichian: a luminous full moon (a recurrent motif in Mondrian's paintings, especially in 1906–1908) presides over the surface of a marshy expanse, and the dark silhouette of a windmill looms on the horizon in the compositional position where we might expect Friedrich to have placed the ruined façade of Eldena Abbey.[111]

Mondrian grew up in a devout Dutch Calvinist home and learned to draw at an early age by making devotional lithographs with his father. When he entered the Academy of Fine Art in Amsterdam in 1892, he went to live (until 1895) in the home of Johan Adam Wormser, the publisher and close friend of the massively influential neo-Calvinist theologian and politician Abraham Kuyper.[112] Throughout his time at the academy Mondrian was right in the midst of the most energetic neo-Calvinist thinking going on at the time. In 1893 he switched his church membership (surely against his father's wishes) from the Dutch Reformed Church to the newly established Reformed (Gereformeerde) Church, which had been founded in 1892 under Kuyper's leadership. Mondrian directed some of his artistic energies during this time toward Protestant commissions, including the semicircular painting *Thy Word Is the Truth* (1894)[113] for the National Christian School in Winterswijk (where his

[109]This applies to the majority of the work he made throughout the 1890s. See, for example, *Still-Life with Dried Sunflower, Brass Dish, and Oranges* (1890), *Woman Peeling Potatoes* (c. 1892–1894), and *Still-Life with Oranges* (c. 1900).

[110]See, for example, *Ships in the Moonlight* (1890), *Church Along the Water* (1890), *Mill on the River by Moonlight* (1902–1903) and *Evening Sky with Moon* (c. 1907).

[111]See, for instance, Friedrich's *Winter (Monk in the Snow)* (1807–1808).

[112]Preeminent Kuyper scholar James D. Bratt has written a fascinating essay exploring the connections between Mondrian's painting and Kuyper's theology. See Bratt, "From Neo-Calvinism to *Broadway Boogie Woogie*: Abraham Kuyper as the Jilted Stepfather of Piet Mondrian," in *Calvinism and Culture*, ed. Gordon Graham, vol. 3 of *Kuyper Center Review* (Grand Rapids: Eerdmans, 2013), 117-29. See also Graham Birtwistle, "Evolving a 'Better' World: Piet Mondrian's Flowering Apple Tree," in *Art as Spiritual Perception: Essays in Honor of E. John Walford*, ed. James Romaine (Wheaton, IL: Crossway Books, 2012), 225-37.

[113]This painting pictures a variety of symbols of life and death (an oil lamp, an hourglass, a scythe, etc.) alongside images of human power and pleasure (a crown, a knight's helmet, a goblet, a mirror). In the center of all of this an anchor rests on a huge open Bible bearing the inscription "Rom. 5:1" ("Therefore, since we have been justified through faith, we have peace with God through our Lord Jesus Christ," NIV). The top edge of the painting is inscribed with careful golden lettering: *Uw Woord is de Waarheid* (Thy Word is the Truth).

father was the school principal), a series of twenty-eight lithographs of Protestant martyrs titled *Joint Heirs of Christ* (1896–1897) and panel designs for the
hexagonal pulpit at the English Reformed Church in Amsterdam (1898).

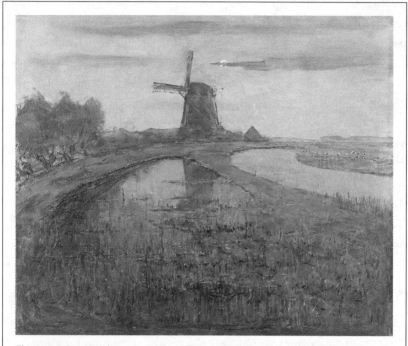

Figure 4.5. Piet Mondrian, *Oostzijdse Mill Along the River Gein by Moonlight*, c. 1903

Around 1900 Mondrian experienced some sort of deep crisis of faith. He
gradually withdrew from the Reformed community and turned to more esoteric forms of spirituality, particularly theosophy—a syncretic blending of
Judeo-Christian mysticism, evolutionary science and a variety of Eastern
spiritualities (especially Indian and Egyptian)—which had become popular
in Europe around the turn of the century.[114] In 1908 he attended a series of

[114]The Theosophical Society was founded in New York City in 1875, and by 1896 it had codified its
official goals into three Objects (objectives): "1. To form a nucleus of the universal brotherhood
of humanity without distinction of race, creed, sex, caste, or color; 2. To encourage the study of
comparative religion, philosophy, and science; and 3. To investigate the unexplained laws of nature and the powers latent in man." The society represented a wide array of (unorthodox) religious
positions and interests, but it was largely composed of disaffected (or former) Christians who
were attempting to reconcile some kind of religious faith and spirituality with the findings of
modern science (especially quantum physics and evolutionary biology), on the one hand, and the
(religious) insights of multiculturalism made possible by modern globalization, on the other. It

lectures by Rudolf Steiner, who was in Holland as part of a wide-ranging speaking tour,[115] and in May 1909 Mondrian formally joined the Dutch chapter of the Theosophical Society.[116] His theosophical beliefs are well documented and have been much discussed,[117] but art historians have tended to frame them solely within a narrative of rupture from his Calvinist upbringing. These accounts often downplay (or wholly ignore) the extent to which Mondrian's painting and writing also demonstrate significant *continuities* with his Reformed roots.

The most important years of development and transition in Mondrian's work were 1912 to 1915, during which he methodically worked toward nonobjective abstraction. He moved to Paris in late 1911 or early 1912 (initially renting a room at the headquarters of the French Theosophical Society) and stayed until 1914 when he returned to the Netherlands to visit his ill father and quickly found himself immobilized by the outbreak of World War I. His exposure to Parisian cubism during those two years deeply impacted him, but he internalized its significance differently than did his French peers: he saw in cubism a new formal language for wrestling with the essentially theological questions that had preoccupied him. As he sought an increasingly "aesthetically purified"[118] mode of painting during this period, the most recurrent pictorial

thus stood opposed to both philosophical materialism and religious dogmatism, positioning itself as compatible with all other forms of "open" inquiry.

[115]Within the array of theosophical positions being debated at the time, Mondrian seems to have been particularly influenced by Steiner, who advocated a theosophy (he later called it anthroposophy) that was rooted in careful "conscious observation" and connected more to Christian mysticism than to Eastern religions. The published text of Steiner's 1908 Dutch lectures was one of the few books that Mondrian kept until the end of his life. See Carel Blotkamp, *Mondrian: The Art of Destruction* (London: Reaktion Books, 1994), 41.

[116]A huge number of artists became involved with theosophy at this time, as might be inferred from the fact that in 1910 the Dutch Theosophical Society devoted two of its quarterly national meetings (April and September) entirely to questions of the relationship between theosophy and art. Whether Mondrian attended these meetings or merely read the published proceedings, it is striking that almost immediately after the September meeting he began painting *Evolution* (1910–1911), his most blatantly theosophical painting.

[117]See, for example, Robert P. Welsh, "Mondrian and Theosophy," in *Piet Mondrian, 1872–1944: Centennial Exhibition*, exh. cat. (New York: Solomon R. Guggenheim Foundation, 1971), 35-51; John Milner, *Mondrian* (New York: Abbeville, 1992), 60-79; Blotkamp, *Mondrian*; and M. T. Bax, "Het Web der Schepping. Theosofie en kunst in Nederland van Lauweriks tot Mondriaan" (PhD diss., Vrije Universiteit Amsterdam, 2004).

[118]Piet Mondrian, "Natural Reality and Abstract Reality" (1919), in Chipp et al., *Theories of Modern Art*, 321. It is worth questioning the extent to which the language and categories that Mondrian employs to speak about his artistic pursuits—including talk of "purification"—are derived from Protestant piety.

subjects through which he focused his experimentations were *seascapes* and *church façades*—thoroughly Friedrichian motifs chosen specifically "to express *vastness and extension*."[119] In Mondrian's theoaesthetic imagination, the most salient forms for alluding to the sacred remained the horizontality of the seemingly endless sea and the verticality of the church façade.

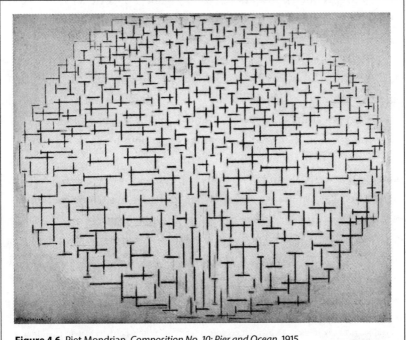

Figure 4.6. Piet Mondrian, *Composition No. 10: Pier and Ocean*, 1915

Over the course of several years he rigorously subjected these motifs to processes of geometric simplification. Paintings like *Seascape at Sunset* (1909) or *Dune V (Dunes near Domburg)* (c. 1909–1910)[120] gave way to gridded abstractions of *The Sea* (1912), at least six versions of *Pier and Ocean* (1914), six versions of *Ocean* (1914–1915), and *Composition No. 10: Pier and Ocean* (1915) (fig. 4.6). Similarly, Mondrian's *Church Tower near Domburg* (1910–1911) was transformed into the increasingly abstract *Church at Domburg* (1914),

[119]See Mondrian, "Dialogue on the New Plastic" (1919), in Harrison and Wood, *Art in Theory, 1900–2000*, 285-86 (emphasis original).

[120]*Dune V* offers a provocative comparison with Friedrich's *Monk by the Sea*. In Mondrian's painting the sandy shoreline has swelled into a mountainous obstacle between the viewer and the vastness of the sea beyond the dune.

Composition with Color Planes: Façade (1914), two versions of *Composition in Oval with Color Planes* (1914) and at least seven versions of *Church Façade* (1914–1915) (fig. 4.7). Carel Blotkamp interprets this preoccupation with abstracted church façades as Mondrian displacing (and replacing) the religious edifices of his childhood: these "dying houses will be replaced by new ones."[121] Indeed, in the earlier façade paintings (1910–1911) there are especially strong echoes of Friedrich's and van Gogh's scrutinizing of the

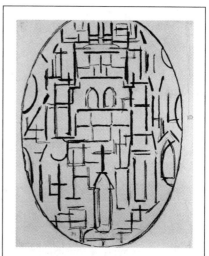

Figure 4.7. Piet Mondrian, *Church Façade 1: Church at Domburg*, 1914

old edifices of the church, but they never appear in ruined form (as they do in Friedrich and van Gogh), and it is unclear that we are justified in interpreting the geometricizing of the façades in terms of either obliteration or replacement. By his own account, Mondrian chose the theme of the church façade to express the "idea of ascending."[122] Is his treatment of this idea a repudiation of the church he was raised in or an attempt to find something deeper *within* it (as it was for Friedrich and van Gogh)?

For Mondrian the process of "abstracting" was not destructive of the things represented; rather, it was a means of clarifying the "mutual relations that are inherent in things"[123]—the fundamental *interrelatedness* that provides structure and meaning in the world. As he saw it, the core deficiency in traditional Dutch painting (and European painting in general) was that the most fundamental relations become "veiled" in "descriptive" naturalistic representations.[124] The problem is not that figurative paintings are illusionistic

[121]Blotkamp, "Annunciation of the New Mysticism: Dutch Symbolism and Early Abstraction," in *The Spiritual in Art: Abstract Painting, 1890–1985*, ed. Maurice Tuchman, exh. cat. (Los Angeles: Los Angeles County Museum of Art; New York: Abbeville Press, 1986), 102.

[122]Mondrian, letter to Theo van Doesburg, quoted in Susanne Deicher, *Piet Mondrian, 1872–1944: Structures in Space* (Cologne: Benedikt Taschen Verlag, 1999), 46.

[123]Mondrian, "Plastic Art and Pure Plastic Art" (1937), in Chipp et al., *Theories of Modern Art*, 353.

[124]Mondrian, "Dialogue on the New Plastic," 284. This language of naturalistic depictions "veiling" more primordial harmonies in the created world—and thus also veiling the deeper meaningfulness

but that they divert too much attention away from the meaningfulness of spatial (and ontic) relations per se. They give us too much information, immediately launching us into thinking about bowls of fruit, the dangers of sailing, the desire for loving companionship, Napoleonic politics and so on—any number of things other than the meaningful "pure plastics" of the painted surface itself.

Rather than reproducing natural appearances, Mondrian believed that modern painters should devote themselves to identifying and distilling the most basic relations of color and shape, within which all other visual forms become thinkable as possibilities. Specifically, he believed that painting becomes more "aesthetically purified" when (1) naturalistic color is pushed toward the primary colors *from which all colors are derived* and (2) naturalistic lines are pushed toward the horizontal and vertical geometric axes *between which all other lines might be conceived.*[125] In one of his most widely quoted passages, he argues that "in nature all relations are dominated by a single primordial relation, which is defined . . . by means of the two positions which form the right angle. This positional relation is the most balanced of all, since it expresses in a perfect harmony the relation between two extremes, and contains all other relations."[126] And he thought that this relation must be expressed in *straight* lines, "because all curvature resolves into the straight [line]."[127] For Mondrian, the kind of painting that traffics in the most primordial spatial relation—that which in fact implies and "contains all other relations"—is one that manages *horizontality* (parallel to the surface of the earth) in relation to *verticality* (perpendicular to the surface of the

of art—recurs throughout Mondrian's writings (throughout his career). It is sometimes assumed that this signals a gnostic schema in Mondrian's thinking, but he is fairly clear that this veiling is an obscuring of the meanings inherent in things, not a simple bifurcation between the world of appearances and an otherworldly Reality. One wonders if Mondrian has in fact adapted this language of veiling not from gnostic sources but from biblical ones (e.g., 2 Cor 3:7–4:7).

[125]See Mondrian, "Natural Reality and Abstract Reality," 321.

[126]Ibid., 323.

[127]In his own recounting of the reasoning behind this claim, he wrote: "The search for the expression of vastness led to the search for the greatest tension: the straight line," because it is this "most tensed line" that "most purely expresses immutability, strength, and vastness." See Mondrian, "Dialogue on the New Plastic," 286. It might be argued that Mondrian's reasoning here is thoroughly beholden to Euclidian geometry and, if taken as absolute statements, would be disputed by contemporary geometers. However, if taken in the context of conventional easel painting, in which the flat rectangular support is indeed utterly Euclidian, his point seems clear.

earth).[128] Indeed, he believed that
managing a painting in this way was
a means of figuring "the *immutable*"
insofar as it achieved a kind of
iconic "plastic expression of immu-
table relationship: the relationship
of two straight lines perpendicular
to each other."[129] By this rationale
he came to regard his grid-based
geometric abstractions as at-
tempting "a pure reflection of life in
its deepest essence"—not by way of
picturing anything but by iconizing,

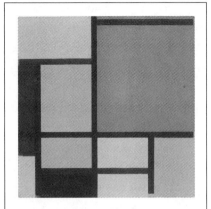

Figure 4.8. Piet Mondrian, *Composition,*
1921

or even instantiating, the unalterable simple relation that contains all other
relations.[130] His paintings increasingly simplified into asymmetrical grids of
primary color: iconic figurations of the immutable ground of being from
which all concrete, mutable existence is given (see fig. 4.8).

This line of thinking wasn't well received by Hans Rookmaaker, who was
suspicious of the theological implications that might be at work here. He rec-
ognized that "Mondrian drew upon a truly profound outlook on life and upon
philosophical principles,"[131] and even that the paintings that he derived from
these principles were "exceptionally lovely."[132] Yet he also believed that Mon-
drian's total withholding of representation meant that these paintings were
either obdurately mute[133] or escapist, insofar as they "endeavored to construct

[128]Interestingly, prior to the 1920s Mondrian mostly continued painting on rectangular canvases that
had a predominantly horizontal or vertical orientation, rather than handling these relations within
a square canvas wherein the vertical and horizontal pressures would be equalized. The exceptions
are the "lozenges" of 1918–1919, which are squares hung at a 45-degree angle. From about 1920
until the mid-1930s, however, Mondrian favored square canvases for his "new plastic" paintings.
[129]Mondrian, "Dialogue on the New Plastic," 288 (emphasis original).
[130]Mondrian, "Natural Reality and Abstract Reality," 322.
[131]Rookmaaker, *Art and Entertainment* (1962), in *CWR*, 3:79.
[132]Rookmaaker, "Why Modern Art?" (1954–1955), in *CWR*, 5:274.
[133]Early in his career, Rookmaaker's engagement with Mondrian's paintings was utterly flat: "When
you follow these ideas to their natural conclusion, you naturally end up with a sterile, meaningless
play of circles, squares and lines which, however well balanced they may be, are not capable of
stirring up any thought or emotion." Rookmaaker, "The Art of the Twentieth Century" (1950),
in *CWR*, 5:219. By the 1960s his view had evolved somewhat: "Because all he set out to do was to
express harmony, his art has beauty, although the underlying world of ideas does not have an

an intellectual and abstract fortress of transcendental beauty beyond this world."[134] And with time Rookmaaker's view of this work became increasingly sour. As he saw it, Mondrian and his colleagues in both Dutch De Stijl and the German Bauhaus had been "building a beautiful fortress for spiritual humanity, very rational, very formal: but they did so on the very edge of a deep, deep abyss, one into which they did not dare to look. For them fear, agony, despair, and absurdity were the real realities."[135]

Mondrian would not have recognized his work in Rookmaaker's assessments of it. For Mondrian, abstract painting was not escapist: his concern was not to avoid or repudiate natural appearances but to intensify our perception of them. He believed that there is a profound sacredness to the world as we perceive it: "Nature is that great manifestation through which our deepest being is revealed and assumes concrete appearance."[136] However, he also became increasingly convinced that nature's disclosure of "our deepest being" is "far stronger and much more beautiful than any *imitation* of it can ever be," and thus "precisely for the sake of nature, of reality, we avoid [imitating] its natural appearance."[137] His decision to abandon the representation of nature (vis-à-vis his training as a Dutch realist painter) cannot be taken as indicating that he had "shunned reality," as Rookmaaker thought;[138] it only indicates that he had shunned pictorial imitations of natural appearances. As with Friedrich and van Gogh, Mondrian echoes Calvin's theology of art in his orientation toward the goodness of the world: "To love things in reality is to love them profoundly; it is to see them as a microcosmos in the macrocosmos." But one also hears in Mondrian's reasoning strong echoes of Calvin's iconoclastic argument: "Precisely on account of its profound love for things, nonfigurative art does not aim at rendering them in their particular appearance."[139] Interestingly, he has extended the reach of Calvin's iconoclasm from religious to *natural* subject matter.

opportunity to shine through"—ultimately "his art seems to fall short with respect to warm humanity." Rookmaaker, *Art and Entertainment* (1962), in *CWR*, 3:79.

[134]Rookmaaker, "Culture and Revolution II: We Live in '1787'" (1967), in *CWR*, 5:255.

[135]Rookmaaker, *MADC*, 143.

[136]Mondrian, "Dialogue on the New Plastic," 287.

[137]Ibid. (emphasis original).

[138]See Rookmaaker, "Do We Need to Be Modern in Order to Be Contemporary?" (1974), in *CWR*, 5:319.

[139]Mondrian, "Plastic Art and Pure Plastic Art," 359.

Directly analogous to the neo-Calvinist Abraham Kuyper,[140] Mondrian did not believe that this refusal undermined painting as much as it freed it and redirected it toward other more vital tasks: a more chastened investigation of reality from within the mechanics of painting itself. Indeed, Mondrian's theory of art could have found its grounding entirely in Kuyper's neo-Calvinism. As Kuyper wrote in his 1898 Stone Lectures:

> Art reveals ordinances of creation which neither science, nor politics, nor religious life, nor even revelation can bring to light. She is a plant that grows and blossoms upon her own root, and without denying that this plant may have required the help of a temporary support, and that in early times the Church lent this prop in a very excellent way, yet the Calvinistic principle demanded that this plant of earth should at length acquire strength to stand alone and vigorously to extend its branches in every direction.... Art, like Science, cannot afford to tarry at her origin, but must ever develop herself more richly, at the same time purging herself of whatsoever had been falsely intermingled with the earlier plant. Only, the law of her growth and life, when once discovered, must remain the fundamental law of art for ever; a law, not imposed upon her from without, but sprung from her own nature. And so, by loosening every unnatural tie, and cleaving to every tie that is natural, art must find the inward strength required for the maintenance of her liberty.[141]

Whether he realized it or not, Kuyper had thus laid out a powerful neo-Calvinist argument for formalist abstract painting—an argument that would find its most potent realization in Mondrian's paintings.[142]

The important point here is that Mondrian's grids are profoundly intelligible from within a Protestant theological framework. They were in many respects meant as theological manifestoes, oriented as visual articulations of the "vastness," "the immutable" and the "real" within which all concrete

[140]In his famous Stone Lectures, delivered at Princeton University in 1898, Kuyper developed his understanding of Calvinism as a comprehensive "life-system" with implications for all facets of human life. He devoted the fifth of his six lectures to "Calvinism and Art," in which he argued that "it is the vocation of art, not merely to observe everything visible and audible, to apprehend it, and reproduce it artistically, but much more to discover in those natural forms the order of the beautiful, and, enriched by this higher knowledge, to produce a beautiful world that transcends the beautiful of nature." Abraham Kuyper, *Lectures on Calvinism: The Stone Foundation Lectures* (Grand Rapids: Eerdmans, 1931), chap. 5; quotation is from p. 154.

[141]Ibid., 163.

[142]An argument for direct influence on this point is tenuous, but it is striking that this was the artist who boarded for three years in the house of Kuyper's publisher.

experience unfolds. Mondrian came to regard his works as "Abstract-Real painting" insofar as each of these paintings is "a composition of rectangular color planes that expresses the most profound reality . . . by plastic expression of relationships and not by natural appearance."[143] Historian Peter Gay was alert to the theology in play here, arguing that Mondrian "never ceased wrestling with his father's rigorous Calvinism, which he at once rejected and incorporated," reconfiguring it into a kind of "secular religiosity" in which his painting became "a form of prayer."[144] That seems right, though it is unclear why (or in what sense) we should regard Mondrian's religiosity as "secular." Susanne Deicher's summary of Mondrian's thinking is more modest, claiming that his writings "were essentially theological, even though the name of God no longer appeared."[145]

And they were not only theological; all of this had a subtle but sharp sociopolitical edge to it. Mondrian believed that "equilibrated relationships in society signify what is *just*," and thereby "one realizes that in art too the demands of life press forward" toward equilibrated relationships.[146] In other words, he saw aesthetics and ethics as deeply linked: the artistic interrogation and balancing of formal aesthetic relationships is intrinsically dependent upon—and elicits questions about—the bases by which we make judgments about the rightness and justness of social relationships. According to Mondrian, "the New Plastic brings its relationships into *aesthetic equilibrium* and thereby expresses *the new harmony*" that we yearn for in all spheres of life.[147] Blotkamp glosses it this way: Mondrian's reduction of painting to "essential contrasts between horizontal and vertical and between the three primary colors, were supposed to express the unity that was the final destination of all beings, the unity that would resolve harmoniously all antitheses."[148] In this sense

[143]Mondrian, *Neo-Plasticism: The General Principle of Plastic Equivalence* (1920), in Harrison and Wood, *Art in Theory, 1900–2000*, 290. Art historian Yve-Alain Bois puts it in these terms: "The goal is no longer to encode the spectacle of the real world in a geometric pattern, but to enact on canvas the laws of dialectics that govern this world." Bois, "Piet Mondrian: Toward the Abolition of Form," in *Inventing Abstraction, 1910–1925: How a Radical Idea Changed Modern Art*, ed. Leah Dickerman (New York: Museum of Modern Art, 2012), 227.

[144]Gay, *Modernism: The Lure of Heresy* (New York: Norton, 2008), 136-37. Gay highlights Mondrian's intellectual independence: "I had to seek the true way alone," writes Mondrian, to which Gay responds: "The pious formulation—'the true way'—is revealing" (137).

[145]Deicher, *Piet Mondrian, 1872–1944*, 46.

[146]Mondrian, "Dialogue on the New Plastic," 287 (emphasis original).

[147]Mondrian, *Neo-Plasticism*, 290 (emphases original).

[148]Blotkamp, "Annunciation of the New Mysticism," 102-3.

Mondrian's abstract panels are emblems of eschatological desire, many of them made in the midst and wake of the profoundly devastating First World War. For all of their austerity and cerebral calculation, they are full of longing for the world to finally be set right.[149]

Striking comparisons might be drawn to the Swedish artist Hilma af Klint (1862–1944) if we had the space. Like Mondrian, she was deeply interested in theosophy, particularly in the esoteric Christian writings of Rudolf Steiner.[150] Following Steiner, Hilma af Klint believed that painting was a powerful means of materializing the spiritual, though unlike Steiner she came to believe that improvisational, even mediumistic, abstract painting was the purest means of achieving this. Throughout the 1890s she had made impressionistic landscape paintings and beautifully delicate floral studies, but by 1906 (several years before Mondrian or anyone else) she had pushed into totally abstract painting. Some of these were massively large, such as *The Ten Largest* (1907), which depicted the four spiritual ages of humankind. Over the course of several years she produced a series of 193 works that she referred to as *The Paintings for the Temple*, intuitively exploring the structure of spiritual realities through geometric and curvilinear forms. Particularly beginning in 1912 (roughly coinciding with Steiner's founding of the Anthroposophical Society), her work became pervaded by Judeo-Christian imagery: Adam and Eve, crosses, the crucifixion, the Tree of Life and Tree of Knowledge, the dove of the Holy Spirit and so on. The scholarship on Hilma af Klint has rapidly expanded in the past decade, but there is much more work yet to be done on the theological impulses and implications of her work.

Vasily Kandinsky and Modernist Apocalyptic Painting

Within the northern modernist discourse on spirituality and art, Vasily Kandinsky (1866–1944) was enormously influential. This influence was due

[149]The spiritual and theological content of Dutch modernist art needs further exploration beyond Mondrian. For example: Georges Vantongerloo's *Triptych* (1921) overtly presents itself as a neo-plasticist altarpiece; Theo van Doesburg's *Stained-glass Compositions* (1917), designed for the De Lange House in Alkmaar, presents De Stijl geometric abstraction in the theologically loaded visual language of stained glass; and Jan van Deene claimed that each of his abstractions was about "the wonder of life, its beauty and sweetness . . . a picture of our Lord one might say, or of animated nature in abstracto" (quoted by Blotkamp in ibid., 104).

[150]For a discussion of Hilma's religious interests and contexts, see Helmut Zander and Iris Müller-Westermann, "There Is No Religion Higher Than Truth," in *Hilma af Klint: A Pioneer of Abstraction*, ed. Iris Müller-Westermann, exh. cat. (Stockholm: Moderna Museet and Hatje Cantz Verlag, 2013), 113-28.

not only to the force and content of his painting practice but also to his charisma and erudition in both speech and writing. In the words of his friend and colleague Paul Klee, Kandinsky was a man with "an exceptionally fine, clear mind" who along with his paintings "also tries to act by means of the word."[151] He was a charismatic teacher, and he published numerous statements of his philosophies of art throughout his lifetime, the most influential of which was his 1911 book *On the Spiritual in Art.*[152]

Kandinsky's theoretical starting points are strongly reminiscent of van Gogh's: a wonder at the givenness of being pervades everything he made. In his 1913 essay "Reminiscences" Kandinsky recounts his attempts to make a painting of "the most beautiful hour of the Moscow day"—the hour before sunset, in which the city is illuminated with such intense color that "like a wild tuba, [it] sets all one's soul vibrating."[153] After repeated efforts to capture this experience in paint—*The Old Town II* (1902) is one such example[154]— Kandinsky became convinced that in comparison to his firsthand experiences, these paintings failed to (re)produce the same "delight that shook me to the depths of my soul." Eventually he concluded that in fact "the aims (and hence the resources too) of nature and of art were fundamentally, organically, and by the very nature of the world different," although "equally powerful."[155] If natural phenomena were capable of setting Kandinsky's soul vibrating in ways that paintings could not reproduce, he became convinced that painting had the potential to produce *another* order of vibrations in the soul that nature does not. And Kandinsky quickly recognized the implications of this line of reasoning: realizing this potential would necessitate that artists more rigorously develop methods and criteria for working other than those oriented toward the pictorial representation of natural phenomena.

[151]Paul Klee, entries 903 and 905 (1911), in *The Diaries of Paul Klee, 1898–1918*, ed. Felix Klee, trans. Pierre B. Schneider, R. Y. Zachary and Max Knight (Berkeley: University of California Press, 1964), 265-66.

[152]Kandinsky's writings are collected in *Kandinsky: Complete Writings on Art*, ed. Kenneth C. Lindsay and Peter Vergo (Boston: Da Capo Press, 1994). Hereafter this volume will be abbreviated as *KCW*.

[153]Kandinsky, "Reminiscences" (1913), in *KCW*, 360.

[154]Kandinsky's early paintings borrow heavily from French impressionism. He identified an early encounter with one of Claude Monet's *Haystacks* (1890–1891) as "the first and foremost" of two events that "stamped my whole life and shook me to the depths of my being." The second of these events was a performance of Richard Wagner's opera *Lohengrin* (1850). See "Reminiscences," in *KCW*, 363.

[155]Ibid., 360.

By the time he painted *Impression 3 (Concert)* (1911), Kandinsky had pursued this line of thinking toward the possibility of a wholly "abstract" or "nonobjective" mode of painting. For Kandinsky this never implied a turning away from the world, as Rookmaaker assumed.[156] To the contrary, abstraction was for him a way of releasing painting to more fully function *within* the world and to more fully develop its distinctive capacities for attuning us *to* the world. Rather than pictorially rendering the experience of other visual phenomena, Kandinsky believed that painting must explore its capacities to generate "a remarkable wealth of forms"[157] to be experienced as uniquely potent phenomena in themselves. He described the immediate effect of this realization as turning him toward the world around him newly sensitized to the miraculous *givenness* of everything:

> Everything "dead" trembled. Everything showed me its face, its innermost being . . . not only the stars, moon, woods, flowers of which [romantic] poets sing, but even a cigar butt lying in the ashtray, a patient white trouser-button looking up at you from a puddle on the street, a submissive piece of bark carried through the long grass in the ant's strong jaws to some uncertain and vital end, the page of a calendar, torn forcibly by one's consciously outstretched hand from the warm companionship of the block of remaining pages.[158]

This sensitivity to a dense meaningfulness pervading all things (and all processes) also necessarily applied to tubes of pigmented oil, turpentine, stretched canvas, paintbrushes and all the combinations of colors, forms and constructions that the disciplines of painting are capable of employing. Alongside the cigar butt or disposable calendar page, every visual form suddenly possessed an intense *thisness* and *hereness* that "was enough for me to 'comprehend,' with my entire being and with all my senses, the possibility and existence of that art which today is called 'abstract,' as opposed to 'objective.'" In this way abstract painting emerged with "a profound sense of gratitude."[159]

[156]Rookmaaker accuses both Kandinsky and Mondrian, "the pioneers of abstract art," of having "shunned reality, the world around us." Rookmaaker, "Do We Need to Be Modern in Order to Be Contemporary?" (1974), in *CWR*, 5:319. And it was specifically Kandinsky's work that he had in view when he wrote that abstract art "is first of all a negation, a negation of the value of the reality around us . . . [and a corresponding effort] to build something detached from reality." Rookmaaker, *Art and Entertainment* (1962), in *CWR*, 3:69-70.

[157]Kandinsky, "On the Question of Form" (1912), *Blaue Reiter Almanac*, in *KCW*, 241.

[158]Kandinsky, "Reminiscences," in *KCW*, 361.

[159]Ibid., 360-61.

One of the ways Kandinsky described this givenness of things was to say that everything has its own "inner sound" (*innerer Klang*).[160] For him the entire world—including the painted surfaces of canvases—is vibrating with (spiritual) energies such that each configuration of forms might be "heard" as meaningful in itself. This hearing is the work of the human soul, which he compared to a vessel or a stringed instrument that was designed to resound and reverberate (and improvisationally harmonize) with the music of the world. If modern people are generally unresponsive to these sounds today, he argued, this is attributable to a utilitarian materialism that reduces beings to their practical and economic use-values. The primary effect of the "nightmare of the materialistic attitude," as he called it, is a pervasive desensitization to the world: a spiritual deafness and dullness in which the soul fails to resonate with the inner sounds of things. In the age of modernity the human capacity for resonance has become severely compromised, "like a beautiful vase discovered cracked in the depths of the earth," and he feared that this tragic muffled state inevitably produces "desperation, unbelief, lack of purpose."[161]

Kandinsky's theory of art logically followed from all of this. The truest form of art is that which is capable of striking and amplifying the world's inner sounds such that other souls are caused to resonate: "Color is the keyboard. The eye is the hammer. The soul is the piano, with its many strings. The artist is the hand that purposefully sets the soul vibrating by means of this or that key."[162] And obviously he believed that the extraordinary range and richness of vibrations remain unnecessarily muted as long as artists use their canvases only to signify the "sounds" of natural appearances. An artist's purpose in striking the eyes and souls of others must have a deeper motivation: "Thus it is clear that the harmony of colors can only be based upon the principle of purposefully touching the human soul [rather than the principle of replicating the appearances of objects]. This basic tenet we shall call the principle of internal necessity."[163] In other words, if the highest aim of art is to amplify the "vibration" of the human soul (the experience of being "in tune" with something greater than oneself), then the truest and most vital way to make paintings—and the highest criteria for judging them—cannot be determined

[160]Kandinsky, *On the Spiritual in Art*, in *KCW*, 157.
[161]Ibid., 128.
[162]Ibid., 160.
[163]Ibid. (emphases removed).

by "external" principles (i.e., mimetic representation or academic aesthetic formulae) but must proceed from needs and intuitions "internal" to the painting process itself. The constellation of forms on the surface of the canvas must be judged by the spiritual resonances that they produce more than by their pictorial depiction of external referents.[164] The Dadaist Hugo Ball (who will receive further treatment in the following chapter) helpfully identified "internal necessity" with "the feeling for the good," phrases that Kandinsky used in direct correlation to each other.[165] And by means of this "feeling for the good" Kandinsky was "searching half consciously, half unconsciously, for the compositional. I was inwardly moved by the word *composition* and later made it my aim in life to paint a '*composition*.' This word itself affected me like a prayer. It filled me with reverence."[166]

For Kandinsky the playful work of composition was indeed deeply prayerful: "When I 'play' in this manner, every nerve within me is vibrating, in my whole body there is the sound of music, and God is in my heart."[167] As such he believed that "every serious work of art has an inner sound like the peaceful and exalted words 'I am here.'"[168] At face value these words announce the sheer givenness of the work-as-inner-sounding, but the "peaceful and ex-alted" character of this "I am here" also reverberates with theological associa-tions: biblically, this is one of the most important phrases by which humans responsively present themselves to God.[169] And this aligns with Kandinsky's theory of art: the highest function of art is to foster a responsive openness to

[164]Thus for Kandinsky healthy "feeling" replaces rigorous observation as central to the artist's *voca-tion*. And he invokes biblical precedent precisely on this point: "Just as the body, if neglected, becomes weak and incapable, so too does the spirit. The sense of feeling with which the artist is born resembles the talent of which the Bible speaks, which is not to be buried [Mt 25:14-30]. The artist who does not use his gifts is a lazy servant." Kandinsky, *On the Spiritual in Art*, in *KCW*, 177.

[165]See Hugo Ball, "Kandinsky" (1917), in *Flight out of Time: A Dada Diary*, ed. John Elderfield, trans. Ann Raimes (New York: Viking Pess, 1974), 227. Kandinsky's discussion of "one's feeling for what is good" appears in his essay "On the Question of Form" in *Der Blaue Reiter Almanac*, in *KCW*, 242. For further discussion of Hugo Ball see chap. 5.

[166]Kandinsky, "Reminiscences," in *KCW*, 367 (emphasis original).

[167]Kandinsky, quoted in Hans Konrad Röthel's introduction to *Vasily Kandinsky: Painting on Glass*, trans. Alfred Werner, exh. cat. (New York: Solomon R. Guggenheim Museum, 1966), 8.

[168]Kandinsky, *On the Spiritual in Art*, in *KCW*, 218n1.

[169]At several pivotal moments in the Old Testament, when God personally addresses individual persons (e.g., Abraham, Jacob, Moses, Samuel, David, Isaiah), they respond with the Hebrew phrase *hinneni*: "here I am." See, for example, Genesis 22:1; 31:11; 46:2; Exodus 3:4; 1 Samuel 3:4-8; Psalm 40:7; Isaiah 6:8. Cf. Mary's response to the annunciation in Luke 1:38, and that of Ananias of Damascus in Acts 9:10.

God, a space in which there might occur a new "revelation of the Spirit."[170] He
ends his "Cologne Lecture," for instance, by sidestepping his numerous critics:
"the artist works not to earn praise or admiration, or to avoid blame and hatred,
but rather obeys that categorically imperative voice, which is the voice of the
Lord, before whom he must humble himself and whose servant he is."[171]

It is crucial to recognize that even though Kandinsky's work turned away
from the pictorial representation of natural phenomena, this does not mean
that he abandoned subject matter. In fact, from 1909 to 1914—the period of
his most intense and groundbreaking experimentations—even his most ab-
stract paintings were derived from sources and subject matter that are still
identifiable, the vast majority of which came directly from Christian escha-
tology. Many of these paintings feature apocalyptic themes drawn from the
Bible, particularly the book of Revelation:[172] there were many versions of the
Resurrection (1910–1911), *Last Judgment* (1911–1912) and *Horsemen of the Apoc-
alypse* (1911, 1914), as well as many more paintings adapted from Christian
theological tradition, including *The Last Supper* (1909–1910), *Crucified Christ*
(1911), *Saint Vladimir* (1911), *Saint Francisca* (1911), *Saint Gabriel* (1911), nu-
merous versions of *Saint George* (1911) (who battles the demonic dragon),
multiple versions of *All Saints Day* (1911) (the resurrection of the dead)

[170]Kandinsky, "Reminiscences," in *KCW*, 377-79. See also *On the Spiritual in Art*, in *KCW*, 219, and
"On the Question of Form," in *KCW*, 236. On this point, it is worth noting that Kandinsky's think-
ing had a sharp iconoclastic edge to it: he worries about treating artworks such that "one exalts
the relative to the level of the absolute. . . . How many of those who sought God ultimately re-
mained standing before a graven image?" (*KCW*, 239).

[171]Kandinsky, "Cologne Lecture" (1914), in *KCW*, 400. This lecture was actually never given. Kan-
dinsky declined to travel to Cologne for the opening reception of his exhibition at the Deutsches
Theater, so he sent a manuscript of this lecture to be read aloud at the reception, which evidently
was never done. See editors' introduction to this lecture in *KCW*, 392.

[172]Some scholars have attributed Kandinsky's eschatological imagery to his interest in theosophy,
particularly the lectures and writings of Rudolf Steiner, who wrote extensively on the Gospel of
John and the book of Revelation. It seems evident that he appreciated some of theosophy's meth-
ods and insights (at least in 1908–1909) and regarded it as "a powerful agent in the spiritual cli-
mate" of his time (*On the Spiritual in Art*, in *KCW*, 145), but he also appears to have maintained
a skeptical distance throughout his career. Kandinsky never joined the Theosophical Society
(though he was almost certainly invited), and he refers to theosophy in only very few places in
his writing: the most substantive are on pp. 143 and 145, both of which are passages written in
1909. It seems that he viewed theosophy as a helpful bulwark against the encroachment of mate-
rialism more than it served as an articulation of his own beliefs. Lindsay and Vergo rightly regard
theosophy as more peripheral to his concerns, arguing that "Kandinsky's eschatological motifs
must be viewed first in relation to [Christian] theological tradition, then in wider art historical
perspectives [including theosophical influences]" (*KCW*, 23; cf. 117).

(fig. 4.9), the Edenic *Paradise* and *Garden of Love* (1911–1912) and so on.[173] And most importantly, the seven large *Compositions* (1910–1913) that Kandinsky produced prior to the First World War fused many of these apocalyptic themes together—all these paintings were devoted, in the words of Nicoletta Misler, to "a free interpretation of his themes of catastrophe and salvation."[174] One of the most poignant examples is *Composition 5* (1911) (plate 4).

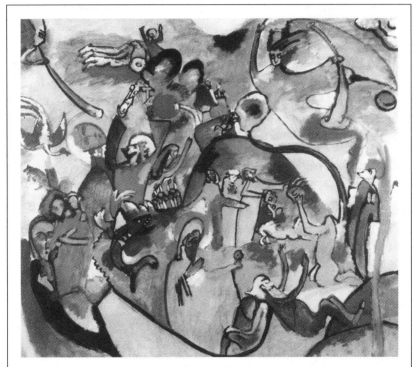

Figure 4.9. Vasily Kandinsky, *All Saints Day II*, 1911

Kandinsky was a founding member of the New Artist's Association of Munich (Neue Künstler-Vereinigung München, or NKVM) in 1909, to which he was immediately appointed president. By 1911, however, the group had begun to suffer from deep disagreements about the meaning and aims of this

[173]Several other works could also be included here that repeat these subjects: e.g., *Small Pleasures* (1911, 1913) includes the horsemen of the apocalypse; *Painting with White Border (Moscow)* (1913) features St. George and the dragon, etc.

[174]Misler, "Apocalypse and the Russian Peasantry: The Great War in Natalia Goncharova's Primitivist Paintings," *Experiment: A Journal of Russian Culture* 4, no. 1 (1998): 63.

collection of "new artists"—disagreements that came to a head in December 1911 when the jury for the third annual NKVM exhibition rejected Kandinsky's huge *Composition 5*. The jury complained about the massive size of Kandinsky's submission (the painting is approx. 6´4˝ × 9´10˝), but most NKVM members recognized the jury's decision as a repudiation of Kandinsky's philosophy of art and his unprecedented lack of pictorial resolution. Kandinsky, Gabriele Münter, Franz Marc and Alfred Kubin promptly resigned in protest and immediately formed the independent artists' group Der Blaue Reiter (The Blue Rider). Anticipating the skirmish, Kandinsky and Marc had already negotiated with art dealer Heinrich Thannhauser to mount an independent exhibition to coincide with the NKVM exhibit. They quickly organized the first Blue Rider exhibition, which opened on December 18, 1911. Among the many works in the exhibition, Kandinsky exhibited his large, controversial *Composition 5*.

Though the painting initially seems entirely nonfigurative, the compositional structure grows out of a complex iconography that Kandinsky had been developing for several years. By his own account, the theme of the painting is the eschatological resurrection of the dead.[175] The toppling towers of a walled "Babylon" are visible in the top central portion of the canvas, and below it an undulating landscape of loosely applied paint seems to heave and lurch. From the congested upper register of the canvas, several thick black lines whip back and forth across the composition, signifying the blaring angelic trumpets announcing an hour of dreadful finality: the holy judgment of the living and the dead. In the lower half of the painting, the dead emerge from the ground of the canvas in thinly applied patches of paint.

On its own, this iconography would likely have been indecipherable to most viewers, but it did not appear alone: simultaneously with this exhibition, Kandinsky published the first edition of his hugely influential book *On the Spiritual in Art*.[176] Striking at the same time, Kandinsky's large painting and his provocative little book functioned as a double manifesto of abstract

[175]See Kandinsky, "Cologne Lecture," in *KCW*, 399.

[176]The first edition of *On the Spiritual in Art, and Painting in Particular* was published in December 1911, but it was dated 1912 so that it would appear "new" throughout the following twelve months. It was such a success that second and third editions were published in 1912 (and plans for a fourth edition were ruined by World War I). Our citations of this text refer to Peter Vergo's translation of the second edition, in *KCW*, 119-219.

painting—and they did so to enormous effect. Kandinsky also exhibited five other paintings alongside this canvas, including the plainly recognizable *Horsemen of the Apocalypse I* (1911) and *All Saints Day I* (1911)[177]—both of which are reverse glass paintings that clearly portray apocalyptic destruction and resurrection, respectively.[178] In *All Saints* Kandinsky rendered the angelic trumpets in bright yellow hues, which follows from his color theory: in *On the Spiritual in Art* he compares bright yellow to "the shrill sound of a trumpet."[179] In *Composition 5*, however, the trumpet blasts are rendered as black lines, a series of deathly voids lashing across the landscape (or paintscape). In Kandinsky's color theory,

> black has an inner sound of nothingness bereft of possibilities, a dead nothingness as if the sun had become extinct, an eternal silence without future, without hope. Musically, it is represented by a general pause, after which any continuation seems like the beginning of another world, for that part which was brought to a close by this pause remains finished, complete for all time.... Black is something extinguished.[180]

The blackness of these apocalyptic trumpet blasts denotes an invading nothingness that tears into the world with the threat of futurelessness, hopelessness. Kandinsky later said that this was one of a handful of paintings conceived with a strong sense of "that cosmic tragedy in which the human element is only one sound."[181] And thus the central question of the painting is unabashedly eschatological: Is "the beginning of another world," or the redemption of this one, imaginable beyond our tragedy?[182]

[177]The six works Kandinsky exhibited included three on canvas—*Composition 5, Impression 1, Improvisation 22*—and three reverse glass paintings—*Deluge, Horsemen of the Apocalypse I*, and *All Saints Day I*.

[178]In fact most of Kandinsky's *Compositions* directly correspond to his much more representational glass paintings: between 1909 and 1913 he completed at least thirty-three reverse glass paintings using techniques borrowed from Bavarian glass painting. Lindsay and Vergo argue that because these paintings are so pictorial they are "crucial to an understanding of the way in which traditional iconography is 'dissolved' in many of his apparently abstract pictures" (introduction to "Reminiscences/Three Pictures," in *KCW*, 355). For further study on the glass paintings and their impact on the abstract paintings, see Röthel, *Vasily Kandinsky: Painting on Glass*; and *Vasily Kandinsky: A Colorful Life*, ed. Helmut Friedel, trans. Hugh Beyer (Cologne: Dumont; New York: Abrams, 1995), esp. 301-471.

[179]Kandinsky, *On the Spiritual in Art*, in *KCW*, 180.

[180]Ibid., 185.

[181]Kandinsky, "Cologne Lecture," in *KCW*, 398.

[182]An evocative comparison might be drawn here to the younger German painter Max Beckmann

The thematic starting point for *Composition 6* (1913) was, similarly, the biblical deluge inflected as an apocalyptic image: a cosmic flood in which evocations of baptism, destruction, exodus and rebirth commingle. Such subject matter was extremely important to Kandinsky—after all, "the choice of object . . . must be based only upon the principle of the purposeful touching of the human soul"[183]—but this forces the question of why he rendered his subject with such a lack of pictorial clarity. In Kandinsky's own words, this was a means of trying to locate his themes more immanently in the material surface of the painting itself: "The original motif out of which the picture came into being (the Deluge) is dissolved and transformed into an internal, purely pictorial, independent, and objective existence. Nothing could be more misleading than to dub this picture the representation of an event."[184] This seems to apply to all of his apocalyptic imagery: he is less interested in *picturing* eschatological events than he is in producing *compositions* that reverberate with the "spiritual sound"[185] of those events. And according to Kandinsky, if we are sensitive to hearing that sound we will find that his apocalyptic themes of "mighty collapse" actually converge into "a living paean of praise, the hymn of that new creation that follows upon the destruction of the world."[186] The trajectory of Kandinsky's entire oeuvre was rooted in a celebration of the goodness of creation and a hope for its reconciliation.

Indeed, this was true for many of the Blue Rider artists, who also originally included Franz Marc, August Macke, Alexei von Jawlensky, Marianne von Werefkin, Lyonel Feininger, Albert Bloch and Paul Klee. All these artists had much to say about religion and (if we had the space) deserve much further investigation in terms of their theological thinking. The Blue Rider staged its second exhibition in February 1912, and then in May of that year it published *Der Blaue Reiter Almanac*, an edited volume featuring fourteen articles and

(1884–1950). Especially in the midst of World War I, Beckmann painted several religious paintings, including *Adam and Eve* (1917), *Christ and the Woman Taken in Adultery* (1917) and *Deposition* (1917). Most notable is his massive unfinished *Resurrection* (1916–1918), which powerfully articulated this same question posed by Kandinsky's apocalyptic *Compositions*. For a study of this painting, see Amy K. Hamlin, "Figuring Redemption: Christianity and Modernity in Max Beckmann's *Resurrections*," in *ReVisioning: Critical Methods of Seeing Christianity in the History of Art*, ed. James Romaine and Linda Stratford (Eugene, OR: Cascade, 2013), 294-309.

[183]Kandinsky, *On the Spiritual in Art*, in *KCW*, 169.

[184]Kandinsky, "Composition 6" (1913), in *KCW*, 388.

[185]See Kandinsky, "Cologne Lecture," in *KCW*, 396.

[186]Kandinsky, "Composition 6," in *KCW*, 388.

nearly 150 images.[187] The approaches and aims of the essayists varied, but they shared a common conviction that art was a primary means of "crystallizing" human spirituality.[188] The images published throughout the *Almanac* included not only reproductions of artworks by artists associated with the Blue Rider but also numerous older works from all over the world, including several Bavarian glass icon paintings, Gothic sculptures and Christian folk art. Kandinsky designed the *Almanac's* cover image, which explicitly identifies the blue rider with Saint George, the Christian knight who symbolizes the ongoing war against—and eschatological triumph over—the demonic dragon that ravages the world.[189] In line with this image, one of Kandinsky's written contributions to the *Almanac* identified the mission of the group as intensifying "the positive, the creative . . . the white, fructifying ray" in opposition to "the negative, the destructive . . . the black, death-dealing hand."[190] And given that the group considered the influence of this deathly hand to be pervasive in Western modernity, Marc insisted that their aims required not only social resistance (against what he called the "cult of modernity") but "a spiritual discipline" that would ground and orient their hope for a better alternative: "To the scornful amazement of our contemporaries, we take a side road, one that hardly seems to be a road. . . . We admire the disciples of early Christianity who found the strength for inner stillness amid the roaring noise of their time. For this stillness we pray and strive every hour."[191]

[187]See Vasily Kandinsky and Franz Marc, eds., *The Blaue Reiter Almanac* (1912); reprint, ed. Klaus Lankheit, trans. Henning Falkenstien (New York: Viking Press, 1974).

[188]To take one example, August Macke launched his article for *Blaue Reiter Almanac* by quoting Jesus: "Is life not more precious than food and the body more precious than clothing?" (Mt 6:25). Macke interpreted this line in terms of a dialectic between comprehensible and incomprehensible forms: "Form is a mystery to us for it is the expression of mysterious powers. Only through it do we sense the secret powers, the 'invisible God.' The senses are our bridge between the incomprehensible and the comprehensible. . . . The joys, the sorrows of man, of nations, lie behind the inscriptions, paintings, temples, cathedrals, and masks, behind the musical compositions, stage spectacle, and dances. If they are not there, if form becomes empty and groundless, then there is no art." Macke, "Masks," in ibid., 85, 89.

[189]Kandinsky's earlier designs for the cover depict the rider as a horseman of the apocalypse (see ibid., 253-55). And it needs to be noted that the frontispiece chosen for the *Almanac* is a Bavarian mirror painting of Saint Martin of Tours on horseback, cutting his cloak in half to offer to an unclothed destitute man (50). Each of these images—the righteous warfare of Saint George, the eschatological announcement of the horseman and the kindness of Saint Martin—all provide different, though presumably complementary, inflections on the mission of the "blue rider."

[190]Kandinsky, "On the Question of Form," in *KCW*, 235-36; cf. *Blaue Reiter Almanac*, 147-48.

[191]Marc, preface to the second edition of *Blaue Reiter Almanac* (1914), 258-59.

In February or March 1913, Marc proposed that the group publish a large-format edition of the Bible collaboratively illustrated by Marc (Genesis), Kandinsky (Revelation), Klee (Psalms), Kubin (Daniel), Oskar Kokoschka (Job), Erich Heckel (his choice of biblical books is unclear) and Natalia Goncharova (Gospels).[192] The work was disrupted by the outbreak of the First World War in 1914, and the project was never realized, though several preliminary drawings and prints exist. Indeed, the war marked the end of the Blue Rider: Macke and Marc both died in combat, and (due to their Russian citizenship) Kandinsky, Werefkin and Jawlensky fled to Russia.

|| ▮▮▮ ||

Rookmaaker's account of modernism was largely preoccupied with Paris, and where he did include the artists discussed in this chapter, he (strangely) overlooked the Protestant roots of their work. One wonders how his understanding of modernism might otherwise have shifted. The trajectories of northern modernism contained distinctly Protestant threads of iconoclastic sensibilities, coupled with a (similarly Protestant) sense of the goodness of creation, the inexplicable givenness of things and the eschatological longing for the redemption of the earth. It is thus with a distinctly Protestant inflection that these works hold together the ineffability of God with the goodness of creation—a convergence that pushed strongly toward abstraction. With the invention of photography, on the one hand, and the waning of the cultural influence of the church, on the other, Protestant painters were particularly poised to explore the possibilities of nonrepresentational abstraction. Within this framework, Rookmaaker's attribution of northern modernist abstraction to a kind of escapist gnosticism misrepresents the history—but so too do arguments that reduce it to either a vague pantheism or a formalist materialism. The artists discussed in this chapter were grappling with and extending a deeply Protestant set of theological sensibilities in their work, even as they did so specifically within the cross-pressures of modernity.

[192]See Marcel Franciscono, *Paul Klee: His Work and Thought* (Chicago: University of Chicago Press, 1991), 179.

Russian Icons, Dada Liturgies and Rumors of Nihilism

Great artists have their own ways of plunging headlong into their doubts, the better to overcome them. Like Plato's pharmakon, their work is both the poison and the antidote.

THIERRY DE DUVE[1]

How can we give the word back its force? By identifying with the word more and more closely. . . . To understand cubism, perhaps we have to read the Early Fathers.

HUGO BALL[2]

Although Vasily Kandinsky made his most significant work in Germany (see previous chapter), he always maintained that the true coordinates of his artistic imagination were thoroughly Russian. Indeed, he referred to his native Moscow as his "spiritual tuning fork."[3] The character of this spiritual

[1]De Duve, *Look, 100 Years of Contemporary Art*, trans. Simon Pleasance and Fronza Woods, exh. cat. (Brussels: Palais des Beaux-Arts; Ghent-Amsterdam: Ludion, 2001), 14.

[2]Ball, entry for December 3, 1916, *Flight out of Time: A Dada Diary*, ed. John Elderfield, trans. Ann Raimes (New York: Viking, 1974), 93.

[3]Kandinsky, letter to Will Grohmann (December 10, 1924), quoted in the introduction to *Kandinsky: Complete Writings on Art*, ed. Kenneth C. Lindsay and Peter Vergo (1982; repr., Da Capo Press, 1994), 15. Hereafter this volume will be abbreviated as *KCW*. Years earlier, in his "Reminiscences" (1913), he put it this way: "Within me sounded Moscow's evening hour, but before my eyes was the brightly colored atmosphere of Munich. . . . I regard this entire city of Moscow, both its internal and external aspect, as the origin of my artistic ambitions. It is the tuning fork for my painting" (*KCW*, 367, 382). Kandinsky's links to Moscow were not simply a matter of memory and sentiment. Throughout his time in Germany he actively participated in the Russian avant-garde, contributing

attunement included many dimensions of Muscovite culture, but it was particularly informed by Russian Orthodox Christianity. In his 1913 "Reminiscences" Kandinsky identified the most formative experiences that propelled him as a painter—particular exhibitions, concerts, scientific lectures and early drawing lessons—almost all of which occurred in Russia. Among these he also included his encounters with the great wooden houses in the Russian province of Vologda, where he traveled in 1889 as an ethnography student. Amidst the brightly colored ornamentation that filled the interiors of these houses, Kandinsky described the powerful effect of the rooms as making him feel as if he were "surrounded on all sides by painting, into which I had thus penetrated." He claimed that these rooms gave him a sense of what it would mean "to move *within the picture*, to live in the picture," and thereafter he specifically associated this sense with worship spaces: "the same feeling sprang to life inside me with total clarity" on several subsequent occasions in Orthodox and Catholic churches and chapels.[4]

In his descriptions of the Vologda houses, he made special note of the traditional Orthodox "beautiful corner" or "red corner" (*krásnyi ugol*).[5] Each wall leading into this corner was usually covered with icons and printed pictures of saints, but the highest position in the corner, where the two walls and ceiling meet, was reserved for the most important icon: either the Holy Face of Christ or the icon of Virgin Hodegetria holding and pointing toward the incarnate Christ child (*hodegetria* means "she who shows the way"). Such corners were illuminated by small red pendant lamps, which Kandinsky evocatively described as "glowing and blowing like a knowing, discretely murmuring, modest, and triumphant star." The overall effect on him was profound: "It was probably through these impressions, rather than in any other way, that my further wishes and aims as regards my own art formed themselves in me."[6]

to significant publications and exhibitions in Moscow (sometimes traveling to participate in person). On December 29 and 31, 1911, a Russian version of his *On the Spiritual in Art* was read aloud at the All-Russian Congress of Artists. And likewise he included various Russian modernists in the publications and exhibitions that he mounted in Munich, including all the artists discussed in this chapter.

[4]Kandinsky, "Reminiscences," in *KCW*, 368-69 (emphasis original).

[5]Historically the Russian word *krásnyi* (red) was used to describe things as beautiful—e.g., Moscow's Red Square is the "beautiful square," the red corner is the "beautiful corner" and so on. For a discussion of the meaning of the red corner, see Andrew Spira, *The Avant-Garde Icon: Russian Avant-Garde Art and the Icon Painting Tradition* (Burlington, VT: Lund Humphries, 2008), 142-44.

[6]Kandinsky, "Reminiscences," in *KCW*, 369.

Kandinsky was not the only Russian modernist deeply affected by the visual culture of Russian Orthodoxy. The manifold religious artifacts and practices—including holy icons, sacred architecture, Easter processionals, liturgical vestments, religious folk art, popular religious prints (*lubki*) and so on—provided much of the visual grammar and conceptual framework for the development of modernism in Russia. From the 1880s into the 1930s, there was an especially strong resurgence of interest in Old Russian icons, many of which were being cleaned of centuries of soot and varnish, restored to their original vibrancy and placed on public display.[7] These exerted a powerful influence on young modernists: under the cross-pressures of the modern age, the icon began to function as "a modernist prism for seeing the world anew."[8] And this function was not "merely aesthetic" (if such a designation is even possible); Orthodox visual theology had deeply shaped the visual imaginations of Russian avant-garde artists—most of whom were raised in the Orthodox faith. In fact, as John Bowlt has pointed out, a significant number of these artists began their careers as icon painters and seminarians.[9]

Nor was this influence simply a matter of generic enculturation: the most innovative years in the development of Russian modernism coincided with an enormous amount of religious and theological energy in Russian culture. As with much of the rest of Europe, Russia experienced a significant spiritual revival in the late nineteenth and early twentieth centuries. Philosophical theology flourished in the universities in the 1890s, and it remained a vital and influential discourse until it was repressed by the Soviets. Particularly in the decade between the Russo-Japanese War (1904–1905) and the beginning of the First World War (1914–1918), artistic modernism thrived alongside a swell

[7]For a helpful volume of essays on this resurgence, see *Alter Icons: The Russian Icon and Modernity*, ed. Jefferson J. A. Gatrall and Douglas Greenfield (University Park, PA: Penn State University Press, 2010).

[8]Jefferson J. A. Gatrall, introduction to ibid., 3.

[9]For example, Pavel Filonov, Filipp Malavin, Pavel Korin and Tatlin trained as icon painters; Boris Kustodiev, Aristarkh Lentulov and Viktor Vasnetsov were theology students. Bowlt also points to the group of symbolist (though not avant-garde) artists who, under the influence of the brilliant Orthodox theologian-scientist Pavel Florensky, contributed to the revival of the city of Zagorsk as a religious and intellectual center in the early 1920s (perhaps the most notable artist in this group was Mikhail Nesterov). See John E. Bowlt, "Orthodoxy and the Avant-Garde: Sacred Images in the Work of Goncharova, Malevich, and Their Contemporaries," in *Christianity and the Arts in Russia*, ed. William C. Brumfield and Milos M. Velimirovic (Cambridge: Cambridge University Press, 1991), 146.

of spiritual and religious activity, both inside and outside of the Russian Or-
thodox Church.[10] Writing in 1910, Aleksandr Mantel reported on the extent
to which Moscow's "auditoria were filled with people listening to lectures on
god-seeking."[11] And in the course of this widespread and multifarious spir-
itual searching, artists often employed the visual grammar that was most
sacred to them, even if they felt that it had to be adapted to a modern context.
According to Bowlt, "far from renouncing the methods of icon painting,
church frescoes, and ceremonies, the [Russian] avant-garde reprocessed and
transmuted them, and direct references to these disciplines can be found in
their major pictorial achievements."[12]

This chapter will press into this claim, exploring the theological implica-
tions of this kind of reprocessing, transmuting and referencing. As we turn our
attention further north and further east, we will investigate some of the most
influential examples of modernism as it developed in Russia,[13] and then we
will loop back around to Germany and Switzerland to look at some similar
developments springing from the roots of the Dada movement in Zurich.

NATALIA GONCHAROVA AND THE MODERNIST ICON

Natalia Goncharova (1881–1962) was arguably the most important Russian
avant-gardist until her initial departure from Russia in the spring of 1914 (and
then her permanent departure in 1915). She believed that the primary insights
of modernism belonged to its neoprimitivism: its turning toward "primitive"
artistic cultures as a means of resisting the dehumanizing aspects of moder-
nity's materialism. She was interested in any and all premodern (or nonmodern)

[10]See, for instance, James H. Billington, "Orthodoxy and Democracy," *Journal of Church and State*
49, no. 1, special issue "Russia" (Winter 2007): 19-26. Billington argues that "modernism in the arts
drew much of its inspiration from the aesthetic theology of Eastern Christendom's 'theology of
pictures,' rather than words" (22).

[11]Mantel, quoted in John E. Bowlt, "Esoteric Culture and Russian Society," in *The Spiritual in Art:
Abstract Painting, 1890–1985*, ed. Maurice Tuchman, exh. cat. (Los Angeles: Los Angeles County
Museum of Art; New York: Abbeville Press, 1986), 170.

[12]Bowlt, "Orthodoxy and the Avant-Garde," 145.

[13]It might be noted that Rookmaaker didn't address Russian modernism in any sustained way in his
writings. He was somewhat aware of it, but like most art historians writing in the 1950s through
1970s (during the height of the Cold War), he had only fragmentary access to or information about
it. The scholarship of early Russian modernism was severely limited for much of the twentieth
century, not only because of strained political relations between the East and West but, more so,
because it had been internally suppressed by the Soviets since the late 1920s (following the death
of Lenin).

artistic traditions, but she came to believe that the deepest resources resided within her own country and its cultural histories. As Alain Besançon summarizes: "In the West, the primitive was somewhere else [in the world]. In Russia, it was within. [Primitivism] did not take you away from the fatherland, it rooted you in it."[14] In particular, Goncharova began to identify the most desirable aspects of the "primitive" with the aesthetics—and aesthetic theologies—of Eastern Orthodoxy: medieval icons and religious folk art were of especially vital importance.

Goncharova was born in the province of Tula into an aristocratic family with strong ties to the Orthodox Church. Her maternal grandfather was a professor of theology at the Moscow Theological Academy, and a number of relatives on that side of the family were priests.[15] She attended church throughout her youth and became versed in Christian theology, and in fact it seems that she remained a religious person throughout her life.

Her artistic career was attended by controversy from early on,[16] most of which revolved around her handling of Christian subject matter. Especially between 1910 and 1912 Goncharova painted numerous religious images in a flattened, roughly hewn visual vernacular,[17] many of which were derived directly from well-known icons.[18] *Saint Michael the Archangel* (1910) (plate 5),

[14]Besançon, *The Forbidden Image: An Intellectual History of Iconoclasm*, trans. Jane Marie Todd (Chicago: University of Chicago Press, 2000), 330.

[15]See Beate Kemfert, "The Life of Natalia Goncharova," in *Natalia Goncharova: Between Russian Tradition and European Modernism*, ed. Beate Kemfert, exh. cat. (Ostfildern, Germany: Hatje Cantz, 2009), 10, 26n5. See also Anthony Parton, *Goncharova: The Art and Design of Natalia Goncharova* (Woodbridge, UK: Antique Collectors' Club, 2010), 15.

[16]Her first solo exhibition consisted of about twenty paintings shown at the elite Society of Free Aesthetics in Moscow on March 24, 1910. The show was denounced in the press for the "disgusting depravation" evidenced by the nudity in the paintings. Within two days the police confiscated three of Goncharova's paintings, including *God[dess] of Fertility* (1909) and two paintings of nude female models that had been made during a figure drawing class. The outrage seems to have centered on the fact that these nudes had been painted and exhibited by a woman—unprecedented at the time. Goncharova and the exhibition's organizers were brought to trial on charges of pornography, though they were acquitted. For a helpful study, see Jane Ashton Sharp, *Russian Modernism Between East and West: Natal'ia Goncharova and the Moscow Avant-Garde* (Cambridge: Cambridge University Press, 2006), 103-19.

[17]Interestingly, it was also during this time (1910-1912) that Goncharova made several paintings of religious Jews. See Cheryl Kramer, "Natalia Goncharova: Her Depiction of Jews in Tsarist Russia," *Woman's Art Journal* 23, no. 1 (Spring-Summer 2002): 17-23.

[18]See, for example, *Madonna and Child* (1910), *The Mighty Savior* (1910), *Christ the Savior* (1910–1911), the triptych *Christ and Archangels* (1910–1911), *The Nativity* (1910–1911), *The Appearance to Joseph* (1910–1911), *Mother of God (with Ornamentation)* (1910–1911), *Coronation of the Virgin* (1910–1911), *The Eagle (Saint John the Evangelist)* (1911), a triptych in which only *Saint Panteleimon*

for example, closely follows the Russian iconic tradition, wherein the angelic archistrategus is often depicted riding a blazing red-winged horse over a dark abyss, trampling the demonic dragon. Goncharova's version of the icon closely adheres to the tradition, presenting a sober-minded, even haunting image of eschatological victory over evil: crowned with a rainbow (Rev 10:1), Saint Michael carries a smoking censer (Rev 8:3-5), holds the Word aloft (Rev 14:6) and inaugurates the apocalyptic judgment of the earth with a blaring trumpet blast (Rev 8:7–9:14). But Goncharova's painting transposes the icon tradition into modernist form: with highly saturated and coarsely painted oil on canvas, the figuration borrows simultaneously from the stiff, flattened figuration of Russian *lubki* (popular religious prints) and the materiality of French modernist painting (which she had seen in the extraordinary collections of Sergei Shchukin and Ivan Morozov, and in the massive 1908 salon of The Golden Fleece). The major questions and controversies about this kind of work (which we will discuss further in a moment) gathered especially around this disarming presentation of traditional religious motifs in "crude" painterly form.

Others of her religious paintings deviated further from the iconic tradition.[19] The large painting of the *Elder with Seven Stars (Apocalypse)* (1910), for example, seems to have no discernible precedent in the icon tradition, though it is a careful handling of the vision of Christ in Revelation 1:12-20: a dark-skinned Son of Man appears amidst a seven-branched lampstand, holding seven stars in his right hand. Goncharova's draftsmanship is deliberately clunky, and the coloration crudely collapses the volume of the forms; but it is easy to agree with Andrew Spira that "there is nothing satirical or patronizing" about her religious paintings.[20] And many of her contemporaries agreed: after seeing several of them in 1911, the critic Sergei Gorodetsky admitted that he was deeply moved by Goncharova's "profound religious compositions."[21]

the *Healer* and *Saint Michael the Archangel* remain (1911), *Adoration of the Virgin* (1911), *The Trinity* (1911), and *Salome* (1912).

[19]In 1911–1912, for instance, Goncharova created two bodies of work (or two large multipanel works), *The Vintage* and *The Harvest*, which unconventionally commingled portrayals of peasant life with imagery from the book of Revelation. For discussions of these works, see Sharp, *Russian Modernism Between East and West*, 192-203; and Parton, *Goncharova*, 172-80, who regards these works as "narrating an apocalyptic judgment against the society of her day" (178).

[20]Spira, *Avant-Garde Icon*, 139.

[21]Gorodetsky, "Soiuz molodezhi" (April 16, 1911), quoted in Parton, *Goncharova*, 173.

Other critics, however, received Goncharova's religious works as blasphemous. The objections spanned a range of issues: In the Orthodox Church the holy vocation of iconography (icon writing) was a sacred duty reserved for (male) monastic scholars and intended for sacred use. The very incidence of a nonordained woman painting these subjects in large oils on canvas for public exhibition inevitably raised questions of irreverence. In an open letter addressed to female readers, Goncharova defended her work—and did so primarily on theological grounds:

> To repeat all of the good and idiotic things that have been said about my sisters a thousand times already is infinitely boring and useless, so I want to say a few words not *about* them, but *to* them: Believe in yourself more, in your strengths and rights before mankind and God, believe that everybody, including women, has an intellect in the form and image of God.[22]

Certainly the most provocative place to assert and test this was in the depiction of holy imagery.

The larger issue, however, had less to do with who she was or what she was depicting than with how she handled these sacred subjects. The deliberately imprecise paint handling struck many viewers as disrespectful. She disagreed, arguing that her work simply acknowledged a deeper diversity within the icon tradition than these viewers were recognizing: "People say that the look of my icons is not that of the ancient icons. But which ancient icons? Russian, Byzantine, Ukrainian, Georgian? Icons of the first centuries, or of more recent times after Peter the Great? Every nation, every age, has a different style."[23] And indeed the pressures of her own age must be worked through yet a different style. Goncharova believed that artists concerned with preserving ancient values must perpetually renegotiate the most fitting "form" for embodying those commitments within present cultural contexts:

> I maintain that religious art and art that exalts the state [*gosudarstvo*] was and will always be the most majestic and complete art, in large part because such art is, above all, not theoretical but traditional. . . . This means that [the artist's]

[22]Natalia Goncharova, "Open Letter" (c. 1913), in *Amazons of the Avant-Garde: Alexandra Exter, Natalia Goncharova, Liubov Popova, Olga Rozanova, Varvara Stepanova, Nadezhda Udaltsova,* ed. John Bowlt and Matthew Drutt, exh. cat. (New York: Guggenheim Museum, 2000), 313-14.

[23]Goncharova, "Album" (c. 1911), in Bowlt and Drutt, *Amazons of the Avant-Garde,* 310.

thought is always clear and definite; the artist has only to create for it the most contemporary and most definitive form.[24]

This contemporizing of form was not meant to empty these (religious) subjects of their (theological) content; to the contrary, Goncharova believed that "during all eras, the subject depicted was and will be important—as important as how it is depicted"—but she also believed that the form of depiction continually needs to be revisited for the ongoing health of the subject.[25]

In fact, Goncharova appears to have thought seriously about the religious subject matter of her work. In personal notes from about 1911 she described an idea for painting a "church mural motif" depicting a garden of trees tended by birds, saints and angels: "A radiant Christ, a pole axe in his hand, descends from a mountain to his church and garden in order to find his withered tree."[26] This is arresting imagery, synthesizing several loaded biblical references into a vision of Christ judging the unfaithfulness of the church.[27] The implications are simultaneously pietistic (calling for repentance) and polemical (accusing the church of being as spiritually dead as the temple—symbolized as a withered tree—that Jesus judged in Mk 11). Given these sharp polemics, Goncharova questioned herself: "Will the Lord not let me paint this? Lord forgive me.... Others argue—and argue with me—that I have no right to paint icons. I believe in the Lord firmly enough. Who knows who believes and how? I'm learning how to fast."[28]

In December 1910 Goncharova and her partner Mikhail Larionov[29] launched the avant-gardist group Knave of Diamonds (*Bubnovyi Valet*)[30]

[24]Goncharova, letter to the editor of *Russkoe slovo* (1912), in Sharp, *Russian Modernism Between East and West*, 272.

[25]Goncharova, quoted in ibid., 272.

[26]Goncharova, "Album," in Bowlt and Drutt, *Amazons of the Avant-Garde*, 309.

[27]The image incorporates prophetic passages of God judging the lifeless tree/vine of Israel (e.g., Is 1:30; 5:1-24; Ezek 17:1-10; 19:10-14) with John the Baptist's proclamation of the immanence of that judgment: "Even now the ax is lying at the root of the trees" (Mt 3:10 NRSV). These are then merged with Jesus judging the temple in the symbolic cursing of the unfruitful fig tree (Mk 11:12-26).

[28]Goncharova, "Album," in Bowlt and Drutt, *Amazons of the Avant-Garde*, 309-10.

[29]Goncharova met the artist Mikhail Larionov (1881–1964) in 1900, and the two became lifelong companions, though they didn't formally marry until 1955 when in their midseventies.

[30]The formation of this group was a response to the mass expulsion of modernist students—including Larionov—from Konstantin Korovin's portrait-genre class at the Moscow Institute. Anthony Parton points out that the term *Bubnovyi Valet* (sometimes translated Jack of Diamonds) was a common epithet for prisoners and social outcasts: "In this way the artists self-consciously put

with an exhibition of thirty-nine artists, including artists working not only in Russia (e.g., Alexandra Exter and Kazimir Malevich) but also in France and Germany (Gleizes, Kandinsky, Münter and Jawlensky). Goncharova was quickly dubbed the "Queen of Diamonds" in the Moscow press,[31] and her apocalyptic inflections were attributed to the group as a whole. She designed the cover for the exhibition almanac, featuring a sword-wielding archangel on horseback—a design that directly prefigured Kandinsky's placement of Saint George on the cover of the *Blue Rider Almanac* (1912). In fact Kandinsky was quite taken with Goncharova's work: he published her apocalyptic drawing of *The Vintage of God* (1911–1912) in that *Almanac* and curated her work into the second Blue Rider exhibition.[32] The two became friends at the Knave exhibition in Moscow and found that they held similar convictions both about the evils of modern materialism and about the role of art in generating spiritual and social renewal.

Goncharova regarded Western modernism (primarily French cubism and Italian futurism) as bearing valuable social and spiritual meanings, but she also grew wary of it, fearing that it was smuggling problematic European philosophical values into Russian society and thus obscuring its own unique spiritual resources. By 1913 she proclaimed:

> I have studied all that the West could give me, but in fact my country has [already] created everything that derives from the West. Now I shake the dust from my feet [alluding to Mt 10:14] and leave the West. . . . My path is toward the source of all arts, the East. . . . At the present time Moscow is the most important center of painting.[33]

Arguing that the Russian "avant-garde" had become too preoccupied with (and deferential to) France, Goncharova and Larionov abandoned Knave and organized the Donkey's Tail,[34] touting a modernism that "derives exclusively

themselves beyond the pale of social acceptability." With tongue-in-cheek humor, the group took this name as a gesture that they "stood for all that was considered outlandish and unintelligible in modern art." Parton, *Goncharova*, 54.

[31] See ibid., 54.

[32] See ibid., 173-75, 225-26.

[33] Goncharova, "Artistic Manifesto," preface to the catalog of her one-woman exhibition in Moscow (1913); available in Kemfert, *Natalia Goncharova*, 67. Goncharova clarifies that her turning toward the East was intended "not to narrow the problems of art but, on the contrary, to make it all-embracing and universal" (69).

[34] Like Knave, the name The Donkey's Tail was chosen (tongue-in-cheek) for its inflammatory

from Russian traditions and does not invite even a single foreign artist."[35] As
they saw it, modernists could find no better models for a robust Russian
spirituality (and a hedge against western European materialism) than in Or-
thodox icons and folk art: "out of respect for ancient national art" they de-
voted a large portion of their group exhibition to collections of old icons and
popular prints.[36]

Goncharova's work dominated the Donkey's Tail exhibition (held in
Moscow in the spring 1912), showing fifty-four paintings in the first hall of the
gallery. At least eight of these paintings depicted religious subjects, the most
prominent of which was the large *Evangelists* (1910–1911), a four-panel painting
derived from images of saints standing on either side of the central icon of
Christ in a traditional Orthodox iconostasis. The presentation of this subject
matter was not intended to be sarcastic, but the stark expressionist coloration
and mark-making struck many viewers as irreverent. The imagery also inexpli-
cably deviated from traditional iconography: the evangelists are depicted with
gray beards and holding scrolls, two attributes conventionally reserved for
Old Testament prophets—perhaps implying that the Gospels had themselves
become an "old" testament. And without any further context provided, the
message of these evangelists—the referent to which they point—was uncom-
fortably absent, and thus open ended. The two evangelists on either side turn
toward the empty space between the central panels, where an Orthodox be-
liever would expect to see the holy image of Christ. Ultimately the tipping
point was the title of the exhibition: the public censor deemed it blasphemous
to include paintings of holy subject matter in an exhibition that was so irrever-
ently titled. The police were ordered to remove all of her religious paintings,
including the *Evangelists*, from the exhibition under the accusation of "anti-
religious blasphemy."[37]

By 1913 Goncharova had become the most visible and influential modernist
painter in Russia. She was featured in the first full-scale retrospective of an

associations. It referred to a well-known hoax in which a French critic exhibited a painting in the
1910 Salon des Indépendants that had been made by tying a paintbrush to the tail of a donkey. See
Parton, *Goncharova*, 63.

[35]Press release for the Donkey's Tail exhibition, quoted in Sharp, *Russian Modernism Between East
and West*, 134.

[36]Ibid.

[37]See Yevgenia Petrova, ed., *Origins of the Russian Avant-Garde*, exh. cat. (St. Petersburg: Palace
Editions, 2003), 89.

avant-gardist in Moscow, which was also the first major exhibition of a female artist.[38] Sponsored by one of Moscow's most important art dealers, Klavdiya Mikhailova (also a woman), the huge exhibition contained 768 works—nearly everything Goncharova had made from 1903 to 1913—and it was accompanied by a published catalog. The show received massive attention: according to one contemporary critic Goncharova became an "overnight sensation."[39] And yet the religious works continued to ignite controversy. This was especially the case in the spring of 1914 when Goncharova presented a smaller version of this show (249 works) in Saint Petersburg in a major solo exhibition at Natalia Dobychina's Art Bureau, the foremost private art gallery in Russia. All the religious paintings exhibited in this show (as many as twenty-two in total) were once again physically removed by the police on the grounds of blasphemy. One particularly offended reviewer railed against Goncharova's "outrageous and repulsive" treatment of the sacred motifs. The *Evangelists* once again drew particular scorn: "the height of outrage are four narrow canvases depicting some kind of monsters labeled in the catalogue as no. 247 'The Evangelists.' ... [This] premeditated deformation of holy persons must not be allowed."[40] However, when the local spiritual censor examined the works following their removal, he overruled the critic's accusations: "finding no blasphemy in them but in fact all the signs of an appropriate style, he allowed the pictures to be hung back up."[41]

With the outbreak of World War I, Goncharova almost immediately published the *Mystical Images of War* (1914), a series of fourteen lithographic prints that commingled imagery of human and angelic warfare. The cover depicts the Angel of the Lord with an uplifted sword in his/her right hand, and

[38]Aleksandra Shatskikh comments on the prominence of female artists and the *relative* lack of gender bias and discrimination in the Russian avant-garde, as opposed to the rampant male chauvinism in the French avant-garde, for instance. Among many others, artists Anna Golubkina, Alexandra Exter, Liubov Popova, Nadezhda Udaltsova, Olga Rozanova, Varvara Stepanova and of course Natalia Goncharova were profoundly influential in the formation of and discourse surrounding Russian modernism. Shatskikh argues that "this special status of women avant-garde artists had its roots in the [Russian] national mentality." Shatskikh, *Black Square: Malevich and the Origin of Suprematism*, trans. Marian Schwartz (New Haven, CT: Yale University Press, 2012), 62-64.
[39]Unnamed critic, quoted in Jane A. Sharp, "Natalia Goncharova," in Bowlt and Drutt, *Amazons of the Avant-Garde*, 162.
[40]A review of the exhibition published in the *Petersburgskii listok* (March 16, 1914) by a reviewer identified only as "W," quoted in Sharp, *Russian Modernism Between East and West*, 240.
[41]According to a news report published April 1, 1914, in the *Petersburgskii kurer*, quoted in Parton, *Goncharova*, 100.

the interior prints unfold through a series of harsh apocalyptic images: *Saint George* drives a spear into the mouth of the demonic dragon; *Angels and Airplanes* engage in aerial combat; angels drop boulders on *The Doomed City*; Death rides *The Pale Horse* over skeletal human remains; the nude Whore of Babylon (*Woman on the Beast*) raises a goblet as she rides a two-headed monster over a field of broken bodies; *Saint Michael the Archistrategus* gallops on horseback over a burning landscape; an archangel soberly presides over *A Mass Grave*; a group of soldiers encounters the Mother and Christ Child in a *Vision in the Clouds*; and so on. The series anticipated the brutalities of modern warfare that would rage in Europe over the next few years, but it did so while casting them specifically into spiritual light.

As evidenced by the controversies surrounding her work, the theological implications of Goncharova's religious paintings remain undecidable. Religious (particularly apocalyptic) subjects were central to her modernism—they provided the site for her to think through the meanings of human life and human history—but in taking up these subjects she felt that she had to twist them out of the grip of convention. For Goncharova, Christian spirituality in a modern age demanded a jolting of one's expectations and an unsettling of conventional religious images just enough to put them in play once again—a task for which modernist painting proved to be quite proficient. It is this jolting, this unsettling that generates much of what is most controversial and most theologically important about modern art.

Similar dynamics demand further consideration in the work of numerous other artists raised in Russia and eastern Europe, for whom we have no space to explore. The controversial works of the Russian symbolist Kuzma Petrov-Vodkin (1878–1939), for example, include paintings of *The Mother of God of Tenderness Toward Evil Hearts* (1914–1915), a haunting modernist icon painted specifically for the moment of Europe's descent into world war, as well as *Our Lady of Petrograd* (1920), which was painted during the extremely turbulent years of the Russian Civil War (1918–1921). Alexei von Jawlensky's (1864–1941) numerous versions of the *Mystical Head* (late 1910s), *Savior's Face* (early 1920s) and *Meditations* (1930s) were overtly intended as modern icons.[42] The pivotal

[42]In a personal letter Jawlensky confessed, "I work for myself, for myself alone and for my God. . . . My work is my prayer—a passionate prayer uttered in paint. . . . I work with ecstasy and with tears in my eyes and I go on until darkness falls. Then I am exhausted. I sit there motionless, half-

work in the career of the Romanian sculptor Constantin Brancusi (1876–1957) was his sculpture of *The Prayer* (1907), a kneeling woman mourning at a gravesite. And following from this work, Brancusi's numerous *Heads* (1910s–1920s) are, as Spira notes, "surely influenced by the heads of saints," particularly those decapitated martyrs that appear in church frescoes throughout his native Moldavia.[43]

Kazimir Malevich: God Is Not Cast Down

Andrew Spira argues that "of all the explicit references to Christian imagery in the art of the Russian avant-garde, surely the most radical and profound was the Suprematist work of Kazimir Malevich. . . . [His work passed] beyond a mere similarity to icons towards a total identification with them."[44] The most salient example of what he has in mind is Malevich's contributions to *The Last Futurist Exhibition of Paintings 0.10 (Zero-Ten)*, which was shown in December 1915 to January 1916 at Natalia Dobychina's gallery in Petrograd (which had been renamed from Saint Petersburg in September 1914)—the same space in which Goncharova's controversial solo exhibition had been shown the previous year. Malevich presented thirty-nine entirely nonrepresentational (he called them "nonobjective") paintings in this exhibition, all but one of them unframed. Nine of the paintings bore individual titles—including some fairly ornate titles such as *Pictorial Realism of a Boy with a Knapsack: Color Masses in the Fourth Dimension* (1915)—whereas the other thirty canvases were grouped under two general titles: *Painterly Masses in Motion* and *Painterly Masses at Rest*, as designated in the exhibition catalog and on large handwritten sheets of paper pinned to the gallery walls. These sheets are visible in the only surviving photograph of the exhibition (fig. 5.1), as are about half of the paintings that he showed in the exhibition. But the most striking aspect of this photograph is that it shows that Malevich had installed his *Black Square* (originally titled *Quadrilateral*) (1915) in the uppermost corner of the room, unmistakably occupying the place of the holiest icon in the Orthodox red corner.

fainting and with terrible pains in my hands. Oh God! Oh God!" Quoted in Hans K. Roethel, *The Blue Rider* (New York: Praeger, 1971), 52.

[43]Spira, *Avant-Garde Icon*, 167n1.

[44]Ibid., 139.

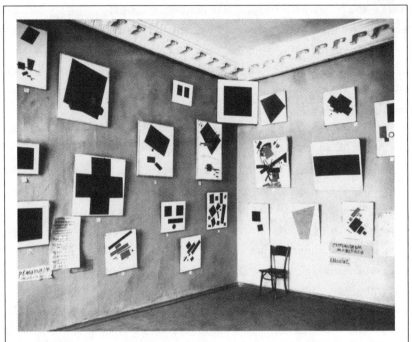

Figure 5.1. Photograph of Malevich's installation at *The Last Futurist Exhibition of Paintings 0.10 (Zero-Ten)*, December 1915 to January 1916

Alexandre Benois, the most prominent of the Petersburg symbolists, immediately recognized the implication: "Without a number but high up in a corner just below the ceiling in the holy place, is hung a 'work' undoubtedly by the same Mr. Malevich, representing a black square against a white background [*oklad*[45]]. There can be no doubt that this is an 'icon.'"[46] But for Benois the pictorial blankness and vacancy of this icon were deeply troubling. He regarded the painting as viciously iconoclastic, a negating or nullifying of

[45]Andréi Nakov provides an important note: "Benois describes the white field in the painting as an оклад [*oklad*]. This term refers specifically to the metal cover traditionally placed over icons . . . encompassing the field around the central figure, which the metal cladding conceals so that the image is effectively limited to the figure's face. Benois's interpretation of *Quadrilateral* ("*Black Square*") was thus not only 'iconistic' but anthropomorphic as well." Nakov, *Malevich: Painting the Absolute* (Burlington, VT: Lund Humphries, 2010), 2:135n74.

[46]Alexandre Benois (sometimes spelled Aleksandr Benua), speech delivered in response to *The Last Futurist Exhibition* on January 1, 1916, and published as an exhibition review in the Moscow newspaper *Rech'* (January 9, 1916), quoted in Spira, *Avant-Garde Icon*, 142. A longer excerpt of this review is available (in a different translation) in Matthew Drutt, ed., *Kazimir Malevich: Suprematism*, exh. cat. (New York: Guggenheim Museum, 2003), 253-54.

the Christian iconic tradition and the ideals that it stands for: this "new icon of the square" proclaimed that "everything that we hold sacred and holy, everything that we loved and lived for has vanished."[47] Indeed, he argued (in lines that could well have been written by Rookmaaker[48]) that the logic of this negation was "nothing less than a call for the disappearance of love, that fundamental principle that provides us with warmth and without which we would inevitably freeze to death and perish."[49] Interestingly, Benois was not dismissive of Malevich but rather considered him "a representative of his time": His work was "not simply a joke, not simply a challenge, not a small casual episode.... [N]o, this is one of those acts of self-assertion, a beginning that ... reduces all to ruin."[50] But if such an icon was indeed representative of the age, then Benois was profoundly unsettled: "How to pronounce the spell which will once more bring back the cherished images of life upon the background of the black square?"[51]

Benois's sharp response should give us reason for pause, but so too should the fact that Malevich thought that it frankly missed the point, insofar as it received the work solely through a pictorial theory of art. Malevich responded to Benois directly, forthrightly acknowledging that he regarded *Black Square* as "a single bare and frameless icon of our times," but he contested the critic's assumptions about what this implied.[52] Perhaps the nakedness and blankness

[47]Benois, "The Last Futurist Exhibition," quoted in Nakov, *Malevich: Painting the Absolute*, 2:133.

[48]Rookmaaker himself wrote almost nothing about Malevich. He referred to him only twice in his writing (*CWR*, 4:455, and *MADC*, 140), and in neither case was there any substantial discussion. As noted earlier in this chapter, the context of the Cold War and the internal suppression of Malevich's work by the Soviet government surely contributed to Rookmaaker's silence on this artist: there was only partial knowledge of Malevich's oeuvre, and there was very little good scholarship available about it.

[49]Benois, "The Last Futurist Exhibition," in Drutt, *Kazimir Malevich: Suprematism*, 253.

[50]Benois, "The Last Futurist Exhibition," quoted in Natalia Avtonomova, "Malevich and Kandinsky: The Abstract Path," in *Rethinking Malevich*, ed. Charlotte Douglas and Christina Lodder (London: Pindar Press, 2007), 44.

[51]Benois, "Last Futurist Exhibition," in Drutt, *Kazimir Malevich: Suprematism*, 254. By way of comparison, contemporary art historian Thierry de Duve reads this work similarly to Benois, though, as an enthusiastic secularist, de Duve views it without any of Benois's gloom and in essentially constructive terms. He asserts that Malevich's *Black Square* "endeavored to redefine the essentially *religious* terms of humanism on *belief-less* bases," thus effectively "inoculating the tradition of the Russian icon with a vaccine capable of preserving its human meaning, for a period which faith in God could no longer keep alive." De Duve, *Look*, 14 (emphases original).

[52]Malevich, letter to Benois (May 1916), in *Malevich: Essays on Art, 1915–1933*, ed. Troels Andersen, trans. Xenia Glowacki-Prus and Arnold McMillin (New York: George Wittenborn, 1971), 45. Aleksandra Shatskikh evocatively translates this same phrase as "the icon of my era, naked without a

of this icon had indeed been meant to displace Benois's "cherished images of life," but Malevich questioned why and how Benois was linking *life* with pictorial familiarity:

> I would very much like to ask you and everyone: is the image of what you are looking for drawn clearly enough? The ancient Magi had a guiding star (the care of the Most High). Do you have an indicator and will you be able to recognize what you are looking for? Are you sure that you will not walk right past it, like the Jews with Christ? Who knows, maybe these new people are to be found here a thousand times over, down some Bath-House Lane [presumably a reference to Christ eating with prostitutes and sinners, e.g., Mk 2:13-17].[53]

So Malevich pressed Benois on precisely this question: "Who has been entrusted with recognizing the living?"[54] If Benois considered *Black Square* a nihilist icon, Malevich spoke of it as if it were brimming with the life of a *Hodegetria* icon: "The square is a living, royal infant,"[55] an "embryo of all possibilities."[56] How can that difference in interpretation be adjudicated?

Malevich was quite serious about positioning the *Black Square* in the holy corner. Several years later he reflected on the meaning of this placement:

> I see the justification and true significance of the Orthodox corner in which the image stands, the holy image, as opposed to all other images and representations of sinners. The holiest occupies the center of the corner, the less holy occupy the walls on the sides. The corner symbolizes that there is no other path to perfection except for the path into the corner. This is the final point of movement. . . . Whether you were to walk in the heights (the ceiling), down below (the floor), on the sides (the wall), the result of your path will be the cube, as the cubic is the fullness of your [three-dimensional] comprehension and is perfection.[57]

frame" (Shatskikh, *Black Square*, 132). Malevich intended his response to be published as an open letter to Benois, but as he writes in the postscript of his letter: "Since the doors of the press are closed to us [suprematists] I am writing to you personally" (Andersen, *Malevich*, 48). Though not published, the letter was circulated widely among other avant-garde artists.

[53]Malevich, letter to Benois, in *Kazimir Malevich: In the Russian Museum*, ed. Yevgenia Petrova (Saint Petersburg: State Russian Museum and Palace Editions, 2000), 393.

[54]Ibid.

[55]Malevich, *From Cubism and Futurism to Suprematism: The New Realism in Painting* (October 1916), in Andersen, *Malevich: Essays*, 38.

[56]Malevich, letter to Matiushin (1915), quoted in John Milner, *Kazimir Malevich and the Art of Geometry* (New Haven, CT: Yale University Press, 1996), 98.

[57]Malevich, "The Book About Objectlessness" (1924), quoted in Spira, *Avant-Garde Icon*, 144.

The sobriety of this statement, and the total lack of sarcasm about the symbolic gravity of the red corner, only deepens the questions about what it means to present this black, seemingly vacant icon in the position of "the holiest." What notion of the holy is Malevich advancing? Is this a negation of Christian theology, or is it a theology *via negativa*? Is *Black Square* a figuration of (ontological) void or a (semiotic) voiding of figuration? An icon of the death of God or an icon of God's unrepresentability? Has the holy corner been appropriated for mockery, lament or apophatic meditation? Is this an act of modernist hubris or theoaesthetic humility?

These questions come into somewhat sharper focus in the wider context of his life and work. Kazimir Malevich (1879–1935) was the eldest of fourteen children (five of whom died during childhood). He was born in Kiev, Ukraine, to parents of noble Polish descent who had fled Poland amidst the violence of the 1863 uprising against the Russian Empire.[58] His parents were proudly Polish Catholic, naming their firstborn son after the fifteenth-century Catholic prince and patron saint of Poland, Kazimierz (Kazimir).[59] Malevich's uncle Lucjan had been a Catholic priest (who was hanged for his role in the uprising), and the family strongly encouraged young Kazimir likewise to go into the priesthood.[60] He threw himself into painting instead, which, in the words of Alain Besançon, "he took up with the seriousness of a religious vocation."[61]

Similarly to Kandinsky, Malevich first produced paintings that were quasi-impressionist landscape studies,[62] but by 1906 he had moved to Moscow and burned many of these earlier "realist" works. Moscow exposed him to intense political unrest (following the revolution of 1905) and also to the most advanced forms of French and Russian symbolist painting—he was particularly interested in Gauguin. In 1907–1908 Malevich began exploring religious subject matter in a symbolist mode, taking unconventional approaches to

[58]For a helpful biography of Malevich, including family origins, see Nakov, *Malevich: Painting the Absolute*, 4:11-131.

[59]See John Milner, "Malevich: Becoming Russian," in *Malevich*, ed. Achim Borchardt-Hume, exh. cat. (London: Tate Publishing, 2014), 34, 226n3.

[60]See Spira, *Avant-Garde Icon*, 66.

[61]Besançon, *Forbidden Image*, 358. Malevich was first drawn to the arts during his teens as he watched artists from Saint Petersburg who had come to his village to decorate the local church. See Charlotte Douglas, *Kazimir Malevich* (New York: Abrams, 1994), 7-8.

[62]For a particularly interesting surviving example, see his heavily impasto painting of a *Church* (c. 1905) in Borchardt-Hume, *Malevich*, 41.

traditional Christian themes such as *Prayer* (1907), *The Triumph of Heaven*
(1907), *Assumption of a Saint* (1907–1908), *Adam and Eve* (1908), *Tree of Life*
(1908) and *Shroud of Christ* (1908). One is struck not only by the meticulous
patterning and sumptuous color throughout these paintings—drawing
heavily from both Russian symbolist painting[63] and the newly restored Or-
thodox icons on view in Moscow—but also by his repeated use of black (rather
than golden) halos to designate the holiness of his figures.[64]

By 1910–1912 Malevich became deeply influenced by Goncharova—John
Milner refers to her as "Malevich's mentor" during these years[65]—and like her,
he was intensely interested in traditional Christian icons. Parallel to Goncha-
rova's move toward a uniquely Russian modernism, and further augmented
by his interest in radical politics, Malevich began making paintings of
peasants—a motif that he would return to throughout his life. As Milner
argues, these paintings were not only politically but also religiously charged:
"Malevich was not simply painting peasants; he was observing the Old
Believers"—a sect of Orthodox Christians who rejected the seventeenth-
century liturgical reforms to the Russian Orthodox Church[66] and "followed
their beliefs at least as devoutly as the peasants of Brittany [with whom
Gauguin had been preoccupied]."[67] Malevich was drawn to the "isolation, co-
hesion, and simplicity of the Old Believers" as they sought to preserve "a cul-
tural identity that was both Russian and defiant, sustaining a cultural heritage
and a devout way of life that had been swept away elsewhere."[68] Works like
Praying Woman (1911–1912) and *Peasant Women in Church* (1911–1912), which

[63]Elena Basner claims that despite his own later repudiation of his work during this period, "Mal-
evich remains one of the most significant Russian Symbolists of the first half of the twentieth
century." Basner, "The Early Work of Malevich and Kandinsky: A Comparative Analysis," in Doug-
las and Lodder, *Rethinking Malevich*, 34.

[64]Note that in *The Shroud of Christ* the blackness of the halo is rhymed by the blackness of the two
suns (or sun and moon?), thus perhaps rendering holiness in terms of an eclipse of vision or a light
so bright that it appears as darkness.

[65]Milner, "Malevich: Becoming Russian," 35.

[66]Initiated in 1652 by Patriarch Nikon of Moscow and finally established at the Great Moscow Synod
of 1666, these reforms attempted to bring the rites, creeds and texts of the Russian Orthodox
Church into alignment with the Greek Orthodox Church. The Old Believers rejected these re-
forms, maintaining that the Russian forms were more ancient. As a result, they suffered (some-
times severe) official persecution until 1905, when Tsar Nicholas II declared religious freedom
throughout Russia.

[67]Milner, "Malevich: Becoming Russian," 36.

[68]Ibid.

he exhibited at the Donkey's Tail exhibition,[69] depict peasant women crossing themselves conspicuously in the manner of the Old Believers (with two extended fingers rather than the reformed convention of two fingers joined with the thumb). Malevich used his lifelong friend Ivan Kliun as a model for several of his paintings of Old Believers, deploying an overtly "icon-like format" in paintings like *Completed Portrait of Ivan Kliun* (1913) and in multiple versions of *The Orthodox* (1912).[70] Milner summarizes Malevich's work during this period as "introducing cubism to the Russian icon," developing an iconic visual language "that would follow Malevich to the end of his life."[71]

Like Mondrian, Malevich took huge leaps in his thinking about art between 1912 and 1916. He undertook rigorous examinations of French cubism and Italian futurism in his painting practice, but he also began collaborating with poets and intellectuals who challenged his thinking. The Stray Dog (*Brodiachaia Sobaka*) cabaret was one such gathering of avant-gardists that generated an enormous amount of artistic energy[72]—the high point of which might be marked at December 1913 with two performances of the futurist opera *Victory over the Sun* (*Pobeda nad solntsem*).[73]

Victory over the Sun was a collaborative project involving the poets Aleksei Kruchenykh (1886–1968) and Velimir Khlebnikov (1885–1922), musician Mikhail Matiushin (1861–1934), and visual artist Malevich, who designed all the sets and costumes. The plot celebrated the "strongmen of the future," who succeed in imprisoning and overthrowing the sun—a symbol for natural temporal cycles and the "light" of natural reason.[74] Significantly, Malevich

[69]Goncharova and Larionov invited Malevich to participate in the Knave of Diamonds exhibit (December 1910–January 1911) and the Donkey's Tail exhibition in Moscow (March-April 1912). Kandinsky included Malevich's *Peasant Head* (1911) in the second Blue Rider exhibition in Munich (February-April 1912).

[70]See, for example, Nakov, *Malevich: Painting the Absolute*, 1:194-95.

[71]Milner, "Malevich: Becoming Russian," 37; cf. Milner, *Kazimir Malevich and the Art of Geometry*, 41-43.

[72]The Stray Dog was founded on New Year's Eve 1911 in Saint Petersburg and lasted until March 1915, when it was closed down by authorities. This cabaret became a hotbed of experimental artistic activity, with a commitment to ennobling everyday life and celebrating artistic forms "as such." Events at the cabaret included poetry readings by Khlebnikov and Osip Mandelstam, the famous debate between the Italian Filippo Tommaso Marinetti and Mikhail Larionov over the tenets of futurism (the young linguist Roman Jakobson served as the translator), and Viktor Shklovsky's lectures, which laid the foundations for Russian formalism.

[73]The opera premiered at Luna Park in Saint Petersburg on December 2, 1913, and despite high ticket prices was entirely sold out.

[74]There have been numerous diverging interpretations of the opera's motif of conquering the sun.

retroactively dated the conception of *Black Square* to the designs he made for the stage curtain for scene three of the opera, which portrayed the eclipse and "burial" of the sun, as well as to the design for the pallbearers who presided over the sun's funeral wearing black squares on their chests and hats. In this context we might interpret *Black Square* as some kind of ideological eclipse.

One of the most particular aspects of this opera was the use of *zaum*, an experimental language created by Kruchenykh and Khlebnikov to produce "dislocations" within the operation of everyday language—a "making strange" (*ostranenie*), to borrow Viktor Shklovsky's term. *Zaum* was a kind of strict formalism that sought an "attunement to the material fabric of language,"[75] but it was specifically aimed at accessing a mode of meaning that transcends formal relationships. In Russian, *zaum* (pronounced "za-oom") combines the prefix за (beyond or outside of) with the noun ум (mind, reason, intellect), such that it is often translated into English as "transrational," "beyond reason," "beyond the mind" or (in Paul Schmidt's translation) "beyonsense" (subtly alluding to yet differentiating it from nonsense).[76]

According to Khlebnikov, "Beyonsense language [*zaumny yazyk*] means language situated beyond the boundaries of ordinary reason, just as we say 'beyond the river' or 'beyond the sea.'"[77] He understood *zaum* as opening the possibility for language to operate on multiple "word planes," accessing a "language of the birds," a "language of the stars," even a "language of the gods."[78] And for this reason, he was interested in any form of language that opened zones of defamiliarized meaning, ranging from prelingual speech (children's babble) to supralingual "tongues" (angelic language, glossolalia). As Sarah Pratt has argued, Khlebnikov was intensely interested in the possibility of

For a sampling, see Charlotte Douglas, "Birth of a 'Royal Infant': Malevich and *Victory over the Sun*," *Art in America* 62, no. 2 (March-April 1974): 45-51; Milner, *Kazimir Malevich and the Art of Geometry*, 90; and Gerald Janecek, *Zaum: The Transrational Poetry of Russian Futurism* (San Diego, CA: San Diego State University Press, 1996), 122-24.

[75]Masha Chlenova, "0.10," in *Inventing Abstraction, 1910–1925: How a Radical Idea Changed Modern Art*, ed. Leah Dickerman (New York: Museum of Modern Art, 2012), 207.

[76]For an excellent introduction, see Janecek, *Zaum*. Janecek helpfully differentiates between three kinds of *zaum* dislocations: (1) "phonetic zaum" is the configuration of letters into combinations unrecognizable as words; (2) "morphological zaum" combines recognizable words or portions of words (roots, prefixes, suffixes) into sentences with indeterminate meanings; and (3) "syntactic zaum" places standard words and word forms into relationships that are grammatically incorrect or garbled (see p. 5).

[77]Khlebnikov, "Our Fundamentals" (1919–1920), quoted in ibid., 140.

[78]Janecek, *Zaum*, 137-52.

zaum language functioning as (or at least in ways parallel to) holy icons.[79] Pratt locates Khlebnikov within the Orthodox tradition of the "holy fool" (*iurodstvo*), even if he sometimes appeared "an unorthodox Orthodox holy fool."[80] In fact *zaum* was drawn from sources that gave it strong theological undertones: Kruchenykh's contributions to *zaum* were, for example, heavily influenced by ethnographic field reports on Christian glossolalia (speaking in tongues), particularly as published in D. G. Konovalov's study of *Religious Ecstasy in Russian Mystical Sects* (1908).[81]

Long after the opera, *zaum* poetry continued to be central to Malevich's development, propelling him to break with representation in pursuit of "*zaum* painting*." In the summer of 1913 Malevich wrote to his collaborator Matiushin, offering his understanding of their common objective:

> We have come as far as the rejection of reason, but we rejected reason because another kind of reason has grown in us, which in comparison with what we have rejected can be called beyond reason [*zaumnyi*], which also has law, con-struction, and sense, and only by learning this shall we have work based on the law of the truly new "beyond reason."[82]

His pursuit of an intelligibility "beyond reason" was thus oriented by a sen-sitivity to another kind of "law" that was in some way higher or deeper than logical formulation allowed. At the heart of Malevich's interest in *zaum*—whether in poetry or painting—was the conviction that the domains of human reasoning and language rely on creaturely functions that cannot ulti-mately account for themselves: the very possibility of intelligible thought and speech is given by and grounded in a reality that necessarily exceeds

[79]Sarah Pratt, "Avant-Garde Poets and Imagined Icons," in Gatrall and Greenfield, *Alter Icons*, 178-83.
[80]Ibid., 179. For a helpful study of the "holy fool" tradition, see Sergey A. Ivanov, *Holy Fools in Byzantium and Beyond*, trans. Simon Franklin (Oxford: Oxford University Press, 2006). Ivanov defines the holy fool as a person who "is seen—accurately or otherwise—as a righteous man who assumes the guise of irrationality for ascetic and educational purposes. . . . Holy foolery always, in our view, involves aggression and provocation. By 'provocation' I mean the deliberate manipulation of a situation such that somebody is forced into an otherwise undesirable action which the provo-cateur can foresee. By 'aggression' I mean an activity whose purpose is to disrupt the status quo in personal relations and which is perceived as hostile by the person at whom it is directed" (7, 9).
[81]See Pratt, "Avant-Garde Poets and Imagined Icons," 26-31; and Charlotte Douglas, "Beyond Rea-son: Malevich, Matiushin, and Their Circles," in Tuchman, *Spiritual in Art*, 187.
[82]Malevich, letter to Mikhail Matiushin (June 1913), quoted in Douglas, "Beyond Reason," 188. See also Rainer Crone and David Moos, *Kazimir Malevich: The Climax of Disclosure* (London: Reak-tion Books, 1991), 107.

their reach and is thus essentially unthinkable and unspeakable. The aim of
zaum was to foster a manner of reasoning that felt for these outer edges of
thinking in order to gesture beyond them. According to Malevich, the
highest function of art is to jolt the recognition that the daily communication
of "each man is only a conduit for the infinite ocean of knowledge and power
that lies behind mankind."[83]

As announced on a leaflet distributed at the *0.10* exhibition, one of Malev-
ich's earliest names for his new austere form of abstract painting was "*zaum*
realism."[84] The other name Malevich applied to this work—the name that
stuck—was "suprematism," a name meant to designate the supremacy of
formal color energy as the primary mode of meaning in painting. Aleksandra
Shatskikh highlights the religious derivation of this term: "The word [*supre-
matism*] had its roots in Malevich's native language, Polish, to which it had
come, in turn, from the Latin of the Catholic liturgy [*supremacia*]."[85] Andréi
Nakov notes that in fact "Latin phrases are sprinkled throughout [Malevich's]
letters. . . . His vocabulary at the time was marked by numerous references to
Christianity and to the Bible, testifying to the religious education deeply im-
printed in his cultural background and which was later to make up the cultural
habitus of his philosophical pronouncements."[86]

This returns us to *Black Square*, which was visual *zaum* in at least two senses.
On the one hand, it was a strict formalism that evacuated the representational
functions of painting and instead began composing works based entirely on
the dimensions of the canvas itself.[87] Malevich considered this "a new,

[83]Malevich, quoted in Douglas, "Beyond Reason," 188.

[84]See Masha Chlenova, "Early Russian Abstraction, as Such," in Dickerman, *Inventing Abstraction*,
203. Cf. Kruchenykh: "I rejoice in the victory of painting as such. . . . *Zaum* language . . . extends
its hand to *zaum* painting" (quoted on p. 203).

[85]Shatskikh, *Black Square*, 54. Cf. Nakov, *Malevich: Painting the Absolute*, 2:110.

[86]Nakov, *Malevich*, 2:112.

[87]According to Paul Wood, Malevich initiated "the possibility not of breaking down a picture from an
image of the world but of building up a painting from an entirely abstract set of components. Re-
garded in this way, the *Black Square* stands as something like the first word in a new language, which
can then be developed, elaborated, and explored." Wood, *Conceptual Art* (London: Tate Publishing;
New York: Delano Greenidge Editions, 2002), 11. Geometrically, the smaller black square was de-
rived by inscribing a circle in the white square of the canvas and then setting the black square within
it, such that the diagonal of the black square is (roughly) equal to the outside edge of the canvas
(since both are equivalent to the diameter of the circle). (However, this description only applies to
the original painting. Malevich painted at least four versions of *Black Square*, all at different sizes
and having different internal proportions. The first version was painted in 1915 [though he conceptu-
ally backdated it to 1913], the second c. 1923, the third 1929 and the fourth in the early 1930s.)

healthier form of art" over against the "moldy vault" of academic tradition, whose pictorial conventions he believed had become self-indulgent, "fattened on wine and debauched Venus de Milos."[88] There was a moral rigor to his defiance: "You will never see sweet Psyche's smile on my square, and it will never be a mattress for love-making."[89] And this formalism also had sharp political edges to it: "Imitative art must be destroyed like the imperialist army. . . . Just as in the old days the West, East, and South oppressed us economically, so it was in art. . . . The creative construction of the new art has produced the Suprematism of the square."[90]

On the other hand, however, this formalizing of pictorial language was motivated specifically by the desire to gesture beyond the traditional pictorial "reasoning" of painting. At the core of Malevich's philosophy was the pursuit of "something more subtle than thought, something more light [*sic*] and more flexible. To express this in words is not merely false, but quite impossible. This 'something' every poet, painter, and musician feels and tries to express, but when he is about to do so, then this refined, light, flexible 'something' becomes 'She,' 'Love,' 'Venus,' 'Apollo,' 'the Naiads [water nymphs],' and so on."[91] Against this tendency, Malevich wanted to know if it was possible to gesture toward the "something more subtle than thought" without condensing it into a recognizable "figure" of thought. Suprematist painting was thus conceived as a rigorous pursuit of "objectlessness" (*bespredmentnost*).

In this sense, there was a profound desolation inscribed in the *Black Square*, but not necessarily in the way that Benois saw it. Malevich repeatedly referred to the objectlessness of his paintings as a "desert" into which he ventured like an ascetic pilgrim seeking purification. In his letter to Benois, Malevich vowed that he would muster the "strength to go further and further into the empty wilderness. For it is only there that that transformation can take place."[92] In this way he repeatedly framed his painting practice as analogous to the ascetic mysticism of the desert fathers: "The ascent to the heights of nonobjective art is arduous and painful. . . . The familiar recedes ever further and further into

[88]Malevich, letter to Benois, in Andersen, *Malevich: Essays*, 44. Malevich's anti-academic outcries are ubiquitous throughout his writing.

[89]Ibid., 48.

[90]Malevich, "The Question of Imitative Art" (1920), in Harrison and Wood, *Art in Theory, 1900–2000*, 297-98.

[91]Malevich, "On Poetry" (1919), in Andersen, *Malevich: Essays*, 76.

[92]Malevich, letter to Benois, in Andersen, *Malevich: Essays*, 45.

the background. . . . No more 'likenesses of reality,' no idealistic images—
nothing but a desert! But this desert is filled with the spirit of nonobjective
sensation which pervades everything."[93] And here we glimpse the extent to
which Malevich's work was rooted in apophatic or "negative" theology—a
mode of theology that meditates on the absolute Fullness and Otherness of
God by way of negating the verbal, visual and conceptual forms used to signify
(and to "grasp") God. The long traditions of Christian apophatic theology
valued this "negative way" not as a means of negating God but as a means of
recognizing the problematic extent to which creaturely speech and thought
reduces God to an object—a being among other beings—forgetting that God
precedes and pervades the Giving of being itself and of the very possibility of
speech and thought. The absence of figuration in Malevich's work, his visual
asceticism, ultimately has less to do with vacancy than it does with recognizing
a pervasive fullness that surpasses and displaces all figurative appearance.
Namely, it is a fullness perceived not by sight but by "feeling": he believed that
the highest form of painting is that "which gives the fullest possible expression
to *feeling as such* and which ignores the familiar appearance of objects."[94] And
thus, "this was no 'empty square' which I had exhibited but rather the feeling
of nonobjectivity."[95]

For Malevich *white* was the color of the suprematist desert.[96] In a whimsi-
cally formulaic passage he spelled out the calculus of *Black Square*: "The square
= feeling; the white field = the void beyond this feeling."[97] By 1917 he began
making paintings preoccupied entirely with the white field, the wholly imper-
ceptible "beyond" all feeling. He painted deserts of *White on White* (1918) in
which "objectless" forms—in one case a rotated square ("square = feeling")—
appear in subtly varying hues of white; and by May 1923 he presented paintings

[93]Malevich, "Suprematism" (1927), in Chipp et al., *Theories of Modern Art*, 342.

[94]Ibid., 341 (emphasis added). Malevich asserted that "a blissful sense of liberating nonobjectivity
 drew me forth into the 'desert,' where nothing is [perceivably] real except feeling . . . and so feeling
 became the substance of my life" (342; ellipsis original).

[95]Ibid., 342.

[96]According to Malevich, "The Suprematist canvas reproduces white but not blue space. The reason
 is obvious: blue does not give a true impression of the infinite. The rays of vision are caught in a
 cupola [of atmospheric color] and cannot penetrate the infinite." Malevich, "Suprematism: 34
 Drawings" (1920), in Andersen, *Malevich: Essays*, 125.

[97]Malevich, "Suprematism," 343. Years earlier he asserted that the white grounds were meant to give
 "a true impression of the infinite" and "the true real conception of infinity." Malevich, "Supre-
 matism: 34 Drawings," 125, 121.

composed only of a singular blank whiteness—paintings that he collectively referred to as the "Suprematist Mirror."[98]

Malevich's work was theologically charged throughout his career, but around 1920—in the midst of the most tumultuous years of the Russian Revolution (1917–1923)—he began connecting it more explicitly to Russian Orthodox Christianity. In a letter to Mikhail Gershenzon in the spring of 1920 he confessed:

> Now, I have returned, or entered into the world of religion. . . . I go to church, I look at the saints and at all the protagonists of the spiritual world, and I see in myself and perhaps in the whole world that the moment for religious change is beginning. . . . I see in Suprematism, in the three squares and the cross, a beginning that is not just pictorial, but encompasses everything.[99]

This return to religion corresponded with a return to painting (which he had abandoned for a period of time to focus entirely on teaching and writing) and a reintroduction of figurative imagery—specifically religious imagery. Matthew Drutt summarizes this as "the period during which the spiritual dimensions of Suprematism became more formally linked with religious painting through Malevich's adaptation of the Orthodox cross."[100] He produced numerous paintings of crosses, including *Suprematism (Hieratic Suprematist Cross)* (1920–1921), *Suprematism (White Suprematist Cross)* (1920–1921), *Suprematism of the Spirit* (or *Suprematism of the Mind*) (1920) and multiple remakes of *Black Cross* (1920). He also painted multiple versions of distinctly Russian Orthodox crosses (depicted with an angled foot bar)—all titled *Mystic Suprematism* (1920–1922) (and sometimes given differentiating subtitles like *Black Cross Red Oval*). As Nakov puts it, Malevich began "'crucifying' his initial square, so to speak."[101]

At the same time, Malevich continued to devote a great deal of energy to writing, especially his essay *God Is Not Cast Down* (written in 1920 and published

[98]The monochrome white paintings were presented in the Academy of Art in Petrograd on May 17, 1923, in a massive exhibition of more than 1600 artworks created by the members of Malevich's school UNOVIS. Alongside the exhibition, Malevich published a radically apophatic manifesto titled "The Suprematist Mirror" (1923), in Andersen, *Malevich: Essays*, 224-25.

[99]Malevich, letter to Gershenzon (April 11, 1920), quoted in Lodder, "Living in Space," in Douglas and Lodder, *Rethinking Malevich*, 201.

[100]Drutt, "Kazimir Malevich: Suprematism," in Drutt, *Kazimir Malevich: Suprematism*, 28.

[101]Nakov, *Malevich: Painting the Absolute*, 3:239.

in 1922).[102] In this essay he argued that "man has divided his life into three paths: the spiritual or religious, the scientific or factory, and that of art. . . . They are the three paths along which man moves towards God."[103] Though they often appear to be in conflict—especially in the violent and volatile early years of the Soviet state—Malevich saw them as ultimately complementary and convergent: three concrete paths that find their beginning and end in the transcendent God. As he saw it, all human thinking and working are pressed along these paths through "a process, an activity of an unknowable stimulus [*vozbuzhdenie*]." In other words, we always already find ourselves existing and stimulated into consciousness in such a way that ultimately we cannot account for the Giving of this stimulus in the first place; we can only receive it and work within it. There is thus an Unthinkable on which all thinking relies, and "that is why Nothing [the Unthinkable] has an influence on me, and why Nothing, *as an entity*, determines my consciousness; for everything [all that is thinkable] is stimulus."[104] Malevich's "Nothing" is thus not an ontological absence but a means of designating a fullness that is intrinsically imperceptible and ineffable: "infinity has no ceiling or floor, no foundations or horizon, and, therefore, the ear cannot catch the rustle of its movement, the eye cannot see its limit, and the mind cannot comprehend."[105] Malevich's contention is that the fullness of the infinite can only appear (phenomenologically speaking) as a "nothing, i.e. incomprehensible to consciousness."[106]

Malevich's appeal to "Nothing, as an entity" is thus not nihilistic but is rather radically apophatic. Despite his bombastic rhetoric, Malevich's theology was centered on the acknowledgment of human limit: "There stands before God the limit of all senses, but beyond the limit stands God in whom there is no sense. . . . His senselessness should be seen in the absolute final limit as nonobjective."[107] Malevich proclaims that "God Is Not Cast Down" because

[102]Malevich, *God Is Not Cast Down: Art, Factory, Church* (1920–1922), in Andersen, *Malevich: Essays,* 216. Unless otherwise noted, all quotations of this essay will be from Andersen's volume.

[103]Ibid. Interestingly, Malevich devotes very little of this long essay (basically one paragraph) to the path of art. He is much more concerned with the paths of church and factory.

[104]Malevich, *God Is Not Cast Down,* as quoted in T. J. Clark, *Farewell to an Idea: Episodes from a History of Modernism* (New Haven, CT: Yale University Press, 1999), 256 (emphasis added). However, the translation has been modified to retain "stimulus" (Andersen) rather than "excitation" (Clark) as the translation of *vozbuzhdenie.*

[105]Malevich, *God Is Not Cast Down,* 192.

[106]Ibid., 191.

[107]Ibid., 204.

God is not an object; there is never any sense in which it could be intelligible for the Giving of being as such to be "cast down." According to Besançon, "Malevich sees God as being's beyond" for which the only appropriate signifier is a kind of "nothingness" (no-thingness).[108] Malevich's ideology thus has much less to do with Russian nihilism than it does with the Christian mysticism of Pseudo-Dionysius, for whom God is "the wholly unsensed and unseen . . . beyond every denial, beyond every assertion."[109]

Jean-Claude Marcadé urges us to recognize that "neither pictorial Suprematism nor Suprematist philosophy is iconoclastic or nihilist"; rather it is a form of "'transmetaphysical thought' that seeks a new relationship with God," who is beyond the reach of the representational operations of pictorial imagination and philosophical metaphysics alike.[110] Malevich's apophaticism obviously *does* engage in a kind of iconoclasm, but Marcadé argues that it is an iconoclasm that leaves the *domain* of the icon intact, even as it forces its imagery to become nonpictorial. As T. J. Clark puts it, "part of the point was the non-naming, the *un*meaning" that takes place precisely in a framework of expectations for paintings to conduct namings and meanings.[111] As Malevich himself said, "The square is not an image, just as a switch or a socket is not yet an electric current."[112] The "yet" in that statement is key: the square is the open (im)possibility of seeing an image of God.

God Is Not Cast Down cut directly against the grain of Soviet materialism, and as a consequence it was harshly criticized. With the death of Lenin in 1924 the political scrutiny directed toward Malevich increased exponentially, and the remaining years of his life were exceedingly difficult. In June 1926 he organized an exhibition of artists associated with GINKhUK (State Institute of Artistic Culture), which was met with a scathing article by the critic Grigory Seryi: "A monastery has taken shelter under the name of a state institution. It is inhabited by several holy crackpots who, perhaps unconsciously, are engaged

[108]Besançon, *Forbidden Image*, 371.

[109]See "The Mystical Theology," in *Pseudo-Dionysius: The Complete Works*, trans. Colm Luibheid (Mahwah, NJ: Paulist Press, 1987), 135-36. See also Vladimir Lossky, *The Mystical Theology of the Eastern Church* (Crestwood, NY: Saint Vladimir's Seminary Press, 1957), esp. chap. 2.

[110]Marcadé, "Malevich, Paintings, and Writing: On the Development of a Suprematist Philosophy," in Drutt, *Kazimir Malevich: Suprematism*, 41.

[111]Clark, *Farewell to an Idea*, 252.

[112]Malevich, quoted in Achim Borchardt-Hume, "An Icon for a Modern Age," in Borchardt-Hume, *Malevich*, 24.

in open counterrevolutionary sermonizing, and making fools of our Soviet scientific establishments."[113] It was a slanderous and politically motivated hit-piece, but Seryi's association of the institute with a monastery had merit: the exhibition was designed to mimic an Orthodox sanctuary, complete with what amounted to an iconostasis screen composed of a giant suprematist banner flanked on three sides by remade versions of *Black Square, Black Circle* and *Black Cross*. Seryi's complaints led to formal investigations of Malevich, and by the end of the year he had been fired and GINKhUK closed.

In 1928 his longtime friend Ivan Kliun wrote a letter to Malevich appealing to him to rethink his commitment to objectlessness:

> You must take up the brush, the time has come; it is time to come out of the desert. I am not deciding the question of what and how you must paint, but I know that you must paint a picture, and you yourself will see how your voice will ring out firmly, as it once did. Now it is necessary.... Only the hammer and sickle will help you get out of the desert of objectlessness.[114]

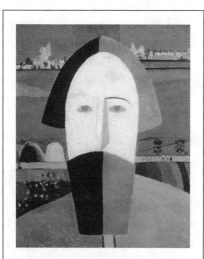

Figure 5.2. Kazimir Malevich, *Head of a Peasant Man*, 1929–1932

Malevich's paintings did come out of the desert, but it was not the hammer and sickle that brought them out; it was once again religious imagery. Malevich's *Head of a Peasant Man* (1929–1932) (fig. 5.2) riffed on the portraits he had painted of Kliun twenty years earlier, but this time he explicitly painted him as an image of Christ. A red cross form appears immediately behind this bearded figure's head, borrowed directly from an iconic motif of Christ's face that was well known throughout Russia, and he allocated

[113]Grigory Seryi (Grigory Sergeevich Ginger), "A Government-Supported Monastery" (June 10, 1926), quoted in Douglas, *Kazimir Malevich*, 33.
[114]Kliun, letter to Malevich (1928), quoted in Natalia Avtonomova, "Malevich and Kandinsky: The Abstract Path," in Douglas and Lodder, *Rethinking Malevich*, 61.

the mystical color white to the face of Christ.[115] He played up the iconic overtones by placing the painting in a painted gold frame. According to Alfia Nizamutdinova, this is the image of "Malevich's Golgotha," and as such it as "the key to understanding the peasant theme in Malevich's oeuvre and the artist's own personal philosophy of the world."[116]

In the midst of a wave of Soviet antireligious measures, Malevich defiantly painted overtly religious imagery. In the late 1920s and early

Figure 5.3. Kazimir Malevich, *The Artist (Self-Portrait)*, 1933

1930s he painted and sketched numerous "mystics" who bear the sign of the Russian Orthodox cross on their otherwise blank faces, hands and feet. *Praying Figure* (c. 1922) is a particularly striking example but so too are *Face with Orthodox Cross* (c. 1930–1931), *Black Head with Orthodox Cross* (1930–1931), *Mystical Black Face* (c. 1930–1931), *Figure with Arms Crossed* (c. 1930), *Figure Forming a Cross* (1930–1931) and *Female Figure with Arms Extended Crosswise* (c. 1930–1931). One of Malevich's last paintings is *The Artist (Self-Portrait)* (1933) (fig. 5.3). Though initially triggering references to Italian Renaissance painting, the odd pose more directly references *Hodegetria* icon paintings (see fig. 5.4)—the role of the artist is to be "one who points the way." Malevich does indeed point, but without an image of the incarnate Christ child; he points us beyond the frame of the canvas toward the unseen, or toward what is in fact altogether unseeable. In many ways this self-portrait is a figurative counterpart to the apophaticism of his earlier suprematism. Tellingly, in the lower right corner Malevich signed the painting only with a black square.[117]

[115]See Douglas, *Kazimir Malevich*, 108-9.

[116]See Petrova, *Origins of the Russian Avant-Garde*, 192.

[117]Fruitful comparisons (and contrasts) can be drawn between Malevich and the German-born American painter Josef Albers (1888–1976), particularly with regard to Albers's numerous paintings titled *Homage to the Square* (1949–1976). Albers was a practicing Catholic throughout his life, which seems to have deeply shaped the extent to which he understood his paintings as "icons." Though this aspect of his work is generally ignored in the scholarship, recent exceptions include exhibitions from 2012 and 2013, both organized by Nicholas Fox Weber. See Weber, ed., *The Sacred*

Figure 5.4. Lambardos Emmanuel, *The Virgin Hodegetria*, first half of the seventeenth century

HUGO BALL AND THE
THEOLOGY OF ZURICH DADA

At the same time that Malevich was developing his apophatic, non-objective paintings in Russia, some of the most radical artists in the European avant-garde, the Dadaists, were beginning to meet and collaborate in Germany and Switzerland—and, as we will see, developing in ways that function as striking theological counterparts to Malevich.[118] Within the canons of Western art history Dada is generally represented as the most blatantly nihilistic moment of the modernist

avant-garde—an antirationalist, anarchist, even misanthropic revolt against Western social values. And in fact there is much to commend this view: there are numerous examples and proof-texts one might cite to convey the extent to which Dada "radiated a contemptuous meaninglessness," to borrow Hal Foster's memorable phrase.[119] Within Christian circles Dada usually functions as an epitome of modernism at its theological worst, a tragic convergence (or inverted apotheosis) of everything that is most problematic about the post-Christian avant-garde. The prevailing view in these circles still generally accords with Hans Rookmaaker's description of Dada as "a nihilistic, destructive movement of anti-art, anti-philosophy . . . a new gnosticism, proclaiming that this world is without meaning or sense, that the world is evil—but with no God to reach out to."[120] And while this accurately describes some of what

Modernist: Josef Albers as a Catholic Artist, exh. cat. (Cork, Ireland: Lewis Glucksman Gallery, 2012); and Weber, ed., *Josef Albers: Spirituality and Rigor*, exh. cat. (Milan, Italy: Silvana Editoriale, 2013).

[118]A version of this section was presented by Jonathan Anderson at the 2015 biennial conference of Christians in the Visual Arts (CIVA), theology and the visual arts track, Calvin College (Grand Rapids, MI), June 12, 2015.

[119]Hal Foster, Rosalind Krauss, Yve-Alain Bois and Benjamin H. D. Buchloh, *Art Since 1900: Modernism, Antimodernism, Postmodernism* (New York: Thames & Hudson, 2004), 1:138.

[120]Rookmaaker, *MADC*, 130.

Dada was, there is much else that it doesn't account for. The historical unfolding of Dada, especially from its origins in Zurich, is much more variegated and interesting than its typical relegation to nihilism—and in fact much more theologically substantive.

The academic literature on Dada has swelled over the past few decades, and in the process it has become increasingly clear that, as Debbie Lewer puts it, "there are almost as many 'Dadaisms' as there were Dadaists."[121] There was remarkable intellectual diversity and difference of purpose not only between the various Dada groups—Zurich Dada had a very different sense of itself than did Paris Dada, for instance—but also among the original Dadaists[122] themselves, who continuously struggled with each other over the meanings and implications of what they were doing. These meanings were deeply political, aesthetic and philosophical, but they were also intensely *theological*—and they were so from the beginning.

Though Dada would later become strongly associated with influential artists in Berlin, Paris and New York (e.g., Hausmann, Picabia and Duchamp), its initial formation occurred in Zurich among an international group of artists who fled to neutral Switzerland in the early months of World War I. By all accounts Hugo Ball (1886–1927) stands at the fountainhead of Dada "activity" (he objected to calling it a movement or an -ism), and he was undoubtedly one of its most articulate exegetes and commentators.[123] Ball was raised in a

[121]Lewer, "Hugo Ball, Iconoclasm, and the Origins of Dada in Zurich," *Oxford Art Journal* 32, no. 1 (2009): 17-35. Lewer is particularly interesting for our purposes here because she is one of a handful of scholars who have begun rethinking the diverse theological positions within these Dadaisms. See also Leonard Aldea, "The Implicit Apophaticism of Dada Zurich: A Spiritual Quest by Means of Nihilist Procedures," *Modern Theology* 29, no. 1 (January 2013): 157-75.

[122]Whether Dada can be understood in terms of Dada*ism* or Dada*ists* has been a matter of debate. See, for example, Michel Sanouillet, "Dada: A Definition," in *Dada Spectrum: The Dialectics of Revolt*, ed. Stephen C. Foster and Rudolf E. Kuenzli (Madison, WI: Coda Press and University of Iowa, 1979), 15-27.

[123]Among Ball's most important and brilliant writings is a collection of his diary entries from 1913 to 1921. He began editing these diaries for publication in December 1923 and published them under the title *Die Flucht aus der Zeit* in January 1927, the last year of his life. It wasn't until 1974 that this volume was finally translated into English as Hugo Ball, *Flight out of Time: A Dada Diary*, ed. John Elderfield, trans. Ann Raimes (New York: Viking, 1974).

　　Flight Out of Time—hereafter simply referred to as *Flight*—is a primary resource for what follows, though its controversial status needs to be acknowledged. Because Ball edited them after his conversion back to Christianity, some scholars regard these as "corrupted" versions of his diaries, arguing that Ball redacted them to modify his views and to show a clearer trajectory back to Catholicism than would have otherwise appeared in the original writings. Ball himself states that he conceived the book as a "diary from exile" but "highly reworked" from the original

devoutly Catholic home in a predominantly Protestant part of Germany, shaping him in ways that would be deeply important throughout his life.[124] His renunciation of Christianity roughly corresponded to the beginning of his studies at the University of Munich, where from 1906 to 1910 (with one year at the University of Heidelberg) Ball studied philosophy and began writing a doctoral dissertation on Friedrich Nietzsche.[125] During this time he read voraciously in the fields of socialist and anarchist political theory and (under the influence of Nietzsche's philosophy of art) became deeply interested in poetry and theater. In 1910 he left Munich abruptly, without finishing his PhD, and moved to Berlin to pursue a career in theater. Over the next decade Ball would become a key contributor to some of the most radical artistic experiments in the European avant-garde, including the launch of Dada in February 1916. Throughout this time, however, he was wrestling with difficult theological questions and concerns, and by the summer of 1920 Ball had reconverted to Catholicism and devoted the remaining seven years of his life[126] to ascetic religious practice and theological study.

And thus the question that will orient the rest of this chapter: How should we understand Hugo Ball's Dadaism in relation to his Christianity? Was there a sharp discontinuity between the two, such that his conversion was a radical break; or was there in fact some kind of deep continuity throughout, such that the ostensible nihilism of his Dadaism was actually underwritten by a deeply

writings; however, this reworking seems to have been an effort of distilling more than rewriting: "they are only extracts" (Ball, quoted in Erdmute Wenzel White, *The Magic Bishop: Hugo Ball, Dada Poet* [Columbia, SC: Camden House, 1998], 179, 185). A simplistic relegation of the diaries to the status of "corrupted texts" is problematic, given that (1) the texts were "corrupted" by the author himself from writings that were never meant to be published; (2) Ball did indeed convert back to the Catholic Church, making it unclear on what basis we should accuse Ball of constructing a false trajectory back to Christian belief; and (3) this criticism generally collapses into a projection screen for the reader's assumptions about what Ball was "really" thinking during the Dada years. For an overview of the controversy, see the introduction to Philip Mann, *Hugo Ball: An Intellectual Biography* (London: Institute of Germanic Studies, 1987), 1-14.

[124]Ball's childhood seems to have deeply structured his theological imagination. Throughout his published diaries he repeatedly refers to childhood as a time of unusual clarity and enchanted profundity; indeed, he looked to childhood to provide resources for an authentic resistance "against senilities and the adult world. The child will be the accuser at the Last Judgment." See Ball, August 5, 1916, *Flight*, 72; cf. 66, 83, 105, 204, 214.

[125]Begun while at the University of Munich (but never completed), Ball's dissertation was titled "Nietzsche in Basel: A Contribution to the Renewal of Germany." This unfinished dissertation was first published five decades after Ball's death as "Nietzsche in Basel: Eine Streitschrift [A Polemic]," ed. Richard Sheppard and Annemarie Schütt-Hennings, *Hugo Ball Almanach* 2 (1978): 1-65.

[126]Tragically, Ball died of stomach cancer in 1927 at the age of forty-one.

serious theological struggle? In short, what kinds of theology were in play in Zurich Dada?[127]

The birth of Dada is often dated to February 5, 1916, the opening day for the Cabaret Voltaire in Zurich.[128] Ball's advertisements for the cabaret announced "a group of young artists and writers . . . whose aim is to create a center for artistic entertainment," featuring performances and readings at daily meetings.[129] The young collaborators who joined Ball would become central to the life of Dada (internationally) over the next few years, including Emmy Hennings (his partner and future wife), Hans Arp, Sophie Taeuber, Tristan Tzara, Marcel Janco (often accompanied by his brother Georges), Richard Huelsenbeck, and later Hans Richter and Viking Eggeling.

The numerous events and soirées that took place at the cabaret were notoriously transgressive and seemed to relish the offensively nonsensical. Concerts were played on typewriters, kettledrums, rakes and pot covers and were often accompanied by an out-of-tune piano. Poems were recited in French, German and Russian—languages spoken on both sides of the war—and soon the poems became indecipherable altogether. A common feature of the Dada soirée was the "simultaneous poem," consisting of three or more participants speaking, singing, whistling or bellowing different "poems" at the same time. This simultaneity generally brought together a mixture of high poetry, popular songs, boring journalistic ramblings and nonsense word sequences; and these contrapuntal recitations were then often accompanied by an assortment of inorganic noises: crashes, sirens, the beating of a giant drum, an *rrrrrrrrrrrrrrrrr* drawn out for several minutes and so on. The effect was abrasive and cacophonous, but Ball argued that for the sensitive viewer the implications of these performances are actually remarkably subtle, even heartbreaking:

> The "simultaneous poem" has to do with the value of the voice. The human
> organ represents the soul, the individuality in its wanderings with its demonic
> companions. The noises represent the [material, cultural and spiritual]

[127]Addressing these questions seems to have been Ball's primary reason for publishing his diaries. Taken as a whole, *Flight out of Time* amounts to an argument that Dada was a time in Ball's life of deep questioning and struggle, which pushed him back toward Roman Catholicism.

[128]The clearest explanation Ball gives for naming the cabaret after Voltaire is from a note in his diary on June 16, 1916: "The ideals of culture and of art as a program for a variety show—that is our *Candide* against the times" (*Flight*, 67).

[129]The press notice was published February 2, 1916. See the full text of the notice in Ball, *Flight*, 50.

background—the inarticulate, the disastrous, the decisive. The poem tries to elucidate the fact that man is swallowed up in the mechanistic process. In a typically compressed way it shows the conflict of the *vox humana* [human voice] with a world that threatens, ensnares, and destroys it, a world whose rhythm and noise are ineluctable.[130]

This motif of the vulnerable human person threatened by (and protesting against) the cool violence of mechanized modernity is recurrent throughout Ball's thinking and is central to the concerns that drove development of Dada—and the development of Dada theology.

Whatever theological content was in play in the Cabaret Voltaire was, however, pivoting on a radically unconventional theory of art—one that relentlessly demeaned aesthetic quality, craftsmanship and professionalism. The effect—indeed the stated intention—was to shift the hermeneutical center of gravity from the aesthetic character of the *art object* to the critical social consciousness implied in the *artist's activity*:

> For us art is not an end in itself—more pure naïveté is necessary for that—but it is an opportunity for true perception and criticism of the times we live in. . . . Our debates are a burning search, more blatant every day, for the specific rhythm and the buried face of this age. . . . Art is only an occasion for that, a method.[131]

The "age" in which Dada emerged was that which had launched World War I, precisely as the logics of technological industrialization and philosophical idealism were converging with unspeakably devastating effects. As European nations devoted themselves to industrialized warfare on an unprecedented scale, the Dadaists devoted themselves to sardonic "nonsense" and mean-spirited laughter. Ball understood this as an ethical maneuver, a means of establishing "distance"[132] from which to stand "against the agony and the death throes of this age."[133] In a diary entry from mid-April 1916, when the Cabaret Voltaire was little more than two months old, Ball declared: "Our cabaret is a gesture. Every word that is spoken and sung here says at least this one thing:

[130]Ball, March 30, 1916, *Flight*, 57.
[131]Ball, April 5, 1916, *Flight*, 58-59.
[132]According to Ball, "Only our will to establish distance will be new and noteworthy" (May 5, 1917, *Flight*, 111).
[133]Ball, June 12, 1916, *Flight*, 66. An alternative translation memorably renders this phrase: "The dadaist fights against the death-throes and death-drunkenness of his time." "Dada Fragments," in Harrison and Wood, *Art in Theory, 1900–2000*, 251.

that this humiliating age has not succeeded in winning our respect."[134] And with this he launched into a series of deflationary taunts:

> What could be respectable and impressive about it? Its cannons? Our big drum drowns them. Its idealism? That has long been a laughingstock, in its popular and its academic edition. The grandiose slaughters and cannibalistic exploits? Our spontaneous foolishness and our enthusiasm for illusion will destroy them.[135]

Over against the calculable mechanized efficiency of both the frontline machine gun and the backline munitions factory (and the rhetorical systems that held them together), Zurich Dada mobilized itself into a theater of incompetence, confusion and traumatized powerlessness. It protested against abusive cultural powers, and it did so through deliberately pathetic gestures. These gestures were tactical: "As no art, politics, or knowledge seem able to hold back this flood [of cultural pathologies], the only thing left is the practical joke [*blague*] and the bloody [or bleeding] pose."[136] In this way Dada's spectacle of unprofessional pranks and displays of weakness was meant to function as a desperate ethical refusal.[137] As Hal Foster has put it, "Ball regarded the Dadaist as a traumatic mime who assumes the dire conditions of war, revolt, and exile, and inflates them into buffoonish parody." But this was parody with principles: "Dada mimes dissonance and destruction in order to purge them somehow."[138]

Hans Arp once described the cabaret as full of people "shouting, laughing, and gesticulating. Our replies are sighs of love, volleys of hiccups, poems, moos, and meowing of medieval bruitists.... We were given the honorary title of nihilists."[139] But this title is clearly a misleading designation for many of the Zurich Dadaists—particularly for Hugo Ball. Far from a nihilistic embrace of

[134]Ball, April 14, 1916, *Flight*, 61.

[135]Ibid.

[136]Ball, June 12, 1916, *Flight*, 66. In an entry four days later: "They cannot force our quivering nostrils to admire the smell of corpses. They cannot expect us to confuse the increasingly disastrous apathy and coldheartedness with heroism. One day they will have to admit that we reacted very politely, even movingly. The most strident pamphlets did not manage to pour enough contempt and scorn on the universally prevalent hypocrisy" (June 16, 1916, *Flight*, 67).

[137]The manifest weakness of Dada was very much the point, and it proved to be strangely poignant as a form of lamentation: "Mountains are being displaced and cities lifted up in the air. So why shouldn't the plaster around human hearts get splits and cracks in it?" Ball, October 5, 1915, *Flight*, 31.

[138]Hal Foster et al., *Art Since 1900*, 136-37.

[139]Arp, "Dadaland" (1948), in *Arp on Arp: Poems, Essays, Memories*, ed. Marcel Jean, trans. Joachim Neugroschel (New York: Viking, 1972), 234.

"nothingness," Ball asserted that "what we call dada is a farce of nothingness [*Narrenspiel aus dem Nichts*] in which all higher questions are involved; a gladiator's gesture, a play with shabby leftovers, the death warrant of posturing morality and abundance."[140] Ball's characterization of Dada as a farcical nihilism is thus coupled with a disarming list of metaphors that do indeed call up high questions: (1) the gesture of a gladiator whose life is at stake for entertainment (what is the value of human life?), (2) a playful recovery of the detritus of consumer culture (what are our metrics of value?), and (3) the severest indictment of false moralities designed to augment wealth (what is the good life, morally or materially?). One might even say that Ball sought to invert the charge of nihilism, accusing the established powers—"This age, with its insistence on cash payment, has opened a jumble sale of godless philosophies"[141]—of manifesting a nihilism far deeper and more death-oriented than any "simultaneous poem" performed at the Cabaret Voltaire.

In his most evocative summary of Dada, Ball announced, "What we are celebrating is both buffoonery and a requiem mass."[142] This disorienting meld of images—an aggressive eschewal of rationalism, professionalism and politeness (buffoonery) commingled with formal liturgical lamentation (Requiem Mass)—provocatively signals a theological self-understanding intertwined with the social and political content of Dada's protests. Or, taking an even more disarming religious image, Ball once compared Dada to "a gnostic sect whose initiates were so stunned by the image of the *childhood* of Jesus that they lay down in a cradle and let themselves be suckled by women and swaddled. The Dadaists are similar babes-in-arms of a new age."[143] Erdmute Wenzel White is quite right to argue that in Ball's case we mustn't allow the apparent foolishness and bombastic rebellion to "disguise the intense spiritual longing that informs all his life and work."[144]

Contrary to general perception, the events in the Cabaret Voltaire made surprisingly frequent references to religious images and motifs. On June 3, 1916—in the middle of the summer and amidst ongoing war reportage (most recently from the disastrous Battle of Jutland)—the cabaret presented a

[140]Ball, June 12, 1916, *Flight*, 65.
[141]Ibid., 66.
[142]Ball, March 12, 1916, *Flight*, 56.
[143]Ball, June 13, 1916, *Flight*, 66.
[144]White, *Magic Bishop*, 191.

performance of Ball's *Krippenspiel* (Nativity Play), a simultaneous poem and bruitist "noise concert" that corresponded to and accompanied readings from the Gospel accounts of the birth of Christ.[145] Short adaptations of the biblical narrative were read aloud while actors performed the scenes behind a diaphanous screen, using nonword vocalizations and various objects to sonically construct the settings and activities of the nativity.

The *Krippenspiel* unfolded in a series of seven scenes. The first two scenes portrayed the annunciation to the shepherds and the setting of the stable in the rural "silent night"—which was in fact full of sound[146]—and then the scenes run through the journey of the magi. The final scene jolts the narrative forward into a prophetic foreshadowing of the crucifixion, culminating in an uproar of all the characters and animals yelling, jeering, bellowing, mooing and wailing. The final crescendo gives way to "nailing and screaming. Then thunder. Then bells." And (most likely) the last words spoken in the play had been handwritten into the otherwise already typed script: "And as he was crucified / much warm blood was shed."[147] Performed in the summer of 1916, the violence of this final scene would have had a twentieth-century referent as much as a first-century one. The *Krippenspiel* situated the brutality of the war within a theological framework, rendering a palpable image of human violence having "bloodied and soiled the good God."[148] Despite the occasionally

[145]For a helpful analysis of *Simultan Krippenspiel* see ibid., 87-100; and a full translation of the "score" is available on pp. 223-27. According to White, the noise concert and the narrative readings happened simultaneously, such that the work was actually "composed of two parallel scores" that "proceed alongside each other on an equal footing, like voices in early polyphonic song" (89).

[146]The play opened with a loudly vocalized "f f f f f f f f f fff f ffff t t"—the sound of wind blowing across the landscape—which was accompanied by the cracking of whips, stomping of hoofs, shepherds shouting and the "sound of the holy night" vocalized as an ongoing "hmmmmmmmm-mmmm." The second scene placed the audience in the stable among the noisy sounds of the animals, amidst which Mary and Joseph are heard praying: "ramba ramba ramba ramba ramba—m-bara, m-bara, m-bara, -bara- ramba bamba, bamba, rambabababababa." And simultaneously with all of this the narrator repeated over and over: "But Mary and Joseph were on their knees in the stable at Bethlehem and prayed to the Lord . . ." See ibid., 223-27.

[147]Ibid., 92.

[148]This phrase is taken from Ball's poem "Totentanz [Dance of Death] 1916" (1915–1916), which was performed the second night of the cabaret (see February 6, 1916, *Flight*, 51). This poem was set to the tune of a military marching song "with the assistance of the revolutionary chorus"; it is a scathing protest against the logic of the "Great War" and a lament for the dying soldiers. The poem asserts that the suffering of the soldiers is in fact a terrible wounding of the divine image: the war has "bloodied and soiled the good God." See White, *Magic Bishop*, 216-17, who summarizes the poem as ending with "a lullaby [to Herr Kaiser] disturbed by the trumpet sounds of the Last Judgment" as the bodies of innumerable dead soldiers wait beneath the surface of the ground (Ball, *Flight*, 52).

cacophonous soundscape of this summer nativity, the performance, according to Ball, had "a gentle simplicity that surprised the audience. The ironies had cleared the air. No one dared to laugh. One would hardly have expected that in the cabaret, especially in this one. We welcomed the [Christ] child, in art and in life."[149]

Perhaps the most renowned of the cabaret's events occurred about three weeks later on June 23, 1916, with a performance that has come to be known as the "magic bishop."[150] Ball appeared on stage to perform a series of his new "sound poems" (*Lautgedichte*)—poems that were carefully constructed sequences of unrecognizable sound-words.[151] He wore a costume of rigid, shiny blue cardboard cylinders, such that he stood on the stage "like an obelisk" (fig. 5.5). A cardboard cape (he called it "a huge coat collar") hung off his shoulders like a priestly cope, colored scarlet on the inside and gold on the outside; and on his head he wore a tall cylindrical blue-and-white-striped "shaman's hat" (*Schamanenhut*). The handwritten texts of his poems were placed on three music stands that stood in a semicircle around him on the stage, emphasizing the musical status of the sound poems. Unable to walk in his costume, Ball was carried onto the darkened stage, and as the lights came up he began to read "slowly and solemnly":

> gadji beri bimba
> glandridi lauli lonni cadori
> gadjama bim beri glassala
> glandridi glassala tuffm i zimbrabim
> blassa galassasa tuffm i zimbrabim

After delivering the entirety of this introductory poem from the central music stand, he turned to the stands on either side, delivering (at least) one poem at each, finally returning to the center for a second recitation of "gadji beri bimba."

[149]Ball, June 3, 1916, *Flight*, 65. Erdmute White goes so far as to argue that "in mood and subject matter, *Krippenspiel* was the cradle of Dada and its center of stillness. Rising up out of the soul, it was Dada's 'inner sound' and 'christening.'" White, *Magic Bishop*, 96.

[150]The following description of the performance relies heavily on Ball's entry for June 23, 1916, *Flight*, 70-71.

[151]Ball also referred to these poems as "verse without words" (*Flight*, 70), but it would be more accurate (even if clunky) to say that these are "verse with words of uncertain denotative function." The words were not entirely abstract but were full of color and sound, "touching lightly on a hundred ideas without naming them." Ball, June 18, 1916, *Flight*, 68. For an excellent discussion of the sound poems, see Mann, *Hugo Ball*, 87-91.

Figure 5.5. Hugo Ball in his "magic bishop" costume for a performance of *Lautgedichte*, 1916

At the stand on the right he performed the poem "Wolken [Clouds]" (or La-bada's Song to the Clouds), and then at the left stand he read "Karawane" (or "Elefantenkarawane [Elephant Caravan]"). The poems refused to coalesce into recognizable words, but the sound effects made when read aloud were carefully constructed to correspond to the subject matter alluded to in their titles[152]: rain from heavy clouds soaks the earth with "gluglamen gloglada gleroda glandridi," on the one hand, and the heavy "wulubu ssubudu uluwu ssubudu" lumbers onward with the plodding rhythm of a caravan of elephants, on the other.[153]

Ball was determined "at all costs" to maintain composure and seriousness throughout the performance, and as he proceeded through the poems he found the performance taking a form he had not intended:

> Then I noticed that my voice had no choice but to take on the ancient cadence of priestly lamentation, that style of liturgical singing that wails in all the Catholic churches of East and West. . . . I began to chant my vowel sequences in a church style like a recitative, and tried not only to look serious but to force myself to be serious. For a moment it seemed as if there were a pale, bewildered face in my cubist mask, that half-frightened, half-curious face of a ten-year-old boy, trembling and hanging avidly on the priest's words in the requiems and high masses in his home parish. Then the lights went out, as I had ordered, and bathed in sweat, I was carried down off the stage like a magical bishop.[154]

[152]One of Ball's most important influences in the development of the sound poems was Vasily Kandinsky. In late 1912 or early 1913 Kandinsky published *Klänge* (Sounds), a volume of thirty-eight prose poems paired with fifty-six abstract woodcut prints. Kandinsky's *Klänge* proved to be very influential for Zurich Dadaists, as inferred from the fact that they were read aloud in the Cabaret Voltaire on February 6, 1916, the second night of the cabaret's existence, and at the second Dada soirée (April 14, 1917). When the Galerie Dada was opened in 1917 the adjacent café was immediately named the Kandinsky Room. At the dedication of the café Ball delivered a lecture on the importance of Kandinsky's work (Ball, "Kandinsky," in *Flight*, 222-34), culminating with high praises for the "purely spiritual processes" of *Klänge*: "Nowhere else, even among the futurists, has anyone attempted such a daring purification of language" (234). As far as Ball was concerned, the most important alternative to "Picasso the faun" was "Kandinsky the monk" (226).

The possible influence of Russian modernist poetry should also be noted. The Berlin Dadaist Raoul Hausmann claimed that Ball knew of the Russian *zaum* poets, especially Velimir Khlebnikov, through his interactions with Kandinsky. See Elderfield, introduction to Ball, *Flight*, xlivn25.
[153]The three poems presented that night in June 1916 were part of a larger cycle of six sound poems. In addition to "gadji beri bimba," "Wolken [Clouds]" and "Karawane [Elephant Caravan]," the series also included "Katzen und Pfauen [Cats and Peacocks]," "Seepferdchen und Flugfische [Seahorses and Flying Fish]" and "Totenklage [Funeral Chant]."
[154]Ball, June 23, 1916, *Flight*, 71.

In this figure of the "magical bishop" Ball had encountered something of his Catholic childhood—the half-frightened, half-curious adolescent witnessing a requiem—but in a form that was strangely reclaiming his Dada insurrections and reframing them as some kind of a priestly function. His sound poems suddenly became some kind of prayer by which he found himself both attending and presiding over religious lamentation.

John Elderfield has argued that the sound poems "were close in spirit to Catholic chants,"[155] and according to Erdmute White one can trace "a direct line from plainchant to *Lautgedichte* [sound poetry]."[156] The performance had followed a liturgical *inclusio* format, in which "gadji beri bimba" was recited at both the beginning and the end of the cycle with two "meditations" in between—one oriented toward the sky (clouds) and the other toward the earth (caravan). The first of these—the extremely beautiful poem "Wolken"—hinges on the phrase "elomen elomen lefitalominai" (with only slight variation, this forms the first line of both the first and last stanza). As several commentators have pointed out, this phrase is a direct allusion to Christ's cry from the cross: "*Eloi, Eloi, lama sabachthani?*"—"My God, my God, why have you forsaken me?" (Mk 15:34 NRSV; cf. Mt 27:46; Ps 22:1).[157] Ball's song to the clouds is structured around Christianity's most tragic and profound address toward God.

Philip Mann has shown that Ball's "magic bishop" performance was not only performed in June at the Cabaret Voltaire but was also repeated at the first "public" Dada soirée on July 14, 1916, at Zurich's Waag Hall.[158] Ball prefaced this performance by reading his "Dada Manifesto" in which he flatly declared: "I shall be reading poems that are meant to dispense with conventional language" in the conviction that these poems "have the potential to cleanse this accursed language of all the filth that clings to it, as to the hands of stockbrokers worn smooth by coins."[159] Ball implored his audience to try to hear "The word, the word, the word outside your domain. . . . The word,

[155]Elderfield, "'Dada': A Code-Word for Saints?," *Artforum* (February 1974): 46.

[156]White, *Magic Bishop*, 126.

[157]Mann persuasively identifies further references in the poem to the cross, to cries of lamentation, and to a river or deluge that perhaps flows from or envelops the cross. Mann, *Hugo Ball*, 90.

[158]Mann, "Hugo Ball and the 'Magic Bishop' Episode: A Reconsideration," *New German Studies* 4, no. 1 (Spring 1976): 43-52.

[159]Ball, "Dada Manifesto" (1916), trans. Christopher Middleton, in *Flight*, 220-21. The last sentence has been modified to follow Debbie Lewer's more accurate translation. See Lewer, "Hugo Ball, Iconoclasm, and the Origins of Dada in Zurich," 29.

gentlemen, is a public concern of the first importance."[160] And not just a public concern: the "word outside your domain" is a theological concern of the highest order.

At the center of Ball's philosophy of language was an acknowledgment of "the power of the living word," which must be handled with the greatest care: "each word is a wish or a curse."[161] He saw a deep and vital link between a society's regard for the sacredness of language and the ethical treatment of others: "As respect for language increases, the disrespect for the human image will decrease. . . . It is with language that purification must begin, [and] the imagination be purified."[162] And he believed that the power of language resides not only in the *referential* function of words but on a more intrinsic, *ontological* level. For him the relations between vowels and consonants are "heavenly constellations"[163] that are in themselves potentially capable of wakening and strengthening "the lowest strata of memory."[164] The abjuring of everyday language in the sound poems was thus conceived as a strategy that was at once political and theological: "In these phonetic poems we totally renounce the language that journalism has abused and corrupted. We must return to the innermost alchemy of the word; we must even give up the word too, to keep for poetry its last and holiest refuge."[165]

The "holiest refuge" of poetry was for Ball the sheer recognition of the astonishing miracle that language is intelligible at all—that sounds and markings are capable of mediating the meanings of a world. For Ball this recognition opened a realm of enchantment—he didn't know how else to refer to the inexplicable link between word and meaning other than to call it "magical." The true achievement of sound poetry, he argued, was that it "loaded the word with strengths and energies that helped us to rediscover the evangelical concept of the 'Word' (*logos*) as a magical complex image. . . . We tried to give the isolated vocables the fullness of an oath [covenant], the glow of a star [cosmos]."[166] On this point Ball delved into Christian mysticism. He was, for

[160]Ball, "Dada Manifesto," in *Flight*, 221.
[161]Ball, November 25, 1915, *Flight*, 49.
[162]Ball, August 13, 1916, *Flight*, 76.
[163]Ball, quoted in White, *Magic Bishop*, 126.
[164]Ball, June 18, 1916, *Flight*, 68.
[165]Ball, June 24, 1916, *Flight*, 71.
[166]Ball, June 18, 1916, *Flight*, 68.

instance, familiar with the mystical *Lingua Ignota* (unknown language) of the twelfth-century abbess Hildegard von Bingen.[167] Hildegard's lengthy indexes of indecipherable word formations—strikingly comparable to Ball's sound poetry—were constructed for prayer and sacred speech. Perhaps we should take Ball quite seriously when he claimed that "we say the 'gadji beri bimba' as our bedtime prayer."[168]

In fact, Ball increasingly foregrounded mystical theology in his contributions to Dada events. The fourth public Dada soirée on May 12, 1917 (repeated a week later), included a number of readings excerpted from mystical theological texts: Mechthild of Magdeburg's *Flowing Light of the Godhead* (c. 1250–1280), *The Great German Memorial* (1383–1384) by the Alsatian mystic Rulman Merswin, *The Book of the Seven Degrees* (c. 1320) by the anonymous Monk of Heilsbronn, a selection from Jakob Böhme's *Aurora* (1612), as well as a series of poems (probably written by Hennings) titled "O You Saints."[169] Such a list makes manifest Leonard Forster's claim that "Dada was not merely the product of a certain set of circumstances, but also stood in a long tradition of mystical utterance."[170] And this tradition provided Ball with a theological framework for even the most bizarre experiments with sound poetry: "I realized that the whole world . . . was crying out for magic to fill its void, and for the word as a seal and ultimate core of life. Perhaps one day when the files are closed, it will not be possible to withhold approval of my strivings for substance and resistance."[171]

According to Philip Mann, Ball's theory of language was increasingly a "theological Realism," wherein both language and world are sustained and connected by the same *logos* that speaks and sustains all being. As Mann states, ultimately "it was in Christ, as the Word incarnate, that Ball found this fusion of sign and object."[172] Indeed, as Ball later wrote, "The great, universal blow

[167]See White, *Magic Bishop*, 127. For further study of *Lingua Ignota*, see Sarah L. Higley, *Hildegard of Bingen's Unknown Language: An Edition, Translation, and Discussion* (London: Palgrave Macmillan, 2007).

[168]Ball, quoted in White, *Magic Bishop*, 126.

[169]For an account of the fourth Dada soirée, see Ball, May 12, 1917, *Flight*, 112-13. See also Richard Sheppard, "Dada and Mysticism: Influences and Affinities," in Foster and Kuenzli, *Dada Spectrum*, 94-95, 102-4.

[170]Forster, *The Poetry of Significant Nonsense* (Cambridge: Cambridge University Press, 1962), 38 (emphases removed).

[171]Ball, July 23, 1920, *Flight*, 191.

[172]Mann, *Hugo Ball*, 98.

against rationalism and dialectics, against the cult of knowledge and abstractions, is: the incarnation."[173] Ultimately Ball's attack on the "journalistic" word was undergirded and oriented by a wager that all words find their origin and *telos* in the Word made flesh.

Following his conversion in 1920, Ball devoted himself to the study of early Christian and medieval mystical theology, leading to the publication of his book *Byzantine Christianity* (1923), a study of the church fathers John Climacus, Simeon the Stylite and Dionysius the Areopagite. The Christian apophatic theologian Dionysius the Areopagite[174] was especially influential, prompting major shifts in Ball's theology and in his (retrospective) understanding of Dada. This theologian was decisive in Ball's movement away from Nietzsche, as he came to believe that "Dionysius the Areopagite is the refutation of Nietzsche in advance."[175] But Dionysius also clarified the meaning of Dada for Ball: he would later claim that the term *Dada* bore the double inscription of the Areopagite's initials: "When I came across the word 'dada' I was called upon twice by Dionysius. D.A.–D.A."[176] Given the multiplicity of meanings assigned to the word *Dada* this is almost certainly a revisionist narrative created after the fact, but it does identify an aspect of Ball's Dadaism that was there from the beginning.[177] As John Elderfield writes, "it would be strange indeed if hidden in the alchemy of letters that

[173]Ball, July 31, 1920, *Flight*, 191-92. And in the same place he clarifies the lines of demarcation: "I declare myself on the side of the most rigorous of the [church] Fathers, who opposed the ancient philosophy [Platonism] skeptically and indeed censoriously."

[174]Dionysius the Areopagite was the name of an Athenian philosopher who became a follower of Paul following his discourse in the council of the Areopagus on Mars Hill (see Acts 17:34). Most scholars believe that the Greek writings attached to that name were, however, written by a fifth- or sixth-century Syrian monk, who is thus generally referred to as Pseudo-Dionysius. For an introduction and a complete collection of his writings, see *Pseudo-Dionysius: The Complete Works*, trans. Colm Luibheid (Mahwah, NJ: Paulist Press, 1987).

[175]Ball, April 17, 1921, *Flight*, 201. Mann argues that for Ball the Areopagite functioned as an "orthodox Dionysius" over against the Nietzschean Dionysianism that had attracted him in earlier years. Ball found in the Christian Pseudo-Dionysius the possibility of synthesizing what Nietzsche had torn apart: "Instead of seeing irreconcilable opposites in Judaic and Hellenic thought, as Nietzsche had done, Pseudo-Denis had conclusively united them." Mann, *Hugo Ball*, 152-55.

[176]Ball, June 18, 1921, *Flight*, 210. For further discussion of the relation between Ball and Pseudo-Dionysius, see Aldea, "Implicit Apophaticism of Dada Zurich," 157-75.

[177]Richard Huelsenbeck similarly asserted that the word *Dada* was neither accidental nor nonsensical: "To be sure, the choice of the word Dada in the Cabaret Voltaire was selective-metaphysical, predetermined by all the idea-energies with which it was now acting upon the world—but no one had thought of Dada as babies' prattle." Huelsenbeck, *En Avant Dada* (1920), in *The Dada Painters and Poets*, ed. Robert Motherwell (New York: Wittenborn, 1951), 31.

denoted the most scurrilous of modern movements lies a saint who dreamed of a hierarchy of angels."[178]

‖ ▌▌▌ ‖

The artists in this chapter borrowed heavily from iconic and liturgical forms that were deeply rooted in Christian traditions: from the Orthodox Church in the case of many Russian artists, like Goncharova and Malevich, and from Roman Catholicism in the case of Ball, Henning and some of the other Zurich Dadaists. Because of the nontraditional handling of these forms, this borrowing has often been interpreted as antagonistic or demeaning toward the religious traditions and institutions from which they were derived. But, as we've argued, such interpretations leave too much unaccounted for. Despite their varying difficulties with the church, and even their varying degrees of heterodoxy, the central concerns that preoccupied each of these artists included deeply theological concerns that were framed by (and ultimately remained grounded in) traditions of Christian thought and practice. This is not to argue that their work is straightforwardly Christian in any sense, but it is certainly to argue that it is not straightforwardly secularist (or nihilist) either. In each case, these artists were particularly preoccupied with the problems and possibilities of *referring*—whether visually or verbally—to the holy. In the extremely fraught historical context of World War I (and the subsequent construction of the Soviet communist state) these artists were wrestling with religious doubts and pursuing theological questions in the midst of extraordinary cultural cross-pressures, and as they did so they were trying to work out relevant ways to continue to address the sacred amidst these pressures. As we turn our attention to a very different context, we will see similar kinds of wrestling with religious traditions in North America.

[178]Elderfield, "'Dada': A Code-Word for Saints?," 47.

North America and the Expressive Image

America was an image before it was a fact.

JOHN WILMERDING[1]

Pictures must be miraculous. . . . The picture must be for [the artist], as for anyone experiencing it later, a revelation, an unexpected and unprecedented resolution of an eternally familiar need.

MARK ROTHKO[2]

The American vanguard painter took to the white expanse of the canvas as Melville's Ishmael took to the sea.

HAROLD ROSENBERG[3]

The history of painting in the United States has been dominated from the beginning with two themes: the portrait of outstanding persons in its history and the transcription of its diverse and vibrant natural environment into landscapes of all kinds. Both of these emphases have their roots in the Protestant Reformation, and, contrary to what is often asserted, both carry deep religious resonances—tones that echo and were sometimes influenced by the northern

[1]Wilmerding, *American Art* (Middlesex, UK: Penguin, 1976), 3.
[2]Rothko, "The Romantics Were Prompted" (1947), in *Art in Theory, 1900–2000: An Anthology of Changing Ideas*, ed. Charles Harrison and Paul Wood (Malden, MA: Blackwell, 2003), 572.
[3]Rosenberg, "American Action Painters," *Art News* 51 (December 1952), reprinted in *American Art: Sources and Documents, 1700–1960*, ed. John W. McCoubrey (Englewood Cliffs, NJ: Prentice Hall, 1965), 218.

romantic tradition discussed in chapter four. Portraits were, after all, images of those whom Christians insist were created in God's own image; landscapes also bore the semblance of the Creator, even representing, as Calvin wrote, a theater for the glory of God. But these emphases found unique expression, and a particular accent, in the development of art in the United States. Landscape and portraiture in fact could merge into autobiography: images could become expressions of personal visions and, often, of personal faith. We pick up this story in the mid-nineteenth century.[4]

When Thomas Cole (1801–1848) painted *Saint John the Baptist Preaching in the Wilderness* (1827) (plate 6), he sought to lift landscape painting to a new aesthetic level. He described his goal to his patron Robert Gilmore as a "higher style of landscape."[5] This work references both Cole's indebtedness to European traditions and his deep American roots. On the one hand, the painting recalled the elevated tradition of history painting and its moral purposes; on the other, its celebration of untamed wilderness signaled a substantial departure from that tradition and a milestone in the development of art in America.

Against the backdrop of a massive rockface, the tiny figure of John the Baptist appears on a lighted promontory, pointing at a cross. Ellen Avitts Menefee has proposed that Cole presents here a multiepisodic portrayal of Christ's life, from his birth (represented by the small flight into Egypt in the lower right), through the cross (representing his death), up to the burst of light on the mountain above (representing his resurrection).[6] She notes that the forms are massed along a series of rising and overlapping diagonals while the viewer appears suspended, looking down at the scene. All this comes to focus on the tiny figure of John, who points the crowd below him (and the viewer) toward the cross, a gesture that recalls John the Baptist pointing to the crucified Christ in Matthias Grünewald's *Isenheim Altarpiece* (c. 1512–1516). The words Grünewald placed beside John's pointing finger may have been in Cole's mind: "He must increase, but I must decrease" (Jn 3:30 NRSV).

[4] The early history of this story is told in more detail in William Dyrness, *Reformed Theology and Visual Culture: The Protestant Imagination from Calvin to Edwards* (Cambridge: Cambridge University Press, 2004), 212-39.

[5] Franklin Kelly, *Thomas Cole's Paintings of Eden*, exh. cat. (Fort Worth: Amon Carter Museum, 1994), 17, 26.

[6] Menefee, "The Early Biblical Landscapes of Thomas Cole, 1825-1829" (master's thesis, Rice University, 1987), 10, 11.

Like the work of his contemporary Caspar David Friedrich, Cole's painting represented the tradition that Robert Rosenblum called the northern romantic tradition, which he claimed owed its impulse to the Reformers' focus on the spiritual character of creation.[7] But there is a significant difference that betrays Cole's American roots. As Barbara Novak points out, Friedrich went out of his way to add Christian symbols and allegorical meaning to his landscapes, whereas for Americans and for Cole in particular "nature was by definition already Christian and Spiritual."[8] Both artists insisted that God was directly and personally encountered through the natural order rather than through the sacramental traditions of the church.

Though Cole's understanding of his faith developed over his lifetime—he did not formally join the Anglican Church until 1842—his conviction that God was accessible through the natural order was constant. He surely had this *Saint John* painting in mind when he wrote later in his "Essay on American Scenery" (1836) that "rural nature" is the place where prophets spoke to God. For creation, and art that follows nature, Cole believed, can "mend our hearts." He goes on to describe the typical observer: "In gazing on the pure creations [*sic*] of the Almighty, he feels a calm religious tone steal through his mind, and when he has turned to mingle with his fellow men, the chords which have been struck, cease not to vibrate."[9] In this picture, John with the small figures gathered around represents less the tradition of the saints and their virtue than the American everyman who understands nature itself as a vehicle for God's presence. As Cole wrote, "Wilderness is yet a fitting place to speak of God."[10] Matthew Baigell observed that *Saint John* allowed him to personify the religious impulses he felt when in nature.[11] One can be lifted up toward God in a way that parallels John's own gestures toward (and beyond) the cross.

Here is the beginning of a uniquely American painterly voice, shaped by European traditions yet at the same time reaching deep into America's own

[7]Rosenblum, *Modern Painting and the Northern Romantic Tradition: Friedrich to Rothko* (1975; repr., New York: Harper & Row, 1988).

[8]Novak, *Nature and Culture: American Landscape Painting, 1825–1875*, 3rd ed. (New York: Oxford University Press, 2007), 225.

[9]Cole, "Essay on American Scenery," in *Thomas Cole: The Collected Essays and Prose Sketches*, ed. Marshall Tymn (Saint Paul, MN: John Colet Press, 1980), 5.

[10]Cole, quoted in Andrew Wilton and Tim Barringer, *American Sublime: Landscape Painting in the United States, 1820–1880*, exh. cat. (London: Tate Publishing, 2002), 14.

[11]Baigell, *Thomas Cole* (New York: Watson-Guptill, 1981), 42.

religious sensibilities. Cole's sentiments on nature resonate with Ralph Waldo Emerson's famous essay on "Nature," also published in 1836. Emerson opined that art is an expression of nature, in miniature, where one may experience— indeed merge one's senses with—the divine: "Nature wears the colors of the Spirit. . . . Nature is our tradition." And contemplation of great art "draws us into a state of mind which may be called religious."[12] But rather than seeing Cole as dependent on Emerson, it is better to see both Cole and Emerson as drawing on a version of the Puritan religious tradition that has so profoundly shaped American culture. How might this tradition be understood, and how did it come to have such an important cultural impact?

As we have pointed out, the American religious tradition, from its inception, reflected the impact of the Protestant Reformation. First, there was the conviction that nature, or better creation, was the setting in which God was not simply present but was actively working out the divine purposes. John Calvin had famously called creation the theater in which God is like a great dramatist playing out transcendent objectives.[13] This notion became influential on the Anglo-Saxon interpretation of history, and it came in the baggage of the New England Puritans. This accounts for the persistent conviction that God was doing a new thing in this wilderness and that Americans had a particular responsibility to further these divine goals, first in the westward expansion in North America and later abroad in what became known as America's manifest destiny. One sees the influence of these ideas on Cole's famous series on *The Course of Empire* and in Frederic Edwin Church's massive landscapes of South America.

Second, because God was present (and active) in the created order, it was possible to have a personal and direct experience of God in and through the created order. Around this time John Ruskin (1819–1900), the English critic widely read in North America, complained that American scenery lacked the "associations" that European landscape displays. Thomas Cole could have been responding directly to Ruskin when he wrote, "[Though ours is a] shoreless ocean un-islanded by the deeds of man . . . the associations are of God the

[12]Emerson, *Collected Essays,* ed. Larzer Ziff (Middlesex, UK: Penguin, 1982), 39, 43, 77.

[13]Cf. John Calvin: "Let us not be ashamed to take pious delight in the works of God open and manifest in this most beautiful theater." Calvin, *Institutes of the Christian Religion,* ed. John T. McNeill, trans. Ford Lewis Battles (Philadelphia: Westminster Press, 1960), 1.14.20. On this see Dyrness, *Reformed Theology and Visual Culture,* esp. chaps. 4 and 7.

creator—they are His undefiled works and the mind is cast into the contem-
plation of eternal things."[14] What Europeans saw as a defect, Americans cel-
ebrated. This "democratic ethos" and its religious overtones suffuse all of
Cole's work and that of his Hudson River contemporaries. As David Reynolds
puts it, these artists "tried to present the world naturally and directly, without
many of the 'high art' devices associated with European art." Walt Whitman
shared this ethos, Reynolds argued, seeking to "push the notion of art beyond
the limits of visual representation to the realms of behavior and political
action."[15] But throughout this period, the notion that religion was the per-
sonal and direct experience of God was normative.

The continuity between the early Puritans and the nineteenth-century
writers was pointed out half a century ago by Perry Miller. Though he recog-
nized a gulf between Jonathan Edwards and Emerson, he argued:

> What is persistent, from the covenant theology . . . to Edwards and to Emerson
> is the Puritan's effort to confront, face to face, the image of a blinding divinity
> in the physical universe, and to look upon that universe without the interme-
> diacy of ritual, of ceremony, of the Mass and the confessional.[16]

This continuity has been nuanced more recently by Janice Knight, who has
argued that this tradition had two sides: one more rational and countercul-
tural (which she calls Amesian, after William Ames), the other more affective
and culturally engaged (which she denominates the Sibbesian Brethren after
Richard Sibbes). It is this latter stream, she thinks, that had a stronger con-
tinuing influence on nineteenth-century American culture. She argues:

> Emerson's conversion on Cambridge Common makes sense as the romantic
> embodiment of the Brethren's notion of privative sin and divine effulgence.
> Whitman's chant of the body politic is easily construed as a secularist incar-
> nation of their Christian community, his song of Democratic Vistas an evo-
> cation of their postmillennial optimism.[17]

[14]Cole, "Essay on American Scenery," 8, 16.
[15]Reynolds, *Walt Whitman's America: A Cultural Biography* (New York: Knopf, 1995), 279-80.
[16]Perry Miller, *Errand into the Wilderness* (Cambridge, MA: Belknap / Harvard University Press,
1956), 185.
[17]Knight, *Orthodoxies in Massachusetts: Rereading American Puritanism* (Cambridge, MA: Harvard
University Press, 1994), 199. See also Dyrness, *Reformed Theology and Visual Culture*, chap. 6.

THE GREAT AWAKENING AND THE BIRTH OF AMERICAN ART

The Sibbesian focus on the direct and personal experience with God received fresh impetus in the first half of the nineteenth century through the Second Great Awakening that swept through New England and the frontier, beginning in 1805. Those living through this period would have found it impossible to escape the impact of this movement. Not only Thomas Cole but many other artists, including Frederick Law Olmsted and even Albert Pinkham Ryder, felt the impact of these revivals. This was also the period in which Emerson and the so-called transcendentalists called for immediate experience with the Oversoul. While there are significant differences between the revivalists and their transcendentalist neighbors, it is important to note the similarities in their impulses and their influences on the arts. While the revivalist Charles Finney sought to reflect a personal spirituality of the renewed "common mind" that avoided the trumpery of traditional theology, Emerson and the transcendentalists sought to work outward from within. Both sought to avoid the deadening rationalism (and the rejection of miracles!) that had invaded the churches. (In fact, when Emerson left the ministry, arguably it was the rational exposition of doctrine that he rejected rather than its personal meaning of faith.)[18] Both championed an inner moral sentiment and personal religious experience.[19] While they had their differences over belief in a personal God (which was reflected in the visual artists in these traditions), they both worked in the shadow of the Sibbesian Brethren and both contributed to forming a uniquely American sensibility.[20]

Thomas Cole. These influences were particularly reflected in the work of Thomas Cole (1801–1848). Though born in England, he immigrated with his family in 1821. His pastor and biographer Louis B. Noble reports that although he had little religious training growing up, he had deeply felt religious feelings

[18]See Robert Richardson Jr., *Emerson: The Mind on Fire* (Berkeley: University of California Press, 1994), who argues that Emerson in 1832 did not break with theism, nor a religious view of things, but with a specific interpretation of the fall and salvation. Christianity, Emerson testified when he left the ministry, is not something added, but "it is a new life of those faculties you have" (125-26).

[19]On these differences and similarities see E. Brooks Holifield, *Theology in America: Christian Thought from the Age of the Puritans to the Civil War* (New Haven, CT: Yale University Press, 2003), 362, 435-43. He notes how difficult it is to specify beliefs of the transcendentalists since they "contradicted each other at every turn" (435).

[20]Cf. Andrew Wilton, who argues that in America "the instinct to find spiritual significance in nature was not only an insight of evangelical religious groups. It was inherent in the broadly devout American consciousness." See Wilton and Barringer, *American Sublime*, 14.

that led to his baptism in the Anglican Church in 1842—though he had faith-
fully attended long before.[21] *Saint John in the Wilderness* and his other early
works married the large scale of Baroque and Renaissance painting (as well as
Benjamin West's panoramas) with a sensitive observation of the natural world.
This was a popular art form designed to be shown in a dramatic setting where
ordinary people could view it for a few cents. During this time the painted
landscape replaced prints as the dominant medium.[22] In 1828 Cole painted
several large-scale works with the theme of the Garden of Eden and expulsion
from the garden. Finding inspiration from the book of Genesis and John Mil-
ton's *Paradise Lost* (especially the depiction of Eden in book 4, lines 216-63),
Cole was drawn to the garden theme: the theme "excites me," he wrote to his
patron Daniel Wadsworth. The garden became a symbol of indwelling the
"beautiful" as opposed to the "sublime" apocalyptic notion of expulsion. There
were also natural symbols in the painting: the stag (speaking of God's faith-
fulness), the fruit of paradise and the daisy (the eye of God). These would be
themes that spoke directly to the religious sensitivities of those who crowded
in to see the work.[23]

Cole's biographer, Louis Noble, reports that though these paintings reflect
his movement from a simple enjoyment of nature to the development of a
strong moral and imaginative language, they did not yet reflect the deep per-
sonal faith that the painter would later develop.[24] Beginning in 1835, Cole
painted the famous *Course of Empire* series, an obvious allegory of American
history moving from early purity through imperial splendor toward eventual
decay, an elaboration of convictions expressed in his famous essay that "we are
still in Eden; the wall that shuts us out of the garden is our own ignorance and
folly."[25] It was only after this great series, Noble believes, that Cole began to
understand his own vocation more clearly. He began to appreciate the anon-
ymous Gothic artist who "works to God," and he understood the careful

[21]The most complete biography of Cole is that by Noble, first published in 1853. See Noble, *The Life
and Works of Thomas Cole*, ed. Elliot S. Vesell (Cambridge, MA: Belknap / Harvard University
Press, 1964).
[22]Tim Barringer notes that during this period forms of high and low art overlapped. See Wilton and
Barringer, *American Sublime*, 39-45.
[23]On this see Kelly, *Thomas Cole's Paintings of Eden*, 17-42; quotation is from p. 17.
[24]Noble, *Life and Work of Thomas Cole*, 59. Cole later regretted his early ambition and vague reli-
gious sentiments. Noble thinks his real Christian life is reflected only in his last ten years (287, 302).
[25]Cole, "Essay on American Scenery," 17.

depiction of creation to be the artist's "lowly imitation of the creative power of the Almighty," which helped creation to fulfill its created purposes.[26]

At the end of his life Cole regretted that *The Course of Empire* lacked the specific Christian content and reference to the cross that he wished he had given it.[27] The significance of the cross, Noble thinks, only became clear to him toward the end of his life when the church and the Christian life became his favorite topics of conversation: "I am going to work for the Church," he told his sister Sarah.[28] In his studio he kept his marked-up Bible, a Book of Common Prayer and other devotional writings: "his painting room was likewise a study and an oratory."[29] One of his last works, *The Cross and the World* (c. 1846–1847), captures these late sensitivities. The center and source is the light of God, the glorified redeemer. Here is "nature transfigured," a new heaven and new earth. Noble summarizes Cole's intent: "It is Faith's victory. . . . Faith is all changing into sight, hope into the inheritance itself: angels approach with the palm and crown."[30] Another picture of the cross and the world was left unfinished at his death in February 1848.

Frederic Edwin Church. From 1844 to 1846 Cole took on his only student, Frederic Edwin Church (1826–1900), who brought the tradition of large-scale landscapes to its highest level. By the middle of the nineteenth century, landscape painting had become, according to John Wilmerding, the "new vehicle for moral imperatives. . . . It had helped define and ennoble the national consciousness."[31] Church shared Cole's Reformed faith but also displayed the influence of John Ruskin and the German philosopher Wilhelm von Humboldt. Ruskin's *Modern Painters* and *Stones of Venice* were deeply influential on artists of this period. Large sections from these works were reprinted in the periodical *The Crayon* in the 1850s.[32] There Ruskin, who was himself a product of the Reformed tradition in England, could speak of artists following the

[26]Noble, *Life and Work of Thomas Cole*, 214, 251.

[27]Ibid., 287.

[28]Ibid., 291-92, 301.

[29]Ibid., 298.

[30]Ibid., 303.

[31]Wilmerding, *American Art*, 76, 82.

[32]*The Crayon* appeared in seven volumes between 1855 and 1861, originally edited by W. J. Stillman and J. Durand (Stillman withdrew in 1856). Though it was the vehicle of German idealism (esp. Hegel) and Ruskin, it stood firmly for the medieval ideal in art against the individualism of modern art: the former, the editors lamented, is "exalted by what it sees"; the latter is "the minister to his own importance" (editorial in *Crayon* 1, no. 1 [1855]: 3).

"constitution of the world": what is delightful there surely reflects "some type of God's nature or God's laws."[33] Von Humboldt's descriptions of his travels in South America, in which he identified the dramatic landscape as a transcript of God's work, was deeply influential on Church and inspired his own travels there. A further influence on Church was James McCosh's book *Typical Forms and Special Ends in Creation* (1856), which portrayed geology as the "bible in stone"—just as much a revelation of God as Scripture itself. These major cultural influences served to support Cole's and then Church's providential view of creation and even of geological development. In his *Heart of the Andes* (1859) (fig. 6.1), Church portrayed a God's eye view of the paradisiacal New World. As David Huntington says of Church's work, "like Adam at the dawn of human consciousness the beholder awakens to the beauty of the earth which has been so long preparing for him."[34] But Church insisted that only someone reborn in Christ could truly "see all things new." His faith, Huntington insists, deeply influenced everything he did: "one cannot separate what he painted from what he believed."[35]

Figure 6.1. Frederic Edwin Church, *Heart of the Andes*, 1859

[33]Ruskin, "The Spiritual Significance of Color," *Crayon* 2, no. 9 (August 29, 1855): 132; and idem, "The Union of Colors," *Crayon* 2, no. 14 (October 3, 1855): 215.

[34]Huntington, "Church and Luminism: Light for America's Elect," in *American Light: The Luminist Movement, 1850–1875*, ed. John Wilmerding, exh. cat. (Washington, DC: National Gallery of Art, 1980), 158.

[35]Ibid., 160.

One can see the significance of this influence by comparing Church with his contemporaries Fitz Hugh Lane (1804–1865) and John Frederick Kensett (1816–1872). These artists were inclined more directly toward the transcendentalism of Emerson and sought a luminous portrayal of infinity, whereas Cole and Church began at the opposite pole—that of the viewer—and sought to convey an experience of the whole. For Cole and Church, God's presence was still personal, and this could be translated into the experience of the viewer. Their compositions lead the viewer into the picture from the foreground to the middle ground and into a paradise, which one is invited to explore.[36] Interestingly, Ruskin critiqued the landscapes of Claude de Lorrain in terms that would apply equally well to Kensett. Claude's idealism renders his landscapes "uninhabitable," Ruskin says, and this can have no effect "on the human heart, except to harden or degrade it; to lead it from the love of what is simple, earnest and pure, to what is sophisticated and corrupt in arrangement."[37] Ruskin believed that the artist, in capturing what is specifically delightful in the created order—and this involved a careful observation and detailing of what is there—can reflect "some type of God's nature or of God's laws."[38] For both Ruskin and Church, the current understandings of science allowed them to see creation structured in such a way as to draw people to faith in God. Barbara Novak summed up Church's goal: "by bringing the aims of the landscapist closer to the divine intention of the Creator, he unveiled the mysteries of Creation to embody them in his art."[39]

Since Church saw the grand landscapes of the New World as a theater for God's providences, he was quick to see Americans as God's chosen people, even as he displayed a Protestant reluctance to portray the actual divine image.[40] As Tim Barringer notes, Church abandoned the explicit religious subjects of his teacher Cole and instead began searching the natural world "for symbols . . . which appeared to be visual testimonies to God's presence."[41] This

[36]Wilton and Barringer, *American Sublime*, 26.

[37]Ruskin, *Modern Painters* (1843–1860), 4th ed. (New York: Wiley and Sons, 1890), preface to 2nd ed., 1:xlii.

[38]Section of Ruskin, *Stones of Venice*, reprinted in *Crayon* 2, no. 9 (1856): 215.

[39]Novak, *Nature and Culture*, 65.

[40]For expanded treatment of this topic as it pertains to a number of American artists, see John Davis, *The Landscape of Belief: Encountering the Holy Land in Nineteenth-Century American Art and Culture* (Princeton, NJ: Princeton University Press, 1996).

[41]Wilton and Barringer, *American Sublime*, 55.

climaxed in his famous *Cotopaxi* (1862), painted in the midst of the Civil War. He painted several views of this famous Ecuadoran volcano, which he saw on his 1853 and 1857 trips. Its cone was considered one of the most perfect and beautiful, but here it is covered by dark smoke. The earth mourns over the suffering of the war; even the sun seems to suffer from the awful evils being inflicted on the earth. This painting, which has been called a visual "Battle Hymn of the Republic" or a Civil War *Guernica*, struck the American people deeply as a transcript of their own anguish over the wrath of God that was being poured out on the United States.[42] But they also would not have missed the biblical allusions in the painting: the rising sun as resurrection of the Son (Church was fond of puns) and the plume of smoke as the pillar of cloud that accompanied the Israelites in the wilderness.[43]

Frederick Law Olmsted. Together Cole and Church made the natural land-scape a uniquely American artifact and even the emblem of her civilization. As a result, landscape painting and the religious impulse behind it furthered the movement to treasure and preserve that heritage. Indeed, the development of urban parks owes something to this same religious heritage. Frederick Law Olmsted (1822–1903), who (along with Calvert Vaux) designed Central Park in New York City, had his artist's sensitivity formed by the Reformed tradition in which he was raised. Witold Rybczynski notes that Olmsted was "earnestly interested in religion," and during the 1846 revival in New Haven he testified to his conversion; afterward he faithfully taught Sunday school in his Presby-terian church. Olmsted saw himself creating three-dimensional landscapes where "work and obligation to others, could lead to redemption" not only of people but of the earth itself.[44] He read Emerson and Ruskin avidly and in the 1850s founded his Society for the Improvement of Staten Island, where his farm was located. The purpose statement is worth quoting as encapsulating the ideals not only of his society but of all those working under the influences that we have been tracing:

[42]See Huntington, "Church and Luminism," 181-87, in which he argues that Church's universe is "Trinitarian." Interestingly, Huntington notes that Cole was more interested in the human drama than Church, whose God is a God of being rather than action and in whose paintings the human figure all but disappears. See 165, 186.

[43]Ibid., 180.

[44]Rybczynski, *A Clearing in the Distance: Frederick Law Olmsted and America in the Nineteenth Century* (New York: Scribner, 1999), 64, 69. Rybczynski notes the influence of Horace Bushnell and the frequent exchange of letters over serious doctrinal issues (73-74, 328).

We believe [the Society] will increase the profit of our labor—enhance the value of our lands—throw a garment of beauty around our homes, and above all, and before all, materially promote Moral and Intellectual Improvement—instructing us in the language of Nature, from whose preaching, while we pursue our grateful labors, we shall learn to revive her Fruits as the bounty, and her Beauty as the manifestation of her Creator.[45]

America's tradition of national parks and of urban green spaces owes much to the central role that landscape painting came to play during this time, and in turn to the religious impulse that lay behind this. It was taken for granted that nature proclaimed the presence of the creator. While it might strike contemporary strollers in Central Park as odd to see any connection with America's religious heritage, the connection would have been assumed when Olmsted was laying his plans. His was, however, the last generation that could make this easy assumption.

Art and a Conflicted Religious Heritage: 1860–1913

After the 1860s it would become difficult to make the same appeal to God's providences in the natural order. For many, the bloody conflict of the Civil War called God's benevolence into question. For others, the appearance of Darwin's *Origin of the Species* (1859) undermined faith in God's special ordering of creation and especially any unique purpose for America in the broader scope of history.[46] Artists continued to focus on the natural order in their work—the prints of Audubon and the towering peaks of Albert Bierstadt, for example, are distinctly American—but many of these artists had become more scientists than preachers. The transcendent references seemed to be missing, realism appeared triumphant and artists increasingly turned toward France rather than Britain for inspiration.[47]

This at least is the dominant narrative for the development of art in America. This period represents, so we are told, the definitive turn toward secularism

[45]Purpose statement for the Society for the Improvement of Staten Island, quoted in ibid., 80. The source of the idea of "preaching" of nature and art is likely Ruskin, who wrote of God's purposes in nature transcribed into art, which would thus "attach to the artist the responsibility of a preacher." Ruskin, *Modern Painters*, 1:xlv.

[46]Interestingly, *The Crayon* included a simple notice of Darwin's book in its next to last issue and then suddenly, in 1861, ceased publication.

[47]It was not until the last part of the twentieth century that interest revived in the landscape artists associated with the Hudson River School. See Wilton and Barringer, *American Sublime*, 37.

and materialism in American culture. It is true that during this period commerce became an American obsession, and religion (Christianity in particular) was put on the defensive.[48] But underneath and even within these very factors there were strong religious currents at play that would influence American culture well into the twentieth century. A telling example of these currents is played out in the religious struggle of Herman Melville and the very different response of Albert Pinkham Ryder.

Herman Melville (1819–1891) was born in New York City in 1819. After his father died in 1841, leaving the family penniless, Melville shipped out on a whaler from New Bedford, Massachusetts. New Bedford had been marked by the revivals in 1823 and 1824 and would later become a center of transcendentalist thought (as well as the birthplace of Ryder in 1847). Melville would have been exposed to Emerson's notion that we find in nature the benevolent image of the divine and that the artist is charged by God to bring forth truth. Though he was raised as a Christian, Melville came to reject the rationalist version of the Christian faith that he inherited from his father's side of the family. Since this view of faith had little use for the imagination, Melville came to reject not only this faith but also the Emersonian optimism that had accompanied it. Indeed, Emerson's ideas are often parodied in Melville's work.[49] *Moby-Dick*, first published in 1851, appears at points to reflect Emerson's influence. But, as Andrew Delbanco argues, Melville treats Ahab's quest to pierce the "pasteboard mask" of appearances as a kind of insanity. In the novel *Pierre* (1852) this is even clearer: there is no divinity behind things, and those who believe this are mad. As Delbanco puts it, "Nature in *Pierre* is a tease and a taunt, flattering us into thinking that what we find in the landscape or seascape is the visage of God, when in fact she is nothing but a mocking reflection of ourselves."[50] Melville, then, is an American version of Ludwig Feuerbach, who argued that our views of God are simply projections of our fondest ideals. Like Feuerbach, Melville believed nature is a supplier of an alphabet with which we write our own lessons—a blank tablet on which we inscribe our fantasies.

[48]Ibid., 31-32.

[49]This paragraph and the next are dependent on Andrew Delbanco, *Melville: His World and Work* (New York: Knopf, 2005), 196, 281.

[50]Ibid., 197.

Later, under the shadow of Darwin and the Civil War, Melville fought his own demons and sense of emptiness that resulted from this loss of faith and his own declining literary success. In the late 1860s he composed a long narrative poem, *Clarel* (1876), in which an American student travels to the Holy Land in search of a lost faith. Science could no longer support divine providence, but neither could it satisfy the heartfelt cravings that Melville depicts in this poem.[51] *Clarel*, though not a great poem, becomes an early expression of the modern artist's hungering for belief. The question that Melville leaves unresolved is whether Ahab's quest, and Melville's own, might not suggest that myths can concentrate meaning and address the present emptiness: if God's presence cannot be read from the surface of things, does this necessarily imply his absence?

Albert Pinkham Ryder (1847–1917) made something very different out of his era and the influences that shaped Melville. He was raised in New Bedford with grandparents, who, along with his mother, had adopted the simple dress promoted by the revivals (they were probably Methodists). Though a quiet child and suffering from eye troubles that plagued him throughout his life, he loved pictures and probably knew painters in New Bedford.[52] After the Civil War he moved to New York, where he studied with William Marshall and after several attempts was finally admitted to the National Academy of Design. A retiring figure, he enjoyed visits from friends and was chivalrous with women. He seemed to particularly struggle with his drawing, feeling incapable of capturing the contour of the natural world, until he experienced a breakthrough sometime in the 1870s. He described later, in one of the very few personal reflections on his own work, how he came to see nature as his teacher. On one occasion while painting out of doors, he became frustrated with his brushes, as being too small for what he wanted to paint:

> I threw my brushes aside. . . . I squeezed out big chunks of pure, moist color and taking my palette knife, I laid on blue, green, white and brown in great sweeping strokes. . . . I saw nature springing into life upon my dead canvas. It was better than nature, for it was vibrating with the thrill of a new creation. Exultantly I painted until the sun sank below the horizon.[53]

[51]Ibid., 279-81.

[52]See Elizabeth Broun, *Albert Pinkham Ryder* (Washington, DC: Smithsonian, 1989), 18.

[53]Ryder, "Paragraphs from the Studio of a Recluse" (1905), in *American Art: Sources and Documents,*

This discovery was important to him not simply as a matter of technique but in allowing him to realize the strong internal vision that was forming. As he said elsewhere in these notes, one must not become a slave to detail: "it is the vision that counts." One must be open to the dream, believing it will come when, he says, it is "pondered over with prayer and fasting."[54]

How are we to understand the source of Ryder's vision? Painters of his generation had turned their eyes toward Europe. For various reasons they saw the heritage of the landscapes of Cole and Church as a burden to be thrown over. Many artists spent time in France (Ryder himself went four times between 1882 and 1896), where the French symbolists attracted attention. Their quest was not simply for a novel technique, however. Brutalized by Darwin and the collapse of a providential view of creation, thoughtful people lacked a spiritual center. For artists this was an era of spiritual searching. Thomas Eakins, though himself agnostic, found himself particularly influenced by the Catholic liturgy and the *logos* as the Word made flesh, coming to see painting itself in these terms. He felt his most representative work was his famous *Crucifixion* (1880), but his work was often considered coldly realistic, incapable of stirring noble emotions.[55]

More influential was the "spiritualism" that flourished during this time, a combination of Christian mystical traditions and Eastern philosophy that we encountered earlier in France during this time. Already in the 1850s Emanuel Swedenborg was being read, and in the 1870s Helena Blavatsky, the Russian mystic and founder of the Theosophical Society in America, lived in New York for a time. George Innes was a convert to Swedenborgianism, which sought correspondences between spiritual and physical elements—light, for example, gave evidence of divine presence.[56]

Ryder was exposed to these influences, but he adapted them in ways that expressed his American roots and, at one remove, the evangelical faith of his family. The period between 1880 and 1900, his most productive, shows

1700–1960, ed. John W. McCoubrey (Englewood Cliffs, NJ: Prentice Hall, 1965), 188.

[54]Ibid., 187.

[55]See Kristin Schwain, *Signs of Grace: Religion and American Art in the Gilded Age* (Utica, NY: Cornell University Press, 2008), 20-41.

[56]See Charles C. Eldredge, *American Imagination and Symbolist Painting*, exh. cat. (New York: New York University Grey Art Gallery and Study Center, 1979), which provides a good survey of these influences on American art, showing that they were not simply imported but came to express native traditions.

influences of Edgar Allan Poe, British poets and above all the Bible. Ryder, like others of his generation, though attracted to a figurative art, had given up Ruskin's focus on exact likeness. Ryder sought rather a spiritual resonance. To produce this effect Ryder developed a unique technique borrowed in part from the old masters: a series of glazes over an underlayer, to diminish the painterly quality, then a covering of varnishes. This technique allowed him to seek the concrete form of his ideas, like a poet, rather than the likeness of the landscapists. In his famous 1885 painting *Jonah* (plate 7), which is the largest painting he had attempted, Ryder created a mystical seascape that recalls not only the biblical prophet but also the novel *Moby-Dick*. At the same time it addresses a theme that preoccupied him: redemption and damnation. Above, the figure of God appears holding a globe in his right hand while holding up his left hand in a sign of blessing. Below, Jonah, already thrown into the sea, looks up toward heaven and reaches out his hands. The water and clouds seem more sculpture than painting, the image having been pared down to stark masses of light and dark—eliminating detail and desaturating the color for the sake of a pure visual idea. But what is that idea? Elizabeth Johns believes that Ryder was seeking to address directly the intellectual longing for a God who was present and yet transcendent. Here was the way around the prevailing doubt: evil and chaos, these images say, do not imply the absence of God or of God's control.[57]

Despite Ryder's isolation and his reticence to write about his work (he kept no journal), it is possible to piece together a picture of his faith. First, though he gave up the search for exact likeness, he did not lose faith in creation's ability to speak of God. "Nature is a teacher who never deceives," he wrote in his "Paragraphs," though the essence must be grasped without distracting details.[58] It will yield its vision if "pondered over with prayer and fasting." Second, it was his dependence on God that served as an anchor during those times of spiritual loneliness. He expressed his feelings in these lines:

> Who knows what God knows?
> His hand he never shows,
> Yet miracles with less are wrought,
> Even with a thought.[59]

[57]Johns, "Albert Pinkham Ryder: Some Thoughts on His Subject Matter," *Arts* 54 (November 1979): 165, 167. She concludes that Ryder was a religious artist even when he painted secular subjects.

[58]Ryder, "Paragraphs from the Studio of a Recluse," 187.

[59]Ryder, quoted in Broun, *Albert Pinkham Ryder*, 108.

And he reiterated the thought in these words: "The artist needs but a roof, a crust of bread and his easel, and all the rest God gives him in abundance. He must live to paint and not paint to live."[60] During the period of his greatest productivity, Ryder often turned to biblical and Christian subjects: the resurrection (twice), Christ appearing to Mary and the *Story of the Cross*. Third, a further clue is indicative of Ryder's impact on his artist friends: though his nickname was Pinky, they frequently called him Bishop or Reverend. His work apparently still managed to preach.

Ryder recalls the similarly reclusive French contemporary Paul Cézanne, whose influence, like Ryder's, was enormous. And clearly for both it was, in part, the spiritual center that gave their work its strength and stability. Marsden Hartley, who testifies to Ryder's influence on his own work, tells of seeing *Jonah* for the first time. It reminded him of his first experience reading Emerson's *Essays*:

> I felt as if I had read a page of the Bible. . . . All my essential Yankee qualities were brought forth out of this picture. . . . It had in it the stupendous solemnity of a Blake mystical picture and it had a sense of realism besides that bore such a force of nature itself as to leave me breathless. The picture had done its work and I was a convert to the field of imagination to which I was born.[61]

Hartley marks an important assimilation of European influences into the American tradition. But before turning to these developments, I want to highlight another place where American religious traditions continued to be influential on art. Henry Ossawa Tanner (1859–1937) was raised in the home of an African Methodist Episcopal pastor and bishop, who thought deeply about art and religion and encouraged his son's artistic vocation. Tanner began painting in 1872, and in 1879 he was accepted by the Pennsylvania Academy of Fine Arts in Philadelphia, where he studied with Thomas Eakins.[62] With Eakins's encouragement, he continued to paint, living for a time in Atlanta and having his

[60]Ryder, quoted in Frederic Fairchild Sherman, *Albert Pinkham Ryder* (New York: privately printed, 1920), 21-22.

[61]Hartley, quoted in Maurice Tuchman, "Hidden Meanings in Abstract Art," in *The Spiritual in Art: Abstract Painting, 1890–1985*, ed. Maurice Tuchman, exh. cat. (Los Angeles: Los Angeles County Museum of Art; New York: Abbeville Press, 1986), 21.

[62]On Tanner's career and life see Dewey F. Mosby, Darrell Sewell and Rae Alexander-Minter, *Henry Ossawa Tanner*, exh. cat. (Philadelphia: Philadelphia Museum of Art, 1991), and the extensive reflections by Tanner's son Jesse in Marcia M. Mathews, *Henry Ossawa Tanner: American Artist* (Chicago: University of Chicago Press, 1969).

first solo exhibit in Cincinnati in 1890 at the Methodist Book Concern. When none of his work sold, a close friend of the family, Bishop Hartzell, bought them all, providing funds for Tanner to travel to Europe.

Tanner, who was painfully shy and frequently experienced racial discrimination while growing up, found Paris a stimulating and welcoming place, and he immediately decided to settle there permanently. He studied at the independent Académie Julien—once canvassing his fellow students to try to change the weekly *concours* from Sunday to Monday, in order not to violate the Lord's Day.[63] France proved a place where both his artistic and his religious impulses were encouraged. He appreciated both the symbolists and the synthetist painters in France, and was drawn especially to their mystical and religious elements. His own marginal status allowed him to immediately identify with the new modernist group in Paris, even as he pursued his own deeply religious vocation.[64] Tanner stayed close to his family, visiting them whenever he returned to North America. In 1894 his father wrote a reflection on religious art:

> By the presentation of visible objects to the eye, divine truths may be most vividly photographed upon the soul. . . . In representation man does not, like the great Originator, create by his own fiat, his world of mental objects. What he reproduces or constructs anew is in some way dependent upon what he has personally experienced.[65]

It may have been the influence of his father that led Tanner in the mid-1890s to turn to specifically religious subjects. These proved to be his most important and successful works. In 1896 his *Daniel in the Lion's Den* received honorable mention in the Paris Salon, and his *Resurrection of Lazarus*, shown in the 1897 Salon, was purchased by the French State. His successes were closely watched in America, and the Philadelphia industrialist John Wanamaker paid Tanner's way to the Holy Land in 1897.[66] The first work done after this trip was the

[63]Mathews, *Henry Ossawa Tanner*, 60. Mathews notes that Tanner attended the American Protestant Church while he was in Paris.

[64]On these influences see Dewey Mosby, *Across Continents and Cultures: The Art and Life of Henry Ossawa Tanner* (Kansas City, MO: Nelson-Atkins Museum of Art, 1995), 35, 78. And see Walter Augustus Simon, "Henry O. Tanner: A Study of the Development of an American Negro Artist, 1859–1937" (PhD diss., New York University, 1961), 134-35, on the role of Tanner's marginal status.

[65]Quoted in Mosby, Sewell and Alexander-Minter, *Henry Ossawa Tanner*, 146. On his success in the salons, his relation with Wanamaker and his father's influence, see 100-125.

[66]For an insightful study of the relation between Tanner and Wanamaker, see Kristin A. Schwain,

stunning *Annunciation* (1898) (fig. 6.2), which was also the first to be pur-
chased by an American museum. Mary's encounter with God's glory, within
an ordinary domestic context, is characteristic of Tanner's deeply felt though
unsentimental approach to biblical subjects. Here a shy young woman shrinks
back from the shining presence of the angel, whose voice is indicated only by
a glowing pillar of light. Tanner also painted the birth of Christ, a crucifixion
and resurrection, the Good Shepherd, Job and his friends, and Christ in the
home of Mary and Martha, all in the same straightforward manner. Especially
interesting for the larger purposes of this book was his enthusiastic reception
in France. His massive painting *The Bridegroom Cometh (the Wise and Foolish
Virgins)* (1907–1908), for example, was considered his masterpiece when it was
exhibited in France. Kristin Schwain calls these "sermons in pictures . . .
encouraging the beholder's personal engagement with the biblical figures."[67]

Figure 6.2. Henry Ossawa Tanner, *The Annunciation*, 1898

"Consuming Christ: Henry Ossawa Tanner's Biblical Paintings and Nineteenth-Century American
Commerce," in *ReVisioning: Critical Methods of Seeing Christianity in the History of Art*, ed. James
Romaine and Linda Stratford (Eugene, OR: Cascade Books, 2013), 276-93.
[67]Schwain, *Signs of Grace*, 58.

The clearest expression of Tanner's faith and its impact on his work comes from the recollections of his son Jesse. The strong social justice theme of his work, Jesse thinks, resulted from Tanner's sense that "there was a unity in human aspirations and revealed truth."[68] Jesse reports that while his father felt that only a few people really listened to God's word and were saved, he was unfailingly generous in his attitudes toward others. Prayer was central to his life. Jesse recalled:

> "Let God guide us" was his principal reason for prayer. This guidance was achieved, he believed, through a receptive state of mind that allows us to know God's will. It is this sort of mystical fourth dimension that my father attempted to give his religious paintings, and which is sensed by so many of his admirers.[69]

Though Tanner lived out his life in Paris, where he died in 1937, he was always proud to consider himself American, and America, for its part, embraced his work. The Harlem Renaissance of the 1920s and 1930s, scholars argue, "would be impossible to imagine . . . without the example of Tanner's single-minded pursuit of artistic success and his subsequent international recognition."[70]

One might wonder why, in a book about the rise of modernism, we have insisted on pointing to nineteenth-century precursors. As we have seen, many of these artists were deeply aware of European developments, but they made use of these in ways that reflected their American heritage and its religious accents. And this native impulse was to shape American versions of modernism in remarkable ways. Rooted in inherited traditions, Ryder and Tanner were precursors of a unique form of American modernism, one that would absorb European styles for its own indigenous purposes.

FROM THE TURN OF THE TWENTIETH CENTURY TO THE ARMORY SHOW: MODERNISM IN AMERICA

Admittedly, many who surveyed American artistic production at the turn of the century did not find much to celebrate. Certainly this was true of those who, like Tanner, found Paris to be a much more vibrant cultural center. T. S. Eliot,

[68]Jesse Tanner, quoted in Mosby, Sewell and Alexander-Minter, *Henry Ossawa Tanner*, 149.

[69]Mathews, *Henry Ossawa Tanner*, xiii-xiv. Mathews claims that Tanner drifted away from orthodoxy later in life but continued to find "emotional fulfillment in personal communion with God" (73).

[70]Mosby, Sewell and Alexander-Minter, *Henry Ossawa Tanner*, 251.

for example, when visiting Paris in 1910 and 1911, was struck by the contrast of its cultural and religious richness in relation to the barrenness of North America. He wrote in *The Criterion* in 1934, "Younger generations can hardly realize the intellectual desert of England and America during the first decade and more of this century. . . . The predominance of Paris was incontestable."[71]

Eliot's characterization of this period is itself a testimony to the complexity of North America's struggle with modernism. The received narrative is that the United States in 1900 was trailing Europe in cultural matters, and that catching up necessarily involved turning from its own religious traditions and adopting the secular ones from Europe. But the reality is more interesting than this. On the one hand, as we have argued in previous chapters, European traditions were themselves steeped in one or another Christian tradition, which continued to influence many artists. Eliot's reasons for turning to Europe were in fact largely based on its rich Christian heritage, represented by Thomism and Maritain, as well as the artists influenced by the Catholic revival. On the other hand, even those in North America who sought to "free themselves" from American religious traditions found this easier said than done.

An excellent example on the American front is the work and influence of artist and teacher Robert Henri (1865–1929). He agreed with those who felt that American art was twenty years behind that of Europe and that overcoming this probably meant discarding its "Puritan influence."[72] But Henri, though exposed to European influence through his travels, worked from values that were deeply American and, despite all protests to the contrary, were indebted to its religious traditions. He insisted that one should paint from life, express one's own time and place and the contemporary experience of the people. This led him to support the work of George Bellows, John Sloan and William Glackens of the so-called Ash Can school of painters, who celebrated the rough and tumble of an urbanizing American life. These artists all

[71]Eliot, quoted in Roger Kojecky, *T. S. Eliot's Social Criticism* (London: Faber & Faber, 1971), 58. Kojecky notes that a big part of this was the influence of Maritain, though Eliot also had in mind Charles Peguy and Anatole France. See 74, 130-31.

[72]See his response to an article in 1904 on America's cultural backwardness in *Readings in American Art: A Documentary Survey*, ed. Barbara Rose (New York: Praeger, 1968), 4-5. On Henri's work see Bernard B. Perlman, *Robert Henri: His Life and Art* (Mineola, NY: Dover, 1991), which highlights Henri's Dutch and Huguenot ancestry.

worked from life, feeling that nature could still be a revelation of transcendent values. Moreover, Henri was deeply motivated by ethical notions of justice and the ideal of brotherhood among people. All of this recalled Whitman (and Emerson), but, more importantly, it was deeply marked by the Progressive movement in late nineteenth- and early twentieth-century America. Behind this was the influence of John Dewey and Jane Addams's Hull House in Chicago. Dewey, as all scholars acknowledge, was deeply influenced by his Reformed Christian heritage, even though he let his church membership lapse when he arrived at the University of Chicago in 1894. Bruce Kuklick, who calls Dewey the last of the Puritan thinkers, argues that the philosopher continued to believe that "God was immanent in culture, and humanity was redeemable through social progress."[73] Kuklick's summary could well be applied to the religious influences on the arts and culture more broadly:

> [Jonathan] Edwards and his followers found value in the natural only because it was the medium in which the supernatural was displayed. Dewey and his successors ruled out the supernatural, but only when they imported its values into the natural.[74]

Robert Crunden has traced the influence of the Progressive movement on Henri and the artists he supported. These artists all firmly believed that American art could only be great by starting with the realities of the people, including their deepest religious traditions—John Sloan claimed allegiance to that "great socialist, Jesus Christ," whose message he felt the churches had mostly lost; George Bellows painted revival preachers; George Luks's street scenes document immigrant religious communities; and so on. Though their own religious convictions were often unclear and even hostile to traditional Christianity, Crunden shows that this movement would be unthinkable apart from the evangelical tradition in America.[75]

[73]Kuklick, *Churchmen and Philosophers: From Jonathan Edwards to John Dewey* (New Haven, CT: Yale University Press, 1985), 242. He says of Dewey: "While yielding the supernatural he would not surrender religion" (251).

[74]Ibid., 256.

[75]Crunden, *Ministers of Reform: The Progressive's Achievement in American Civilization* (New York: Basic Books, 1982). On these influences see pp. 103-15. Britain lacked a progressive phase in its arts, he notes, "having no dominant Evangelical tradition" (97). We question his assertion that the modernism represented by the Armory Show killed progressivism in painting. To the contrary, progressivism's influence continued into the 1930s.

But how do these indigenous impulses fit into the growing exposure to European influences? Half a century ago Milton Brown proposed a typology that distinguishes two separate influences on American art in the first decade of the twentieth century: (1) that of Henri, who celebrated a traditional American realism, and (2) that of his contemporary Alfred Stieglitz (1864–1946), who was responsible for the modernist movement from Paris.[76] While clearly an oversimplification, this does highlight the struggle between native and imported traditions that was taking place early in the century. Henri, though clearly not opposed to French traditions, wanted to promote an indigenous realist tradition, while Stieglitz promoted the modernist view of personal creativity as the secret of great art. But it is wrong to see a secular foreign invasion overwhelming an indigenous tradition often influenced by religion.

Stieglitz's Studio 291 featured abstract artists who reflected European influences, but this did not preclude American (and religious) influence on these same artists. Arthur Dove (1880–1946), for example, showed a series called the *Ten Commandments* in Stieglitz's gallery in 1910. According to Arlette Klaric, these reflect a "sensuous feeling of the earth." Like Marsden Hartley, who was also showing with Stieglitz, Dove's abstraction showed surprisingly little influence of the European artists he knew. The abstraction of these artists, Klaric argues, was a response to their homegrown feelings for nature; it gave them the means to express the experiential sensation that Henri Bergson had recently described as vitalism.[77]

Ryder's vision of "nature springing to life upon my canvas" was far more significant to these artists than European influences. Hartley, remember, was deeply struck when he first saw one of Ryder's paintings in a New York gallery in 1909. The small marine painting "shook the rafters of my being," he reported. In fact Elizabeth Broun counts Hartley as Ryder's truest heir, fusing as he did subject and symbol with deep religious allusions. After seeing Ryder's work, he set to work on a series of bleak landscapes. One of these, *Dark Mountain*,

[76]See Brown, *American Painting from the Armory Show to the Depression, 1913–1929* (Princeton, NJ: Princeton University Press, 1955), 8.

[77]Klaric, "Arthur G. Dove's Abstract Style of 1912: Dimensions of the Decorative and Bergsonian Realities" (PhD diss., University of Wisconsin, 1984), 1-4, 22, 347. Interestingly, Bergson had been an important means of weaning Jacques Maritain from the reigning materialism and opening him to religious faith. Charles Eldredge argues Dove's abstractions in 1910 had roots "firmly planted in the nineteenth-century imagination." Eldredge, "Nature Symbolized: American Painting from Ryder to Hartley," in Tuchman, *The Spiritual in Art: Abstract Painting, 1890–1985*, 113.

Figure 6.3. Marsden Hartley, *The Dark Mountain, No. 2,* 1909

No. 2 (1909) (fig. 6.3), reveals Hartley's combination of European modernism and Yankee brooding sense of the transcendent presence in nature. The influence of Ryder is strong, and one senses in the dark mountain set off by the bright horizon poetic sensitivities that Ryder would appreciate. So deep were his religious convictions at this time that he considered going into the Episcopal ministry. Later he read the Christian mystics—including John Tauler and Meister Eckhart—and out of the "heat of reading" he started to work on his abstractions. For these artists the simple dichotomy of American realism/ European abstraction, or its typical counterpart religious/secular does not fit. Charles Eldredge offers a different summary: "a generation of American modernists, steeped in the tradition of landscape yet seeking to transcend it, was inspired by Kandinsky's words . . . [yet was also] curiously reminiscent of the transcendentalists or Ryder."[78]

[78]Eldredge, "Nature Symbolized," 118. Cf. Broun, *Albert Pinkham Ryder,* 169. Hartley emphatically rejected expressionism, seeking rather to return to nature and to record it faithfully as an intellectual idea. See Hartley, "Art—and the Personal Life," *Creative Art* 2 (June 1928): xxxi-xxxii,

On February 17, 1913, the famous Armory Show opened in New York (closing March 15, though parts of the exhibition traveled later to Boston and Chicago), offering a vivid example of the tensions being played out in American art. Though it served as a turning point in the development of an American voice, its characterization as a "foreign invasion" and a secularizing influence has often been exaggerated. While it exposed the broader public to several major European artists, and in the process set off a lively discussion about art and its role in modern life, it certainly did not mark the complete triumph of European modernism, nor did it "cut short a developing tradition of American realism."[79]

Arguably the influence of Europe, especially of France, had been constant since the middle of the previous century. Many major artists spent time in London and later in Paris, and major galleries like Stieglitz's Gallery 291 had been showing important French artists for some time before the Armory Show. Moreover, a generous selection of American artists (like William Glackens and especially Ryder) was included in that 1913 exhibition. The review of Charles Caffin, appearing in the *New York American* on March 10, 1913, illustrates the contradictory responses the show elicited.[80] On the one hand, Caffin insisted that the exhibition illustrated the way "the old ideas of religion have been gradually supplanted by the new idea of the religion of science." Yet he also goes on to note that around the core of French masters, Albert Pinkham Ryder was honored with ten pictures in the central gallery, more than any other American painter. As Caffin says of Ryder, "in his unobtrusive sincerity he, in fact, anticipated that abstract expression toward which painting is returning and may almost be said to take his place as an old master in the modern movement." No doubt Caffin was right about this, but it is hard to see how Ryder (or many of the French masters, for that matter) could represent the idea of the "religion of science." Ryder had completely withdrawn from public view by this point, but he was still alive to celebrate his triumph. One of the show's organizers, Arthur Davies, persuaded Ryder to visit the Armory Show, and he led the old man on his arm through the gallery with

where he confesses "I am a man of faith." On Hartley's religious convictions see Gail R. Scott, *Marsden Hartley* (New York: Abbeville Press, 1988), 14.

[79]This was Milton Brown's characterization of the Armory Show; see Brown, *American Painting*, 57.

[80]The description of the show and Caffin's response is from Broun, *Albert Pinkham Ryder*, 2.

Ryder's paintings. Davies reported that he "grunted a few times and nodded his head." The Reverend was content.

FROM THE FIRST WORLD WAR TO THE SECOND: FINDING AN AMERICAN VOICE

The struggle over imported and indigenous influences was a real one, however, and it continued, often being played out within the same artist. In general, the avant-garde movement, represented by the artists Stieglitz championed, was more open to modernist influences, whether coming from Germany or France, while others—mostly realists—championed American sources. But Ryder's influence continued beyond the Armory Show especially among those who turned to abstraction. His mantra of "nature springing to life" could easily characterize Georgia O'Keeffe, as well as Dove and Hartley.[81] These were also drawn to the ideas of Vasily Kandinsky (1866–1944). Kandinsky had become well known in North America not primarily through his paintings, though these had been shown, but through his essay *On the Spiritual in Art*, which appeared in English translation in 1914 (though Stieglitz had already published an excerpt in his journal *Camera Work* in July 1912). Artists were especially drawn to Kandinsky's idea that the inner spirit could be transcribed in outer forms, as a kind of visual music. In fact, his actual paintings, which purported to illustrate his ideas, made relatively little impact. As Marsden Hartley put it, Kandinsky "gets it in his writing but not in his paintings."[82]

Hartley's case is particularly interesting because he was considered a major artist in Europe as well as in America, exhibiting with Der Blaue Reiter group in Germany. Still, in a letter to Stieglitz in 1913 he distanced himself from Germany and France (and from Kandinsky), insisting that he remained an American. His 1909 landscapes, for example, were "so expressive of my nature— and it is the same element that I am returning to now with a tremendous increase of power through experience."[83] Part of that experience, remember, was his reading of the Christian mystics. He returned to nature as "an intellectual

[81]Charles Eldredge, "Nature Symbolized," 116-17. Eldredge argues that O'Keeffe and Dove managed "the merger of abstract image and subjective meaning" (117).

[82]Ibid., 118. Sandra Gail Levin has shown that Kandinsky's influence on American avant-garde painters, especially Ernest Bloch and Hans Hofmann as well as Hartley, was primarily through his ideas rather than his work. See Levin, "Wassily Kandinsky and the American Avant-Garde, 1912–1950" (PhD diss., Rutgers University, 1976).

[83]Eldredge, "Nature Symbolized," 118.

idea" and envied the artists of the past who "had the intellectual structure upon which to place their emotions."[84]

This last quote is suggestive of a consistent strain in American art. Though Emerson and the transcendentalists celebrated a kind of personal spiritual experience, American artists tended to resist mysticism per se. As Sandra Levin argues in her study of Kandinsky's influence on American modernism, "Mysticism did not strike a sympathetic chord, but [Kandinsky's] demand that art be based on 'inner necessity' did. The artist is not only justified in using, but is under a moral obligation to use only those forms which fulfill his own need, even if such forms are abstract."[85] Both European and American abstract artists, initially at least, worked from spiritual motivations—whether these were Swedenborgian or Christian. But in the development and practice of abstraction, artists reflected their—very different—American or European settings. The American painter Barnett Newman characterized this difference this way: "To put it philosophically, the European is concerned with the transcendence of objects, the American is concerned with the transcendental experience."[86] Using this same contrast, the British artist and art historian John Golding framed it in somewhat different terms:

> It might perhaps be fair to say that the early European abstractionists had achieved their absolutes, had purified and purged art, by in a sense painting themselves out of their pictures, whereas the Americans were trying to achieve some of the same ends by painting themselves totally into their canvases, by stepping up and into them, even in an odd way by becoming art.[87]

This comment reflects the different attitudes toward art in these places, of course, but it also reflects their very different views of religion. Religion in America has always placed the focus on the individual will and private experience. Even if traditional theism was questioned, this personal quest determined both what art could mean and the role that nature played in its production.

[84]Hartley, "Art—and the Personal Life," xxxiv. Cf. artist John Marin's comment that the artist must return to the elemental forms of nature, sky and mountain to "true himself up" (quoted in Eldredge, "Nature Symbolized," 124).

[85]Levin, "Wassily Kandinsky and the American Avant-Garde," 98.

[86]Newman, quoted in John Golding, *Paths to the Absolute: Mondrian, Malevich, Kandinsky, Pollock, Newman, Rothko, and Still* (Princeton, NJ: Princeton University Press, 2000), 194.

[87]Ibid., 195.

Another important attempt to naturalize European developments for an American audience was represented by the so-called Société Anonyme (SA), a kind of experimental museum established in New York in 1920. Founded by the indomitable Katherine Sophie Dreier (1877–1952) in collaboration with Man Ray and Marcel Duchamp, this movement became an important means of introducing art that, as they put it, "represented the modernist spirit" to the larger American public.[88] This was an important venture since Stieglitz's Gallery 291 had closed in 1917 and the Museum of Modern Art would not open until 1929. Surprisingly, many in the group were highly suspicious of European influence in America (an attitude that even Stieglitz came to share), feeling that America could be a unique site for embodying modernist values.[89] Perhaps even more interesting is the role that religion played in the development of the SA program. Katherine Dreier herself felt strongly that the foundation of the whole modern movement was spiritual. She particularly loved Kandinsky's *On the Spiritual in Art* and had been deeply influenced by Madame Blavatsky's theosophical ideas. She believed that artists have an inner spiritual sense that can discern a deeper reality. Interestingly, Dreier in conjunction with SA became one of the leading presenters of Russian modernism in America, demonstrating an understanding of its deeply religious character. But since she had no other framework in which to place the work, Dreier imprinted her own theosophical beliefs on this work, rather than seeing in it the strong Russian Orthodox impulse that was the more likely source. Marcel Duchamp's connection with the SA, during which he became a naturalized US citizen, is particularly interesting given his immense influence on the European developments we traced in an earlier chapter. Like Dreier, Duchamp had apparently flirted with theosophical ideas early on but, consistent with his French heritage, was drawn more to Catholic symbols in his work. In fact, David Hopkins has argued that Duchamp's Catholic background functioned as "Duchamp's chief aesthetic resource."[90]

[88]See Jennifer R. Gross, "An Artists' Museum," in *The Société Anonyme: Modernism for America*, ed. J. R. Gross, exh. cat. (New Haven, CT: Yale University Press, 2006), 2-3. The group was responsible for more than eighty exhibitions in various venues, representing over 1,000 works of art.

[89]Ibid., 7.

[90]Hopkins, *Marcel Duchamp and Max Ernst* (Oxford: Clarendon Press, 1998), 90. See also Ruth L. Bohan, "Artist Readymade: Marcel Duchamp and the Société Anonyme," in Gross, *Société Anonyme*, 17-29. Later in this book Susan Greenberg argues that the educational mission of SA was deeply marked by the progressive movement in education (97).

Over against SA's celebration of the modern spirit, there were strong pro-
ponents of native traditions in American art who actively resisted what they
called foreign influences. These "regionalist" supporters held up artists like
Thomas Hart Benton or Grant Wood as American originals. In 1931, for ex-
ample, critic Thomas Craven launched a diatribe against the "internationalism"
of Stieglitz. Rather than allowing a distinctly American art to emerge, he wrote,
these influences had a damaging effect on art: "increasing in purity, painting
shrank proportionately in human values until, at last, it appealed to a few souls
divinely endowed with the 'aesthetic emotion.'"[91] Siding with Benton and
Wood, Craven lamented the Armory Show and its "Parisian aesthetics," noting
that American artists have not known how to respond to this assault from
abroad. He summarizes the dilemma with a quote from Benton: "Without
those old cultural ties which used to make the art of each country so expressive
of national and regional character, it has lost not only its social purpose but its
very techniques for expression."[92]

As we have seen, this struggle was not simply a matter of the American
nativists versus the European influenced modernists—both sides cele-
brated their American setting, and both would make their contribution to
the burgeoning art scene in America. Jackson Pollock was one of Benton's
students in the 1930s and was grateful to him, though primarily for giving
him something to react against. But what exactly would Pollock react
against? Certainly not against Benton's Americanism; Pollock was eager to
claim those roots as well. Dennis Raverty in a perceptive recent study has
argued that something much deeper was going on in this debate. He de-
scribes development in the arts of that period as moving from a politically
engaged realism to an apolitical abstractionism. He argues that this
movement was taking place not simply because the avant-garde was re-
placing an earlier realism; it was also happening within the avant-garde it-
self.[93] Raverty describes the way these issues were deeply philosophical and
even religious.

[91]Craven, "Distinctly American Art," in Barbara Rose, *Readings in American Art*, 105.

[92]Ibid., 111. Those cultural ties include the strong religious traditions of America, which were often
prominent in the art of this period. Cf. Robert L. Gambone, *Art and Popular Religion in Evangeli-
cal America, 1915–1940* (Knoxville: University of Tennessee Press, 1989).

[93]Raverty, *Struggle over the Modern: Purity and Experience in American Art Criticism, 1900–1960*
(Madison, NJ: Fairleigh Dickinson University Press, 2005), 9.

During the 1930s, for example, Raverty notes the particular impact of William James and John Dewey. Both sought to preserve a sense of individual dignity and initiative over against various forms of (Nazi and Marxist) determinism—much as Emerson had been trying to shape and treasure the personal development of the person (in opposition to the know-nothing populists) a century earlier. Raverty thinks this was one of the purposes behind Dewey's *Experience and Nature* (1925) and his *Art as Experience* (1934). Raverty signals then the continuing importance of the progressivism that Dewey championed and its call for a socially engaged art. Like Dada before it, this view of art called for somewhat porous boundaries between art and life. Formalism would eventually challenge all this, but that, Raverty thinks, was still a minority view in the 1930s.[94] By the end of this decade, however, things began to change.

MoMA and American Modernism

In 1936 the major exhibition "Cubism and Abstract Art" opened at the new Museum of Modern Art (MoMA), and the dynamics in the American art world shifted. To understand this we need to turn to Alfred H. Barr Jr. (1902–1981), the leading figure behind MoMA and this exhibition in particular. As we noted in our introduction, Barr was a minister's son and an active Presbyterian layman all his life, but, unlike many of his fellow Christians, he was also an early convert to modern art.[95] In his famous essay accompanying the exhibition he built a framework for making sense of this strange collection of abstract images and objects. Whereas the established traditions of Western artmaking had, at least since the Renaissance, been preoccupied with the "pictorial conquest of the external world," Barr's task was to explain why twentieth-century artists were renouncing that conquest: "by a common and powerful impulse they were driven to abandon the imitation of natural appearances," which they came to see as "at best superfluous and at worst distracting."[96] He admits that this renunciation involved "a great impoverishment of painting, an

[94]Ibid., 53, 110.

[95]See Alice Goldfarb Marquis, *Alfred H. Barr, Jr.: Missionary for the Modern* (Chicago: Contemporary Books, 1989): "A minister's son from Baltimore, Barr knew his Bible and had no qualms about preaching a revealed doctrine" (3). She argues that he put his evangelical calling to work in his support of modernism, labeling MoMA a "Pulpit for Mr. Barr" (chap. 4).

[96]Barr, *Cubism and Abstract Art* (New York: Museum of Modern Art, 1936), 11, 13.

elimination of a wide range of values, such as the connotations of subject matter [that are] sentimental, documentary, political, sexual, [and] religious. ... But in his art the abstract artist prefers impoverishment to adulteration."[97] Barr then lays out what was to become a standard genealogy of modern art, which he traced along two streams: the first line is "geometric" and structuralist, running from Cézanne through cubism toward the constructivism of Mondrian and Malevich; the second is "non-geometric" and expressionist, running from Gauguin through Fauvism and on to Kandinsky. He evocatively summarizes these lineages as philosophically, even spiritually, rooted in deeper values: "Apollo, Pythagoras and Descartes watch over the Cézanne-Cubist-geometric tradition; Dionysius, Plotinus and Rousseau over the Gauguin-Expressionist-non-geometric line."[98] Within cubism, which was the focus of the exhibit, he famously distinguished between the early "analytic" approach and the "synthetic" cubism that followed; that is, the impulse to take objects apart later led to the need to add and aggregate elements. (Barr felt that "collage" was the key development of modern art.)[99] Reading Barr's analysis today, one is struck by the imperial reduction of modern movements to these two axes of geometric and nongeometric abstraction. Indeed, he believed that this reduction was simply intrinsic to the logic of modernism: "it was inevitable that the impulse towards pure abstraction should have been carried to an absolute conclusion sooner or later."[100] If Kandinsky had not come along, it seems someone else would have.

But was all this simply inevitable? And what exactly was this powerful "impulse" that led artists to give up the representation of natural appearances? The young art historian Meyer Schapiro (1904–1996) soon raised these questions in a forceful response to Barr's essay. The Marxist critic argued that Barr's reading of things was "essentially unhistorical": it charted the history of modern art "as an internal, immanent process among artists," while largely ignoring the particular social, historical and political contexts in which the

[97]Ibid., 13. In addition to the loss of subject matter, the other two eliminated values he identifies are "the pleasures of easy recognition" and "the enjoyment of technical dexterity in the imitation of material forms and surfaces" (13).

[98]Ibid., 19.

[99]See Sybil Gordon Kantor, *Alfred H. Barr, Jr., and the Intellectual Origins of the Museum of Modern Art* (Cambridge, MA: MIT Press, 2002), 322-23. He shared this assessment of collage with Clement Greenberg.

[100]Barr, *Cubism and Abstract Art*, 122.

artists in question were developing their work.[101] Schapiro characterized the engine of Barr's account as a "theory of immanent exhaustion and reaction": each new art form emerges as "a sheer reaction or as the inevitable response to the spending of all the resources of the old [forms]," and in this way art history is propelled forward by "the perpetual alternating motion of generations."[102] The problem, according to Schapiro, is that this "not only reduces human activity to a simple mechanical movement, like a bouncing ball," but also "in neglecting the [cultural] sources of energy and the [historical] condition of the field, it does not even do justice to its own limited mechanical conception."[103]

Schapiro believed that something far more significant (and indeterminate) was going on. In each case, these modernist "reactions" were not primarily aesthetic but "were deeply motivated in the experience of the artists, in a changing world with which they had to come to terms and which shaped their practice and ideas in specific ways."[104] Thus he argued that the historian's questioning must drive deeper into these experiences: What changed for these artists with respect to the symbolic values of the world around them? Why, for example, did the impressionists come to a conception of art that "transformed nature into a private, unformalized field for sensitive vision, shifting with the spectator"?[105] And why had the postimpressionists reacted against this lack of structure, demanding "salvation" (Schapiro's word!) and "order and fixed objects of belief"?[106] Schapiro insisted that "far from being inherent in the nature of art," these developments "issued from the responses that artists as artists made to the broader situation in which they found themselves."[107] As he saw it, the aesthetic or formal concerns that seemed to drive Barr's history of modernism were profoundly shaped by sociohistorical pressures and thus demanded explanation in those terms: "there is no 'pure art,' unconditioned by experience; all fantasy and formal construction, even the random scribbling

[101]Meyer Schapiro, "Nature of Abstract Art," *Marxist Quarterly* 1, no. 1 (January–March 1937): 77-98; reprinted in Schapiro, *Modern Art: 19th and 20th Centuries; Selected Papers* (New York: George Braziller, 1979), 187-88.

[102]Ibid., 189.

[103]Ibid.

[104]Ibid., 191.

[105]Ibid., 192.

[106]Ibid., 193.

[107]Ibid., 194.

of the hand, are shaped by experience and by nonaesthetic concerns," which flow "from historically changing interests."[108] Contrary to Barr, Schapiro thus believed that modernists turned toward nonobjective abstraction not because "the processes of imitating nature were exhausted" but because "the valuation of nature itself had changed."[109] And, as he argued elsewhere, this revaluation implied that the view of the self in relation to its surroundings—and thus the project of representing those surroundings—had also changed.[110] Modernist abstraction must therefore be (re)investigated in terms of the "longings, tensions and values" that were at stake for these artists.[111] Indeed, as he summarized in thoroughly Rookmaakerian language, "The philosophy of art was also a philosophy of life."[112]

Interestingly, Schapiro recognized that the "longings, tensions and values" that were caught up in these changes had deep religious dimensions. Modernist artworks might not "communicate" in a conventional way, but they do "induce an attitude of communion and contemplation. They offer to many an equivalent of what is regarded as part of religious life: a sincere and humble submission to a spiritual object, an experience of which is not given automatically, but requires preparation and purity of spirit."[113] For example, Schapiro comments on the "quasi-religious beliefs" of the postimpressionists and their search for "a collective spiritual life," interpreting their aim as "groping to reconstitute the pervasive human sociability that capitalism had destroyed."[114]

One feels a certain irony in watching the Marxist Schapiro lecture the Presbyterian Barr on the shaping influences of ultimate (even religious) values on the development of modern art. Barr certainly *did* believe that nonaesthetic factors were in play in these developments, which he would give greater voice to in subsequent years. Despite his early emphasis on the

[108]Ibid., 196.

[109]Ibid., 202.

[110]Schapiro, "Recent Abstract Painting" (1957), in *Modern Art*, 222. More specifically, Schapiro believed that much modernist painting articulated the "fragility of the self within a culture that becomes increasingly organized through industry, economy and the state" (222).

[111]Schapiro, "Nature of Abstract Art," 195.

[112]Ibid., 202.

[113]Schapiro, "Recent Abstract Painting," 224. Schapiro concludes by making the important and often overlooked point that these new means have enlarged the capacity of art and opened to it new regions of feeling and perception (225-26).

[114]Schapiro, "Nature of Abstract Art," 193.

formal lineages of modern art, he did not ignore the tortuous and trauma-tizing events taking place outside the walls of MoMA—how could he? Writing during World War II, Barr bluntly asserted in *What Is Modern Painting?* that "Today nothing is more important than the War."[115] And it was precisely in this context that he believed that the modern work of art might function as "a visible symbol of the human spirit in its search for truth, freedom and perfection"—a mode of searching that might "help us see and understand" the most critical problems of modernity and offer a potent means of resisting them.[116]

For Barr "truth, freedom and perfection" were still deeply religious values. In fact, in the conclusion of *What Is Modern Painting?* he suggests that these "might be proposed as the artist's equivalent of . . . what faith, hope and charity are to the Christian."[117] And he had begun to talk about modern art in terms strongly alluding to the Christian love commands: "Art teaches us not to love, through false pride and ignorance, exclusively that which resembles us. It teaches us rather to love, by a great effort of intelligence and sensibility, that which is different from us."[118] He was particularly interested in modern art's ability to function on this level, recognizing that because "in our civilization a general decline in religious, ethical and moral convictions [has taken place], art may well have increasing importance quite outside esthetic enjoyment."[119] These were intuitions that he would develop in subsequent years. In 1941 he proposed an exhibition at MoMA titled *The Religious Spirit in Contemporary Art*.[120] Beginning in 1954, Barr became the head of the Commission of Art for the National Council of Churches, at the same time that he became influ-ential in proposing religious imagery for publication in *Life* magazine. In 1961

[115]Barr, *What Is Modern Painting?* (New York: Museum of Modern Art, 1943), 6.

[116]Ibid., 3.

[117]Ibid., 38. He also titled a section of the book "Expressionism: The Religious Spirit," in which he focuses on Georges Rouault's *Christ Mocked by Soldiers* (1932) and Max Beckmann's *Departure* (1932–1935). See ibid., 20-21.

[118]Barr, interview with Dwight Macdonald (1931), quoted in Kantor, *Alfred H. Barr, Jr., and the Intel-lectual Origins of the Museum of Modern Art*, 317.

[119]Barr, quoted in ibid., 376.

[120]Related to the premise of this exhibition proposal, Barr argued that modern art is "a revelation of modern life. But by life I do not mean merely the world of ordinary experience—people, families, landscapes, streets, food, clothes, or the collective life of work, politics and war, but also the life of the mind and the heart—of poetry and wit, science and religion, the passion for change or for stability, for freedom or perfection." Barr to Stephen C. Clark (1943), quoted in ibid., 353.

he attempted to bring modern art and religion into more mutually enriching conversation by cofounding the Society for the Arts, Religion and Contemporary Culture (ARC) with renowned theologians Paul Tillich and Marvin Halverson, as well as major New York artists including Robert Motherwell and Ad Reinhardt.[121]

But he also clearly felt the tension between the avant-garde art that he championed and the preferences of his fellow believers. In a report he delivered to the National Council of Churches, he admitted that "our churches and churchmen seem, generally speaking, both ignorant and blind" when it comes to art, preferring saccharine images that "corrupt the religious feelings of children and nourish the complacency and sentimentality of their elders."[122] Barr worked hard to change these attitudes, serving on the Commission on the Arts in the National Council of Churches in 1953 and becoming its chair in 1954. The uncomfortable truth—one that Barr may have not wanted to recognize—was that avant-garde art was increasingly seen as an elitist affair, one that the average layperson tended not to appreciate without proper tutoring. And at the same time, as he well knew, popular religious culture was producing readily accessible devotional images, as most famously exemplified by the paintings of Warner Sallman. Though the dichotomy between "high culture" and "popular culture" (wherein popular culture receives the subordinate valuation) was to change dramatically in the 1960s, this dichotomy was sharp when Barr was writing. He surely believed his support for modern art was grounded in his Reformed faith, but those who stared uncomprehendingly at the images exhibited at his museum just as surely felt religious motivation to oppose them. This tension—or rather these multiple tensions—provides graphic illustration of the difficulty of tracking down the precise role of religion, either positively or negatively, in artistic developments. But it also underlines its persistent salience. Sally Promey rightly argues that "in the United Sates, religion acts, disproportionately, as a crucible for conflict

[121]For more on the second half of this paragraph see Sally M. Promey, "Interchangeable Art: Warner Sallman and the Critics of Mass Culture," in *Icons of American Protestantism: The Art of Warner Sallman*, ed. David Morgan (New Haven, CT: Yale University Press, 1996), 172-73.

[122]Barr, quoted in ibid., 173. This report, drawn from the archives in MoMA, shows how Barr felt that modern art was a religious and humanistic response to atheism and how he worked to change attitudes toward this new art, including, among other things, inviting Paul Tillich to come to MoMA to speak.

between different visual cultures," precisely because when artworks are considered within a religious framework "a religious and ethical overlay adheres to aesthetic judgment."[123]

ABSTRACT EXPRESSIONISM AND THE ARRIVAL
OF AMERICAN MODERNISM

This religious and ethical overlay was especially significant during the 1940s as New York replaced Paris as the center of the art world. This migration partly had to do with the mass displacements caused by the war, which stimulated many prominent artists to flee to New York. But more influential was the spiritual dislocation caused by the carnage of that war and the subsequent dark threat of the mushroom cloud hanging over human civilization. Modernist artists powerfully articulated their sense of trauma and ethical outrage, even if their resources for envisioning positive renewal seemed unclear. Strong voices of cultural critique were raised against all modernist values, many in the name of Christianity: Hans Sedlmayr (who was very influential on Rookmaaker) lamented the loss of a center; Romano Guardini called for a return to the Christian doctrine of redemption. But as Werner Haftmann argues, in the field of art it was proving difficult for artists to find in Christianity a vision for their work.[124]

Despite the influx of immigrant artists, the central players in the rise of New York modernism either were born in America or, like Willem de Kooning and Mark Rothko, were longtime residents there. And for these artists the quest for revitalized forms was more informed by American traditions than it was a reaction against modernism in Europe. We recall that the two dominant characteristics of religion in America had been (1) the inclination to find in nature the presence of God, or at least a source of transcendent value, and (2) the need to personally and directly appropriate this presence. Both of these characteristics influenced the rise of abstract expressionism in North America, and both had continuing religious resonance, even if many of these artists distrusted religious institutions.

[123]Ibid., 177.
[124]Haftmann, *Painting in the Twentieth Century*, ed. and trans. Ralph Manheim (New York: Praeger, 1965), 1:311. In addition to Sedlmayr and Guardini, Haftmann also refers to Wilhelm Hausenstein in Germany, Wyndham Lewis in England and Vladimir Weidlé in France.

The best representative of these values, and arguably the most decisive influence on the rise of American modernism, was Jackson Pollock (1912–1956). Pollock was born in Cody, Wyoming, in 1912 of stern Scotch-Irish and Presbyterian parents. Spiritual issues were always important for Pollock, and he actively sought insight from a wide variety of spiritual traditions. While he was a student at the Manual Arts High School in Los Angeles, his art teacher introduced him to a variety of Eastern and esoteric religious systems, including Hinduism, Buddhism and Rosicrucianism.[125] When he was expelled from high school in 1929, he informed his parents that though he had dropped religion "for the present" he was still interested in mysticism and the occult. Later he studied theosophy and became familiar with Native American religious rituals and mythology.[126]

In the 1930s he studied with Thomas Hart Benton and was already struggling with alcoholism, moving in and out of therapy. His first major New York show at the McMillen Gallery in 1942 explored intensely mythical themes through a mixture of symbolic and abstract forms that caught the attention of Peggy Guggenheim. Soon after this, he married Lee Krasner, a Jewish woman. Though an agnostic, Pollock insisted on a church wedding, and they were married in the Marble Collegiate Presbyterian Church in New York.[127] Having thrown over the influence of Benton, his work was mostly generated through abstract mark-making, and filled with occult and religious imagery. He was working with a Jungian therapist during this period. In 1946 he moved to a farm in East Hampton, where he began his famous drip paintings. His titles revealed Pollock's sense of magic and the mythical role of the artist: *Alchemy, Cathedral, Totem, Gothic, Lucifer, Enchanted Forest. Cathedral*, painted in 1947, marks the arrival of the new style of thrown or dribbled painting. But it is also one of the first appearances of silver aluminum paint, which attracted Pollock

[125]See Elizabeth Langhorne, "The Magus and the Alchemist: John Graham and Jackson Pollock," *American Art* 12, no. 3 (1998): 50.

[126]On this development see B. H. Friedman, *Jackson Pollock: Energy Made Visible* (New York: McGraw-Hill, 1972), 4-13.

[127]According to Krasner, Pollock felt a sense of "great loss" "because of the absence of religion in his life." She later recounted that at the time of their marriage he was "tending more and more to religion." See Lee Krasner's interview with Francine du Plessix and Cleve Gray in "Who Was Jackson Pollock?," *Art in America* 55, no. 3 (May-June 1967), 48-51; reprinted in *Jackson Pollock: Interviews, Articles, and Reviews*, ed. Pepe Karmel (New York: Museum of Modern Art, 1999), 31.

because of its ceremonial and ritual connections. Clearly for Pollock, if not for the general public, there were religious dimensions to what he was doing.

The natural environment was still critical for Pollock, but it was now being experientially absorbed into the artist's own creative activity. Earlier, when Hans Hofmann had asked Pollock about the role of nature, Pollock had replied, "I am nature."[128] In fact artmaking had itself become a ritual, like the Indian sand painting that Pollock loved. That deeply metaphysical and religious elements were central to his work was clear even to his early promoter, the formalist critic Clement Greenberg. Writing about Pollock, Rothko and Gottlieb in 1947, Greenberg acknowledged the importance of these mythmakers, even though he disliked the myths: "I myself would question the importance this school attributes to the symbolical or 'metaphysical' content of its art; there is something . . . revivalist, in a familiar American way, about it."[129] Greenberg wanted to leave all that behind, and in so doing he entirely collapsed the (central) role that spirituality played in the work of each of these artists. Pollock openly acknowledged the impasse: "It's not something you can discuss with Greenberg."[130] Though they wanted emphatically to turn away from European influence—to make paintings, as they said, "without benefit of European history"—they sought to record nature substantially, as a timeless subject matter. Rather than importing European styles into American painting, it is more accurate to say that Pollock brought western US and Native American sensitivities into the mainstream of global art.[131] Pollock was rooted deeply in his American setting, though he believed that the most important modernist paintings had, at least up until the mass emigrations of World War II, been done in France. In 1944 he asserted that "American painters have generally missed the point of modern painting from beginning to end. (The only American master who interests me is Ryder.)"[132]

Though claimed by the formalist critics, Pollock argued that his work was more about modern life than pure form: "It seems to me that the modern

[128]Friedman, *Jackson Pollock*, 64-65.

[129]Greenberg, quoted in Irving Sandler, *The Triumph of American Painting: A History of Abstract Expressionism* (New York: Harper & Row, 1970), 88.

[130]Pollock, quoted in Langhorne, "The Magus and the Alchemist," 48.

[131]Friedman, *Jackson Pollock*, 116-20.

[132]Pollock, answers to a questionnaire, *Arts and Architecture* 61, no. 2 (February 1944): 14; reprinted in Rose, *Readings in American Art*, 151-52.

painter cannot express this age, the airplane, the atom bomb, the radio, in the old forms of the Renaissance or of any other past culture. Each age finds its own technique."[133] Clearly for Pollock the ability to "express this age" mattered; he was not simply intent on using art to escape or create an alternative world. Rookmaaker seemed to recognize this positive goal, arguing that "inevitably we are drawn into an argument with modern man about his ideas . . . and our responsibility to help build a future world."[134] And for Pollock this responsibility rested more on spiritual foundations than on political ones.

The desire to separate art from politics, which was so evident in the 1930s, proved harder to sustain in the next decade. And as Barr's odyssey illustrates, it would prove even more difficult to disentangle art from religion and ritual. Though expressing the longstanding American impulse toward personal and direct religious experience, Pollock's work was a new expression of this tradition—one built entirely on personal conviction and experience. The transcendent had for these painters collapsed. In 1952 Pollock expressed this in a radio interview: "Today painters do not have to go to a subject matter outside themselves. Most modern painters work from a different source, they work from within . . . expressing the energy, the motion and other inner forces."[135] But the mystery that he conveyed had a religious quality to it. This was the assessment of Betty Parsons, in whose gallery he had a highly successful show in 1948: "He had a sense of mystery. His religiousness was in those terms—a sense of the rhythm of the universe, of the big order—like the oriental philosophies."[136] This is evident in *Easter and the Totem* (1953) (fig. 6.4), where one sees the painterly influence of Picasso and Matisse, but underlying this is the thematic push of the Mexican muralists and Native American religions.[137] The juxtaposition of themes in the title calls attention to the dynamic

[133]Pollock, "Interview with William Wright" (1950), in *Theories and Documents of Contemporary Art: A Sourcebook of Artists' Writings*, ed. Kristine Stiles and Peter Selz (Berkeley: University of California Press, 1996), 22.

[134]Rookmaaker, *MADC*, 168. He is referring here to Pollock along with others. But elsewhere he makes this puzzling judgment of Pollock: "A man like Jackson Pollock set out to destroy all (rational) meaning and significance. That is to say that for him art could only be true if it could show us the deepest meaning of things, and that was the complete absence of meaning." See "Do We Need to Be Modern in Order to Be Contemporary?" (1974), in *CWR*, 5:319.

[135]Pollock, quoted in Friedman, *Jackson Pollock*, 175-76.

[136]Parsons, quoted in ibid., 181.

[137]Ellen G. Landau also sees the strong influence (growing during this period) of Lee Krasner. See Landau, *Jackson Pollock* (New York: Abrams, 1989), 223.

fusing of diverse forms of religious hope in the work—Pollock, like Picasso, believed in the power of putting disparate images together. The energy released by this juxtaposition echoed the energy created by his famous drip paintings.

Pollock talked frequently with his friend, the artist Tony Smith, about the latter's Catholic faith. Friedman thinks Pollock may have considered becoming Catholic. The two of them engaged in extensive discussions with Alfonso Ossorio about designing a Catholic church on Long Island.[138] But during this time he struggled with

Figure 6.4. Jackson Pollock, *Easter and the Totem*, 1953

alcoholism and his language grew more obscene, seeking perhaps through his work and drink to forge an identity he may have felt was slipping away from him. In 1956 he was killed in an automobile accident near his farm and the barn that had become his studio in East Hampton. Krasner made sure he had a church funeral, which she knew he would have wanted.[139] Pastor George Nicholson, at Krasner's instructions, read from the Phillips translation of Romans 8:

> The whole creation is on tiptoe to see the wonderful sight of the sons of God coming into their own. The world of creation cannot as yet see reality, not because it chooses to be blind, but because in God's purpose it has been so limited—yet it has been given hope. And the hope is that in the end the whole of created life will be rescued from the tyranny of change and decay, and have its share in the magnificent liberty which can only belong to the children of God! (Rom 8:19-21 J. B. Phillips translation)

[138]Friedman, *Jackson Pollock*, 203. See also E. A. Carmean Jr., "The Church Project: Pollock's Passion Themes," *Art in America* 70, no. 6 (1982): 110-22; and Linda Stratford, "Spiritually Charged Visual Strategy: Jackson Pollock's Autumn Rhythm," in *Art as Spiritual Perception: Essays in Honor of E. John Walford*, ed. James Romaine (Wheaton, IL: Crossway, 2012), 249.
[139]For a description of the funeral, see ibid., 251.

While Clement Greenberg famously championed this abstract expressionism as the new American modernism, other critics struggled to make sense of the movement on entirely different bases. Writing in 1952, Harold Rosenberg coined the term "action painting," noting ironically that what connected these artists was what they did individually. And thus Rosenberg shifted the emphasis from the materiality of the medium (which was Greenberg's concern) to the activity of the artist: "At a certain moment the canvas began to appear to one American painter after another as an arena in which to act—rather than a space in which to reproduce, redesign, analyze or 'express' an object, actual or imagined. What was to go on the canvas was not a picture but an event."[140] In this act aesthetics has been subordinated to the dramatic interest created by the act, the "taking place" of the work as an extension of the biography of the artist. Art and life have been merged. But tellingly, Rosenberg notes, "The American vanguard artist took to the white expanse of the canvas as Melville's Ishmael took to the sea. On the one hand, a desperate recognition of moral and intellectual exhaustion; on the other, the exhilaration of an adventure over the depths in which he might find reflected the true image of his identity."[141] It is, this critic claims, a religious movement in secular terms, creating private myths.[142] All of this recalls Emerson and Whitman, who almost could be said to have anticipated Pollock's working process: "When I am *in* my painting, I'm not aware of what I am doing.... I have no fears about making changes, destroying the image, etc., because the painting has a life of its own. I try to let it come through."[143]

If Pollock and his contemporaries agreed that religion, and Christianity in particular, no longer provided a compelling vision for their art, clearly they did not for all that give up their own spiritual sense of the world. Robert Motherwell could have been speaking for many of his generation when in the mid-1940s he wrote:

> The social condition of the modern world which gives every experience its form is the spiritual breakdown which followed the collapse of religion. . . . The

[140]Rosenberg, "American Action Painters," *Art News* 51 (December 1952), reprinted in McCoubrey, *American Art: Sources and Documents*, 213-22.

[141]Ibid., 218.

[142]Rosenberg notes that, at that time, the movement had neither the audience nor the critical understanding it needed. See ibid., 222.

[143]Pollock, "My Painting" (1947), in Rose, *Readings in American Art*, 152.

consequence is that the modern artist tends to become the last active spiritual being in the great world. It is true that each artist has his own religion. . . . It is the artists who guard the spirit in the modern world.[144]

And in 1948, the year after Pollock painted *Cathedral*, Barnett Newman would say that artists were freeing themselves of all outmoded legend and myth: "We are reasserting man's natural desire for the exalted. . . . Instead of making cathedrals out of Christ, man or 'life,' we are making it [*sic*] out of ourselves, out of our own feelings. The image we produce is the self-evident one of revelation, real and concrete."[145]

The intense spiritual sensitivities we have been describing exist despite the dominance of Greenberg's formalism. And these coincide with what is generally recognized as the triumph of high modernism in America. Clearly the correlation with modernism and secularism, persistent though it is, has been a reductive reading (or simply a misreading) of this period. But this is not to say that these developments can be easily described in traditional religious categories. In fact it seems that traditional understandings of religion and religious art provided little guidance in anticipating the transformations in art that Pollock presaged.

It is possible that the religious references and the promiscuous borrowing from multiple spiritualities reflect simply Pollock's desire to, once for all, free himself from his Christian heritage. This reading is possible, but we still cannot deny the presence of these various religious impulses as though they made no difference to his work. No artists work from purely aesthetic or economic impulses; artists always work out of a wider range of emotional and spiritual resources—they are not, as Schapiro argues, like bouncing balls. In the interest of the interpretive generosity we have been proposing, then, religious sensitivities must be acknowledged alongside other motivations—artistic, economic, political and philosophical. Which of these will resonate most deeply with a viewer will of course depend on which sensitivities he or she brings to the experience. But the invitation to find a richness in the work must be extended and elaborated as widely as possible.

[144]Motherwell, "The Modern Painter's World" (1944), in Rose, *Readings in American Art*, 131-32.
[145]Newman, "The Sublime Is Now," in Barbara Rose, *Readings in American Art*, 160.

7

North America in the Age of Mass Media

The vernacular glance is what carries us through the city every day, a mode of almost unconscious or at least divided attention. . . . The vernacular glance sees the world as a supermarket.

BRIAN O'DOHERTY[1]

Perhaps nothing is more urgent—if we really want to engage the problem of art in our time—than a destruction of aesthetics that would, by clearing away what is usually taken for granted, allow us to bring into question the very meaning of aesthetics as the science of the work of art. . . . And if it is true that the fundamental architectural problem becomes visible only in the house ravaged by fire, then perhaps we are today in a privileged position to understand the authentic significance of the Western aesthetic project.

GIORGIO AGAMBEN[2]

No idea is clear to us until a little soup has been spilled on it. So when we are asked for bread, let's not give stones, not stale bread. . . . Let's chase down an art that clucks and fills our guts.

DICK HIGGINS[3]

[1]O'Doherty, *American Masters: The Voice and the Myth* (New York: Random House, 1974), 201.
[2]Agamben, *The Man Without Content*, trans. Georgia Albert (Stanford, CA: Stanford University Press, 1999), 6.
[3]Higgins, "A Something Else Manifesto" (1966), in *Theories and Documents of Contemporary Art: A Sourcebook of Artists' Writings*, ed. Kristine Stiles and Peter Selz (Berkeley: University of California Press, 1996), 730.

ALLAN KAPROW AND JOHN CAGE: THE ART OF LIVING

In 1958—two years after Pollock's tragic death—Allan Kaprow (1927–2006) published his assessment of "The Legacy of Jackson Pollock," in which he argued that the famous American action painter had "created some magnificent paintings. But he also destroyed painting."[4] Or more precisely, the drip paintings he made between 1947 and 1950 had flung the conventional constraints of painting so wide open that it no longer seemed capable of sustaining its disciplinary boundaries: "with the huge canvas placed upon the floor, thus making it difficult for the artist to see the whole or any extended section of 'parts,' Pollock could truthfully say that he was 'in' his work."[5] He was also *on* his work. He walked and knelt on the canvas and put out his cigarettes on it. Handprints and footprints are interwoven with the dripping trails of paint, as are an array of things normally kept outside the space of a painting: coins, matches, buttons, nails, tacks, sand and bugs all found their way into the densely layered oil and enamel. The canvas rectangle on the floor marked out a specially charged zone within the space of Pollock's life, but it was also very much continuous with the rest of his life. It was a flat material surface on which (and against which) he acted, as if it were, in the words of Kirk Varnedoe, only "an extension of the physicality of the world, not a window onto anything else."[6]

As Kaprow saw it, the primary consequence of this was that the edges of the painting began to appear as "an abrupt leaving off of the activity, which our imaginations continue outward indefinitely, as though refusing to accept the artificiality of an 'ending.'"[7] The key point is that in Pollock's case this imaginative projection "outward indefinitely" was not pictorial: it had nothing to do with imagining the world *of the image* extending beyond the pictorial frame (journeying further into a represented landscape, for instance). Rather, it was the imagined possibility *of the artistic activity* (and the "medium" of that activity) extending indefinitely beyond the arbitrary shape of the canvas. If what is most interesting about Pollock's painting is that he was "living on the canvas,"

[4]Kaprow, "The Legacy of Jackson Pollock" (1958), in *Essays on the Blurring of Art and Life*, ed. Jeff Kelley, exp. ed. (Los Angeles: University of California Press, 2003), 2.
[5]Ibid., 4.
[6]Varnedoe, *Pictures of Nothing: Abstract Art Since Pollock* (Princeton, NJ: Princeton University Press, 2006), 99.
[7]Kaprow, "Legacy of Jackson Pollock," 5.

as Harold Rosenberg had argued in 1952,[8] then it becomes conceivable that the *artwork*—that which is most meaningful about what the artist has made—has more to do with this concentrated kind of living than with the canvas artifact that is presented afterward. And if that is the case, then it seems that confining the scope of that activity to the space and materiality of oil on canvas is a limitation imposed by convention more than by necessity. In fact, according to Kaprow the logical next step beyond Pollock (and into a fuller artistic practice) was "to give up the making of paintings entirely—I mean the single flat rectangle or oval as we know it"[9]—and instead to push into the possibility of an art composed of living *without* the canvas.

Kaprow argued that those artists who were prepared to follow him into this relinquishing of traditional art materials and formats (as a painter himself he recognized the real sense of loss this might entail) would need to entirely resensitize themselves to the world around them. Those willing to lose their artistic lives must find them again in the experiences of everyday living:

> Pollock, as I see him, left us at the point where we must become preoccupied with and even dazzled by the space and objects of our everyday life, either our bodies, clothes, rooms, or, if need be, the vastness of Forty-second Street. Not satisfied with the suggestion through paint of our senses, we shall utilize [as artistic media] the specific substances of sight, sound, movements, people, odors, touch. Objects of every sort are materials for the new art: paint, chairs, food, electric and neon lights, smoke, water, old socks, a dog, movies, a thousand other things that will be discovered by the present generation of artists.[10]

This is strongly reminiscent of Kandinsky's epiphanic experiences, which similarly left him dazzled by the space and objects of his own everyday life—*this* cigar butt, trouser-button, disposable calendar page and so on (see chapter four)—but Kaprow's response was to try to redefine artmaking around the cultivation of those experiences. The point was not simply to make artworks that were more about life; it was to make an art *of* life, or to conduct everyday life in such a way that it is meaningful *as* art. As far as Kaprow was concerned, the profoundest form of art is one that functions as a way of living a meaningful

[8]Rosenberg, "American Action Painters" (1952), in *Art in Theory, 1900–2000: An Anthology of Changing Ideas*, ed. Charles Harrison and Paul Wood (Malden, MA: Blackwell, 2003), 590.
[9]Kaprow, "Legacy of Jackson Pollock," 7.
[10]Ibid., 7-9.

life (and thus it might not look like art all). Or conversely, it makes con-
spicuous the meanings of the lives we have already been living:

> Not only will these bold creators show us, as if for the first time, the world we
> have always had about us but ignored, but they will disclose entirely unheard-of
> happenings and events, found in garbage cans, police files, hotel lobbies; seen
> in store windows and on the streets; and sensed in dreams and horrible acci-
> dents. An odor of crushed strawberries, a letter from a friend, or a billboard
> selling Drano; three taps on the front door, a scratch, a sigh, or a voice lecturing
> endlessly, a blinding staccato flash, a bowler hat—all will become materials for
> this new concrete art.[11]

To this end Kaprow theorized the "happening"—an intentionally initiated
occurrence that engages the materials and activities of everyday life in such a
way that they stand out as unusual, unexpected, salient. He distinguished hap-
penings from theatrical events in the sense that they have no plot, no clear
symbolism, no defined audience or institutional framing; they are improvisa-
tional, vulnerable to chance, unrepeatable and sometimes utterly mundane in
tone and setting. A happening "might surprisingly turn out to be an affair that
has all the inevitability of a well-ordered middle-class Thanksgiving dinner. . . .
But it could [also] be like slipping on a banana peel, or going to heaven."[12] The
most thoughtful of the artists involved (Kaprow later called them "un-artists")
wanted to dissociate these activities from the trappings of high "Art" but pri-
marily for the sake of channeling the kind of critical self-awareness of art into
everyday life: the happenings "worked" when they generated the sense that
"here is something important." In the happening "nothing obvious is sought
and therefore nothing is won, except the certainty of a number of occurrences
to which we are *more than normally attentive.*"[13]

Many of the earliest happenings were staged in the spaces of galleries or
theaters: Kaprow's first fully developed public happening was *18 Happenings
in 6 Parts* at the Reuben Gallery in New York in October 1959. At an appointed
time audience members were ushered into the gallery and given programs that
directed their participation. The space was divided into three makeshift rooms

[11]Ibid., 9.
[12]For this paragraph see Kaprow, "Happenings in the New York Scene" (1961), in *Essays on the
Blurring of Art and Life*, 15-26. This quotation is from p. 20.
[13]Ibid., 16-17 (emphasis added).

made of stretched plastic sheeting, in which a total of six artists each performed tightly scripted "scores" of root directions, including squeezing oranges, sweeping the floor, sitting on a chair, scaling a ladder, shouting a political slogan, giving a concert on toy instruments and so on. There was no plot or characterization of the performers, only the "happenings" of human activity in relation to the activities of those who constituted the audience. The logic of the happenings, however, almost immediately pushed them outside of institutional art spaces and away from self-conscious audiences. As Kristine Stiles puts it, "Happenings were meant to destroy the nonparticipatory gaze, shatter the proscenium [of the theatrical stage], and involve an audience in the creation of a work of art."[14] This implied that the art activity must become as open and as decentralized as possible and should unfold within the common spaces of daily life: in laundromats, subway trains, Times Square, during friendly introductions at a party, while sitting alone in front of a mirror.[15] They could be as disruptive as banging pots and pans or as subtle as carefully controlling one's own breathing.

Part of Kaprow's argument is that the kind of attentiveness we devote to art objects should (primarily) be focused toward the rest of life. When we approach a painting in a museum—anything from Courbet's *Burial* to Pollock's *Cathedral*—we do so with a structure of expectations that is specifically ordered toward having a *meaning-full* encounter. Whatever forms this takes—anything from careful philosophical reflection to delighting in surprising formal relationships—we expect artworks to deliver meaningful experience. These expectations are carefully managed and sustained by fairly complex efforts to isolate art objects in spaces specifically set aside for this kind of focused attention. A painted object is installed at eye level under controlled lighting; the gallery structure is constructed, arranged and colored to maximize the visual impact of this object; museum staff maintain open hours for visitors to spend time with such objects—all of these are intervals of time and space set aside for practicing meaningful encounter and "contemplation." And it works: endless discourse flows from the meaningful encounters that people

[14]Stiles, "Performance," in *Critical Terms for Art History*, ed. Robert S. Nelson and Richard Shiff, 2nd ed. (Chicago: University of Chicago Press, 2006), 85.

[15]For some examples of Kaprow's descriptions of particular happenings, see "Nontheatrical Performance" (1976), "Participation Performance" (1977) and "Performing Life" (1979) in *Essays on the Blurring of Art and Life*, 163-98.

have in front of paintings. Kaprow's complaint, however, is that the intervals of human life for which we reserve this kind of expectation are too narrow and too insulated: "with the emergence of the picture shop and the museum in the last two centuries as a direct consequence of art's separation from society, art came to mean a dream world, cut off from real life and capable of only indirect reference to the existence most people knew."[16] His goal was not to abolish these institutions as much as it was to instigate experiences that were, in the words of Jeff Kelley, capable of "reversing the signposts that mark the crossroads between art and life," redirecting our expectations for rich aesthetic meaning away from the specialized museum space toward the particular places and mundane events of daily human experience.[17]

If Kaprow was to turn away from "Art" as providing the primary points of reference for the happenings, then he first had to recognize that "there were abundant alternatives in everyday life routines: brushing your teeth, getting on a bus, washing dinner dishes, asking for the time, dressing in front of a mirror, telephoning a friend, squeezing oranges. Instead of making an objective image or occurrence to be seen by someone else, it was a matter of doing something to experience it yourself." It was a matter of *"doing life, consciously."*[18] What distinguished everyday toothbrushing from toothbrushing-as-art was therefore the level of consciousness with which one attended to the experience of living in this or that way. And of course committing to "doing life consciously" in this way renders everyday life as fairly strange: "paying attention changes the thing attended to" in the sense that it "exaggerates the normally unattended aspects of everyday life . . . and frustrates the obvious ones."[19] But this is not strangeness for the sake of being strange; the point was to enrich and deepen our alertness to the structure of the lives we live together. For example, Bill remembers participating in one of Kaprow's happenings in Portland, Oregon, in the early 1970s in which participants were

[16]Kaprow, *Assemblages, Environments, and Happenings* (1966), in Harrison and Wood, *Art in Theory, 1900–2000*, 718.

[17]Kelley, introduction to Kaprow, *Essays on the Blurring of Art and Life*, xii. Though it often isn't recognized as such, this line of argument finds extraordinary resonance in Nicholas Wolterstorff's *Art in Action: Toward a Christian Aesthetic* (Grand Rapids: Eerdmans, 1980).

[18]Kaprow, "Performing Life," 195 (emphasis added).

[19]Ibid., 195, 198. He offers a concise example of just how readily everyday routines become strange through attention to one's actions: "just try to pump a hand[shake] five or six times instead of two and you'll cause instant anxiety" (195).

invited, in pairs, to take mirrors out into the city to learn to see it with fresh (and multiple) eyes, while at the same time learning to see themselves seeing.

The resulting strangeness inevitably had social and ethical implications, and for Kaprow these implications emerged particularly with respect to the powerful shaping influence of mass media on the American social imaginary:

> Happenings are moral activity, if only by implication. Moral intelligence, in contrast to moralism or sermonizing, comes alive in a field of pressing alternatives. . . . The Happenings in their various modes resemble the best efforts of contemporary inquiry into identity and meaning, for they take their stand amid the modern information deluge. In the face of such a plethora of choices, they may be among the most responsible acts of our time.[20]

As Kaprow saw it, "the modern information deluge" creates profound challenges to living a life that is attentive, reflective and responsible. With increasing speed and efficiency we have grown accustomed to reducing things and moments to quickly consumable data, entertainment or merchandise, which are all available "choices" in an inundating flow of information. The moral drive of the happenings was to interrupt and slow down one's experience of life in ways that strategically resisted any conversion into data, entertainment or merchandise. And for Kaprow, if it was really going to function as moral activity, it had to deal with the life one is actually living: "the spirit and body of our work today is on our TV screens and in our vitamin pills."[21]

However, all of this was also theologically charged. The life-affirming "moral activity" of the happenings intrinsically carries questions of theological cosmology, anthropology and eschatology. And Kaprow seems to have been quite conscious of these questions; references to religious and theological (particularly Christian) ideas appear in his writings with surprising frequency, generally as components of unresolved problems and questions. Kaprow's family was Jewish, but he spent most of his youth away from home and was relatively disengaged from his family's faith. In the late 1970s he began practicing Zen Buddhism, but in the intervening years, from the 1950s into the 1970s (during the most significant formulation of the happenings), his theological views seem to have been those of someone suspicious of religious

[20]Kaprow, "Pinpointing Happenings," in *Essays on the Blurring of Art and Life*, 88-89.
[21]Kaprow, "The Artist as a Man of the World" (1964), in *Essays on the Blurring of Art and Life*, 57.

codification and organization but genuinely seeking the understanding and insights religious traditions might offer. Kaprow was relatively well acquainted with Christian theology, though he was critical of the midcentury American church (at least in its popular manifestations). His views during this period are perhaps best summarized in his 1963 essay "Impurity" (in a passage discussing Mondrian's theological beliefs):

> To the extent that philosophy and theology aspire to be wisdom as well as analysis or description, we may expect to be enlightened when we have understood what is said and when we have modified our existence according to the precepts learned. We like to assume that philosophers are wise from their philosophy and that those who are holy are personally acquainted with the spirit they preach. These assumptions may be valid, but the preparation and the enlightenment, however they may be connected, are still two different things.[22]

To the extent that the happenings were "moral activity," they were also spiritual activity—sites in which he attempted to attentively modify his existence and to work out how his own theological "preparation" and "enlightenment" might be more integrally connected amid, or in the face of, the modern information deluge.

Kaprow studied art history at Columbia University under Meyer Schapiro, completing a master's thesis on Mondrian in 1952, and he quickly received a teaching position at Rutgers University. While teaching art history at Rutgers in 1957 (the year prior to the publication of his essay on Jackson Pollock), Kaprow attended a musical composition class at the New School for Social Research taught by musician and composer John Cage (1912–1992)—a class that would prove to be transformative.

Cage was interested in testing the distinction between "music" (which exhibits some kind of structured intelligibility) and "noise" (unintelligible or unwanted happenstance). In questioning this distinction he began borrowing some key insights from Eastern philosophy: "Quite a lot of people in India feel that music is continuous; it is only we who turn away."[23] Indeed, this notion provided the basis for one of the central ideas that Kaprow would learn from

[22]Kaprow, "Impurity" (1963), in *Essays on the Blurring of Art and Life*, 34.

[23]Cage, in William Duckworth, *Talking Music: Conversations with John Cage, Philip Glass, Laurie Anderson, and Five Generations of American Experimental Composers* (New York: Schirmer Books, 1995), 14.

Cage: the fundamental difference between music and noise is not in the qual-
ities of the sounds but in the attentiveness of the listener.

Many of Cage's most salient insights into the nature of music emerge from
his investigations into *silence*. In 1951 he visited an anechoic chamber at
Harvard University in an effort to hear true and total silence. Upon exiting
the chamber Cage reported that (against his expectations) he actually heard
two sustained sounds while inside—one high and one low—which he was
informed were his eardrums picking up the activity of his nervous system
(high) and the circulation of his blood (low). This was an enormous reve-
lation to the musician: absolute silence is absolutely elusive because there is
always the sound of hearing itself, the sound of one's own body supporting
the listening, the sound of *being here*. Eventually Cage would see that the same
observation might be made on a more massive social scale, with respect to
the social body: "The sound experience which I prefer to all others is the ex-
perience of silence. And the silence almost everywhere in the world now is
traffic."[24] For Cage the definition of "silence" flipped around: it cannot be a
total absence of sound but rather only a silencing of oneself in order to really
hear the sounds that the world is (always) giving and to hear the systems that
are (always) operating in the "background"—whether those systems are
physiological, economic or otherwise.

The experience in the Harvard chamber propelled Cage into his most in-
famous exploration of silence: his 4'33" (1952), a piano performance in three
movements lasting a total of four minutes and thirty-three seconds. The work
was first performed on August 29, 1952, by the remarkable young pianist David
Tudor at the Maverick Concert Hall in Woodstock, New York. After walking
onto the stage and taking his seat at the piano, Tudor (per Cage's instructions)
initiated the beginning of each movement by *closing* the lid of the piano key-
board and the end of each movement by opening it. The three movements
were assigned specific durations of musical rest—30", 2'23" and 1'40"—which
Tudor timed using a stopwatch while depressing a different foot pedal
throughout each of the movements. Not a single note was played on the piano
for the entirety of the work. When Tudor finally opened the keyboard lid for
the final time and stood up from the piano, the already frustrated audience

[24]Cage, video interview in the film *Écoute*, dir. Miroslav Sebestik (Centre Georges Pompidou, 1992;
Facets, 2004).

burst into "a hell of a lot of uproar," "infuriated" and "dismayed" according to those recalling their experience of the event.[25] Cage certainly expected this kind of response, but he believed that there were much deeper implications available to those willing to give it further consideration: "I knew it would be taken as a joke and a renunciation of work, whereas I also knew that if it was done it would be the highest form of work."[26] As he consistently maintained, this work emerged with the conviction that it was a good and meaningful thing to do: "I have never gratuitously done anything for shock, though what I have found necessary to do I have carried out, occasionally and only after struggles of conscience, even if it involved actions apparently outside the 'boundaries of art.'"[27]

No notes were played on the piano for the duration of 4'33", but the music hall was in fact full of sounds. The Maverick Concert Hall is a rustic theater in which the back wall (opposite the stage) opens out into a surrounding forest. "After the first embarrassed shuffling of feet," writes Tony Godfrey, "the audience, if they were prepared to, could detect far-off bird songs or cars traveling or wood creaking—silence was surprisingly noisy."[28] Or rather, silence was surprisingly full of *sounds* that might be experienced as musical. And it seems this was exactly the point: an attentive audience had gathered here to hear music, but the artwork they were offered withheld everything they expected to hear (a carefully composed series of vibrations on the piano's strings) and instead gave the temporal space of the performance over entirely to the sounds of the hall itself and its surroundings. Presumably *this* was the music the audience was being prompted to attend to.

The outrage that ensued was the result of (understandably) frustrated expectations. The concertgoers who had gathered at the Maverick that August evening were there to support the Benefit Artists Welfare Fund; these were people who generally supported modernist music.[29] But even they felt they

[25]Earle Brown and Peter Yates, quoted in David Revill, *The Roaring Silence: John Cage; A Life* (New York: Arcade, 1992), 166. Had he been there, Rookmaaker would have been one of the dismayed: he often pointed to 4'33" as evidence that "art in a way is dying—as a high human endeavor" and "has really become superfluous." Rookmaaker, *MADC*, 194-95.

[26]Cage, in Richard Kostelanetz, *Conversing with Cage*, 2nd ed. (New York: Routledge, 2003), 69.

[27]Cage, "Letter to Paul Henry Lang" (1956), in *John Cage: An Anthology*, ed. Richard Kostelanetz (New York: Da Capo Press, 1970), 117.

[28]Godfrey, *Conceptual Art* (London: Phaidon, 1998), 61.

[29]In fact David Revill points out that many members of the audience that night were musicians from

had been jilted, refused the kind of sonic experience they had come for. They were poised to hear innovative and challenging musical performances, and they found themselves (at least for four and a half minutes) given only the sounds of their own listening and the sounds that had been going unnoticed all around them. In addition to the ambient sounds of the concert hall, it was thus also the structure of the audience's (denied) expectations—and the cultural norms that support them—that was exhibited in plain sight.

The fact that Cage regarded this as "the highest form of work" obviously has nothing to do with its deployment of skill or artistic genius (or even cleverness), nor with any construction of narrative, symbol or formal compositional complexity. Rather, his regard for the importance of this work derives from his overriding belief that art is whatever intentional human activity functions as "a means of converting the mind, turning it around, so that it moves away from itself out to the rest of the world."[30] The highest form of art is whatever discloses the sheer givenness of experience itself and turns one toward the world with a deep sense of meaning and gratitude. For Cage this kind of art belonged to "a purposeful purposelessness or a purposeful play" that is oriented toward "an affirmation of life—not an attempt to bring order out of chaos nor to suggest improvements in creation, but simply a way of waking us up to the very life we're living, which is so excellent once one gets one's mind and one's desires out of its way and lets it act of its own accord."[31]

Cage's experiments in music had extensive influence in the visual arts. Kaprow, for instance, identified the implications for his own artistic practice: "As Cage brought the chancy and noisy world into the concert hall (following Duchamp, who did the same in the art gallery), a next step was simply to move right out into that uncertain world and forget the framing devices of concert hall, gallery, stage, and so forth."[32] And thus the happenings. "But here," says Kaprow, "is the most valuable part of John Cage's innovations in music: experimental music, or any experimental art of our time, can be an

the New York Philharmonic on vacation. See Revill, *Roaring Silence*, 165.

[30]Cage, in Kostelanetz, *Conversing with Cage*, 241. Cage also aligns himself with a line from an unnamed English composer: "'The purpose of music is to sober and quiet the mind thus making us susceptible to divine influences.' I then determined to find out what was a 'quiet mind' and what were 'divine influences'" (230; cf. 43).

[31]John Cage, "Experimental Music" (1957), in *Silence: Lectures and Writings* (Middletown, CT: Wesleyan University Press, 1961), 12.

[32]Kaprow, "Right Living" (1987), in *Essays on the Blurring of Art and Life*, 225.

introduction to right living; and after that introduction art can be bypassed for the main course."[33] If the goodness of art is in its ability to turn us toward a fuller living of life, then of course art could not be the end in itself. In 1988, in a conversation with composer William Duckworth, Cage affirmed the extent to which his *4'33"* had indeed become a way of life: "No day goes by without my making use of that piece in my life and in my work. I listen to it every day. . . . I don't sit down to do it. I turn my attention toward it. I realize that it's going on continuously. More than anything, it is the source of my enjoyment of life."[34]

Kaprow helpfully identifies the underlying idea: "In Cage's cosmology (informed by Asiatic philosophy) the real world was perfect, if we could only hear it, see it, understand it. If we couldn't, that was because our senses were closed and our minds were filled with preconceptions."[35] Kaprow almost gets it right, but designating the world as "perfect" somewhat muddles the issue; the point is rather that Cage regarded the world as inherently *good*—good simply in that it *is* and good in that we have experience of it—if we could only hear it, see it, receive it as the perpetual, gratuitous gift that it is. The world is inexplicably and gratuitously "given" at all moments, full of sounds (even if only the sound of the blood supply flowing through one's own eardrums), which are profoundly meaningful and surprisingly beautiful "music" if truly attended to.

And it is precisely there that Cage's ethic of "right living" comes into view, as well as (by implication) the possibility of wrong living—of being asleep to the life one has been given, of having one's mind and desires very much in the way of experiencing the world in its abundance. Cage occasionally vocalized his concerns about how prevalent he believed the collapsed life was:

> Many people in our society now go around the streets and in the buses and so forth playing radios with earphones on and they don't hear the world around them. They hear only . . . whatever it is they've chosen to hear. I can't understand why they cut themselves off from that rich experience which is free. I think this is the beginning of music, and I think that the end of music may very well be in those record collections.[36]

[33]Ibid.
[34]Cage, in Duckworth, *Talking Music*, 13-14.
[35]Kaprow, "Right Living," 225.
[36]Cage, in Kostelanetz, *Conversing with Cage*, 251.

Indeed, like Kaprow, Cage worried that mass media might be generally threatening to "right living" to the extent that it deadens our capacities for attentiveness, gratitude and ultimately joy.[37]

Thus, as one digs into Cage's aesthetics, one finds an ethics, which is itself rooted in an essentially religious ontology. On the one hand, this ontology is strongly influenced by Zen-Buddhist practices of mindfulness, which Cage discovered in his thirties. On the other hand, these Buddhist principles were appropriated into a particularly American religious sensibility that was more deeply rooted in Protestant Christianity—both that of his own upbringing and that of the broader culture in which he was raised. Whereas the Buddhist notion is to move out from oneself in order to "lose" oneself (*anatta*), the effect that Cage (and many of the artists he influenced) most valued was to "find" himself experiencing the sheer good givenness of being in all of its astonishing particularity. The silent mindfulness that directed Cage's work was oriented toward personal experiences that issue in fuller and more thankful ways of receiving the world as it is.

Interestingly, Cage was a devout Protestant Christian as a young man—to the point that he even considered "devoting my life to religion."[38] And he continued to think about his work in relation to Christian theology, even after leaving the church. For instance, he linked his love for the givenness of environmental sounds to Jesus' admonition to "consider the lilies." In the Sermon on the Mount, Jesus urges those who hear him to reorient their affections:

> I say to you, do not worry about your life, what you will eat or what you will drink; nor about your body, what [clothes] you will put on. Is not life more than food and the body more than clothing? . . . Consider the lilies of the field, how they grow: they neither toil nor spin; and yet I say to you that even Solomon in all his glory was not arrayed like one of these. (Mt 6:25-30 NKJV; cf. Lk 12:22-31)

[37]Cage repeatedly stated that he thought the ultimate end of art was joy. His greatest hope for the future of the arts was that they would "intermingle in a climate very rich with joy and . . . bewilderment." Cage, *For the Birds: John Cage in Conversation with Daniel Charles* (Boston: Marion Boyars, 1981), 219-20. And on this point he also believed that "there is a close connection between art and religion or what we call a spiritual life because of the enjoyment [that they seek]. . . . I think that relationship of art to the spirit continues." Kostelanetz, *Conversing with Cage*, 45.

[38]Cage, "An Autobiographical Statement" (1989), in *John Cage, Writer: Selected Texts*, ed. Richard Kostelanetz (New York: Copper Square Press, 1993), 241.

For Cage, the sonic equivalent was to say that even Beethoven in all his glory could not compose sounds like those going on around us at every moment. Cage sought to quiet his own aesthetic "worry" for musical meaning and to instead receive the given sounds of the world as richly meaningful in themselves: "The work of the lilies is not to do something other than [be] themselves . . . and that, I think, could bring us back to silence, because silence also is not silent—it is full of activity."[39] Indeed, he believed that this conviction that "everything communicates," even in silence, is in fact "very Christian."[40]

Unfortunately the Christian churches that Cage attended as a young man were anemic institutions preoccupied with otherworldly sentimentalities. By his own recounting:

> When I was growing up, church and Sunday School became devoid of anything one needed. . . . I was almost forty years old before I discovered what I needed— in Oriental thought. . . . I was starved—I was thirsty. These things had all been in the Protestant Church, but they had been there in a form in which I couldn't use them. Jesus saying, "Leave thy Father and Mother," meant "leave whatever is *closest* to you."[41] (cf. Mt 19:29)

It is precisely on this point that Rookmaaker (and other Christians) should have found great sympathy with Cage. The kind of escapist Protestantism that left him spiritually starving and thirsty is exactly the same "gnostic" religiosity that Rookmaaker objected to and sought to correct. And though Cage didn't quite say it in these terms, the currents of his work were oriented toward the practical recovery of a more thoroughgoing creational theology—one that sought to *return* to all the "closest" aspects of creaturely existence and to become more fully conscious of and thankful for the gratuitous goodness and givenness of the world. This was the theological orientation that Cage recognized as latent in the Protestant church (though too often warped into unusable forms), and this is what might have resonated deeply with Rookmaaker had his conventional theory of art and the sheer momentum of his narrative not precluded him from recognizing it. Sadly, he utterly misinterpreted and

[39]Cage, in Kostelanetz, *Conversing with Cage*, 245.

[40]Ibid., 278.

[41]Ibid., 13-14 (emphasis original). Elsewhere Cage identifies his college years as the turning point: "At college I had given up high school thoughts about devoting my life to religion." Cage, "Autobiographical Statement," 241.

underappreciated Cage's work, regarding it as the epitome of "meaningless and essentially inhuman freedom since there is no possibility of communication."[42] And because he reduced the function of the artwork to the "possibility of communication," he entirely missed the point: "As such it means death and absolute alienation."[43] Obviously we wish to argue almost the exact inverse of that position: Cage's primary concern was with life and deliberate reconnection.

ROBERT RAUSCHENBERG: THE RECEPTOR SURFACE

While he was a student at the experimental Black Mountain College in North Carolina, Robert Rauschenberg (1925–2008) met John Cage in 1951, and according to Rauschenberg it was obvious that they "were soul mates right from the very beginning, philosophically or spiritually."[44] Their mutual affinity included strong sensitivities to the spiritual implications of artmaking, tempered by a similar dissatisfaction with the American appropriation of the Christian gospel.

Throughout his youth, Rauschenberg's family belonged to Sixth Street Church of Christ, a strict fundamentalist congregation in Port Arthur, Texas. His mother, Dora, was especially devout and urged her son to grow in the faith; he attended church and Sunday school every week and went to Bible study classes during summer breaks. By the time he was thirteen, young Milton (he later changed his name to "Bob" as he began pursuing a career in art) had set his heart on becoming a pastor, though experiences in his church would soon discourage him from this. "The Church of Christ made the Baptists look like Episcopalians," Rauschenberg later joked. "There wasn't an idea you could have that couldn't lead somebody else astray."[45] A particular point of contention was dancing, which was one of Rauschenberg's great joys but was adamantly forbidden by his family's church. As Elizabeth Richards puts it, he gradually "became disillusioned with a church that, as he felt, restrained its

[42]Rookmaaker, *The Creative Gift: Essays on Art and the Christian Life* (1981), in *CWR*, 3:170.
[43]Ibid.
[44]Rauschenberg, video interview with David A. Ross, Walter Hopps, Gary Garrels and Peter Samis, San Francisco Museum of Modern Art, May 6, 1999. Unpublished transcript at the SFMOMA Research Library and Archives, N6537.R27 A35 1999a, 45.
[45]Rauschenberg, quoted in John Richardson, "Rauschenberg's Epic Vision," *Vanity Fair* 445 (September 1997): 278-89.

community from enjoying life."[46] After moving away from home he continued to attend a variety of churches into his mid-twenties but eventually abandoned the church altogether. He later confessed, "Giving that up was a major change in my life."[47] Even so, the split was not absolute: Richards notes that his "rejection of organized religion did not dictate any rejection of spirituality and, in fact, his art often incorporated aspects of ritual and ceremony that recall his religious upbringing."[48]

Rauschenberg's first solo exhibition was at the well-known Betty Parsons Gallery in New York City. Parsons represented the major figures of American abstract expressionism—including Pollock, Still, Rothko, Reinhardt and Newman—and yet she unexpectedly offered the twenty-five-year-old Rauschenberg an exhibition based on a handful of paintings he brought into her gallery. The show opened in May 1951 in the smaller of Parsons's two exhibition rooms (the larger main room featured the more established Walter Tandy Murch) and consisted of thirteen oil-and-collage paintings. Rauschenberg's titling of the works was curious: some of the titles followed the abstract expressionist convention of numbering (*Untitled No. 1, No. 2* and so on), while others incorporated weighty poetic or religious references, including *Eden* (c. 1950), *Trinity* (c. 1949–1950), and *Crucifixion and Reflection* (c. 1950).[49] The exhibition received little attention, and most of the works were subsequently destroyed, lost or painted over—one of only a handful that remain is *Mother of God* (c. 1950).

The "figure" of the *Mother of God* is an irregular circular white form whose center is stationed two-thirds of the way up the surface of the painting, precisely where in a traditional icon of the Mother and Child one would generally find either Mary's face (and halo) or her torso (womb). Surrounding this form are collaged portions of twenty-two city maps that have been cut or torn from Rand McNally road atlases: the yellowed pages simultaneously evoke the

[46]Richards, "Rauschenberg's Religion: Autobiography and Spiritual Reference in Rauschenberg's Use of Textiles," *Southeastern College Art Conference Review* 16, no. 1 (2011): 43.

[47]Rauschenberg, quoted in John Richardson, "Rauschenberg's Epic Vision," 278-89.

[48]Richards, "Rauschenberg's Religion," 43. For another helpful discussion of the religious themes in Rauschenberg's (especially early) works, see Lisa Wainwright, "Resurrecting the Christian Rauschenberg," in "Reading Junk: Thematic Imagery in the Art of Robert Rauschenberg from 1952 to 1964" (PhD diss., University of Illinois at Urbana-Champaign, 1993), 58-88; as well as Wainwright, "Rauschenberg's American Voodoo," *New Art Examiner* 25, no. 8 (May 1998): 28-33.

[49]Barbara Rose attributes Rauschenberg's use of Christian themes in the early 1950s to the fact that "he was still worried about salvation; indeed, he always would be." Rose, "Seeing Rauschenberg Seeing," *Artforum* 47, no. 1 (September 2008): 434.

gold-leafed space of an icon and the earthly landscape backdrop of a Renais-
sance Madonna (with a topographical twist). The bottom fifth of the painting
is a kind of parapet[50] or predella[51] painted in the same white paint as the
central circular figure, and along the bottommost edge of the panel a strip of
silver paint (which has dulled and darkened over the years) appears like a
leaden weight in contrast to the buoyancy of the white orb. In the lower right
corner of the white parapet a torn fragment from a newspaper (about four
inches wide) bears the words of a book blurb: "'An invaluable spiritual road
map . . . As simple and fundamental as life itself'—*Catholic Review*" (ellipsis
original). The singularity of the blurb seems at odds with the multiplicity
(even confusion) of the maps: they exert interpretive pressure on one another
such that this "spiritual road map" seems "to function simultaneously as an
ironic joke and as an utterly sincere message," as one critic has put it.[52] And
Rauschenberg himself underscores this ambiguity: "It's made of maps. So you
follow one road or another and you're gonna get there."[53]

The "there" to which these earthly roads point is presumably the circular
white *Theotokos* in the center. Branden Joseph argues that "by keeping collage
from the center of the painting, Rauschenberg . . . signified that the white was
at once in the world and to be understood as somehow separate from it. The
white would thereby seem to be symbolic of the divine." Joseph thus reads the
work as seriously pondering the possibility of incarnation: "Like the body of
the Virgin Mary, Rauschenberg's *Mother of God* serves as a material or bodily
vessel for the manifestation of the divine."[54] In this vein, Susan Davidson sees
the circular form as "alluding to pregnancy" and suggestive of a (God-bearing)
womb.[55] That may be, but especially given Rauschenberg's strict religious

[50]One might think of the format of this painting as reminiscent of Bernardo Daddi's *Mary with
Saints Thomas Aquinas and Paul* (c. 1330): in the central panel Mary stands behind (and reaches
over) a short parapet wall that occupies the bottom portion of the composition.

[51]See, for instance, Lippo Memmi's *Madonna and Child with Saints and Angels* (c. 1350), which
happened to have been at the Metropolitan Museum of Art in New York at the time Rauschenberg
painted his *Mother of God*.

[52]Fred Camper, "The Unordered Universe," *Chicago Reader* (March 26-April 1, 1992): 31.

[53]Rauschenberg, video interview at SFMOMA (May 6, 1999), unpublished transcript, 13.

[54]Joseph, *Random Order: Robert Rauschenberg and the Neo-Avant-Garde* (Cambridge, MA: MIT
Press, 2003), 26. See also Joseph, "White on White," *Critical Inquiry* 27, no. 1 (Autumn 2000): 90-
121.

[55]Davidson, "*Mother of God*," *Rauschenberg Research Project*, San Francisco Museum of Modern Art
(July 2013), §8, www.sfmoma.org/explore/collection/artwork/37592/essay/mother_of_god.

upbringing, the aniconic character of the work seems to reveal distinctly Protestant inclinations. In a conversation with Rauschenberg about this painting in 1999 David Ross referred to this white space as "void," which Rauschenberg rejected: "There's nothing missing there. . . . It's full."[56] His withholding of figurative imagery was apparently in the service of figuring some kind of fullness (rather than simply negation).

In the months following his exhibition at Betty Parsons's gallery, the fecund white womb in the center of *Mother of God* seems to have expanded to encompass an entire series of canvases known as the *White Paintings* (1951). These large canvases were painted with even layers of flat white house paint applied with a roller, creating uniform white fields with as little surface variation as possible.[57] Each painting in the series consisted of a different number of adjoined panels: there are one-, two-, three-, four- and seven-panel iterations—all combinations that ostensibly were meant to have sacred connotations.[58] According to the artist, his decision to terminate the series with a heptaptych was due to the idea that "seven was infinity."[59]

In fact these seemingly blank paintings emerged at the height of what Rauschenberg later called a "short-lived religious period."[60] In mid-October 1951, less than five months after his first show, he wrote an impassioned letter to Parsons telling her about these new paintings.[61] His opening lines identify

[56]Rauschenberg, video interview at SFMOMA (May 6, 1999), 45-46.

[57]It should be noted that Rauschenberg wasn't the first avant-garde artist to present entirely white canvases. In the spring of 1920 Kazimir Malevich (see chap. 5) had his first one-man exhibition in Moscow—a midcareer retrospective of about 150 paintings titled "Kazimir Malevich: Journey from Impressionism to Suprematism"—which concluded with a square, totally white monochromatic canvas. He repeated this gesture again in 1923 in the *Exhibition of Petrograd Artists of All Movements, 1918–1923*, in which he exhibited at least one white painting (maybe two), which he titled *Suprematist Mirror*. For a discussion of Malevich's white paintings, see Aleksandra Shatskikh, *Black Square: Malevich and the Origin of Suprematism*, trans. Marian Schwartz (New Haven, CT: Yale University Press, 2012), 266-71.

[58]There was also a five-panel *White Painting* created in 1951, but it was dismantled or destroyed without ever being shown, and Rauschenberg never refabricated it, as he did with all the other versions of the white paintings. Intriguingly, it seems that there never was a six-panel version, which suggests that simply executing a serial progression was not his only concern. See Sarah Roberts, "*White Painting* [three panel]," *Rauschenberg Research Project*, San Francisco Museum of Modern Art (July 2013), §1n1; www.sfmoma.org/explore/collection/artwork/25855/essay/white_painting.

[59]Rauschenberg, video interview at SFMOMA (May 6, 1999), 14.

[60]Rauschenberg, unpublished interview with Walter Hopps (January 18-20, 1991), quoted in Susan Davidson, "*Mother of God*," §10.

[61]A facsimile of this letter is published in Walter Hopps, *Robert Rauschenberg: The Early 1950s*

the spiritual impulses behind these works: "I have since putting on shoes . . . felt that my head and heart move through something quite different than the hot dust the earth threw at me. The results are a group of paintings that I consider almost an emergency." His description of the paintings is especially evocative: "They are large white (1 white as 1 GOD) canvases organized and selected with the experience of time and presented with the innocence of a virgin." This analogizing of the singularity of the white color with the unity of God—which manifests itself across a multiplicity of panels that presumably denote an "experience of time"—gives way to a series of enigmas: these paintings articulate the "body of an organic silence, the restriction and freedom of absence, the plastic fullness of nothing, the point a circle begins and ends." Ultimately he claimed that "they are a natural response to the current pressures of the faithless and a promoter of intuitional optimism. It is completely irrelevant that I am making them—*Today* is their creater [*sic*]." In fact he felt such urgency about the relevance of these works that he declared himself willing to "forfeit all rights to ever show again for their being given a chance to be considered for this year's calendar." Parsons declined.

Because they appeared in the early 1950s, Kaprow argued that "in the context of Abstract Expressionist noise and gesture," these white paintings "suddenly brought us face to face with a numbing, devastating silence."[62] If indeed it could be said that the abstract expressionists "took to the white expanse of the canvas as Melville's Ishmael took to the sea,"[63] Rauschenberg's paintings give us only the sheer expanse itself—or perhaps only the deathly whiteness of Melville's monster.[64] If these canvases do stand for a kind of silence, Rauschenberg apparently considered it a holy silence. In presenting these surfaces without any image, without any markings, without any "color"

(Houston: Houston Fine Art Press and Menil Foundation, 1991), 230. See also Joseph, *Random Order*, 25-29. All quotations in this paragraph are from this letter (emphases original).

[62]Kaprow, "Experimental Art" (1966), in *Essays on the Blurring of Art and Life*, 70.

[63]Rosenberg, "American Action Painters," 591.

[64]One thinks of Melville's profoundly haunting discourse on the meaning of *whiteness*, which he associates simultaneously with sacredness and deathliness: "Yet for all these accumulated associations with whatever is sweet, and honorable, and sublime, there yet lurks an elusive something in the innermost idea of this hue, which strikes more of panic to the soul than that redness which affrights in blood." Indeed, Melville's lines might be fairly apt: "The palsied universe lies before us a leper; and like willful travelers in Lapland, who refuse to wear colored and coloring glasses upon their eyes, so the wretched infidel gazes himself blind at the monumental white shroud that wraps all the prospect around him." Herman Melville, *Moby-Dick* (New York: Harper, 1851), chap. 42.

(in terms of occupying a discrete location on the color spectrum), he was effectively quieting painting down to an apophatic speechlessness. Their "blankness" was a gesturing toward the unrepresentable fullness of God (1 white as 1 GOD), "the plastic fullness of nothing [no-thing], the [unidentifiable] point a circle begins and ends." The decision to subdivide this apophatic whiteness into a series of modular polyptych formats introduces a sense of temporality ("organized and selected with the experience of time"), but it also has the possible effect of "framing" the silence of the work in religious terms, redeploying formats traditionally associated with Christian altarpieces and manuscripts.[65] These polyptychs present no holy visage or script; they only conduct silent vigil.

It is not difficult to see Cage's *4'33"* and Rauschenberg's *White Paintings* as interrelated investigations into "silence." Cage openly associated the two works and in doing so assigned the precedence to Rauschenberg: "To Whom It May Concern: The white paintings came first; my silent piece came later."[66] In fact Cage would become one of the most influential interpreters of these canvases, construing them as surfaces hypersensitive to the visual phenomena around them in much the same way his *4'33"* was to auditory phenomena: "The white paintings were airports for the lights, shadows and particles"; they visually "caught whatever fell on them."[67] Adopting a different metaphor, Rauschenberg referred to them as "clocks": if they were attended to with enough sensitivity it was possible "that you could read it, that you would know how many people were in the room, what time it was, and what the weather was like outside."[68] In other words, for Rauschenberg (and Cage) these paintings were not attempts to reduce painting to a state of aesthetic "purity" (as theorized by Greenberg) or sheer material "presences" (as theorized by the minimalists);[69] rather, they were a means of visually "silencing" a series

[65]It might be sensible to compare the divisions between the panels with the numinous divisions ("zips") in the paintings of Barnett Newman. It is worth noting that Newman exhibited a number of zip paintings, including his massive *Vir Heroicus Sublimis* (1950–1951), at the Betty Parsons Gallery in April-May 1951, immediately prior to Rauschenberg's first show.

[66]Cage, *Silence*, 98.

[67]Cage, "On Robert Rauschenberg, Artist, and His Work" (1961), in *Silence*, 102, 108.

[68]Rauschenberg, video interview at SFMOMA (May 6, 1999), 18.

[69]The fact that the *White Paintings* first appeared in 1951 is historically remarkable. In one move they simultaneously (1) consolidated much of the discussion surrounding the abstract expressionism of the late 1940s—as paintings they were a near total "surrender to the resistance of its medium," to borrow Greenberg's 1940 phrase—and (2) strongly anticipated both the minimalism and

of art objects (ultimately an entire exhibition space)[70] in order to receive and amplify the life going on in front of, around and behind them. As with Cage's performance of musical rest, when these paintings fell silent they impelled the viewers' interpretive efforts to shift toward whatever else was in the (social, physical, temporal) space they were standing in and (at least for the more self-reflective viewers) toward whatever structure of expectations might cause someone to feel scandalized by the silence.

Thus for Cage these paintings turned out to be utterly affirmative of the tangible, generous *thisness* of the world:

> Having made the empty canvases (*A canvas is never empty.*), Rauschenberg became the giver of gifts. Gifts, unexpected and unnecessary, are ways of saying Yes to how it is, a holiday. The gifts he gives are not picked up in distant lands but are things we already have ... and so we are converted to the enjoyment of our possessions. Converted from what? From wanting what we don't have, art as pained struggle.[71]

The upshot of saying yes to the world as it presents itself is that we begin to find that "beauty is now underfoot wherever we take the trouble to look. (This is an American discovery.)"[72]

Rauschenberg was quick to see the implications of experiencing the white paintings in this way. When painting is brought close to visual silence, the result is not an experience of absence or an ongoing meditation on "the void"; rather, it elicits a finer "listening" to what *is* present and provokes heightened

(especially) conceptualism that would soon emerge in New York in the late 1950s and 1960s.

[70]Though initially painted in 1951, the five *White Paintings* were not shown as a complete series until 1968, when they were remade for an exhibition titled *White Paintings 1951* at the Leo Castelli Gallery in New York City. The two- and seven-panel white paintings were shown in a two-person exhibition with Cy Twombly at the Stable Gallery in September-October 1953, but they received terribly unsympathetic reviews. Most if not all of the original white paintings were painted over in the 1950s, providing the supports for other well-known paintings. Sarah Roberts rightly argues that this readiness to destroy and remake them "testifies to the artist's understanding of these works as primarily conceptual rather than material" (Roberts, "White Painting," §4).

[71]Cage, "On Robert Rauschenberg, Artist, and His Work" (1961), in *Silence*, 103.

[72]Ibid., 98. Why Cage designates this as a specifically "American discovery" is unclear, though it is striking that he doesn't attribute it to Buddhism or one of the other Eastern philosophies that had influenced his thinking, which we might expect him to (perhaps he considers it a distinctly American appropriation of Buddhist mindfulness). It's also unclear if he has any specific Americans in mind here (beyond Rauschenberg) to whom he would credit this discovery of the gratuitous ubiquity of beauty in the world. The American theologian Jonathan Edwards would be a strong candidate.

sensitivities to the sheer miraculous *hereness* of everything. As Rauschenberg would later say, the series is "not a negation; it's a celebration."[73] As far as painting is concerned (or any aspect of human experience), there is no possibility of void; all of *this* is simply and inexplicably "given." Thus, whatever apophasis originally motivated the *White Paintings* becomes inverted: once we truly quiet ourselves down (whether in painting or everyday life), what we experience is not (only) the stillness of God but the astonishing presence of the world God gives. As in all great apophatic thought, holy silence is not simply about attuning oneself to the Fullness that outstrips human sight, speech and thought; it also leaves one differently attuned to the fullness of what *is* seeable, speakable, thinkable. However we conceptualize that Fullness (or No-thingness) that precedes and sustains all being, all of *this* appears within it and is given by it.

The further implication is that bringing painting to this level of silence does not give us any simple essence of "painting" as much as it reveals the manifold human activity that composes and supports the practices of painting. Like Cage's silent work, the hypersensitivity of Rauschenberg's white canvases points us not only toward the immediate environment (and the beauty that is everywhere underfoot) but also to the cultural worlds in which these canvases are produced, handled, exhibited and discussed—and in which they become intelligible. Rauschenberg stated the matter bluntly: "I stretched the canvas— I knew what it was—it's a piece of cloth. And after you recognize that the canvas you're painting on is simply another rag then it doesn't matter whether you use stuffed chickens or electric light bulbs or pure forms."[74] The hyperbolic use of the word *rag* here is often misinterpreted. This was not meant as a flippant belittling of painting, as if the canvas serves no meaningful function beyond that of a rag (absorbing oil). Rather, Rauschenberg was describing the recognition that the materials of painting—cloth, wood, nails, pigment, refined oil, solvents, etc.—are products of manufacturing and cultural custom that have been taken out of everyday commerce (removed from a range of other possible functions) and used specifically for the discourse and commerce

[73]Rauschenberg, video interview at SFMOMA (May 6, 1999), 23.

[74]Rauschenberg, in "Multi-Media: Painting, Sculpture, Sound" (transcript of a panel discussion, November 1966), in Jeanne Siegel, *Artworks: Discourse on the '60s and '70s* (1985; repr., New York: Da Capo Press, 1992), 154-55.

of art. But once recognized as such, why would artists limit themselves to these materials? The conventions of artistic medium that distinguish the cloth of the artist's canvas from the cloth of the pants he is wearing began to appear to Rauschenberg as increasingly arbitrary and in fact preventative to an art more fully engaged in the dense meanings of the lives we are living—perhaps the pant leg needed to go into the painting as well. And for that matter, why not also the taxidermies, light bulbs, drapes, scraps of furniture, postage and "pure forms" that structured the spaces of daily life? Indeed, suddenly the entire field of his immediate surroundings became full of artistic media, and it became increasingly obvious that "there are very few things that happen in my daily life that have to do with turpentine, oil, and pigments."[75] In some ways Rauschenberg's work becomes a counterpoint to Kaprow's extrapolation of Pollock: whereas Kaprow discarded the canvas and paint for the sake of making art of the rest of life, Rauschenberg sought to bring the rest of life back into the domain of canvas and paint.

This shift in Rauschenberg's thinking might be clearly encapsulated in the transition from the triptych *White Painting* (1951) to *Collection* (1954). The two paintings are of similar size (72 × 108 in. and 80 × 96 in., respectively) and share the same triptych format, but their materiality is radically different. The three vertical panels of the latter "painting" are traversed by layered bands of paint, newspapers, pieces of fabric, pictures torn out of books and a variety of other materials.[76] The surface functioned as an "airport" not only for lights, shadows and particles but also for the diverse materiality of the studio space in which the work was made, as well as the materiality of the urban spaces in which the studio was situated and by which the life of the studio was supported. Leo Steinberg famously argued that Rauschenberg's picture plane "makes its symbolic allusion to hard surfaces such as tabletops, studio floors, charts, bulletin boards—any receptor surface on which objects are scattered, on which data is entered, on which information may be received, printed, impressed—whether coherently or in confusion. . . . Though they hung on the

[75]Rauschenberg, quoted in Irving Sandler, *The New York School: The Painters and Sculptors of the Fifties* (New York: Harper & Row, 1978), 177.

[76]These three panels were each initially overlaid with a brightly colored silk fabric in one of the primary colors: red, yellow and blue (from left to right), which seems to indicate that Rauschenberg was conceiving the starting point of the work in relation to (and defiance of) the kind of endgame formalism exemplified by Rodchenko's *Red Yellow Blue* (1921). See Walter Hopps, *Robert Rauschenberg* (Washington, DC: Smithsonian, 1976), 77.

wall, the pictures kept referring back to the horizontals on which we walk and sit, work and sleep."[77] And thus we are no longer oriented to look "into" the artwork as though it were a pictorial window;[78] instead we are faced with a surface on which appears the stuff of life that was normally bracketed out of the experience of looking at art. Not only paint but also the tubes and cans it was packaged in, the mass-distributed newspapers and magazines read prior to getting to work,[79] the art textbooks that funnel the pressures of history into the studio, the debris cast off from the daily consumption and (re)building of the city—all of it impinges upon the meaning of the work, and all of it is considered viable material for the construction of the work. This resulted in "paintings" that were exceedingly sculptural assemblages of recognizable everyday objects. Rasuchenberg called them "Combines."

In the context of this study, a twofold point must be made: (1) for Rauschenberg these cultural "horizontals" of life included religious structures, and (2) the transition from the white paintings to the Combines involved (unavoidably) theological questions and difficulties. In 1952–1953 the white paintings were followed by paintings of glossy black oil over disheveled newspaper grounds,[80] and then by a series of small iconic *Elemental Paintings* (c. 1953) consisting of a single accumulated material: dirt, clay, white lead paint, tissue paper or gold leaf.[81] In the series of gold paintings, the surface of the gold leaf—a material traditionally used to signify the transcendent light of God—is mangled, distressed, tarnished and exceedingly delicate. When the transcendent reference in these icons is thus interrupted by the materiality and fragility of these surfaces, the (open) question is poignantly posed: Is the light of God visible even here, on the fragile *surface* of things? Presented in a gold-leafed frame, Rauschenberg's landmark work *Erased de Kooning* (1953)

[77]Steinberg, *Other Criteria: Confrontations with Twentieth-Century Art* (New York: Oxford University Press, 1972; repr., Chicago: University of Chicago Press, 2007), 84.

[78]Rauschenberg plays on this desire to look "into" paintings by often embedding small mirrors into his Combine paintings. *Collection*, for example, has a circular mirror (originally covered by a veil) at about eye level on the right side of the central panel. Efforts to look "into" this painting are thus turned back on the viewer as a looking at oneself looking.

[79]Mass media became an important point of reference in his work: "I was bombarded with TV sets and magazines, by the refuse, by the excess of the world. . . . I thought that if I could paint or make an honest work, it should incorporate all of these elements, which were and are a reality." Rauschenberg, quoted in Joseph, *Random Order*, 180.

[80]Kaprow saw this pairing of white and black paintings as having "salvational overtones." Kaprow, "Experimental Art," 70.

[81]See Joseph, *Random Order*, 92.

raises similar questions through an iconic vernacular:[82] the figuration of an otherwise "expressive" and "valuable" work of art has been almost entirely erased, revealing the fragile material-cultural givenness of the paper itself. *Automobile Tire Print* (1953) is a twenty-two-foot-long strip of adjoined papers on which Rauschenberg prompted Cage to "print" a single line of tire-text in black ink by driving over it with his Model A Ford. The work is presented as a (rarely completely extended) scroll, such that the tire print appears as a kind of sacred writ—Rauschenberg later referred to it as "a Tibetan prayer wheel."[83] Questions of spiritual anthropology seem to provide the thematic framework for works like *Soles* (or *Souls*—it is uncertain which spelling the artist intended, c. 1953) and *Untitled (Cube in a Box)* (c. 1953), both of which explore the idea of hidden inner substances within rough outer skins or casings. The rather extensive series of *Elemental Sculptures* (1953) takes up similar questions, repeatedly displaying tethered stones in ways that allegorically activate issues of heaviness and release.[84]

And the religious references proliferate through the Combines as well. Rauschenberg's *Untitled* black painting with a funnel (c. 1955) is presented as a kind of figure: the open circular collar of a t-shirt positions a head relatively high in the field, and the fragment of a sleeve on the right-hand edge indicates a lifted hand. Nearly all of the collaged scraps of cloth and paper on the surface are painted over in flat black paint—one of the few portions that is not is a prayer card just to the right of the center of the painting that displays a reproduction of Carl Bloch's *Doubting Thomas* (1881). Flurries of red, yellow, green and white paint have been slashed across the surface immediately below this image (the only place such color appears in the painting), which within the figure suggested by the cloth fragments correspond to the position of the wound in Christ's side, as depicted in the prayer card. The painting's surface subtly stands in for the wounded body of the resurrected Jesus, and as such

[82]Rauschenberg specifically considered the gold-leaf framing to be part of the work. At some point he instructed a studio assistant to write in block lettering on the back of the work: "Do not remove / drawing from frame / *Frame is part of drawing.*"

[83]Rauschenberg, video interview at SFMOMA (May 6, 1999), 25.

[84]There were at least nineteen of the *Elemental Sculptures*, though only nine are extant. For a helpful overview see Hopps, *Robert Rauschenberg: The Early 1950s*, 155-60, 174-97. Interestingly, Rauschenberg returned to his use of tethered stones in his 1973 *Venetian* series. See Walter Hopps and Susan Davidson, eds., *Robert Rauschenberg: A Retrospective*, exh. cat. (New York: Guggenheim, 1998), 342-47.

the ball of twine placed in the funnel on the left side of the panel becomes doubly suggestive of incarnation (descending downward into the funnel) and ascension (being pulled upward out of the funnel). But if Rauschenberg is allegorizing the surface of the painting with the resurrected body of Christ, then he is also placing himself (and the viewer) in the position of the incredulous Thomas. It is a painting that powerfully articulates both a longing to touch and to see (Lk 24:39; cf. Lk 6:19) and the persistence and seeming ineluctability of doubt in the age of modernity (including the doubt that images, much less paintings, can any longer serve as vehicles for the kind of religious touching and seeing that we long for). Like much modern art, this is not a work of unbelief as much as it is of fragilized belief, one that is caught oscillating (or struggling) between doubt and belief.

In fact several of the Combines include materials and forms with strong religious associations: in the center of *Untitled* (1955) an obscured fragment of a tract asks in bold lettering "Does God Really Care?" *Odalisk* (1955–1958) includes a church donation envelope and a reproduction of the resurrected Christ addressing Mary Magdalene with the words *Noli me tangere* ("touch me not" from Jn 20:17). *Pilgrim* (1960) implies the spiritual assumption (or ascension) of a seated figure through a horizontal slit in the canvas. *Franciscan II* (1972) seems to depict a monk in prayer, evoking forms reminiscent of Jusepe de Ribera's *Saint Francis in Ecstasy* (1642) or Édouard Manet's *Monk in Prayer* (1865). Rauschenberg's 1981 series of sculptures collectively titled *Kabal American Zephyr* is packed with religious references related to the problem of evil. See, for example, *The Ancient Incident, Tree of Life Prune, The Proof of Darkness* and *The Parade of the Wicked Thoughts of the Priest*. And so on.[85]

Hymnal (1955) provides a particularly interesting example because the crucified "hymnal" in the niche in the upper central portion of the work is actually a telephone book. In direct continuity with Rauschenberg's theological trajectory, the work asks what it would mean to regard the phonebook, listing thousands of one's unknown neighbors, as a kind of hymnal—an index (or

[85]Several other works could also be investigated here: *Monk* (1955) was Rauschenberg's homage to the great jazz pianist Thelonious Monk (a fragment of his single *'Round About Midnight* is visible in the center of the canvas), but the simplicity of the title serves to highlight the spiritual (even monastic) gravitas of the musician. *Co-existence* (1961) includes a reliquary of a saint's tooth. Rauschenberg's series of lithographic *Veils* (1974) inevitably evoke religious associations (e.g., Saint Veronica's Veil, shrouds, a transcendent realm "beyond the veil," etc.).

chorus) of all those overlooked human images of God who surround us daily. And given the way that he has pierced this phonebook, we might even wonder about the association of the body of Christ with those innumerable names (lives). In a move that actually finds profound resonance in Christian theology, this utterly mundane phonebook is thus reframed as a text that is potentially as pertinent to one's sense of sacredness in the world as all those hymnals that remain closed in the church pews six days out of the week. Unfortunately Rookmaaker flatly interpreted Rauschenberg's work as asserting an essential arbitrariness and meaninglessness of the world: he saw these works as allegories of "a shabby world in which all things are of equal value, but no great values persist."[86] One wonders why a Reformed thinker like Rookmaaker shouldn't instead have seen these as allegories of a world in which all seemingly "shabby" things are actually of astonishing value (if only we had the eyes to see).

ANDY WARHOL: POSTMODERN *VANITAS* PAINTING

One of the most theologically enigmatic yet pivotal of all twentieth-century artists is certainly Andy Warhol (1928–1987). The interpretations of his work are as diverse and divergent as possible, and yet almost every rendering of twentieth-century art history runs through him. In recent years, the religious and theological implications of his work have increasingly become an object of discussion and debate. In unpacking these implications, there are at least three crucial components that must be accounted for.

Warhol's late works (1980s). In the last five or six years of his life (he died in February 1987), Warhol completed an astonishing number of paintings with overtly religious subject matter.[87] These included paintings of both religious symbols—*Crosses* (1981–1982), *Details of Renaissance Paintings* (1984), etc.— and religious phrases—*Repent and Sin No More* (1985–1986), *Heaven and Hell Are Just One Breath Away* (1985–1986), etc. These paintings present many interpretive difficulties: Are they cynical, sincere or tragic? Does the repetition

[86]Rookmaaker, *MADC*, 167. Even though he sees this work as manifesting "deep and difficult problems" in which his "own view of reality is challenged," he nevertheless finds some redemptive value: "The positive good in this art is that it makes all cheap answers, all worn-out traditions, all ideas that are not firmly based in real truth, pale and useless and senseless" (168).

[87]For a helpful study on the religious and theological significance of Warhol's late paintings, see Jane Daggett Dillenberger, *The Religious Art of Andy Warhol* (New York: Continuum, 1998).

in these paintings denote cheap banality or ritual devotion? Most notable of Warhol's late religious paintings is a series of paintings based on Leonardo da Vinci's famous fresco of *The Last Supper* (1498)—a series that included more than one hundred paintings, drawings and silkscreen prints, many of which are enormous.

To take one example, *The Last Supper (Dove)* (1986) (plate 8) presents a line drawing of Leonardo's famous painting overlaid with a price tag and the corporate logos of General Electric and Dove soap, all of which make cheap puns in the context of the Christian subject matter. GE is a cheeky play on the "light of the world" (Jn 1:9; 9:5). The inclusion of a soap brand creates a deflationary allusion to being "washed" in Christ by the Spirit (Eph 5:26; 1 Cor 6:11; Heb 10:22); the Dove insignia descends through the opening in the ceiling like the Holy Spirit at Pentecost;[88] and the 59¢ label is suggestive of either Judas's betrayal of Jesus for money (Mt 26:15) or a fairly crude reference to Eucharistic bread (assuming this label was taken from a box of crackers). And all of these are laid over a somewhat schmaltzy line-drawn rendition of Leonardo's painting taken from a nineteenth-century encyclopedia.[89] How is this convergence of images to be interpreted? Is this a devout religious painting attempting to "energize sacred subjects" from within the idiom of pop art? Is it a sharp critique of the American commodification of religion? A cynical mockery of Christian doctrine? An iconoclastic leveling of religious signs to the same order of mass-media simulacra that seizes all other signs? With Warhol the answers to such questions are almost never straightforward, but much rides on how we attempt to answer: the ways we interpret such works are entirely bound up with how we interpret the decades of Warhol's work that preceded them.

Warhol's religious biography. Immediately after Warhol's death, many stories and accounts surfaced attesting to a serious Christian faith that Warhol maintained throughout his life. Born to Slovakian immigrants, he grew up in a devoutly Byzantine Catholic home in Pittsburgh: his church followed the Ruthenian Rite, which is Roman Catholic but uses the liturgy and architectural customs of the Byzantine Eastern Orthodox Church. His mother, Julia

[88]The only biblical reference to the Spirit descending "like a dove" is at Christ's baptism (e.g., Mk 1:10), but Christian painters have traditionally also connected Christ's anointing both to the annunciation and to Pentecost by representing the Spirit as a dove in all three motifs.

[89]See Dillenberger, *Religious Art of Andy Warhol*, 81.

Warhola, was devout throughout her life, and she lived with Andy in New York for twenty years until shortly before her death in 1972.[90] According to Henry Geldzahler, "He and his mother went to mass all the time, not only on Sunday, and it was all very very real to him."[91] Warhol's brother John similarly described the artist as "really religious, but he didn't want people to know about that because [it was] private."[92] And circumstantial evidence supports this private devotion: his diaries are filled with references to his faith, as was his apartment décor; most notably, he kept a crucifix and a well-worn prayer book beside his bed.[93] He evidently wore a cross on a chain around his neck, and according to his friend David Bourdon he regularly carried a pocket missal and rosary.[94] But it was not entirely private: Warhol's priest attested to the fact that he regularly attended Mass two or three times a week at his church, Saint Vincent Ferrer, and he donated and volunteered "with dedicated regularity" to serve meals to homeless New Yorkers at the Church of the Heavenly Rest on Thanksgiving, Christmas and Easter.[95]

One of the most influential accounts of Warhol's faith has been the eulogy that art historian John Richardson gave at Warhol's memorial service at Saint Patrick's Cathedral on April 1, 1987. This eulogy was entirely devoted to illuminating "a side of his character that he hid from all but his closest friends: his spiritual side." And according to Richardson this side is in fact "the key to the artist's psyche": when adequately accounted for, this "secret piety" reframes our interpretation of what Warhol was trying to do and "inevitably changes our perception of an artist who fooled the world into believing that his only obsessions were money, fame, glamor, and that he was cool to the point of callousness." Specifically, he encourages at least two revisions: (1) Over against

[90]Andy's given name was Andrew Warhola, though once he moved to New York City in 1949 and began working as an illustrator he quickly shortened it to Andy Warhol. All other members of his family retained the original Warhola.

[91]Geldzahler, quoted in Zan Schuweiler Daab, "For Heaven's Sake: Warhol's Art as Religious Allegory," *Religion and the Arts* 1, no. 1 (Fall 1996): 18.

[92]John Warhola, quoted in ibid., 18. Daab recorded both of the preceding quotations from personal interviews that he did with Geldzahler and Warhola in 1991.

[93]Warhol's prayer book was *Heavenly Manna: A Practical Prayer Book of Devotions for Greek [Byzantine] Catholics* (1954); his copy bears markings on selected prayers.

[94]Bourdon, *Warhol* (New York: Abrams, 1995), 38.

[95]Warhol's service of meals to the homeless was attested to by Rev. C. Hugh Hildesley, the rector of the Church of the Heavenly Rest, who wrote "A Lesser-Known Element in the Portrait of Andy Warhol," which was printed on the program distributed at the Warhol memorial Mass at St. Patrick's Cathedral. See Dillenberger, *Religious Art of Andy Warhol*, 16.

the image of Warhol as a dissolute bohemian (his Factory studio had a repu-
tation for its debaucherous parties), Richardson asserted that "as a youth, he
was withdrawn and reclusive, devout and celibate; and beneath the disin-
genuous public mask that is how he at the heart remained." He maintained an
"ability to remain uncorrupted, no matter what activities he chose to film, tape,
or scrutinize." And (2) over against the image of Warhol as a shallow and
callous opportunist, he argues that "Andy's detachment—the distance he es-
tablished between the world and himself—was above all a matter of inno-
cence and art," an effort to construct a "revealing mirror" for a generation
marked by spiritual searching, mass consumption and sociopolitical insta-
bility. With regard to both Warhol's work and his public self-presentation,
Richardson argued that we must "never take Andy at face value"—there was
always more tactical shrewdness and religious seriousness going on behind
the public persona.[96]

Warhol's seminal works (1960s). Ultimately the argument about the theo-
logical content of Warhol's religious works then finally turns on how we un-
derstand his most pivotal earlier works, particularly those made in the aston-
ishingly prolific years of 1962–1964. What is primarily at issue is how we are to
understand the trajectory of Warhol's conceptual impulses, which appears to
have been remarkably consistent throughout his career.[97] This consistency
is such that any discussion of the religious content of the late paintings is
framed by and necessarily raises difficult questions about the (ir)religious
content of the earlier work. Warhol's artistic program trafficked in a consum-
erist superficiality that was shrewdly systematic, and thus the primary dis-
agreements about his work depend on whether we interpret this superficiality
as *complicit* or *critical* with regard to the consumerism they traffic in. In an
influential essay from 1987 Thomas Crow offers a summary that still largely

[96]The full text of John Richardson's "Eulogy for Andy Warhol" (1987) is reproduced in Dillen-
berger, *Religious Art of Andy Warhol*, 13-14. See also the afterword to John Richardson, *Andy War-
hol: Heaven and Hell Are Just One Breath Away! Late Paintings and Related Works, 1984–1986* (New
York: Gagosian Gallery and Rizzoli, 1992). All quotations in this paragraph are from this eulogy.

[97]It might be argued that there was a significant turning point in Warhol's thinking, particularly
with regard to religion, in June 1968 when he was shot by Valerie Solanas and barely survived (he
was pronounced dead upon arrival to the hospital before being resuscitated in open-chest surgery).
This event deeply affected Warhol and seems to have generated a greater religious attentiveness on
a personal level; however, the evidence of the work itself suggests far more continuity between
early and late work than discontinuity, making the turning-point thesis relatively unpersuasive with
respect to the concerns of art criticism.

holds: "The debate over Warhol centers on whether his art fosters critical or subversive apprehension of mass culture and the power of the image as commodity [e.g., Rainer Crone], succumbs in an innocent but telling way to that numbing power [e.g., Carter Ratcliff], or exploits it cynically and meretriciously [e.g., Robert Hughes]."[98] For his part, Crow poignantly argues for a modified version of the first of these views, claiming that although Warhol "grounded his art in the ubiquity of the packaged commodity," he "produced his most powerful work by dramatizing the breakdown of commodity exchange." More specifically, he believes that the critical power of Warhol's work resides in its ability to create "instances in which the mass-produced image as the bearer of desires was exposed in its inadequacy by the reality of suffering and death."[99] We follow Crow in his reading of Warhol, but we want to advance the suggestion that Warhol's criticality had a theological undergirding all the way through.

One way to understand Warhol's early paintings is to see them as transposing traditional pictorial genres—still-life, landscape and portrait painting—into the visual culture of consumerism. His serial paintings of individual *Campbell's Soup Cans* (1961) might be understood as still-life paintings of daily meals (something on the order of Chardin) but in an age of mass-produced meals and mass-produced imagery to market those meals. These paintings of individual cans quickly gave way to the idea that this kind of seriality could operate within a single canvas. In paintings like *200 Campbell's Soup Cans* (1962) the still life has become a landscape, filling the entire visual field with reiterated images of canned soup (the landscape of the grocery store aisle).[100]

[98]Crow, "Saturday Disasters: Trace and Reference in Early Warhol" (1987/1996), in *Andy Warhol*, ed. Annette Michelson, vol. 2 of *October Files* (Cambridge, MA: MIT Press, 2001), 49. The scholars identified in brackets are those whom Crow identifies in his endnotes.

[99]Ibid., 51. In the same volume of essays (*October Files*, vol. 2) Hal Foster attempts to add a distinction within the "critical" reading, differentiating between those who view Warhol's images as "referential" (e.g., Crow) and those who see them as "simulacral" (Barthes, Baudrillard). Foster's intent is to try to synthesize the insights of both camps into what he calls "traumatic realism" (and essentially to reposition Crow's essay within a psychoanalytic framework). Foster, "Death in America" (1996), in Michelson, *Andy Warhol*, 69-88.

[100]Henry Geldzahler once argued that "pop art is a new two-dimensional landscape painting, the artist responding specifically to his visual environment. The artist is looking around and painting what he sees. . . . We live in an urban society, ceaselessly exposed to mass media. Our primary visual data are for the most part secondhand. Is it not then logical that art be made out of what we see? . . . We can no longer paint trees with great contemporary relevance, so we paint billboards." Geldzahler, statement in "Symposium on Pop Art" (December 13, 1962), at the Museum

Though Warhol's earliest soup cans were hand-painted, by this point he had taken up a method of silkscreen printing that allowed for a quasi-mechanical painting process, quickly repeating the same image numerous times onto each canvas in a decisionless grid pattern (derived from the rectangular shape of the canvas). The resulting paintings were a low-tech mimicking of the mass production of the soups themselves, positioning these canvases simultaneously within the grand old traditions of painting *and* within the modern visual commerce of mechanically reproduced images. In 1962 he similarly devoted large canvases to gridded repetitions of *210 Coca-Cola Bottles, 192 One-Dollar Bills, 64 S&H Green Stamps* and so on—any item that had the logic of mechanical reproduction already inscribed in it was a viable subject. At one level, all Warhol was doing was transcribing the logic of mass production into the traditional motifs and materials of "museum" painting. But the point was to produce a two-way critical distance: he placed the visual culture of mass production under the critical scrutiny of the museum, which in turn also problematized the insular space of the museum.

Warhol's method achieved new conceptual range in the summer of 1962 when he discovered an emulsion process for transferring photographic images onto a silkscreen. This allowed him to shift his focus from mass-produced products (soup, soda, stamps) to mass-produced images (print, film, television)—the mechanically reproducible photographic media that are the lifeblood of consumerist visual culture. Once this phototransfer process was in place, Warhol quickly began running *human* images through his faux factory system.[101] Most famously, he painted Marilyn Monroe in the weeks following her suicide in August 1962.

In *Gold Marilyn Monroe* (1962) the late movie star is presented in the visual vernacular of traditional icon painting. Like the Byzantine-derived icons that

of Modern Art, New York; transcript printed in *Arts Magazine*, April 1963, 35-45.

John Carlin similarly claimed that pop art was in fact the "dominant form of realism in the late twentieth century," provided we recognize that the "primary artistic reference is no longer nature, but culture, that is, the fabricated system of signs that has taken the place of things in our consciousness. Landscape has morphed into sign-scape." Carlin, *Pop Apocalypse*, exh. brochure (New York: Gracie Mansion Gallery, 1988).

[101]His earliest photo-emulsion screen prints included images already widely disseminated through American culture: *Baseball* (1962) appropriated a newspaper photograph of Roger Maris hitting a home run in his record-breaking season; *Statue of Liberty* (1962) imitated a lo-fi 3D-glasses rendition of a tourist postcard; and then came the celebrity portraits of Troy Donahue, Marilyn Monroe, Liz Taylor et al.

Warhol grew up with in his church in Pittsburgh, this image is resolutely flat. But the logic of this flatness is of a different order: whereas Byzantine flatness connotes transcendence (the icon is meant to both reveal and withhold the presence of the saint who stands in the light of God), Marilyn's flatness is that of photographic duplication. The spray-painted metallic gold background does not denote the transcendent presence of God as much as a cheaply contrived glitz. This iconography has little to do with Monroe's passage into a higher world but everything to do with her currency in the world of flattened consumable signs. This is the presentation of a (nearly instant) relic of celebrity media, venerated through the rituals of mass distribution. Nevertheless, there *is* a serious invocation of the holy going on in this painting: in Christian thought the woman pictured here bears and discloses the image of God *as a human person*. The religious trappings of this icon thus become doubly difficult: this is a profane "holy" image of a mass-produced photograph of a *holy* image. The critical question of the work cuts toward the function of the photograph in the middle of that equation: Has our use of this device had much of anything to do with love of God or love of neighbor?

As an individual unit—as it might appear on a magazine page or movie poster, for instance[102]—this photographic image of Marilyn's ambiguously seductive half-smile maintains some of its visual currency, allowing the viewer to gaze upon "her" in admiration, erotic longing, jealousy, resentment or whatever. But when Warhol repeatedly prints the image, accumulating dozens of Marilyns on a single surface, the mediating mechanism becomes conspicuous. With a garish "lipstick-and-peroxide palette"[103] Warhol repeated Marilyn over and over and over and over and over. Jonathan Fineberg calls it an "anaesthetizing repetition."[104] This is dramatized in *Marilyn Diptych* (1962), where we are given fifty Marilyns in one painting: half in bright saccharine colors and half in a ghostly black-on-white. As the singular publicity headshot is diffused into grids of reiterated faces, the haunting suggestion deepens: indeed, "Marilyn Monroe" is (only) a commodity. Certainly there was a Norma Jeane somewhere behind the photographic curtain, but the only

[102]The photographic source that Warhol used for his paintings of Monroe was a publicity photo from the 1953 film *Niagara*.

[103]Adam Gopnik, "The Art World: The Innocent," *New Yorker*, April 10, 1989, 109.

[104]Fineberg, *Art Since 1940: Strategies of Being*, 3rd ed. (Upper Saddle River, NJ: Prentice Hall, 2011), 245.

"Marilyn" we know was (and is, even in her death) a mass-produced *image* packaged in a variety of sizes and formats devised for public consumption. As Thierry de Duve points out, the disquieting reminder in Warhol's work is that "to be a star is to be a blank screen . . . a blank screen for the projection of spectators' phantasmas, dreams, and desires."[105] Warhol's pseudomechanical repetitions are high-art (low-tech) parodies of the mass distribution apparatus that makes this kind of consumption of human images possible. These portraits are faux celebrations of "celebrity," apparitions of "glamor rooted in despair."[106] Along with Michael Fried, we find ourselves deeply moved by these "beautiful, vulgar, heart-breaking icons of Marilyn Monroe."[107]

At the same time that Warhol was making these paintings, he was fashioning his own public persona to support and complicate their reception. In a series of obviously disingenuous statements, Warhol claimed, "I don't feel I'm representing the main sex symbols of our time. . . . I just see Monroe as just another person. As for whether it's symbolical to paint Monroe in such violent colors: it's beauty, and she's beautiful and if something's beautiful it's pretty colors, that's all. Or something."[108] In fact this persona seems to have been specifically designed to deflect and defer the sharp criticality of his artworks, allowing them to continue circulating within celebrity culture.[109] Diametrically

[105]De Duve, in the discussion following Crow, "Saturday Disasters," in Michelson, *Andy Warhol*, 62.

[106]Warhol, *Philosophy of Andy Warhol: From A to B and Back Again* (Orlando: Harcourt, 1975), 10.

[107]Fried, "New York Letter," *Art International* 6, no. 10 (December 1962): 57.

[108]Gretchen Berg, "Andy: My True Story," *Los Angeles Free Press*, March 17, 1967, 3; reprinted in Stiles and Selz, *Theories and Documents of Contemporary Art*, 343.

[109]Warhol was conscious of (though rarely forthright about) the social and political implications of his work. In an issue of *Art in America* devoted to identifying the "New Talent" in American art, published in early 1962, Warhol submitted this statement to appear beneath a reproduction of his painting *Storm Door* (1960): "I adore America and these are some of my comments on it. My image is a statement of the symbols of the harsh, impersonal products and brash materialistic objects on which America is built today. It is a projection of everything that can be bought and sold, the practical but impermanent symbols that sustain us." This short statement is more direct than Warhol would be in subsequent years, but it already anticipates the public persona he would increasingly adopt: it revels in mixed message and disingenuous double-speak ("I adore America," a country built on "harsh, impersonal products and brash materialistic objects"), and it only tenuously relates to the painting on which it is commenting, such that it is unclear which portions are parody and which are not (is this a parody of Americanism or of politically self-righteous artist statements?). And yet that last phrase seems incapable of parody: all of his work is surely about "the practical but impermanent symbols that sustain us"—a phrase that is (at the beginning of his painting career) utterly saturated with associations to *vanitas* painting (see further discussion below). Warhol, "Artist's Comment," *Art in America* 50, no. 1, special issue "New Talent U.S.A." (1962): 42.

opposite of Kaprow and Cage, Warhol positioned himself as (and publically performed the life of) the inundated consumer:[110]

> I had this routine of painting with rock and roll blasting the same song, a 45 rpm, over and over all day long. . . . I'd also have the radio blasting opera, and the TV picture on (but not the sound)—and if all that didn't clear enough out of my mind, I'd open a magazine, put it beside me, and half read an article while I painted. The works I was most satisfied with were the cold "no comment" paintings.[111]

Hal Foster argues that the amalgam of Warhol's artworks and persona generated a critique of commercialized spectacle from inside of it. Rather than resorting to withdrawal or direct confrontation one might become more centralized within the spectacle (which Warhol certainly did): "If you enter it totally, you might expose it; you might reveal its automatism, even its autism, through your own excessive example."[112] And thus Foster sees Warhol as deploying a kind of "strategic nihilism"[113] for the sake of amplifying aspects of consumer culture that already had a latent nihilist logic at work in them.[114] According to Warhol, the strategy was to make the "signage" of consumer culture conspicuous: "Once you 'got' Pop, you could never see a sign the same way again. And once you thought Pop, you could never see America the same way again. The moment you label something, you take a step—I mean, you can never go back again to seeing it unlabeled."[115] We might say that Warhol's work enacted a labeling of the labeling, critically marking spectacle

[110]Geldzahler described Warhol's persona as presenting "a sensibility as sweet and tough, as childish and commercial, as innocent and chic, as anything in our culture." Geldzahler, "Andy Warhol," *Art International* 8, no. 3 (April 25, 1964): 35.

[111]Andy Warhol and Pat Hackett, *POPism: The Warhol '60s* (New York: Harcourt Brace Jovanovich, 1980), 7.

[112]Hal Foster, Rosalind Krauss, Yve-Alain Bois and Benjamin H. D. Buchloh, *Art Since 1900: Modernism, Antimodernism, Postmodernism* (New York: Thames & Hudson, 2004), 2:490. Cf. Foster, "Death in America," 71.

[113]Ibid. Interestingly, when this same sentence appears in "Death in America" (the essay from which Foster's entry for "1964" in *Art Since 1900* was derived), the phrase he uses is "capitalist nihilism" (see 71).

[114]To choose one obvious window into the logic of "strategic nihilism" by which he amplified aspects of entertainment culture, Warhol once observed (with tongue in cheek): "Apparently, most people love watching the same basic thing, as long as the details are different. But I'm just the opposite: if I'm going to sit and watch the same thing I saw the night before, I don't want it to be essentially the same—I want it to be exactly the same. Because the more you look at the same exact thing, the more the meaning goes away, and the better and emptier you feel." Warhol and Hackett, *POPism*, 50.

[115]Ibid., 39-40.

as spectacle. This marking was generally oriented toward (1) interrupting the processes of mass-media culture that he considered unethical and idolatrous and (2) facilitating greater self-reflection about the forms of social life we are living. In a statement that could have been written by Cage or Kaprow, in 1966 Warhol gave an uncharacteristically frank explanation of his work: "Few people have seen my films or paintings, but perhaps those few will become more aware of living by being made to think about themselves. People need to be made aware of the need to work at learning how to live because life is so quick and sometimes it goes away too quickly."[116]

All of this, we argue, is grounded in Warhol's *theological* imagination. One way to frame this argument is to show (as many art historians have) that Warhol's work is twentieth-century *vanitas* painting. The seventeenth- and eighteenth-century Dutch and Flemish traditions of *vanitas* still-life painting engaged and celebrated sensual pleasure, depicting objects that are pleasing to the senses—fruit, flowers, musical instruments—each rendered with rich painterly detail. At the same time, these paintings were also about the inevitability of loss: intermingled with these objects of pleasure are signs of decay—a flower has begun to wilt; the fruit is beginning to turn brown; flies and ants have begun to feed. To drive the point home, painters sometimes included a human skull among the items portrayed: the human being (in body, heart and mind) is itself full of both goodness and decay. Derived from the Latin translation of Ecclesiastes 1:2—"*vanitas vanitatum omnia vanitas* [vanity of vanities; all is vanity]"—the term identifies this painting tradition as a meditation on ephemerality. In English *vanity* has accumulated more negative moral associations than the original Hebrew intended; a closer translation would emphasize the fragility and delicacy of the world: "breath, breath; all is breath." All things are to be received with delight and thanksgiving but, the paintings say, beware: a life devoted to grasping, possessing and controlling pleasures is ultimately a vain pursuit (akin to holding one's breath). The driving question of both Ecclesiastes and *vanitas* painting thus remains: What is it to live a truly beautiful life once one recognizes the passing of all things and truly comes to face one's own *memento mori* ("remember that you must die")?

[116]Warhol, quoted in Alan Solomon, *Andy Warhol*, exh. cat. (Boston: Institute of Contemporary Art, 1966), n.p.

The Dutch *vanitas* tradition is perhaps most concisely summarized in David Bailly's (1584–1657) *Self-Portrait with Vanitas Symbols* (1651) (fig. 7.1). The youthful artist holds a portrait of himself as an old man, surrounded by a virtual catalog of symbols of human frailty and mortality: flowers, bubbles, a snuffed candle, a tipped wineglass, a human skull. This painting, however, was made when Bailly was sixty-six or sixty-seven years old. The young man sitting at the table is a memory (a phantom) of himself at the beginning of his career, whereas it is actually the portrait that the young man is holding—the painting within the painting—that depicts the artist at the time the work was made. And it portrays someone who had suffered great loss: art historians conjecture that the oval portrait of the young woman immediately next to the oval portrait of the artist (and perhaps the ghostly drawing on the back wall) is the artist's wife, Agneta, who had (as best we can tell) just died of the plague. Bailly's painting is everywhere riddled with beauty and death intermingled.

This finds profound resonance in Warhol's work. Not only were the subjects of his paintings consistently *vanitas* objects—food, flowers, portraits, skulls[117]—more importantly, the *logic* of his work is utterly consonant with *vanitas* painting. All the objects on Bailly's table signify the brevity of life, but the work identifies the image itself as the ultimate *vanitas* symbol: by isolating a particular moment it actually magnifies the passage of time. Warhol makes precisely this same identification, but he does so in the age of mechanically reproduced photographic imagery. Susan Sontag famously argued that in fact "all photographs are *memento mori*. To take a photograph is to participate in another person's (or thing's) mortality, vulnerability, mutability. Precisely by slicing out this moment and freezing it, all photographs testify to time's relentless melt."[118] That may be true of the singular photograph (or rather the single iteration of a photograph), but Warhol's point is that something very

[117]In 1976 Warhol made a series of *Skull* paintings, which his studio assistant Ronnie Cutrone referred to as "the portrait of everybody in the world." Trevor Fairbrother has pointed out that in 1974, two years before Warhol painted his *Skulls*, the Metropolitan Museum of Art acquired the earliest known *vanitas* still-life painting, a 1603 Dutch painting by Jacques de Gheyn II (who happens to have been Bailly's teacher). The painting positions a human skull directly beneath a massive bubble that reflects the various pains of life (a leper's rattle, a torture wheel, a broken glass, a flaming heart) and directly above a row of gold and silver coins, flanked by two vases: one holding a flower (whose beauty will fade) and the other emitting a thin ribbon of smoke (a light that has gone out). Fairbrother, "Skulls," in *The Work of Andy Warhol*, ed. Gary Garrels (Seattle: Bay Press, 1989), 96-97, 108.

[118]Sontag, *On Photography* (New York: Farrar, 1977), 15.

Figure 7.1. David Bailly, *Self-Portrait with Vanitas Symbols*, 1651

strange happens when photographic *mementos* become the objects of mass production and distribution—a kind of forgetfulness sets in. Bill Manville once hauntingly described Warhol's oeuvre as

> *Life* magazine taken to its final ultimate absurd and frightening conclusion, pain and death given no more space and attention than pictures of Elsa Maxwell's latest party. And all of us spectators at our own death, hovering over it all in narcotized detachment, bored as gods with The Bomb, yawning over The Election, coming to a stop at last only to linger over the tender dream photos of Marilyn. (And they call it Life).[119]

If there is any doubt that death had been Warhol's dominant theme since the early 1960s, he made it overt in his 1963 *Death and Disaster* series. In *Five Deaths Eleven Times in Orange* (1963), for example, he silkscreened a horrific photograph of mangled bodies trapped inside an overturned car. And the cruelty of the photo deepens as Warhol coldly repeats the image eleven times and assigns the work its flatly descriptive title. In direct continuity with his previous work, he treats death as a spectacle, compulsively reiterating images

[119]Manville, "Boris Lurie, March Gallery, Images of Life," *Village Voice*, June 16, 1960.

that are, as Donald Kuspit puts it, preoccupied with "premature and public death, instead of what death is supposed to be: a solitary event in which one meets one's maker and oneself."[120] And as Crow rightly argues, this produces an effect that sharply cuts back on itself, generating "moments where the brutal fact of death and suffering cancels the possibility of passive and complacent consumption."[121] However, for Warhol these images were also apparently marked with religious implications. Zan Schuweiler Daab has shown that the photograph used for *Five Deaths* appears on the cover of a religious pamphlet titled *Your Death*, which was found in Warhol's archives.[122] The date and origin of the publication are unknown (printed sometime after 1960), and it shows a slightly tighter cropping of the photo than the one Warhol used (which suggests this isn't his only source for the photo). The pamphlet consists of several articles discussing the fear that the "Judgment Day" may happen at any time and thus the urgency for each person to be spiritually prepared. The pamphlet puts the questions bluntly: "Spiritually, are you living or dead in sin? Have you the Son of God or not?"

And here we can return to Warhol's late religious paintings. The paintings that Warhol chose to make when he was approaching Bailly's age were also reflections on the fragility and contingency of human life, but they were primarily focused on *religious* subject matter. In direct continuity with his serial paintings of consumer products, celebrities and disaster news media, Warhol painted *Christ 112 Times* (1986), an enormous canvas more than thirty-five feet in length. (There are in fact four versions of this painting.) Given his religious biography, we must recognize that Warhol painted these as someone who was a believing Catholic. But especially in light of the earlier work, the logic of this serial repetition must also be seen as a critical gesture. Warhol appears to be handling the image of Jesus with the same tragic seriousness as he did the image of Marilyn. And as with Marilyn, this enormous field of repetitions confronts the observer with the realization that all that is visible here is a heavily mediated Christ—a line-drawn illustration of Leonardo's Jesus from a painting that had come to represent Renaissance art more than the event it

[120]Kuspit, "Warhol's Catholic Dance with Death," in Kuspit, *Redeeming Art: Critical Reveries,* ed. Mark Van Proyen (New York: Allworth Press and the School of Visual Arts, 2000), 258-59.
[121]Crow, "Saturday Disasters," 57-58.
[122]See Daab, "For Heaven's Sake," 16-18.

depicted. And when Warhol plucks a copy of this well-known image out of circulation and then runs it through his critical mimicry of mechanical repro-duction, the distance and the artifice become conspicuous. If there is any sub-limity in Warhol's handling of Jesus, it is that of a "Xeroxed sublime."[123]

The Last Supper (The Big C) (1985–1986) is similarly massive (thirty-two and one-half feet long), but it eschews gridded repetition and instead scatters fragments of Leonardo's Christ (he appears four times in different scales) among various commercial images—an image from a motorcycle ad repeated three times, a potato chip brand logo and so on—all distributed irregularly across the canvas. Presumably "The Big C" is a somewhat irreverent reference to Christ; however, Warhol directly appropriated the phrase from a news-paper article that he saved: "The Big C: Can the Mind Act as a Cancer Cure?"[124] Thus the referent of "C" begins to slide around: it refers both to Christ and to Cancer, or perhaps also to the Cure, the Church, or holy Communion—or, given the massive central "$6.99" price tag, to Commerce. And the point is that it becomes increasingly difficult to preserve the integrity of these ref-erents as they collapse into one another, and as the cheapness of the image of Christ is equalized to the cheapness of the motorcycle's trite allusions to freedom, rebellion or male machismo. And this is similarly true of *The Last Supper (Dove)*, to return to our earlier example. Warhol's collating of pro-found elements of the Christian gospel with merchandizing logos (GE = Light of the world; Dove soap = sanctifying Holy Spirit; etc.) enacts a brutally efficient crushing of doctrinal meaning. Warhol's *Last Suppers* are images of Christianity in an appallingly degraded state: the gospel reduced to a consumer product and transposed into the language of marketing. To adapt Fried's phrase, these are "beautiful, vulgar, heart-breaking icons" of consumerist Christianity.[125]

[123]Special thanks to Karen Kleinfelder at California State University Long Beach for this phrase.

[124]See Dillenberger, *Religious Art of Andy Warhol*, 91-92.

[125]In this context, Jane Dillenberger's conclusions about these paintings are untenable: she argues that in these paintings "the cool and distanced artist abandoned his mask. Warhol finally created paintings in which his secret but deeply religious nature flowed freely into his art." Dillenberger, *Religious Art of Andy Warhol*, 99. But equally untenable are the counterclaims of many of Dil-lenberger's critics, who want to preclude any theological seriousness from these works. Canadian art historian Johanne Lamoureux, for example, wants "to undo the Catholic instrumentalization of Warhol's last work" in favor of boiling *The Last Suppers* down to a coded gay rebuke of the Catholic Church. Lamoureux, "Ending Myths and the Catholic Outing of Andy Warhol," in *Pre-carious Visualities: New Perspectives on Identification in Contemporary Art and Visual Culture*, ed.

However, as with all of his other works we've seen thus far, Warhol's subversive parodies are aimed not at his subject matter but at the systems of mediation and the "handling" of that subject matter. We argue that Warhol's late religious paintings are best understood as the work of a Christian wrestling with the problematic visuality of his faith, submersed as it is in a bog of visual kitsch and cliché, and profoundly vulnerable as it is to the visual culture of commercial marketing and advertising. In the age of mechanical reproduction, religious imagery is every bit as exposed to the latent nihilism of the "vernacular glance" as photos of celebrities or newscasts about human tragedies. The sharp, ironic criticality of these religious paintings is that of a believer scrutinizing the common signage of his faith as it passes through the machinery of mass media. Warhol subjects this signage to the logic of *vanitas* painting, not for the sake of attacking religious belief but for the sake of "labeling" one of the major modern obstacles to it.

The Los Angeles–based artist Ed Ruscha (1937–) also demands investigation on this point, though we don't have space to adequately do so here. Ruscha is well known for his deadpan paintings of single words or phrases, which from early in his career included religiously charged words: *Church* (1965), many versions of *Sin* (1967–1970), *Faith* (1972), *Gospel, Hope, Mercy, Purity, Evil* (1973), multiple versions of *Truth* (1973), *A Particular Kind of Heaven* (1983), *Heaven/Hell* (1988), *Sin/Without* (1990) and so on. Hal Foster rightly notes that these word paintings simultaneously evoke profundity and cliché, highlighting "the paradoxical conjunction of the charged and the drained" that coexists within consumerist culture.[126] Foster refers to this conjunction as the "Hollywood sublime,"[127] which seems to be precisely what art critic Christopher Knight had in mind when he dubbed Ruscha "the visual poet laureate of spiritual displacement and psychological homelessness."[128] However, Foster argues that "for every impulse to mock, even to destroy" the normative power of these words, Ruscha's work also demonstrates "a counterimpulse to reclaim the degraded commonplace as a shared vernacular" in

Olivier Asselin, Johanne Lamoureux and Christine Ross (Montreal: McGill-Queen's University Press, 2008), 101.

[126]Hal Foster, *The First Pop Age: Painting and Subjectivity in the Art of Hamilton, Lichtenstein, Warhol, Richter, and Ruscha* (Princeton, NJ: Princeton University Press, 2012), 234.

[127]Ibid., 239.

[128]Christopher Knight, quoted in Charlene Spretnak, *The Spiritual Dynamic in Modern Art: Art History Reconsidered, 1800 to the Present* (New York: Palgrave Macmillan, 2014), 189.

order to recover "forms of possible commonality even within a condition of pervasive commodification."[129] And for Ruscha, as with Warhol, this commonality has always included a religious dimension.

Raised in a Catholic home in Oklahoma City, Ruscha admits, "I kind of spring from Catholicism. I felt like I had this perspective from the Church and going to Mass that was an early childhood base for a lot of my thinking. Some of my work comes out of a quasi-religious thing."[130] In a recent interview with Charlene Spretnak, Ruscha acknowledges that his Catholicism "has had a lasting affect [*sic*] on how I proceed to make an object of art. Icons and their presentation, religious tableaux, incense pendulums, chalices, holy cards, stigmata and rays of light, vestments, the Stations of the Cross, symmetry, and framing all combine to be part of my thinking. . . . They enrich my approach to the world and are things I don't want to or need to escape."[131] As with the other artists explored in this chapter (and in this book), there are distinctly theological roots to Ruscha's work, particularly as it self-consciously struggles with the fragilization of belief in the age of mass media.

‖ **▮▮▮** ‖

In the years following World War II the United States experienced an astonishing expansion both in economic power and in mass-media technology, and the artists discussed in this chapter each in their own ways attempted to understand and come to terms with the ways these changes were reshaping American (and global) culture. Through a series of interventions ranging from silence to parodic visual noise, each of these artists sought to open up greater critical distances from which to freshly perceive, reassess and (to varying extents) resist the reorganizing of human life into the patterns of mass consumer culture. And for each of these artists these interventions were theologically charged, not only in terms of the religious roots and motivations that subtly oriented their work but, moreover, in the ways their artworks raise difficult and important

[129]Foster, *First Pop Age*, 226-28, 231. Indeed, Foster believes that "this commonplace [is] his primary medium" (228).

[130]Ruscha, quoted in Amei Wallach, "The Restless American: On Ed Ruscha's Road," *New York Times*, June 24, 2001. Ruscha then immediately adds, "I was a believer for a while and then I began to see the hypocrisy." As is so often the case, Ruscha's retreat from the church evidently had less to do with the content of religious belief than with religious social experience (namely, the hypocrisy of other Catholic believers).

[131]Ruscha, quoted in Spretnak, *Spiritual Dynamic in Modern Art*, 189.

questions about the cultural cross-pressures that mass media were (and still
are) exerting on religious belief. These questions multiply: As images and ob-
jects are increasingly framed in terms of their use value—or, increasingly, their
entertainment value— how does one retain and cultivate a sense of the holy
gratuity of existence? And when religious imagery is sucked up into the ma-
chinery of mass marketing and consumption alongside every other visual form,
how are the (theological) meanings once mediated by that imagery affected?
And if religious content does become part of the media noise and spectacle,
how does one guard against the commodifying and trivializing (or ironizing)
effects that inevitably ensue? In short, what does it *look* like to conduct serious
theological thinking in the visual culture of modern mass media?

Unfortunately, art historians and Christian commentators alike have tended
to collapse these questions (or to simply disconnect them from the discourse
about these artists altogether). Rookmaaker kept these questions in play but
seemed to get them the wrong way round, interpreting these artistic disrup-
tions of mass visual culture as advocating negative and dysfunctional "messages"
about reality itself. As such he characterized the artists discussed in this chapter
as evangelists of "the gnostic message." Naming Rauschenberg, Cage and
Warhol specifically, he argued that "in all this we are confronted with the
message of 'no meaning,' the ugliness and evil of reality, the inner silence—a
world to which no god ever spoke or will speak."[132] In other words, they are only
examples of the nihilistic endgame of modernity's "closed box" ideology, within
(or against) which modernists could only muster an art of disillusionment.
Rookmaaker's reading was dark indeed: this is a generation "great in its tech-
nology, great in its organization, but without an answer to the basic human
questions, with God murdered, a generation left to live in a world hopeless,
forlorn, desperate, frustrated, full of agony, a world over which Moloch reigns.
God is dead and Moloch reigns."[133] While this might accurately name some of
modernism's malaise, it is a reductive handling of the artists discussed in this
chapter, each of whom struggled with both Moloch and God in more inter-
esting and important ways than Rookmaaker gave them credit for.

[132]Rookmaaker, "Modern Art and Gnosticism: An Open Letter to Prof. Dr. Jan Aler" (1973), in
 CWR, 5:302. He adds: "Theologically speaking there is an affinity here with the attitude towards
 God expressed in the twentieth century by the phrase 'God is dead'" (303).
[133]Rookmaaker, *MADC*, 183.

Epilogue

This brief epilogue marks, we hope, a pause in the conversation rather than its conclusion. We have argued that the "grain" of the history of modernist art, which has so often been interpreted from within a secularization narrative, needs to be deeply reconsidered with respect to the ways that this grain was formed within religious contexts and shaped by theological questions and concerns. This history offers many points of contact for richer conversations between religious history, theology and art criticism, and hopefully this has been borne out in the preceding chapters.

But even still these conversations feel like they are really just beginning. There is increasing openness to issues of theology and religion in modern art history, yet the scholarship still needs much more development. We have surveyed some of the artists who might be included, but many others surely could be explored. From the perspective of France, Isabelle Saint-Martin has highlighted the "re-employment" of Christian vocabulary and symbols outside of strictly religious reference.[1] The very fact that these are available for use suggests an unacknowledged efficacy, even a metaphysical viability, that portends greater openness to conversation. Even in post-Christian Europe and the secular academy in the United States, there is increasing acknowledgment that images and symbols still carry the weight of their past, as Walter Benjamin insisted, even as they are made strange by the passage of time.[2] And although we have ended our study at roughly 1970, the year that Rookmaaker's famous book was published, this merely stages a host of new questions about the relationship between art and religion in an increasingly globalized and digitized

[1]Saint-Martin, "Christ, Pietà, Cène, à l'affiche: écart et transgression dans la publicité et le cinéma," *Ethnologie française* 36, no. 1 (2006): 65-81.
[2]Howard Eiland and Michael W. Jennings, *Walter Benjamin: A Critical Life* (Cambridge, MA: Belknap / Harvard University Press, 2014), 343-45.

context, and about how theological questioning is functioning in the arts *after* modernism. Contemporary art forms—installations, performances, relational art, net art and so on—are proposing and testing not just the imagery of our time but our iconology and basic value structures.[3] And as this recodifying of knowledge in the face of dominant commercial ideologies takes on an expanded political and moral charge, it also inevitably raises religious and theological questions. And as Charles Taylor has pointed out, these questions might well demand deeper sources than are currently on offer.

This raises a further question that we have mostly left unaddressed: In what ways might this conversation have a reflexive influence on the religious traditions themselves? Whether artistic or religious, traditions are not fixed entities; they are always under construction. As Renato Poggioli has written, "Tradition itself ought to be conceived not as a museum but as an atelier, as a continuous process of formation, a constant creation of new values, a crucible of new experience."[4] Although Enlightenment assumptions once supported the notion that art and religion were mutually independent, in actuality the mutual influence between the two has continued, perhaps often unnoticed, throughout the past two centuries. Our study wagers on the possibility (even the hope) that these evolving traditions may still positively inform and enrich one another, as they have done so often in the past.

Within these traditions, we have written this book with a double aim, and thus with a double audience in mind. On the one hand, we are (in one way or another) intellectual children of Rookmaaker, who embrace his impulse to reread modernism as theologically significant, even as we challenge the ways he conducted that reading. On the other hand, we are also lovers of modern art who embrace much of the wonderful scholarship being done today in modern art history, even while challenging the still pervasive tendency to exclude religion and theology from its fields of questioning. As a result, this book vacillates in its audience(s), speaking simultaneously to those in religious communities who also have inherited Rookmaaker's influence (or the influence of others like him) and to those in academic art communities who

[3]This is the argument of David C. Miller, ed., *American Iconology: New Approaches to Nineteenth-Century Art and Literature* (New Haven, CT: Yale University Press, 1994), 1-17. His use of iconology is indebted to W. J. T. Mitchell.

[4]Poggioli, *The Theory of the Avant-Garde*, trans. Gerald Fitzgerald (Cambridge, MA: Belknap / Harvard University Press, 1968), 159.

have ignored his project entirely—and perhaps ignored the question of religion in relation to modernism entirely. This double aim grows from our deep regard for both of these communities and from our dissatisfactions with the dominant discourse in each. The church and the seminary tend to have weak (or simply misinformed) understandings of modern and contemporary art history, while the museum and the art academy tend to have anemic (or simply misinformed) understandings of theology. This book is an attempt to help bring the better parts of each into more meaningful contact with the other, and to do so in charitable and irenic ways. It is of course an incomplete and inadequate effort, but hopefully it is a step in the right direction.

At the very least it should be clear by now that the diverse religious influences running through modernism should discourage any simple ways of dichotomizing what is secular from what is religious. Just as this should not discourage religious people from having critical engagements with certain themes that have driven modern movements—nihilism, surrealism, deconstruction and the like—nor should it occlude the possibility that religious traditions continue to provide aesthetic resources for both believers and unbelievers. If our study has suggested the possibility of fruitfully exploring such influences, even motivated some to do so, then it will have reached its goal.

With regard to people of faith (whether Christian or otherwise) we have had a more particular goal in mind: we wish to broaden the scope of what we look for when we stand before modernist works of art, and we wish to do so through what we called in the first chapter a hermeneutic of charity. Hans-Georg Gadamer has proposed that looking at a work of art involves the ability to "play along" with what the artwork proposes, to give ourselves to the experience with an openness, generosity and "sacred seriousness."[5] It is our conviction that inviting attention to the theological implications of modernist art and to the religious impulses that shaped its histories opens a rich and necessary space for playing along, and even the potential for deeper religious and theological insights.

[5]See Gadamer, *The Relevance of the Beautiful and Other Essays*, ed. Robert Bernasconi (Cambridge: Cambridge University Press, 1986).

Afterword

So What?

Jonathan Anderson and Bill Dyrness have collaborated on a book that is a breath of fresh air for me, a specialist in the history of modern art who, as an evangelical, has often struggled to justify my vocation, not only to others but also to myself. Their book offers an alternative interpretative framework to Dutch art historian H. R. Rookmaaker's *Modern Art and the Death of a Culture*, which, with its story of cultural demise and nihilism, has exerted a strong and problematic influence on evangelicals who *want* to care about culture and its artifacts. Anderson and Dyrness, on the other hand, show through an analysis of several key episodes in the history of modern art that religion, spirituality and Christianity are not only *not* banished but play an important role in the history and development of modern artistic practice. In contrast to the art of the Renaissance, Baroque and academic tradition, in which artists represented Christian subjects and themes, modern artistic practice itself *becomes* a religious practice requiring faith and belief. Even an atheist like Gustave Courbet, condemned by Rookmaaker because of his "realism," was in fact an artist whose commitment to the importance of painting can be described as faith.

Well done, Bill and Jon. But the question that will emerge, the question I will ask, is, *so what?*

Why should anyone care but a few artists, collectors and art educators who like "modern art" and happen to be Christians or academics working in seminaries and Christian colleges who like to talk about "theology and the arts" amongst themselves, in their own journals, at their own conferences? Why

should it matter that modern art receives a much more nuanced, less polemical, and a more historically and theologically sophisticated treatment by a theologian and an artist than the Dutch art historian was willing or able to offer? What if, as I firmly believe, and believe that this book affirms, that evangelicalism—out of fear or ignorance, or in its zeal to transform the world—has simply gotten modern art wrong; that in its eagerness to make modern culture safe for the gospel and Christian values (not often in that order) evangelicalism has distorted it? And if evangelicalism and the North American church have modern art wrong, then is it possible that other, more popular and perhaps more "influential" cultural artifacts, like music, film and television have suffered a similar fate? And if that is the case, which, again, I believe it is, then the North American church needs to completely rethink how it understands culture and creative cultural artifacts. This book might be helpful in this process.

‖ ▌▌▌ ‖

In this book Anderson and Dyrness treat modern art—and a particular slice at that—on its own terms, taking seriously what its adherents, practitioners—its believers—say and do on its behalf. And they do so without drawing broadbrushed abstract conclusions about the fate of art or the fate of culture, conclusions and pronouncements that have been *de rigeur* among cultural commentators within the North American church since the 1960s. Armed with an understanding of culture that is neither pessimistic, nostalgic nor idealistic, Anderson and Dyrness are liberated to focus their considerable intellectual and imaginative gifts on the artists and the works of art that capture their attention. Both Anderson and Dyrness are adamant that this is just the beginning, that Christian approaches to thinking historically, philosophically and theologically about modern art can and *must* take place without the narrative of cultural decline that usually accompanies it and, as a life-giving cultural practice, one that does not deny tensions and conflicts but nevertheless sees God's presence in the history and development of modern art even as it is often experienced as *absence*.

This book does the historical, theoretical and theological work to clear the brush that obscures the view of modern art, allowing us to see freshly, and with clearer and more sober eyes, this God-haunted creative cultural tradition as a practice imbued with profound human integrity that deserves

to be understood theologically, historically, theoretically and Christianly. And such a historically astute and theologically informed study can offer a model for how evangelicals and other North American Christians can think about and interpret their own experiences and relationships with creative cultural artifacts.

The question "so what?" does not come only from those who don't care about the fine arts or who have felt safe to remain protected by the narrative of cultural decline that shapes Christian "engagements" with culture. It also comes from those Christians who are deeply involved in the contemporary art world, who have their BFAs and MFAs and are curating and showing in exhibitions with non-Christians in such centers of the art world as Los Angeles and New York. If they are aware of it or think about it at all, they believe that the theology-and-arts conversation that takes place in seminaries and Christian colleges is simply not relevant to the questions they are asking and the decisions they are making in their studios. For many of them, the entire enterprise of connecting their Christian faith to their studio practice is irrelevant. They're Christians, but they've come to the conclusion that neither Rookmaaker nor Aquinas nor Paul can offer them much help as artists. They are simply responding to the false choice that was presented to them by the church and by the Rookmaakers of their world, either explicitly or implicitly: *to be theologically engaged as Christians in the visual arts means that their work has to look and or behave in a certain way, and that look or behavior is at odds with what they experience in the art world, with what probably attracted them to artistic practice in the first place.*

And, given that false choice, who can blame them? I certainly felt that pressure as an undergraduate art history major in the late 1980s. Perhaps this book will help them recognize that there might be new opportunities to think theologically again about their own artistic practice that don't require that they become "Christian artists" and talk about "Beauty," but can help them think about their work more deeply.

|| ▋▋ ||

But "so what?" also comes from the contemporary art world, for which the modern tradition of artistic practice is often considered antiquated or worse, dead, entombed in crypts in public or private collections, and thus largely

irrelevant to contemporary practice. Why care about modern art when so much contemporary artistic practice over the past several decades after modern art (call it postmodernism if you like) has rendered irrelevant the very history and tradition that this book labors to restore, including the tradition of museum artifacts like painting and sculpture?[6]

I would suggest that the problems that face the contemporary art world, including the various creative cul-de-sacs it has found itself trapped in, are the result of not plugging into the depth of the modern artistic tradition. Like the rich kid who relies on his vast inheritance while at the same time claiming to ignore it as irrelevant, the refusal or inability of the contemporary art world to drink deeply from the modern artistic tradition has had the result of transforming artistic practice into simply a more precious form of entertainment and creative decoration with no historical context and cultural memory.[7] And without that memory, without its capacity to live deeply into a living tradition that modern art has given them, artists, critics, dealers, curators and collectors are too often trapped in the ceaselessly turning wheel of the entertainment cycle, an ever recurring "now" that makes it impossible to think about artistic practice as a lifelong arc, to think about the past and future in any meaningful way, or following Augustine, as quoted by art historian Terry Smith, to think about "a present of things past, a present of things present, and a present of future things."[8]

Is it possible that scholars who are thinking theologically might be able to offer a more compelling history of modern art, one that can show the contemporary art world that the modern tradition of artistic practice is not a progression of stylistic innovation but a belief system, a way of understanding the self and its relationship to the world that continues to be viable and can address the present situation in the art world, and connect with them as human beings? (As an important aside, nothing I have said or will say in my argument for the importance of the modern artistic tradition has anything to do with or makes any presumptions about subject matter or medium. It is not about a nostalgic or reactionary return to previous styles, content, working methods,

[6]See Donald B. Kuspit, "The Contemporary and the Historical," *Artnet*, April 2005, www.artnet .com/magazine/features/kuspit/kuspit4-14-05.asp.
[7]See Terry Smith, "Contemporary Art and Contemporaneity," *Critical Inquiry* 32 (Summer 2006): 681-707.
[8]Quoted in ibid., 700.

media or institutions. It is so much deeper than merely those superficial external manifestations. Can I say that it is not about behavior but about the heart?) Artists working in the modern tradition understood or believed their studio practice to be inextricable from and an outgrowth of their belief about who they were or could be in the world. It was enlisted in their attempt to become more human, to understand or clarify who they were in relationship to the world, and to address what they experienced to be their world's deep injustice and pain.

In smearing pigment along scraps of canvas, and doing so outside the established institutional frameworks of the academy, the church and the state, these artists were making their artistic gestures bear the incredibly heavy burden of their vocations, not just as painters *but also as human beings*. Hence, their passion, their urgency, their arrogance, their pain and suffering, their inflated optimism, and their faith that those scraps of canvas actually *do* something. The history of modern art is an aesthetic practice of faith that can be recovered by the contemporary art world.

‖ ▮▮▮ ‖

From where I stand, and I must admit that I stand on the margins of *both* the theology-and-the-arts conversation and the contemporary art world, I would like to offer one possible future direction of the many paths that will no doubt come into view from the cleared-out vista that Anderson and Dyrness have provided.

The history and development of modern art cannot be understood fully unless the history and development of writing about it is explored in all its depth and complexity. I would suggest that this history begins with Gustave Courbet's "Realist Manifesto" (1855), written to offer the interpretive context for his independent solo exhibition, which he called "The Realist Pavillion" as a protest to the Salon exhibition that was on view during the Universal Exposition in Paris.[9]

Artists have written about their work in the past—Michelangelo and Delacroix come quickly to mind. But until Courbet's protest exhibition, no artist wrote a public document from the need of offering an alternative interpretive

[9]Courbet, "Realist Manifesto" (1855), in *Art in Theory, 1815–1900: An Anthology of Changing Ideas*, ed. Charles Harrison, Paul Wood and Jason Gaiger (Malden, MA: Blackwell, 1998), 372-73.

context for his own work. For artists like Michelangelo and Delacroix, the context of the commission or the context of the Academy offered sufficient interpretive and institutional context. From Courbet onward, what artists say about their work becomes an increasingly important part of their interpretive context. To step outside the established interpretive and institutional framework of the Academy was not merely to break from the past or to be freed from the shackles of tradition. It deprived Courbet, and every artist working in his ideological wake, of a stable interpretive and experiential context for their paintings. And so not only statements by artists but also essays and reviews by sympathetic writers-turned-apologists were crucial for providing new interpretive contexts for experiencing these seemingly awkward, violent or incompetent paintings that appear to violate so many of the artistic values of the Academy. Throughout the development of modernism in the nineteenth and twentieth centuries, the words of artists and critics will be inextricably linked and associated with the works of art, especially as the shifting, changing and competing contexts in which these works were offered demanded more and more explanation.

Those in the church who have commented on the visual arts have, to a person, viewed the increasingly visible and important role that these words have played in the history of modern art as a negative development. This is pointed to as one of the primary evidences of its invalidity, its incompetence— that works of Courbet's, Manet's, Cézanne's, Picasso's, Duchamp's or Pollock's can't "stand on their own" but require what the artist says about them or what an authoritative critic tells us about them to give them significance. This response ignores the fact that artists working in the Academy or within the patronage structure of the institutional church did not need to talk about, explain or justify their work; the intricate and stable institutional frameworks within which they worked did the "talking" for them.

Those in the church who want to think theologically or Christianly about modern art need to devote attention to these words and their relationship to the artifacts from which they come. What an artist says about his or her work as well as what a critic says about the work before which he or she stands, and how that critic contextualizes it in the larger narrative of their artistic worldview (as well as the critic's own worldview), is almost entirely unnoticed or unremarked on by Christians.

And yet this is a theologically rich subject, given the importance that Christianity and the church places on the word and on language, whether from Orthodox, Catholic or Protestant theological perspectives. Can the exploration of the history of artists' statements and utterances about their work as well as what others (critics, writers, poets, politicians, dictators) have said about them benefit from theological work that has reflected on the Word as event, that human language is a creative response to being addressed by God?[10]

Let's get one thing straight. There is no pure visual experience. Every experience before a work of art is always already inextricably connected to language, emerging in and, then, perhaps for the briefest of moments, as a flash, out of it, only to return into the flux of discourse. The task of language, of words, is to give an account of the experience of this "flash" or to create the space in the reader's or hearer's imagination for that "flash" (call it an "image event"?) to occur, to dwell and take root and begin to grow. And so, although language is everywhere present in and through the visual, the task of language is, however, to bear evocative witness and to grow that flash, that moment in which the visual does something to us that defies language. This responsibility does not lie only with art critics but with all who use language around works of art, whether in the seminar room, comment section of a blog post or art gallery.

The study of the words in, around and under works of art has important consequences and implications, both inside and outside the church. In a remarkably insightful literary dialogue, "The Critic as Artist" (1890), Oscar Wilde's Gilbert says, "More difficult to do a thing than to talk about it? Not at all. That is a gross popular error. It is very much more difficult to talk about a thing than to do it."[11] Wilde's observation should ring true for those in the church who recognize that the tongue is a source of both blessings and curses and who recognize the ninth commandment's prohibition against bearing false witness against our neighbors. The church has often been more comfortable using words to judge, limit, categorize and sometimes dismiss culture and its

[10]See for example Oswald Bayer, *A Contemporary in Dissent: Johann Georg Hamann as a Radical Enlightener* (Grand Rapids: Eerdmans, 2012); Gerhard Ebeling, *God and Word*, trans. James Leitch (Philadelphia: Fortress, 1967); and Eberhard Jüngel, "Metaphorical Truth: Reflections on Theological Metaphor as a Contribution to a Hermeneutics of Narrative Theology," in *Theological Essays* (New York: Bloomsbury T&T Clark, 2014), 16-71.
[11]Wilde, "The Critic as Artist" (1890), in *De Profundis, The Ballad of Reading Gaol & Other Writings* (London: Wordsworth Classics, 2002), 193.

creative artifacts—especially those of modern art—rather than use words that give such works life and a space to breathe, to give them grace. The history of the words around modern art shows the life-giving power of words, offering other ways in which words have been used by critics who believed in the beauty of an artist's work and used language to express that belief, an expression that can still captivate, if not instruct us, and give us more productive and creative models for talking and writing about our relationships with works of art.

Before he achieved success as an artist, Henri Matisse bought a small painting by Paul Cézanne titled *Three Bathers* (1879–1882), paying much more than he could afford at the time. (In fact, his wife pawned a cherished ring she had received as a wedding present in order to pay for it.) Over thirty years later, well after Matisse had become "Matisse," he donated that little painting to a museum in France and felt obligated to send a note to the curator about what that little painting meant to him:

> If you only knew the moral strength, the encouragement that his remarkable example gave me all my life! In moments of doubt, when I was searching for myself, frightened sometimes by my discoveries, I thought: "If Cézanne is right, I am right." And I knew that Cézanne had made no mistake.

Matisse continued, "It has sustained me morally in the critical moments of my venture as an artist. . . . I have drawn from it my *faith and perseverance*."[12] The history of modern art is the history of the impact of such works of art on artists (and critics) who are searching for works of art and words that can sustain them morally and give them faith and perseverance as artists.

This episode reveals one of the most important yet often overlooked realities in the history and development of the words associated with modern art—whether on the part of the artist or the critic: that works of art are vulnerable, fragile artifacts, easily susceptible to condemnation, distortion, censorship and destruction.[13] Artists in the modern tradition recognized that their works needed help. Abstract expressionist Mark Rothko once said that it's a risky business to send a work of art out into the world. A crucial part of the history of modern art is the history of art's vulnerability and fragility and

[12]Matisse, quoted in Alex Danchev, *Cézanne: A Life* (New York: Pantheon, 2012), 15 (emphasis added).

[13]For an example, see my *"Piss Christ Revisited,"* in Siedell, *Who's Afraid of Modern Art? Essays on Modern Art & Theology in Conversation* (Eugene, OR: Cascade, 2015), 96-101.

its need for words—words that give space to breathe, to fan the flame of life in them and to give their makers strength and confidence.

So what?

Whether or not the world needs "Christian artists" as a response to the nihilism and "death" of modern culture as Rookmaaker (and Francis Schaeffer) believed, I am coming to believe that the world just might need Christian artists and cultural critics who think theologically about their experience before works of art, who through their language, the words they use, give life to those works of art in which they believe and with which they have relationships, giving "faith and perseverance" to those who read or hear their words.

This book is a gift to those whose lives as Christians have been shaped by modern art and culture. It reveals the authors' love for their subject. Their words are nothing if not life-giving.

Thank you, Jon and Bill.

<div style="text-align:center">‖ ▐█▌ ‖</div>

Daniel A. Siedell (PhD, University of Iowa) is Presidential Scholar and art historian in residence at The King's College, New York City, and associate professor of Christianity and Culture at Knox Theological Seminary in Fort Lauderdale, Florida. He is the author of *God in the Gallery: A Christian Embrace of Modern Art* (Grand Rapids: Baker Academic, 2008) and *Who's Afraid of Modern Art? Essays on Modern Art & Theology in Conversation* (Eugene, OR: Cascade, 2015).

Bibliography

Agamben, Giorgio. *The Man Without Content*. Translated by Georgia Albert. Stanford, CA: Stanford University Press, 1999.

Aldea, Leonard. "The Implicit Apophaticism of Dada Zurich: A Spiritual Quest by Means of Nihilist Procedures." *Modern Theology* 29, no. 1 (January 2013): 157-75.

Alley, Ronald. *Graham Sutherland*. London: Tate Gallery, 1982.

Andersen, Troels, ed. *Malevich: Essays on Art, 1915–1933*. Translated by Xenia Glowacki-Prus and Arnold McMillin. New York: George Wittenborn, 1971.

Anderson, Jonathan A. "The (In)visibility of Theology in Contemporary Art Criticism." In *Christian Scholarship in the Twenty-First Century: Prospects and Perils*, edited by Thomas M. Crisp, Steve L. Porter and Gregg Ten Elshof, 53-79. Grand Rapids: Eerdmans, 2014.

Arp, Hans. "Dadaland." In *Arp on Arp: Poems, Essays, Memories*, edited by Marcel Jean, translated by Joachim Neugroschel, 232-36. New York: Viking, 1972.

Arthurs, Alberta, and Glenn Wallach, eds. *Crossroads: Art and Religion in American Life*. New York: New Press, 2001.

Arya, Rina, ed. *Contemplations of the Spiritual in Art*. Bern: Peter Lang, 2013.

Asad, Talal. *Formations of the Secular: Christianity, Islam, Modernity*. Stanford, CA: Stanford University Press, 2003.

Aston, Nigel. *Art and Religion in Eighteenth-Century Europe*. London: Reaktion Books, 2009.

———. *Christianity and Revolutionary Europe, 1750–1830*. Cambridge: Cambridge University Press, 2003.

Aurier, G. A. "Le Symbolisme en peinture: Paul Gauguin." *Mercure de France* 2 (March 1891).

Avtonomova, Natalia. "Malevich and Kandinsky: The Abstract Path." In *Rethinking Malevich*, edited by Charlotte Douglas and Christina Lodder. London: Pindar Press, 2007.

Baigell, Matthew. *Thomas Cole*. New York: Watson-Guptill, 1981.

Ball, Hugo. *Flight out of Time: A Dada Diary*. Edited by John Elderfield. Translated by
 Ann Raimes. New York: Viking, 1974.

———. "Nietzsche in Basel: Eine Streitschrift." Edited by Richard Sheppard and
 Annemarie Schütt-Hennings. *Hugo Ball Almanach* 2 (1978): 1-65.

Bann, Stephen. *Ways Around Modernism*. Theories of Modernism and Postmodernism
 in the Visual Arts 2. New York and London: Routledge, 2007.

Barr, Albert H., Jr. *Cubism and Abstract Art*. New York: Museum of Modern Art, 1936.

———. *What Is Modern Painting?* New York: Museum of Modern Art, 1943.

Basner, Elena. "The Early Work of Malevich and Kandinsky: A Comparative Analysis."
 In *Rethinking Malevich*, edited by Charlotte Douglas and Christina Lodder, 27-39.
 London: Pindar Press, 2007.

Baudelaire, Charles. *Curiosités esthétiques, Salon 1845–1859*. Paris: Michel Lévy Frères,
 1868.

Bax, M. T. "Het Web der Schepping. Theosofie en kunst in Nederland van Lauweirks
 tot Mondriaan." PhD diss., Vrije Universiteit Amsterdam, 2004.

Bayer, Oswald. *A Contemporary in Dissent: Johann Georg Hamann as a Radical En-
 lightener*. Grand Rapids: Eerdmans, 2012.

Begbie, Jeremy S. *Voicing Creation's Praise: Towards a Theology of the Arts*. Edinburgh:
 T&T Clark, 1991.

Benezit, Emmanuel, ed. *Dictionnaire des Peintres, Sculpteurs, Dessinateurs et Graveurs*.
 14 vols. Paris: Grund, 1999.

Berg, Gretchen. "Andy: My True Story." *Los Angeles Free Press*, March 17, 1967.

Berger, Peter L., ed. *The Desecularization of the World: Resurgent Religion and World
 Politics*. Washington, DC: Ethics and Public Policy Center; Grand Rapids:
 Eerdmans, 1999.

———. "Secularism in Retreat." *National Interest* 46 (Winter 1996–1997): 3-12.

Bernard, Émile. "Ce que c'est que l'art mystique." *Mercure de France* 13 (March 1895).

Besançon, Alain. *The Forbidden Image: An Intellectual History of Iconoclasm*. Translated
 by Jane Marie Todd. Chicago: University of Chicago Press, 2000.

Billington, James H. "Orthodoxy and Democracy." *Journal of Church and State* 49, no.
 1, special issue "Russia" (Winter 2007): 19-26.

Birtwistle, Graham. "Evolving a 'Better' World: Piet Mondrian's Flowering Apple
 Tree." In *Art as Spiritual Perception: Essays in Honor of E. John Walford*, edited by
 James Romaine, 225-37. Wheaton, IL: Crossway, 2012.

Blotkamp, Carel. "Annunciation of the New Mysticism: Dutch Symbolism and Early
 Abstraction." In *The Spiritual in Art: Abstract Painting, 1890–1985*, edited by
 Maurice Tuchman, 89-111. Los Angeles: Los Angeles County Museum of Art;
 New York: Abbeville Press, 1986. Exhibition catalog.

———. *Mondrian: The Art of Destruction*. London: Reaktion Books, 1994.

Bøe, Alf. *Edvard Munch*. Barcelona: Ediciones Poligrafa, 1989.

Boime, Albert. *Art in an Age of Civil Struggle, 1848–1871*. A Social History of Modern Art 4. Chicago: University of Chicago Press, 2007.

Bois, Yve-Alain. "Pablo Picasso: The Cadaqués Experiment." In *Inventing Abstraction, 1910–1925: How a Radical Idea Changed Modern Art*, edited by Leah Dickerman, 40-42. New York: Museum of Modern Art, 2012.

Borchardt-Hume, Achim, ed. *Malevich*. London: Tate Publishing, 2014. Exhibition catalog.

Bourdon, David. *Warhol*. New York: Abrams, 1995.

Bowlt, John E. "Esoteric Culture and Russian Society." In *The Spiritual in Art: Abstract Painting, 1890–1985*, edited by Maurice Tuchman, 165-83. Los Angeles: Los Angeles County Museum of Art; New York: Abbeville Press, 1986. Exhibition catalog.

———. "Orthodoxy and the Avant-Garde: Sacred Images in the Work of Goncharova, Malevich, and Their Contemporaries." In *Christianity and the Arts in Russia*, edited by William C. Brumfield and Milos M. Velimirovic, 145-50. Cambridge: Cambridge University Press, 1991.

Bowlt, John E., and Matthew Drutt, eds. *Amazons of the Avant-Garde: Alexandra Exter, Natalia Goncharova, Liubov Popova, Olga Rozanova, Varvara Stepanova, Nadezhda Udaltsova*. New York: Guggenheim Museum, 2000. Exhibition catalog.

Boyle-Turner, Caroline. *Gauguin and the School of Pont-Aven*. London: Royal Academy of Art, 1986.

Bracke, Sarah. "Conjugating the Modern/Religious, Conceptualizing Female Religious Agency: Contours of a 'Post-secular' Conjuncture." *Theory, Culture & Society* 25, no. 6 (2008): 51-67.

Bratt, James D. "From Neo-Calvinism to *Broadway Boogie Woogie*: Abraham Kuyper as the Jilted Stepfather of Piet Mondrian." In *Calvinism and Culture*, edited by Gordon Graham, 117-29. Vol. 3 of *The Kuyper Center Review*. Grand Rapids: Eerdmans, 2013.

Broun, Elizabeth. *Albert Pinkham Ryder*. Washington, DC: Smithsonian, 1989.

Brown, Milton. *American Painting from the Armory Show to the Depression, 1913–1929*. Princeton, NJ: Princeton University Press, 1955.

Buchloh, Benjamin H. D. "Reconsidering Joseph Beuys: Once Again." In *Joseph Beuys: Mapping the Legacy*, edited by Gene Ray, 75-89. New York: Distributed Art, 2001.

Buckle, Richard. *Jacob Epstein: Sculptor*. London: Faber & Faber, 1963.

Bury, J. P. T., ed. *The Zenith of European Power: 1830–1870*. Vol. 10 of *The New Cambridge Modern History*. Cambridge: Cambridge University Press, 1960.

Butterfield, Andrew. "Recreating Picasso." Review of *A Life of Picasso: The Triumphant Years, 1917–1932*, by John Richardson. *New York Review of Books*, December 20, 2007, 12-16.

Cage, John. *For the Birds: John Cage in Conversation with Daniel Charles*. Boston: Marion Boyars, 1981.

———. *John Cage: An Anthology*. Edited by Richard Kostelanetz. New York: Da Capo Press, 1970.

———. *John Cage, Writer: Selected Texts*. Edited by Richard Kostelanetz. New York: Copper Square Press, 1993.

———. *Silence: Lectures and Writings*. Middletown, CT: Wesleyan University Press, 1961.

———. Video interview in the film *Écoute*, directed by Miroslav Sebestik. Centre Georges Pompidou, 1992; Facets, 2004.

Calvin, John. *Institutes of the Christian Religion*. Edited by John T. McNeill. Translated by Ford Lewis Battles. Philadelphia: Westminster Press, 1960.

Camper, Fred. "The Unordered Universe." *Chicago Reader*, March 26-April 1, 1992, sec. 1, pp. 30-33.

Carlin, John. *Pop Apocalypse*. New York: Gracie Mansion Gallery, 1988. Exhibition brochure.

Chipp, Herschel B., with Peter Selz and Joshua C. Taylor, eds. *Theories of Modern Art: A Source Book by Artists and Critics*. Berkeley: University of California Press, 1968.

Chlenova, Masha. "0.10." In *Inventing Abstraction, 1910–1925: How a Radical Idea Changed Modern Art*, edited by Leah Dickerman, 206-8. New York: Museum of Modern Art, 2012.

———. "Early Russian Abstraction, as Such." In *Inventing Abstraction, 1910–1925: How a Radical Idea Changed Modern Art*, edited by Leah Dickerman, 200-203. New York: Museum of Modern Art, 2012.

Clark, T. J. *Farewell to an Idea: Episodes from a History of Modernism*. New Haven, CT: Yale University Press, 1999.

———. *Image of the People: Gustave Courbet and the 1848 Revolution*. London: Thames & Hudson, 1973.

Compton, Susan, ed. *British Art in the 20th Century: The Modern Movement*. London: Royal Academy of Art; Munich: Prestel-Verlag, 1986. Exhibition catalog.

Crawley, C. W., ed. *War and Peace in an Age of Upheaval: 1793–1830*. Vol. 9 of *The New Cambridge Modern History*. Cambridge: Cambridge University Press, 1965.

Crone, Rainer, and David Moos. *Kazimir Malevich: The Climax of Disclosure*. London: Reaktion Books, 1991.

Crouch, Andy. *Culture Making: Recovering Our Creative Calling*. Downers Grove, IL: InterVarsity Press, 2008.

Crow, Thomas. "Saturday Disasters: Trace and Reference in Early Warhol." In *Andy Warhol*, edited by Annette Michelson. Vol. 2 of *October Files*, 49-68. Cambridge, MA: MIT Press, 2001.

Crunden, Robert M. *Ministers of Reform: The Progressive's Achievement in American Civilization*. New York: Basic Books, 1982.

Daab, Zan Schuweiler. "For Heaven's Sake: Warhol's Art as Religious Allegory." *Religion and the Arts* 1, no. 1 (Fall 1996): 15-31.

Danchev, Alex. *Cézanne: A Life*. New York: Pantheon, 2012.

Davidson, Susan. *"Mother of God,"* *Rauschenberg Research Project*, San Francisco Museum of Modern Art, July 2013. www.sfmoma.org/explore/collection/artwork/37592/essay/mother_of_god.

Davis, John. *The Landscape of Belief: Encountering the Holy Land in Nineteenth-Century American Art and Culture*. Princeton, NJ: Princeton University Press, 1996.

de Duve, Thierry. *Look, 100 Years of Contemporary Art*. Translated by Simon Pleasance and Fronza Woods. Brussels: Palais des Beaux-Arts; Ghent-Amsterdam: Ludion, 2001. Exhibition catalog.

———. "Mary Warhol/Joseph Duchamp." In *Re-Enchantment*, edited by James Elkins and David Morgan, 87-106. Vol. 7 of *The Art Seminar*, edited by James Elkins. New York: Routledge, 2009.

Deicher, Susanne. *Piet Mondrian, 1872–1944: Structures in Space*. Cologne: Benedikt Taschen Verlag, 1999.

Delbanco, Andrew. *Melville: His World and Work*. New York: Knopf, 2005.

Denis, Maurice. *Du symbolisme au classicisme: théories*. Edited by Oliver Revault d'Allonnes. Paris: Hermann, 1964.

———. *Histoire de l'art religieux*. Paris: Flammarion, 1939.

———. *Nouvelles théories sur l'art moderne sur l'art sacré, 1914–1921*. Paris: Rouart & Watelin, 1922.

Dickerman, Leah, ed. *Inventing Abstraction, 1910–1925: How a Radical Idea Changed Modern Art*. New York: Museum of Modern Art, 2012. Exhibition catalog.

Dillenberger, Jane Daggett. *The Religious Art of Andy Warhol*. New York: Continuum, 1998.

———. *Secular Art with Sacred Themes*. Nashville: Abingdon, 1969.

Dillenberger, Jane Daggett, and John Handley. *The Religious Art of Pablo Picasso*. Berkeley: University of California, 2014.

Dionysius the Aeropagite. *Pseudo-Dionysius: The Complete Works*. Translated by Colm Luibheid. Mahwah, NJ: Paulist Press, 1987.

Dixon, John W., Jr. "Faith and Twentieth-Century Forms." *Theology Today* 26 (April 1969): 14-33.

———. "On the Possibility of a Christian Criticism of the Arts." *Christian Scholar* 40, no. 4 (December 1957): 296-306.

Douglas, Charlotte. "Beyond Reason: Malevich, Matiushin, and Their Circles." In *The Spiritual in Art: Abstract Painting, 1890–1985*, edited by Maurice Tuchman, 185-99. Los Angeles: Los Angeles County Museum of Art; New York: Abbeville Press, 1986. Exhibition catalog.

———. "Birth of a 'Royal Infant': Malevich and *Victory over the Sun*." *Art in America* 62, no. 2 (March-April 1974): 45-51.

———. *Kazimir Malevich*. New York: Abrams, 1994.

Douglas, Charlotte, and Christina Lodder, eds. *Rethinking Malevich*. London: Pindar Press, 2007.

Drutt, Matthew, ed. *Kazimir Malevich: Suprematism*. New York: Guggenheim Museum, 2003. Exhibition catalog.

du Plessix, Francine, and Cleve Gray. "Who Was Jackson Pollock?" *Art in America* 55, no. 3 (May-June 1967): 48-51.

Duckworth, William. *Talking Music: Conversations with John Cage, Philip Glass, Laurie Anderson, and Five Generations of American Experimental Composers*. New York: Schirmer Books, 1995.

Dyrness, William A. *Reformed Theology and Visual Culture: The Protestant Imagination from Calvin to Edwards*. Cambridge: Cambridge University Press, 2004.

———. *Rouault: A Vision of Suffering and Salvation*. Grand Rapids: Eerdmans, 1971.

Ebeling, Gerhard. *God and Word*. Translated by James Leitch. Philadelphia: Fortress, 1967.

Egbert, Donald D. "The Idea of the 'Avant-Garde' in Art and Politics." *American Historical Review* 73, no. 2 (1967): 339-66.

Eiland, Howard, and Michael W. Jennings. *Walter Benjamin: A Critical Life*. Cambridge, MA: Belknap / Harvard University Press, 2014.

Elderfield, John. "'Dada': A Code-Word for Saints?" *Artforum*, February 1974, 42-47.

Eldredge, Charles C. *American Imagination and Symbolist Painting*. New York: New York University Grey Art Gallery and Study Center, 1979. Exhibition catalog.

Elkins, James. "From Bird-Goddesses to Jesus 2000: A Very, Very Brief History of Religion and Art." *Thresholds* 25 (2002): 75-80.

———. *Master Narratives and Their Discontents*. Vol. 1 of *Theories of Modernism and Postmodernism in the Visual Arts*. New York: Routledge, 2005.

———. *On the Strange Place of Religion in Contemporary Art*. New York: Routledge, 2004.

———. *Pictures & Tears: A History of People Who Have Cried in Front of Paintings*. New York: Routledge, 2001.

Elkins, James, and David Morgan, eds. *Re-Enchantment*. Vol. 7 of *The Art Seminar*. New York: Routledge, 2009.

Emerson, Ralph Waldo. *Collected Essays*. Edited by Larzer Ziff. Middlesex, UK: Penguin, 1982.

Epstein, Jacob. *Epstein: An Autobiography*. London: Studio Vista, 1955.

Erickson, Kathleen Powers. *At Eternity's Gate: The Spiritual Vision of Vincent van Gogh*. Grand Rapids: Eerdmans, 1998.

Eversole, Finley, ed. *Christian Faith and the Contemporary Arts*. New York: Abingdon, 1962.

Fairbrother, Trevor. "Skulls." In *The Work of Andy Warhol*, edited by Gary Garrels, 93-114. Seattle: Bay Press, 1989.

Faulkner, Peter. *William Morris and Eric Gill*. London: William Morris Society, 1975.

Faunce, Sarah, and Linda Nochlin. *Courbet Reconsidered*. New Haven, CT: Yale University Press; New York: Brooklyn Art Museum, 1988. Exhibition catalog.

Fineberg, Jonathan. *Art Since 1940: Strategies of Being*. 3rd ed. Upper Saddle River, NJ: Prentice Hall, 2011.

Fish, Stanley. "One University, Under God?" *Chronicle of Higher Education* 51, no. 18 (January 7, 2005): C1, C4.

Forster, Leonard. *The Poetry of Significant Nonsense*. Cambridge: Cambridge University Press, 1962.

Foster, Hal. "Death in America." In *Andy Warhol*, edited by Annette Michelson. Vol. 2 of *October Files*, 69-88. Cambridge, MA: MIT Press, 2001.

———. *The First Pop Age: Painting and Subjectivity in the Art of Hamilton, Lichtenstein, Warhol, Richter, and Ruscha*. Princeton, NJ: Princeton University Press, 2012.

Foster, Hal, Rosalind Krauss, Yve-Alain Bois and Benjamin H. D. Buchloh. *Art Since 1900: Modernism, Antimodernism, Postmodernism*. 2 vols. New York: Thames & Hudson, 2004.

Foster, Stephen C., and Rudolf E. Kuenzli, eds. *Dada Spectrum: The Dialectics of Revolt*. Madison, WI: Coda Press and University of Iowa, 1979.

Franciscono, Marcel. *Paul Klee: His Work and Thought*. Chicago: University of Chicago Press, 1991.

Fried, Michael. "New York Letter." *Art International* 6, no. 10 (December 20, 1962): 54-58.

Friedel, Helmut, ed. *Vasily Kandinsky: A Colorful Life*. Translated by Hugh Beyer. Cologne: Dumont; New York: Abrams, 1995.

Friedman, B. H. *Jackson Pollock: Energy Made Visible*. New York: McGraw-Hill, 1972.

Fryberger, Betsy G., et al. *Picasso: Graphic Magician, Prints from the Norton Simon Museum*. Palo Alto, CA: Iris and B. Gerald Cantor Center for the Visual Arts at Stanford University, 1998.

Gablik, Suzi. *The Re-Enchantment of Art*. New York: Thames & Hudson, 1991.

Gadamer, Hans-Georg. *The Relevance of the Beautiful and Other Essays*. Edited by Robert Bernasconi. Cambridge: Cambridge University Press, 1986.

Gambone, Robert L. *Art and Popular Religion in Evangelical America, 1915–1940*. Knoxville: University of Tennessee Press, 1989.

Gamwell, Lynn. *Exploring the Invisible: Art, Science, and the Spiritual*. Princeton, NJ: Princeton University Press, 2002.

Gasque, Laurel. *Art and the Christian Mind: The Life and Work of H. R. Rookmaaker*. Wheaton, IL: Crossway, 2005.

Gatrall, Jefferson J. A., and Douglas Greenfield, eds. *Alter Icons: The Russian Icon and Modernity*. University Park, PA: Penn State University Press, 2010.

Gay, Peter. *Modernism: The Lure of Heresy*. New York: W. W. Norton, 2008.

Geldzahler, Henry. "Andy Warhol." *Art International* 8, no. 3 (April 25, 1964): 34-35.

———. "A Symposium on Pop Art." Edited by Peter Selz. *Arts Magazine*, April 1963, 35-45.

Gill, Eric. *Eric Gill: Autobiography*. London: Cape, 1940.

Godfrey, Tony. *Conceptual Art*. London: Phaidon, 1998.

———. *Vincent van Gogh: Letters to Émile Bernard*. Edited and translated by Douglas Lord. New York: Museum of Modern Art, 1938.

Golding, John. *Paths to the Absolute: Mondrian, Malevich, Kandinsky, Pollock, Newman, Rothko, and Still*. Princeton, NJ: Princeton University Press, 2000.

Gopnik, Adam. "The Art World: The Innocent." *New Yorker*, April 10, 1989, 109.

Gorringe, T. J. *Earthly Visions: Theology and the Challenges of Art*. New Haven, CT: Yale University Press, 2011.

Gorski, Philip S., ed. *The Post-Secular in Question: Religion in Contemporary Society*. Brooklyn, NY: Social Science Research Council, 2012.

Gray, Nicolete. *The Paintings of David Jones*. London: John Taylor, Lund Humphries and Tate Gallery, 1989.

Green, Christopher. *Art in France, 1900–1940*. New Haven, CT: Yale University Press, 2000.

Greenberg, Clement. "The Present Prospects of American Painting and Sculpture." *Horizon*, October 1947, 20-29.

Gregory, Brad S. *The Unintended Reformation: How a Religious Revolution Secularized Society*. Cambridge, MA: Belknap / Harvard University Press, 2013.

Grewe, Cordula. *The Nazarenes: Romantic Avant-Garde and the Art of the Concept.* University Park, PA: Penn State University Press, 2015.

Griffiths, Richard. *The Reactionary Revolution: Catholic Revival in French Literature, 1870–1914.* London: Constable, 1966.

Gross, Jennifer R., ed. *The Société Anonyme: Modernism for America.* New Haven, CT: Yale University Press, 2006.

Guérin, Daniel, ed. *The Writings of a Savage: Paul Gauguin.* Translated by Eleanor Levieux. New York: Viking Press, 1978.

Gunton, Colin. *The One, the Three, and the Many: God, Creation and the Culture of Modernity.* Cambridge: Cambridge University Press, 1993.

Haftmann, Werner. *Painting in the Twentieth Century.* Edited and translated by Ralph Manheim. 2 vols. New York: Praeger, 1965.

Halttunen, Karen, ed. *A Companion to American Cultural History.* Malden, MA: Blackwell, 2008.

Hammer, Michael. *Graham Sutherland: Landscapes, War Scenes, Portraits, 1924–1950.* London: Scala, 2005.

Harned, David B. *Theology and the Arts.* Philadelphia: Westminster Press, 1966.

Harris, Jonathan. *The New Art History: A Critical Introduction.* New York: Routledge, 2001.

Harrison, Charles. *English Art and Modernism, 1900–1939.* New Haven, CT: Yale University Press, 1981.

———. *Modernism.* Cambridge: Cambridge University Press, 1997.

Harrison, Charles, and Paul Wood, eds. *Art in Theory, 1900–2000: An Anthology of Changing Ideas.* Malden, MA: Blackwell, 2003.

Harrison, Charles, Paul Wood and Jason Gaiger, eds. *Art in Theory, 1815–1900: An Anthology of Changing Ideas.* Malden, MA: Blackwell, 1998.

Hazelton, Roger. *A Theological Approach to Art.* Nashville: Abingdon, 1967.

Heartney, Eleanor. *Postmodern Heretics: The Catholic Imagination in Contemporary Art.* New York: Midmarch Arts Press, 2004.

Hegeman, David Bruce. "The Importance of Hans Rookmaaker." *Comment Magazine* 22, no. 9 (November 1, 2004). www.cardus.ca/comment/article/244/the-importance -of-hans-rookmaaker.

Heller, Ena Giurescu, ed. *Reluctant Partners: Art and Religion in Dialogue.* New York: Gallery at the American Bible Society, 2004.

Hempton, David. *Evangelical Disenchantment: Nine Portraits of Faith and Doubt.* New Haven, CT: Yale University Press, 2008.

Herbert, Robert. "Godfather of the Modern?" *New York Review of Books,* August 13, 2009, 21.

Heyer, George S. *Signs of Our Times: Theological Essays on Art in the 20th Century.* Grand Rapids: Eerdmans, 1980.

Higley, Sarah L. *Hildegard of Bingen's Unknown Language: An Edition, Translation, and Discussion.* London: Palgrave Macmillan, 2007.

Hills, Patricia. "'Truth, Freedom, Perfection': Alfred Barr's *What Is Modern Painting?* as Cold War Rhetoric." In *Pressing the Fight: Print, Propaganda, and the Cold War,* edited by Greg Barnhisel and Catherine Turner, 251-75. Amherst: University of Massachusetts Press, 2010.

Hlavajova, Maria, Sven Lütticken and Jill Winder, eds. *The Return of Religion and Other Myths: A Critical Reader in Contemporary Art.* Utrecht: BAK and Post Editions, 2009.

Hofmann, Werner. *Caspar David Friedrich.* London: Thames & Hudson, 2000.

Holifield, E. Brooks. *Theology in America: Christian Thought from the Age of the Puritans to the Civil War.* New Haven, CT: Yale University Press, 2003.

Holmes, Lewis M. *Kosegarten: The Turbulent Life and Times of a Northern German Poet.* New York: Peter Lang, 2004.

———. *Kosegarten's Cultural Legacy: Aesthetics, Religion, Literature, Art, and Music.* New York: Peter Lang, 2005.

Hopkins, David. *Marcel Duchamp and Max Ernst.* Oxford: Clarendon Press, 1998.

Hopps, Walter, ed. *Robert Rauschenberg.* Washington, DC: Smithsonian Institution, 1976.

———. *Robert Rauschenberg: The Early 1950s.* Houston: Houston Fine Art Press and Menil Foundation, 1991.

Hopps, Walter, and Susan Davidson, eds. *Robert Rauschenberg: A Retrospective.* New York: Guggenheim, 1998. Exhibition catalog.

Huelsenbeck, Richard. *En Avant Dada.* In *The Dada Painters and Poets: An Anthology,* edited by Robert Motherwell, 21-47. New York: Wittenborn, 1951.

Huffington, Arianna. *Picasso: Creator and Destroyer.* New York: Avon Books, 1988.

Huntington, David C. "Church and Luminism: Light for America's Elect." In *American Light: The Luminist Movement, 1850–1875,* edited by John Wilmerding, 155-90. Washington, DC: National Gallery of Art, 1980. Exhibition catalog.

Ivanov, Sergey A. *Holy Fools in Byzantium and Beyond.* Translated by Simon Franklin. Oxford: Oxford University Press, 2006.

Jameson, Frederic. *The Modernist Papers.* New York: Verso, 2007.

Janecek, Gerald. *Zaum: The Transrational Poetry of Russian Futurism.* San Diego, CA: San Diego State University Press, 1996.

Johns, Elizabeth. "Albert Pinkham Ryder: Some Thoughts on His Subject Matter." *Arts* 54 (November 1979): 164-71.

Jones, Caroline. "Caroline Jones Responds [to James Elkins, 'From Bird-Goddesses to Jesus 2000']." *Thresholds* 25 (2002): 83.

Jones, Zoë Marie. "Spiritual Crisis and the 'Call to Order': The Early Aesthetic Writings of Gino Severini and Jacques Maritain." *Word and Image* 26, no. 1 (January-March 2010): 59-67.

Joseph, Branden W. *Random Order: Robert Rauschenberg and the Neo-Avant-Garde.* Cambridge, MA: MIT Press, 2003.

———. "White on White." *Critical Inquiry* 27, no. 1 (Autumn 2000): 90-121.

Jüngel, Eberhard. "Metaphorical Truth: Reflections on Theological Metaphor as a Contribution to a Hermeneutics of Narrative Theology." In *Theological Essays,* 16-71. New York: Bloomsbury T&T Clark, 2014.

Kandinsky, Vasily. *Kandinsky: Complete Writings on Art.* Edited by Kenneth C. Lindsay and Peter Vergo. Boston: Hall, 1982. Reprint with new preface and additional plates, Boston: Da Capo Press, 1994.

Kandinsky, Vasily, and Franz Marc, eds. *The Blaue Reiter Almanac.* 1912. Reprint, edited by Klaus Lankheit, translated by Henning Falkenstien. New York: Viking Press, 1974.

Kantor, Sybil Gordon. *Alfred H. Barr, Jr., and the Intellectual Origins of the Museum of Modern Art.* Cambridge, MA: MIT Press, 2002.

Kaprow, Allan. *Essays on the Blurring of Art and Life.* Edited by Jeff Kelley. Expanded ed. Los Angeles: University of California Press, 2003.

Karmel, Pepe, ed. *Jackson Pollock: Interviews, Articles, and Reviews.* New York: Museum of Modern Art, 1999.

Kaufmann, Eric. *Shall the Religious Inherit the Earth? Demography and Politics in the Twenty-First Century.* London: Profile Books, 2011.

Kaufmann, Eric, Anne Goujon and Vegard Skirbekk. "The End of Secularization in Europe? A Socio-Demographic Perspective." *Sociology of Religion* 73, no. 1 (Spring 2012): 69-91.

———. "Secularism, Fundamentalism, or Catholicism? The Religious Composition of the United States to 2043." *Journal for the Scientific Study of Religion* 49, no. 2 (June 2010): 293-310.

Kelly, Franklin. *Thomas Cole's Paintings of Eden.* Fort Worth: Amon Carter Museum, 1994. Exhibition catalog.

Kemfert, Beate, ed. *Natalia Goncharova: Between Russian Tradition and European Modernism.* Ostfildern, Germany: Hatje Cantz, 2009. Exhibition catalog.

Klaric, Arlette. "Arthur G. Dove's Abstract Style of 1912: Dimensions of the Decorative and Bergsonian Realities." PhD diss., University of Wisconsin, 1984.

Klee, Paul. *The Diaries of Paul Klee, 1898–1918.* Edited by Felix Klee. Translated by

Pierre B. Schneider, R. Y. Zachary and Max Knight. Berkeley: University of California Press, 1964.

Knight, Janice. *Orthodoxies in Massachusetts: Rereading American Puritanism.* Cambridge, MA: Harvard University Press, 1994.

Koerner, Joseph Leo. *Caspar David Friedrich and the Subject of Landscape.* 2nd ed. London: Reaktion Books, 2009.

Kojecky, Roger. *T. S. Eliot's Social Criticism.* London: Faber & Faber, 1971.

Kosky, Jeffrey L. *Arts of Wonder: Enchanting Secularity—Walter De Maria, Diller + Scofidio, James Turrell, Andy Goldsworthy.* Chicago: University of Chicago Press, 2013.

Kostelanetz, Richard. *Conversing with Cage.* 2nd ed. New York: Routledge, 2003.

Kramer, Cheryl. "Natalia Goncharova: Her Depiction of Jews in Tsarist Russia." *Woman's Art Journal* 23, no. 1 (Spring-Summer 2002): 17-23.

Krauss, Rosalind. "Grids." *October* 9 (Spring 1979): 50-64.

———. "The Sculpture of David Smith." PhD diss., Harvard University, 1969.

Kuklick, Bruce. *Churchmen and Philosophers: From Jonathan Edwards to John Dewey.* New Haven, CT: Yale University Press, 1985.

Kuspit, Donald B. "The Contemporary and the Historical." *Artnet*, April 2005. www .artnet.com/magazine/features/kuspit/kuspit4-14-05.asp.

———. *Redeeming Art: Critical Reveries.* Edited by Mark Van Proyen. New York: Allworth Press and the School of Visual Arts, 2000.

Kuyper, Abraham. *Lectures on Calvinism: The Stone Foundation Lectures.* Grand Rapids: Eerdmans, 1931.

Lamoureux, Johanne. "Ending the Myths and Catholic Outing of Andy Warhol." In *Precarious Visualities: New Perspectives on Identification in Contemporary Art and Visual Culture*, edited by Olivier Asselin, Johanne Lamoureux and Christine Ross, 100-119. Montreal: McGill-Queens University Press, 2008.

Landau, Ellen G. *Jackson Pollock.* New York: Abrams, 1989.

Langhorne, Elizabeth. "The Magus and the Alchemist: John Graham and Jackson Pollock." *American Art* 12, no. 3 (1998): 46-67.

Levin, Sandra Gail. "Wassily Kandinsky and the American Avant-Garde, 1912–1950." PhD diss., Rutgers University, 1976.

Lewer, Debbie. "Hugo Ball, Iconoclasm, and the Origins of Dada in Zurich." *Oxford Art Journal* 32, no. 1 (2009): 17-35.

Lodder, Christina. "Living in Space." In *Rethinking Malevich*, edited by Charlotte Douglas and Christina Lodder. London: Pindar, 2007.

Lossky, Vladimir. *The Mystical Theology of the Eastern Church.* Crestwood, NY: St. Vladimir's Seminary Press, 1957.

Lövgren, Sven. *The Genesis of Modernism: Seurat, Van Gogh, and French Symbolism in the 1880s*. Stockholm: Almqvist & Wiksell, 1959.

MacCarthy, Fiona. *Eric Gill: A Lover's Quest for Art and God*. New York: Dutton, 1989.

Mann, Philip. *Hugo Ball: An Intellectual Biography*. London: Institute of Germanic Studies, 1987.

———. "Hugo Ball and the 'Magic Bishop' Episode: A Reconsideration." *New German Studies* 4, no. 1 (Spring 1976): 43-52.

Manville, Bill. "Boris Lurie, March Gallery, Images of Life." *Village Voice*, June 16, 1960.

Marcadé, Jean-Claude. "Malevich, Paintings, and Writing: On the Development of a Suprematist Philosophy." In *Kazimir Malevich: Suprematism*, edited by Matthew Drutt. New York: Guggenheim Museum, 2003. Exhibition catalog.

Maritain, Jacques. *Art and Scholasticism and the Frontiers of Poetry*. Translated by Joseph W. Evans. New York: Scribner, 1962.

———. *Creative Intuition in Art and Poetry*. New York: Meridian, 1954.

Marquis, Alice Goldfarb. *Alfred H. Barr, Jr.: Missionary for the Modern*. Chicago: Contemporary Books, 1989.

Mathews, Marcia M. *Henry Ossawa Tanner: American Artist*. Chicago: University of Chicago, 1969.

Mattison, Robert S. *Robert Rauschenberg: Breaking Boundaries*. New Haven, CT: Yale University Press, 2003.

Maunier, George. "The Nature of Nabi Symbolism." *Art Journal* 23 (Winter 1963–1964): 96-102.

McCoubrey, John W., ed. *American Art: Sources and Documents, 1700–1960*. Englewood Cliffs, NJ: Prentice Hall, 1965.

Melville, Herman. *Moby-Dick*. New York: Harper, 1851.

Menefee, Ellen Avitts. "The Early Biblical Landscapes of Thomas Cole, 1825–1829." Master's thesis, Rice University, 1987.

Michalski, Sergiusz. *The Reformation and the Visual Arts: The Protestant Image Question in Western and Eastern Europe*. New York: Routledge, 1993.

Michelson, Annette, ed. *Andy Warhol*. Vol. 2 of *October Files*. Cambridge, MA: MIT Press, 2001.

Milbank, John. *Theology and Social Theory: Beyond Secular Reason*. 2nd ed. Malden, MA: Wiley-Blackwell, 2006.

Miles, Jonathan, and Derek Shiel. *David Jones: The Maker Unmade*. Bidgend, Wales: Seren, 1995.

Miller, David C., ed. *American Iconology: New Approaches to Nineteenth-Century Art and Literature*. New Haven, CT: Yale University Press, 1994.

Miller, Perry. *Errand into the Wilderness*. Cambridge, MA: Belknap / Harvard University Press, 1956.

Milner, John. *Kazimir Malevich and the Art of Geometry*. New Haven, CT: Yale University Press, 1996.

———. "Malevich: Becoming Russian." In *Malevich*, edited by Achim Borchardt-Hume, 34-38. London: Tate Publishing, 2014. Exhibition catalog.

———. *Mondrian*. New York: Abbeville, 1992.

Misler, Nicoletta. "Apocalypse and the Russian Peasantry: The Great War in Natalia Goncharova's Primitivist Paintings." *Experiment: A Journal of Russian Culture* 4, no. 1 (1998): 62-76.

Morgan, David. *The Forge of Vision: A Visual History of Modern Christianity*. Oakland: University of California Press, 2015.

———. "Visual Religion." *Religion* 30 (2000): 41-53.

Mosby, Dewey F. *Across Continents and Cultures: The Art and Life of Henry Ossawa Tanner*. Kansas City, MO: Nelson-Atkins Museum of Art, 1995.

Mosby, Dewey F., Darrell Sewell and Rae Alexander-Minter. *Henry Ossawa Tanner*. Philadelphia: Philadelphia Museum of Art, 1991. Exhibition catalog.

Müller-Westermann, Iris, ed. *Hilma af Klint: A Pioneer of Abstraction*. Stockholm: Moderna Museet and Hatje Cantz Verlag, 2013. Exhibition catalog.

Naifeh, Steven, and Gregory White Smith. *Van Gogh: The Life*. New York: Random House, 2011.

Nakov, Andréi. *Malevich: Painting the Absolute*. 4 vols. Burlington, VT: Lund Humphries, 2010.

Nelson, Robert. *The Spirit of Secular Art: A History of the Sacramental Roots of Contemporary Artistic Values*. Melbourne: Monash University ePress, 2007.

Nelson, Robert S., and Richard Shiff, eds. *Critical Terms for Art History*. 2nd ed. Chicago: University of Chicago Press, 2006.

Newton, Eric. *Stanley Spencer*. Harmondsworth, UK: Penguin, 1947.

Noble, Louis L. *The Life and Works of Thomas Cole*. Edited by Elliot S. Vesell. Cambridge, MA: Belknap / Harvard University Press, 1964.

Novak, Barbara. *Nature and Culture: American Landscape Painting, 1825–1875*. 3rd ed. New York: Oxford University Press, 2007.

O'Doherty, Brian. *American Masters: The Voice and the Myth*. New York: Random House, 1974.

Panofsky, Erwin. "Comments on Art and Reformation." In *Symbols in Transformation: Iconographic Themes at the Time of the Reformation*, edited by Craig Harbison, 9-14. Princeton, NJ: Princeton University Art Museum, 1969. Exhibition catalog.

Parton, Anthony. *Goncharova: The Art and Design of Natalia Goncharova.* Woodbridge, UK: Antique Collectors' Club, 2010.

Perlman, Bernard B. *Robert Henri: His Life and Art.* Mineola, NY: Dover, 1991.

Perlmutter, Dawn, and Debra Koppman, eds. *Reclaiming the Spiritual in Art: Contemporary Cross-Cultural Perspectives.* Albany: SUNY Press, 1999.

Petrova, Yevgenia, ed. *Kazimir Malevich: In the Russian Museum.* St. Petersburg: State Russian Museum and Palace Editions, 2000.

———, ed. *Origins of the Russian Avant-Garde.* St. Petersburg: Palace Editions, 2003.

Pichard, Joseph. *L'Art sacré moderne.* Paris: Arthaud, 1953. Exhibition catalog.

Poggioli, Renato. *The Theory of the Avant-Garde.* Translated by Gerald Fitzgerald. Cambridge, MA: Belknap / Harvard University Press, 1968.

Polistena, Joyce Carol. "Historicism and Scenes of 'The Passion' in Nineteenth-Century French Romantic Painting." In *ReVisioning: Critical Methods of Seeing Christianity in the History of Art,* edited by James Romaine and Linda Stratford, 260-75. Eugene, OR: Cascade Books, 2013.

———. *The Religious Paintings of Eugène Delacroix (1798–1863): The Initiator of the Style of Modern Religious Art.* Lewiston, NY: Mellen, 2008.

Preziosi, Donald. *Art, Religion, Amnesia: The Enchantments of Credulity.* New York: Routledge, 2014.

Preziosi, Donald, and Claire Farago. *Art Is Not What You Think It Is.* Malden, MA: Wiley-Blackwell, 2012.

Promey, Sally M. "Interchangeable Art: Warner Sallman and the Critics of Mass Culture." In *Icons of American Protestantism: The Art of Warner Sallman,* edited by David Morgan, 149-80. New Haven, CT: Yale University Press, 1996.

———. "The 'Return' of Religion in the Scholarship of American Art." *Art Bulletin* 85, no. 3 (September 2003): 581-603.

———, ed. *Sensational Religion: Sensory Culture in Material Practice.* New Haven, CT: Yale University Press, 2014.

———. "Situating Visual Culture." In *A Companion to American Cultural History,* edited by Karen Halttunen, 279-94. Malden, MA: Blackwell, 2008.

Provence, M. "Cézanne chrétien." *Revue des Lettres,* December 1924.

Rauschenberg, Robert. Video interview with David A. Ross, Walter Hopps, Gary Garrels and Peter Samis, San Francisco Museum of Modern Art, May 6, 1999. Unpublished transcript at the SFMOMA Research Library and Archives, N6537. R27 A35 1999a.

Raverty, Dennis. *Struggle over the Modern: Purity and Experience in American Art Criticism, 1900–1960.* Madison, NJ: Fairleigh Dickinson University Press, 2005.

Read, Herbert. *Art Now: An Introduction to the Modern Theory of Painting and Sculpture.* 2nd ed. London: Faber & Faber, 1960.

Reuther, Manfred. *Emil Nolde: The Religious Paintings.* Translated by Sean Gallagher. Köln: Nolde Stiftung Seebüll and DuMont Buchverlag, 2011. Exhibition catalog.

Revill, David. *The Roaring Silence: John Cage; A Life.* New York: Arcade, 1992.

Rewald, John. *Post-Impressionism: From Van Gogh to Gauguin.* 3rd ed. New York: Museum of Modern Art, 1986.

———, ed. *Paul Cézanne: Correspondance.* Paris: Grasset, 1978.

Rewald, John, Dore Ashton and Harold Joachim. *Odilon Redon, Gustave Moreau, Rodolphe Bresdin.* New York: Museum of Modern Art, 1961. Exhibition catalog.

Reynolds, David S. *Walt Whitman's America: A Cultural Biography.* New York: Knopf, 1995.

Richards, Elizabeth. "Rauschenberg's Religion: Autobiography and Spiritual Reference in Rauschenberg's Use of Textiles." *Southeastern College Art Conference Review* 16, no. 1 (2011): 39-48.

Richardson, John. *Andy Warhol: Heaven and Hell Are Just One Breath Away! Late Paintings and Related Works, 1984–1986.* New York: Gagosian Gallery and Rizzoli, 1992.

———. "How Political Was Picasso?" *New York Review of Books,* November 25, 2010.

———. "Rauschenberg's Epic Vision." *Vanity Fair* 445 (September 1997): 278-89.

Richardson, Robert Jr. *Emerson: The Mind on Fire.* Berkeley: University of California Press, 1994.

Robbins, Bruce. "Enchantment? No, Thank You." In *The Joy of Secularism: 11 Essays for How We Live Now,* edited by George Levine, 74-94. Princeton, NJ: Princeton University Press, 2011.

Robbins, Daniel. *Albert Gleizes, 1881–1953: A Retrospective Exhibition.* New York: Solomon R. Guggenheim Foundation, 1964. Exhibition catalog.

Roberts, Sarah. "*White Painting* [three panel]," *Rauschenberg Research Project,* San Francisco Museum of Modern Art (July 2013). www.sfmoma.org/explore/collection /artwork/25855/essay/white_painting.

Romaine, James, ed. *Art as Spiritual Perception: Essays in Honor of E. John Walford.* Wheaton, IL: Crossway Books, 2012.

Romaine, James, and Linda Stratford, eds. *ReVisioning: Critical Methods of Seeing Christianity in the History of Art.* Eugene, OR: Cascade Books, 2013.

Rookmaaker, H. R. *Art Needs No Justification.* Downers Grove, IL: InterVarsity Press, 1978.

———. *The Complete Works of Hans R. Rookmaaker.* 6 vols. Edited by Marleen Hengelaar-Rookmaaker. Carlisle, UK: Piquant, 2003.

————. *Modern Art and the Death of a Culture*. Downers Grove, IL: InterVarsity Press, 1970. Reprint, Wheaton, IL: Crossway Books, 1994.

————. "Synthetist Art Theories: Genesis and Nature of the Ideas on Art of Gauguin and His Circle." PhD diss., University of Amsterdam, 1959. Published as *Gauguin and Nineteenth-Century Art Theory*. Amsterdam: Swets & Zeitlinger, 1972.

Rose, Barbara, ed. *Readings in American Art: A Documentary Survey*. New York: Praeger, 1968.

————. "Seeing Rauschenberg Seeing." *Artforum* 47, no. 1 (September 2008): 432-36.

Rose, June. *Demons and Angels: A Life of Jacob Epstein*. London: Constable, 2002.

Rosen, Aaron. *Art + Religion in the 21st Century*. New York: Thames & Hudson, 2015.

Rosenblum, Robert. "The Abstract Sublime." *ARTnews* 59, no. 10 (February 1961): 38-41, 56, 58.

————. *Modern Painting and the Northern Romantic Tradition: Friedrich to Rothko*. 1975. Reprint, New York: Harper & Row, 1988.

Rosenblum, Robert, and H. W. Janson. *Art of the Nineteenth Century: Painting and Sculpture*. London: Thames & Hudson, 1984.

Röthel, Hans Konrad. *The Blue Rider*. New York: Praeger, 1971.

————. *Vasily Kandinsky: Painting on Glass*. Translated by Alfred Werner. New York: Solomon R. Guggenheim Museum, 1966. Exhibition catalog.

Rothenstein, Elizabeth. *Stanley Spencer*. Oxford: Phaidon, 1945.

Rouault, Georges. *Soliloques*. Neuchâtel: Ides et Calendes, 1944.

Rouault, Georges, and André Suarès. "Moreau." *L'Art et les artistes* (April 1926).

Ruskin, John. *Modern Painters* (1843–1860). 4th ed. 5 vols. New York: Wiley and Sons, 1890.

Rybczynski, Witold. *A Clearing in the Distance: Frederick Law Olmsted and America in the Nineteenth Century*. New York: Scribner, 1999.

Saint-Martin, Isabelle. "Christ, Pietà, Cène, à l'affiche: écart et transgression dans la publicité et le cinéma." *Ethnologie française* 36, no. 1 (2006): 65-81.

Sandler, Irving. *The New York School: The Painters and Sculptors of the Fifties*. New York: Harper & Row, 1978.

————. *The Triumph of American Painting: A History of Abstract Expressionism*. New York: Harper & Row, 1970.

Sandler, Irving, and Amy Newman, eds. *Defining Modern Art: Selected Writings of Alfred H. Barr, Jr*. New York: Abrams, 1986.

Sanouillet, Michel. "Dada: A Definition." In *Dada Spectrum: The Dialectics of Revolt*, edited by Stephen C. Foster and Rudolf E. Kuenzli, 15-27. Madison, WI: Coda Press and University of Iowa, 1979.

Schapiro, Meyer. *Modern Art: 19th and 20th Centuries; Selected Papers*. New York: Braziller, 1979.

———. *Vincent van Gogh*. New York: Abrams, 1950.

Schleiermacher, Friedrich Daniel Ernst. *On Religion: Speeches to Its Cultured Despisers*. 1799. Translated and edited by Richard Crouter. 2nd ed. Cambridge: Cambridge University Press, 1996.

Schloesser, Stephen. *Jazz Age Catholicism: Mystic Modernism in Postwar Paris, 1919–1933*. Toronto: University of Toronto Press, 2005.

Schmidt, Otto. *Die Ruine Eldena im Werk von Caspar David Friedrich*. Vol. 25 of *Der Kunstbriefe*. Berlin: Mann, 1944.

Schmied, Wieland. *Caspar David Friedrich*. Translated by Russell Stockman. New York: Abrams, 1995.

Schuré, Édouard. *Les grands initiés: Esquisse de l'histoire secrète des religions*. Rev. ed. 1921. Reprint, Paris: Librairie Académique Perrin, 1960.

Schwain, Kristin. *Signs of Grace: Religion and American Art in the Gilded Age*. Utica, NY: Cornell University Press, 2008.

Scott, Gail R. *Marsden Hartley*. New York: Abbeville Press, 1988.

Seerveld, Calvin. *A Christian Critique of Art and Literature*. Toronto: Association for Reformed Scientific Studies, 1968.

———. *Rainbows for the Fallen World: Aesthetic Life and Artistic Task*. Toronto: Tuppence Press, 1980.

Selz, Peter Howard. "John Heartfield's Photomontages." *The Massachusetts Review* 4, no. 2 (Winter 1963): 309-36.

Sharp, Jane Ashton. "Natalia Goncharova." In *Amazons of the Avant-Garde: Alexandra Exter, Natalia Goncharova, Liubov Popova, Olga Rozanova, Varvara Stepanova, Nadezhda Udaltsova*, edited by John E. Bowlt and Matthew Drutt, 155-65. New York: Guggenheim Museum, 2000.

———. *Russian Modernism Between East and West: Natal'ia Goncharova and the Moscow Avant-Garde*. Cambridge: Cambridge University Press, 2006.

Shatskikh, Aleksandra. *Black Square: Malevich and the Origin of Suprematism*. Translated by Marian Schwartz. New Haven, CT: Yale University Press, 2012.

Sheehan, Jonathan. *The Enlightenment Bible: Translation, Scholarship, Culture*. Princeton, NJ: Princeton University Press, 2007.

Sheppard, Richard. "Dada and Mysticism: Influences and Affinities." In *Dada Spectrum: The Dialectics of Revolt*, edited by Stephen C. Foster and Rudolf E. Kuenzli. Madison, WI: Coda Press and University of Iowa, 1979.

Sherman, Frederic Fairchild. *Albert Pinkham Ryder*. New York, privately printed, 1920.

Siedell, Daniel A. *God in the Gallery: A Christian Embrace of Modern Art.* Grand Rapids: Baker Academic, 2008.

———. *Who's Afraid of Modern Art? Essays on Modern Art & Theology in Conversation.* Eugene, OR: Cascade, 2015.

Siegel, Jeanne. *Artwords: Discourse on the '60s and '70s.* Ann Arbor, MI: UMI Research Press, 1985. Reprint, New York: Da Capo Press, 1992.

Silverman, Debora. *Van Gogh and Gauguin: The Search for Sacred Art.* New York: Farrar, Straus & Giroux, 2000.

Simmel, Georg. "The Metropolis and the Mental Life." Translated by H. H. Gerth and C. Wright Mills. In *The Sociology of Georg Simmel,* edited by Kurt H. Wolff, 409-24. Glencoe, IL: Free Press, 1950.

Simon, Walter Augustus. "Henry O. Tanner: A Study of the Development of an American Negro Artist, 1859–1937." PhD diss., New York University, 1961.

Smith, James K. A. *How (Not) to Be Secular: Reading Charles Taylor.* Grand Rapids: Eerdmans, 2014.

Smith, Terry. "Contemporary Art and Contemporaneity." *Critical Inquiry* 32 (Summer 2006): 681-707.

Solomon, Alan. *Andy Warhol.* Boston: Institute of Contemporary Art, 1966. Exhibition catalog.

Sontag, Susan. *On Photography.* New York: Farrar, 1977.

Sorkin, David. *The Religious Enlightenment: Protestants, Jews, and Catholics from London to Vienna.* Princeton, NJ: Princeton University Press, 2011.

Spira, Andrew. *The Avant-Garde Icon: Russian Avant-Garde Art and the Icon Painting Tradition.* Burlington, VT: Lund Humphries, 2008.

Spretnak, Charlene. *The Spiritual Dynamic in Modern Art: Art History Reconsidered, 1800 to the Present.* New York: Palgrave Macmillan, 2014.

Stark, Rodney. "Secularization, R.I.P." *Sociology of Religion* 60, no. 3 (Fall 1999): 249-73.

Steinberg, Leo. *Other Criteria: Confrontations with Twentieth-Century Art.* New York: Oxford University Press, 1972. Reprint, Chicago: University of Chicago Press, 2007.

Stiles, Kristine, and Peter Selz, eds. *Theories and Documents of Contemporary Art: A Sourcebook of Artists' Writings.* Berkeley: University of California Press, 1996.

Stoker, Wessel. *Where Heaven and Earth Meet: The Spiritual in the Art of Kandinsky, Rothko, Warhol, and Kiefer.* Translated by Henry Jansen. New York: Rodopi, 2012.

Sund, Judy. "The Sower and the Sheaf: Biblical Metaphor in the Art of Vincent van Gogh." *Art Bulletin* 70, no. 4 (December 1988): 660-76.

Sutherland, Graham. "Trends in English Draughtsmanship." *Signature,* no. 3 (July 1936).

Sutton, Denys. *Gauguin and the Pont-Aven Group*. London: Tate Gallery, 1966.

Swatos, William H., Jr., and Peter Kivisto. "Max Weber as 'Christian Sociologist.'" *Journal for the Scientific Study of Religion* 30, no. 4 (1991): 347-62.

Taylor, Charles. *Modern Social Imaginaries*. Durham, NC: Duke University Press, 2004.

———. *A Secular Age*. Cambridge, MA: Belknap / Harvard University Press, 2007.

Taylor, Mark C. *Refiguring the Spiritual: Beuys, Barney, Turrell, Goldsworthy*. New York: Columbia University Press, 2012.

Teilhet-Fisk, Jehanne. *Paradise Reviewed: An Interpretation of Gauguin's Polynesian Symbolism*. Ann Arbor, MI: UMI Research Press, 1983.

Tillich, Paul. "Contemporary Visual Arts and the Revelatory Character of Style." In *On Art and Architecture*, edited by John Dillenberger and Jane Dillenberger, 126-38. New York: Crossroad, 1987.

Toussaint, Hélène. *Gustave Courbet*. London: Arts Council of Great Britain, 1978.

Trapp, Frank Anderson. *The Attainment of Delacroix*. Baltimore: Johns Hopkins University Press, 1971.

Tuchman, Maurice, ed. *The Spiritual in Art: Abstract Painting, 1890–1985*. Los Angeles: Los Angeles County Museum of Art; New York: Abbeville Press, 1986. Exhibition catalog.

Tymn, Marshall, ed. *Thomas Cole: The Collected Essays and Prose Sketches*. St. Paul, MN: John Colet Press, 1980.

van Gogh, Vincent. *Vincent van Gogh, The Letters: The Complete Illustrated and Annotated Edition*. Edited and translated by Leo Jansen, Hans Luijten and Nienke Bakker. 6 vols. Amsterdam: Van Gogh Museum and Huygens ING; New York: Thames & Hudson, 2009. vangoghletters.org.

Van Prooyen, Kristina. "The Realm of the Spirit: Caspar David Friedrich's Artwork in the Context of Romantic Theology, with Special Reference to Friedrich Schleiermacher." *Journal of the Oxford University History Society* 2 (2004). sites.google.com/site/jouhsinfo/issue2%28trinity2004%29.

Varnedoe, Kirk. *Northern Light: Nordic Art at the Turn of the Century*. New Haven, CT: Yale University Press, 1988.

———. *Pictures of Nothing: Abstract Art Since Pollock*. Princeton, NJ: Princeton University Press, 2006.

Vaux, Kenneth L. *The Ministry of Vincent van Gogh in Religion and Art*. Eugene, OR: Wipf & Stock, 2012.

Wainwright, Lisa. "Rauschenberg's American Voodoo." *New Art Examiner* 25, no. 8 (May 1998): 28-33.

———. "Resurrecting the Christian Rauschenberg." In "Reading Junk: Thematic

Imagery in the Art of Robert Rauschenberg from 1952 to 1964." PhD diss., University of Illinois at Urbana-Champaign, 1993.

Walford, E. John. *Jacob van Ruisdael and the Perception of Landscape*. New Haven, CT: Yale University Press, 1991.

Wallach, Amei. "The Restless American: On Ed Ruscha's Road." *New York Times*, June 24, 2001.

Warhol, Andy. "Artist's Comment." *Art in America* 50, no. 1 (1962): 42.

———. *Philosophy of Andy Warhol: From A to B and Back Again*. Orlando: Harcourt, 1975.

Warhol, Andy, and Pat Hackett. *POPism: The Warhol '60s*. New York: Harcourt Brace Jovanovich, 1980.

Weber, Max. *From Max Weber: Essays in Sociology*. Translated and edited by H. H. Gerth and C. Wright Mills. New York: Oxford University Press, 1946.

———. *The Protestant Ethic and the Spirit of Capitalism*. 1930. Translated by Talcott Parsons. New York: Routledge, 1992.

Welsh, Robert P. "Mondrian and Theosophy." In *Piet Mondrian, 1872–1944: Centennial Exhibition*. New York: Solomon R. Guggenheim Foundation, 1971. Exhibition catalog.

Wessels, Anton. *Van Gogh and the Art of Living: The Gospel According to Vincent van Gogh*. Translated by Henry Jansen. Eugene, OR: Wipf & Stock, 2013.

White, Erdmute Wenzel. *The Magic Bishop: Hugo Ball, Dada Poet*. Columbia, SC: Camden House, 1998.

Wilde, Oscar. "The Critic as Artist" (1890). In *De Profundis, The Ballad of Reading Gaol & Other Writings*, 173-244. London: Wordsworth Classics, 2002.

Williams, Rowan. *Grace and Necessity: Reflections on Art and Love*. London: Morehouse, 2005.

Wilmerding, John. *American Art*. Middlesex, UK: Penguin, 1976.

———, ed. *American Light: The Luminist Movement, 1850–1875*. Washington, DC: National Gallery of Art, 1980. Exhibition catalog.

Wilton, Andrew, and Tim Barringer. *American Sublime: Landscape Painting in the United States, 1820–1880*. London: Tate Publishing, 2002. Exhibition catalog.

Wolterstorff, Nicholas. *Art in Action: Toward a Christian Aesthetic*. Grand Rapids: Eerdmans, 1980.

———. *Art Rethought: The Social Practices of Art*. Oxford: Oxford University Press, 2015.

———. "On Looking at Paintings: A Look at Rookmaaker." *Reformed Journal* 22, no. 2 (February 1872): 11-15.

Wood, Paul. *Conceptual Art*. London: Tate Publishing; New York: Delano Greenidge
 Editions, 2002.

Worley, Taylor. "Theology and Contemporary Visual Art: Making Dialogue Possible."
 PhD diss., University of St. Andrews, 2009.

Illustrations

4.6. Piet Mondrian (Dutch, 1872–1944), *Composition No. 10: Pier and Ocean*, 1915, oil on canvas, 85 × 108 cm. Kröller-Müller Museum.

4.7. Piet Mondrian (Dutch, 1872–1944), *Church Façade 1: Church at Domburg*, 1914, pencil, charcoal and ink on paper, 63 × 50.3 cm. Gemeentemuseum, The Hague.

4.8. Piet Mondrian (Dutch, 1872–1944), *Composition*, 1921, oil on canvas, 19 1/2 × 19 1/2 in. The Metropolitan Museum of Art, Jacques and Natasha Gelman Collection (1998), www.metmuseum.org.

4.9. Vasily Kandinsky, *All Saints Day II*, 1911. Städtische Galerie im Lenbachhaus, Munich.

5.1. Photograph of Malevich's installation at *The Last Futurist Exhibition of Paintings 0.10 (Zero-Ten)*, December 1915 to January 1916 at Natalia Dobychina's gallery in Petrograd.

5.2. Kazimir Malevich, *Head of a Peasant Man*, 1929–1932. Hermitage, St. Petersburg, Russia. HIP / Art Resource, NY. Used by permission.

5.3. Kazimir Malevich, *The Artist (Self-Portrait)*, 1933. Russian State Museum, St. Petersburg, Russia. HIP / Art Resource, NY. Used by permission.

5.4. Lambardos Emmanuel (Russian, 1587–1631), *The Virgin Hodegetria*, first half of the seventeenth century, 8.82 × 6.89 in. Benaki Museum, Athens.

5.5. Hugo Ball in his "magic bishop" costume for a performance of his *Lautgedichte*, 1916.

6.1. Frederic Edwin Church, *Heart of the Andes*, 1859.

6.2. Henry Ossawa Tanner (American, 1859–1937), *The Annunciation*, 1898, oil on canvas, 57 × 71 1/4 in. Philadelphia Museum of Art, purchased with the W. P. Wilstach Fund, 1899.

6.3. Marsden Hartley (American, 1877–1943), *The Dark Mountain, No. 2*, 1909, oil on paper, 20 × 24 in. The Metropolitan Museum of Art, Alfred Stieglitz Collection (1949), www.metmuseum.org.

6.4. Jackson Pollock, *Easter and the Totem*, 1953. © 2016 The Pollock-Krasner Foundation / Artists Rights Society (ARS), New York. Used by permission.

7.1. David Bailly, *Self-Portrait with Vanitas Symbols*, 1651, oil on wood, 65 × 97.5 cm. Stedelijk Museum De Lakenhal, Leiden.

COLOR INSERT

Plate 1. Paul Gauguin, *Vision After the Sermon [vision du sermon]: Jacob Wrestling with the Angel*, 1888, oil on canvas, 28.4 × 35.8 in. National Galleries of Scotland, Dist. RMN-Grand Palais / Art Resource, NY. Used by permission.

Plate 2. Vincent van Gogh (Dutch, 1853–1890), *The Sower*, 1888, oil on canvas, 32.5 × 40.3 cm. Van Gogh Museum, Amsterdam (Vincent van Gogh Foundation).

Plate 3. Caspar David Friedrich (German, 1774–1840), *Monk by the Sea*, 1808–1810, oil on canvas, 43 × 67.5 in. Alte Nationalgalerie, Berlin.

Plate 4. Vasily Kandinsky, *Composition 5*, 1911. © 2016 Artists Rights Society (ARS), New York. Used by permission.

Plate 5. Natalia Goncharova, *Saint Michael the Archangel*, 1910, oil on canvas, 63 × 51 in. Los Angeles County Museum of Art, purchased with funds provided by George Cukor. © 2016 Artists Rights Society (ARS), New York / ADAGP, Paris. Used by permission.

Plate 6. Thomas Cole, *Saint John the Baptist Preaching in the Wilderness*, 1827.

Plate 7. Albert Pinkham Ryder, *Jonah*, 1885. Oil on canvas, 27 1/4 × 34 3/8 in. Smithsonian American Art Museum, Washington, DC / Art Resource, NY. Used by permission.

Plate 8. Andy Warhol, *The Last Supper (Dove)*, 1986. © 2016 The Andy Warhol Foundation for the Visual Arts, Inc. / Artists Rights Society (ARS), New York. Digital Image © The Museum of Modern Art/Licensed by SCALA / Art Resource, NY. Used by permission.

General Index

References for images are in bold.